D1266812

Stuart Davis American Painter

Stuart Davis American Painter

by **Lowery Stokes Sims**

with contributions by

William C. Agee

Robert Hunter

Lewis Kachur

Diane Kelder

John R. Lane

Lisa J. Servon

Karen Wilkin

THE METROPOLITAN MUSEUM OF ART

Distributed by Harry N. Abrams, Inc., New York

This volume has been published in conjunction with the exhibition
"Stuart Davis, American Painter," held at The Metropolitan Museum
of Art, New York, November 23, 1991–February 16, 1992, and at the
San Francisco Museum of Modern Art, March 26–June 7, 1992

The exhibition is made possible by The Henry Luce Foundation, Inc.

Additional support was provided by the National Endowment for the Arts.

The exhibition catalogue is made possible in part by generous grants
from The Henry Luce Foundation, Inc., and The Andy Warhol Foundation
for the Visual Arts, Inc.

Published by The Metropolitan Museum of Art, New York
John P. O'Neill, Editor in Chief
Ellen Shultz, Editor
Malcolm Grear Designers, Inc., Designers
Helga Lose, Production

Copyright © 1991 by The Metropolitan Museum of Art
Library of Congress Cataloging-in-Publication Data
Sims, Lowery Stokes.
Stuart Davis, American painter/by Lowery Stokes Sims with
contributions by William C. Agee . . . [et al.].
p. cm.
Includes bibliographical references and index.
ISBN 0-87099-627-4.—ISBN 0-87099-628-2 (pbk.).
—ISBN 0-8109-6405-8 (Abrams)
1. Davis, Stuart, 1892–1964—Exhibitions. 2. Davis, Stuart,
1892–1964—Criticism and interpretation. I. Davis, Stuart,
1892–1964. II. Title.
ND237.D333A4 1991
759.13—dc20 91-25901
 CIP

Jacket/cover:
Stuart Davis. *Rapt at Rappaport's*. See catalogue number 147

Page 16:
Stuart Davis in New York, mid-1950s. Photograph by George Wettling,
courtesy of Hank O'Neal

Printed and bound by Arnoldo Mondadori Editore S.p.A., Verona, Italy

Contents

Foreword

A critic writing in 1932 suggested that The Metropolitan Museum of Art might consider acquiring a work by the American painter Stuart Davis (1892–1964) to enliven its walls. The writer postulated that this painting should first be seen in "the landings of the stairways, or possibly the Tea Room." Eventually, "when the whole Museum has been keyed up, then the Stuart Davis could be moved upstairs and given a place of honor. One must plan ahead in such cases." It is now sixty years later. The Tea Room no longer exists at the Metropolitan Museum, but Stuart Davis's art is habitually given a place of honor in the galleries, and the 175 works included in "Stuart Davis, American Painter," predictably enliven the first-floor rooms of the Lila Acheson Wallace Wing, where they are installed. The suggestion of the anonymous critic has thereby become a reality.

The occasion of this exhibition coincides with the centenary of the birth of Stuart Davis, one of the most important American artists of the twentieth century. Davis's enduring contribution to the history of art is his wholehearted celebration of America's new urban and industrial environment. He found inspiration in the relentless energy and upheaval of the modern city: its skyscrapers, automobiles, industry, sports, jazz music, and advertising, and in its consumer culture. At the same time, Davis also left behind a personal portrait of the New England seaport community of Gloucester, Massachusetts, where he spent summers for almost twenty years. The masts and rigging of the fishing boats, the paraphernalia of the fishermen, and the landscape of the town and the surrounding areas also provided thematic material with which Davis could explore his particular vision in his particular style. Davis's distinctive adaptation of the Cubist vocabulary—in which bright, fully saturated color and form became one, and line assumed a primary role in the creation of imagery—was eminently suited to express the rapid cultural transformations that occurred in American society during the first half of this century.

"Stuart Davis, American Painter" was initiated as a result of conversations between Earl Davis, the artist's son, and William S. Lieberman, Jacques and Natasha Gelman Chairman, Department of 20th Century Art. That its timing would be opportune was clear from the outset, for there has not been a complete survey of Davis's career since the mid-1960s. In addition to examining early influences on the artist's development and his perception of the role of art and artists in society, the exhibition, assembled by Lowery Stokes Sims, Associate Curator in the Department of 20th Century Art at the Metropolitan Museum, and William C.

Agee, a noted Davis scholar, also establishes the artist's relationship to and effect on later developments in American art, such as Abstract Expressionism, Pop Art, and Color Field painting. This is further explored in the exhibition catalogue *Stuart Davis, American Painter*, in the critical essays on various aspects of the artist's career contributed by William C. Agee, Robert Hunter, Lewis Kachur, Diane Kelder, John R. Lane, Lowery Stokes Sims, and Karen Wilkin.

In addition, we are pleased that the San Francisco Museum of Modern Art is a partner in this venture. I am grateful to John R. Lane, Director, who not only made a commitment to host the exhibition early on, but also has helped in the organizing process, along with Virginia Carollo Rubin, Director of Development, and Barbara Levine, Exhibitions Coordinator, who were integral in expediting the logistics of the San Francisco venue.

The concern and cooperation of Earl Davis has been key to this project, and we thank him for his help in providing loans from his collection.

The exhibition and its accompanying catalogue would not have proceeded without the interest and support of The Henry Luce Foundation, Inc. We express our thanks to Henry Luce III, Chairman and Chief Executive Officer, and Robert E. Armstrong, President, for their sponsorship. We also wish to acknowledge the National Endowment for the Arts, as well as The Andy Warhol Foundation for the Visual Arts, Inc., for their partial support of the catalogue.

Philippe de Montebello
Director, The Metropolitan Museum of Art

Acknowledgments

The exhibition "Stuart Davis, American Painter" marks the first major presentation of the artist's work since 1978, and the first retrospective of his career since 1966. Although he is recognized as one of America's most important modernist artists, until now the perception of Stuart Davis's achievement for the most part has encompassed the works of the 1920s, including the so-called Tobacco paintings and the Egg Beater series, individual masterpieces of the 1940s such as *Report from Rockport* and *Hot Still-Scape for Six Colors—Seventh Avenue Style,* and finally the compositions of the 1950s, among them *Semé, Owh! in San Pao,* and *Colonial Cubism.* Thus, our goal in assembling this exhibition has been both to underscore the importance of these paintings, and, at the same time, to examine lesser-known aspects of Davis's career in order to expand our understanding of his contribution to twentieth-century art. Not only did we profit immeasurably from the groundwork laid by such earlier pioneering studies on Davis as those of James Johnson Sweeney, H. H. Arnason, Eugene C. Goossen, Diane Kelder, John R. Lane, and Rudi Blesh, but we also had at our disposal the research compiled under the leadership of William C. Agee for an eventual catalogue raisonné of the artist's work—an endeavor that, thus far, has yielded many exciting discoveries and revelations about Davis's life and art.

Several distinct goals guided the organization of this exhibition and its accompanying catalogue. The first was to highlight the beginning of Davis's career, from 1910 to 1920, acknowledging his roots in the Ashcan School. We then sought to show his expeditious evolution into a unique artistic personality through his wide-ranging and inventive exploration of various modernist stylistic modes. The examination of Davis's experimentation with Cubism focuses on works executed between the 1921 Tobacco pictures and the Egg Beater series of 1928, such as the 1922 series of still-life compositions on tables, the isolated studies of eggbeaters, saws, and light bulbs done in 1923 in New Mexico, and the pristine, linear still lifes of 1923–24. These are perhaps not as well known, but they are crucial to Davis's development and to that of Cubism in America during the 1920s. We conclude the survey of the 1920s with a more amplified look at the Paris paintings, suggesting their importance to Davis's career is greater than generally accepted.

The 1930s has been perceived as a period when Davis produced relatively little; however, during that time he created a rich and varied body of work. The artist's particular interest in defining an appropriate relationship between style and subject matter—specifically, its social and political content—is considered in the con-

text of that dynamic decade. All of Davis's extant murals from the 1930s (along with two later ones) are presented together here for the first time. They reflect a variety of styles, confirming Davis's position as the country's foremost muralist.

The exhibition also seeks to shed new light on Davis's creativity in the 1960s, when his career was coming to an end. In their freshness, verve, and innovation, such compositions as *Unfinished Business*, *Standard Brand*, *Punch Card Flutter*, and *Blips and Ifs* reveal the strength of the artist's vision and the continuity of his artistic enterprise. This consistency in Davis's career, underscored by the prophetic phrase "The Amazing Continuity" in his 1951 painting *Visa*, is another theme that forms a focus within the exhibition, where Davis's recycling and reworking of compositional arrangements and motifs from one decade to another becomes clear. One aspect of Davis's oeuvre that is not highlighted is the works on paper, except where specific drawings, watercolors, and gouaches directly relate to the development of his paintings. Neither have we focused on Davis's graphic art, which was catalogued by the Amon Carter Museum in Fort Worth in 1986. A final note: We have attempted to clarify individual titles of Davis's works, relying on the artist's own designations (as well as on his idiosyncratic spelling and punctuation); often, alternate titles are given in entries for specific pictures.

Many individuals have contributed to the success of this exhibition. We first would like to acknowledge the support of William S. Lieberman, Jacques and Natasha Gelman Chairman of 20th Century Art, at The Metropolitan Museum of Art. It was his concept of the exhibition that led to its organization, and the idea that it focus on Davis's mural works was his as well. In addition, he provided cogent suggestions that helped to clarify our endeavors along the way. Earl Davis, the artist's son, was also indispensable to this project. His watchful, caring presence and his cooperation served to ensure that his father's career would be presented in the most complete manner in the exhibition and the catalogue. Lawrence B. Salander and William O'Reilly of the Salander-O'Reilly Galleries, New York, were helpful in too many ways to count, but especially in providing photographic materials for the exhibition and catalogue and in facilitating loans from the artist's estate and from many private collectors. We also thank the gallery staff, particularly Lori Bookstein and Emily Goldstein. We would like to express our thanks as well to B. J. van Damme, who facilitated the cooperation between the Metropolitan Museum and the Estate of the Artist, and prepared the groundwork for all publicity for the exhibition. Carolina Kroon, Chantal Combes, Nanci Barbal, and Joan Packner, at various times part of the staff of the Stuart Davis catalogue raisonné office, answered numerous inquiries and provided much-needed information expeditiously.

We thank the Davis scholars, collectors, and the lenders to the exhibition, many of whom welcomed us into their offices, storerooms, and homes. During our travels for the exhibition we enjoyed the special hospitality of Kent and Charlie Davis, Barney Ebsworth, Hachivi Edgar and Deborah Heap of Birds, William Fageley, Raymond Nasher, Patterson Sims, and Mary Stoflet. For their assistance in various research details we would like to express our appreciation to Carol Drute and Anne Coleman, former staff members, The Brooklyn Museum, New York; Elizabeth Gombosi, Fogg Art Museum, Harvard University, Cambridge, Massachusetts; Judith Zilczer and Anne-Louise Marquis, Hirshhorn Museum and Sculpture Garden, Smithsonian Institution, Washington, D.C.; Carol Mancusi-Ungaro, The Menil Collection, Houston; Jennifer Wells, The Museum of Modern Art, New York; Elizabeth Anderson, National Museum of American Art, Smithsonian Institution,

Washington, D.C.; James Jordan, Director, Music Program, New York State Council on the Arts, New York; Terrie Rouse, Richard Holliger, and Gail Dawson, New York City Transit Exhibit, Brooklyn, New York; Rebecca Dodson, The Phillips Collection, Washington, D.C.; Jennifer Dowden, Tobacco Institute; Peggy Frank Crawford and Joan Washburn, Washburn Gallery, New York; Daisy Voigt, Daisy Voigt Associates, Washington, D.C.; and Caroline Blum, Whitney Museum of American Art, New York.

We would also like to express our appreciation to the many individuals who facilitated our efforts to secure loans: Jock Reynolds, Director, Addison Gallery of American Art, Phillips Academy, Andover, Massachusetts; Jane Keene Muhlert, Director, Doreen Bolger, Curator of Paintings and Sculpture, Jane Myers, Associate Curator, Melissa Thompson, Registrar, and Julie Causey, Assistant Registrar, Amon Carter Museum, Fort Worth; Neal Benezra, Curator of 20th Century Painting and Sculpture, The Art Institute of Chicago; Patricia E. Harris, former Executive Director, and Nanette Smith, Acting Director, Arts Commission of the City of New York; Louis A. Zona, Director, and Clyde Singer, Curator, The Butler Institute of American Art, Youngstown, Ohio; Leslie Schumberger, Cary Ellis Co., Houston; Phillip M. Johnston, Director, and Cheryl A. Saunders, Registrar, The Carnegie Museum of Art, Pittsburgh; Robert H. Frankel, Director, Trinkett Clark, Curator of 20th Century Art, and Catherine Jordan, Registrar, The Chrysler Museum, Norfolk, Virginia; Richard R. Brettell, Director, Kimberly Bush, Registrar, and Judy Cohen, Assistant Registrar for Loans and Exhibitions, Dallas Museum of Art; Samuel Sachs III, Director, Jan van der Marck, Chief Curator and Curator of Twentieth Century Art, and Vada Hays, Associate Registrar for Loans and Exhibitions, The Detroit Institute of Arts; Michael R. Ferrari, President, and Paul Johnson, Plant Manager, Drake University, Des Moines, Iowa; Margaret Kelly, Curator, and Bonnie Kirschstein, Assistant Registrar, The Forbes Magazine Collection, New York; Jane K. Bledsoe, Director, Georgia Museum of Art, The University of Georgia, Athens; Diane Waldman, Deputy Director, and Elizabeth Carpenter, Registrar, The Solomon R. Guggenheim Museum, New York; Richard Andrews, Director, and Judy Sourakli, Curator of Collections, Henry Art Gallery, University of Washington, Seattle; James Demetrion, Director, Phyllis Rosenzweig, Associate Curator, and Margaret Dong, Assistant Registrar for Loans, Hirshhorn Museum and Sculpture Garden, Smithsonian Institution, Washington, D.C.; George R. Ellis, Chief Executive Officer, and James Jensen, Curator of Western Art, Honolulu Academy of Arts; Patricia Hendricks, Associate Curator and Loan Officer, Sue Ellen Jeffers, Registrar, and Meredith Sutton, Assistant Registrar, Archer M. Huntington Art Gallery, The University of Texas at Austin; Adelheid M. Gealt, Director, and Diane Drisch, Registrar, Indiana University Art Museum, Bloomington; Mary H. Kujawski, Director, Jo-Ann Conklin, Curator of Graphic Arts, and Erin A. Barnes, Research Assistant, The University of Iowa Museum of Art, Iowa City; Martin Weyl, Director, and Stephanie Rachum, The David Rockefeller Curator of Modern Art, The Israel Museum, Jerusalem; Thomas W. Leavitt, former Director, and Nancy E. Allyn, Associate Curator, Paintings, Drawings and Sculpture, Herbert F. Johnson Museum of Art, Cornell University, Ithaca, New York; Marsha V. Gallagher, Chief Curator, Joslyn Art Museum, Omaha; Jennie Long Murphy, Meredith Long Gallery, Houston; Earl A. Powell III, Director, Renee S. Montgomery, Registrar, and Pamela C. Tippman, Assistant Registrar, Los Angeles County Museum of Art; Bette Bernstein, Edith and Milton Lowenthal Collection; Lauren Wittles and Martha Schwendener, Luhring Augus-

tine Gallery, New York; Grant Holcomb II, Director, Marie Via, Curatorial Assistant, and Lee Moulton, Registrar, Memorial Art Gallery, University of Rochester; Paul Winkler, Acting Director, and Nancy C. Swallow, Associate Registrar, The Menil Collection, Houston; Russell Bowman, Director, Leigh Albritton, Registrar, and Jean Roberts Guequierre, Assistant to the Registrar, Milwaukee Art Museum; M. J. Czarniecki III, Director, Gloria Kittleson, Curator of Collections, and Leanne A. Klein, Associate Curator for Collections Management, Minnesota Museum of Art, Saint Paul; Paul D. Schweizer, Director, and Patricia L. Serafini, Registrar, Munson-Williams-Proctor Institute, Museum of Art, Utica, New York; Alan Shestack, Director, Theodore E. Stebbins, Jr., John Moors Cabot Curator of American Painting, Linda Thomas, Registrar, Museum of Fine Arts, Boston; Peter C. Marzio, Director, and Alison de Lima Greene, Associate Curator of Twentieth-Century Art, The Museum of Fine Arts, Houston; Kirk T. Varnedoe, Director, Cora Rosevear, Associate Curator, Department of Painting and Sculpture, and Beatrice Kiernan, Assistant Curator, Department of Drawings, The Museum of Modern Art, New York; Elizabeth Broun, Director, and Melissa Kroning, Acting Registrar, National Museum of American Art, Smithsonian Institution, Washington, D.C.; Nancy Miller, Curator, and Patricia Magnani, Assistant Registrar, Neuberger Museum, State University of New York at Purchase; Randall Hays, Director, and Trish Andrew, Registrar, Nevada Museum of Art, Reno; Samuel C. Miller, Director, Audrey Koenig, Registrar, Brett I. Miller, Acting Curator of Collections, and Patricia S. Parry, Registrar, Norton Gallery, West Palm Beach; Thomas R. Toperzer, Director, and Edwin J. Deighton, Assistant Director and Curator of Collections, The University of Oklahoma Museum of Art, Norman; Linda Bantel, Director, The Pennsylvania Academy of the Fine Arts, Philadelphia; Anne d'Harnoncourt, Director, Ann Percy, Curator of Drawings, Innis Howe Shoemaker, Senior Curator of Prints, Nancy Irene Taurins, Registrar, and Nancy S. Quaile, Assistant Registrar, Philadelphia Museum of Art; Laughlin Phillips, Director, and Elizabeth Turner, Associate Curator, The Phillips Collection, Washington, D.C.; Marivi Magsino, Red Eye/Overland/Sing Sing Company, New York; Barbara Milhouse, President, Nicholas B. Bragg, Director, Reynolda House, Inc., Winston-Salem, North Carolina; Carl I. Belz, Director, Rose Art Museum, Brandeis University, Waltham, Massachusetts; James D. Burke, Director, and Marie K. Nordmann, Assistant Registrar, The Saint Louis Art Museum; John R. Lane, Director, Tina Levine, Head Registrar, and Pamela State, Assistant Registrar, San Francisco Museum of Modern Art; Richard Vincent West, Director, Barry M. Husler, Curator of Collections, and Elaine Cobos, Assistant Registrar, The Santa Barbara Museum of Art; Andrew Lona, Loans Officer, Southwestern Bell Corporation, Saint Louis; J. Hornor Davis IV, Director, and Isabelle Umpleby, Fine Arts Curator/Assistant Director, Sunrise Museums, Charleston, West Virginia; Harold P. O'Connell, Director, Terra Museum of American Art, Chicago; Paul N. Perrot, former Director, Frederick R. Brandt, Curator of Twentieth-Century Art, and Lisa Hancock, Registrar, Virginia Museum of Fine Arts, Richmond; Martin Friedman, former Director, Peter W. Boswell, Assistant Curator, and Gwen Bitz, Registrar, Walker Art Center, Minneapolis; Susan M. Taylor, Director, and Nancy L. Swallow, Registrar, Wellesley College Museum, Jewett Arts Center, Wellesley, Massachusetts; Susan C. Larsen, former Curator of the Permanent Collection, and Jane Rubin, Associate Registrar, Whitney Museum of American Art, New York; J. Richard Gruber, Director, and Novelene Ross, Chief Curator, Wichita Art Museum, Kansas; Mary Gardner Neill, Director, Anthony Hirschel, Assistant to the

Director, and Diane Hart, Associate Registrar, Yale University Art Gallery, New Haven.

At The Metropolitan Museum of Art, we wish to thank the Director, Philippe de Montebello, whose enthusiastic response to the exhibition has been encouraging, and Mahrukh Tarapor, Assistant Director, Linda Sylling, Assistant Manager for Operations, and Kay Bearman, Administrator for 20th Century Art, who guided us through the preliminary administrative details. Also in the Department of 20th Century Art, Ida Balboul, Research Associate, Alleyne Miller and Katharine Kim, Administrative Assistants, and Marion Cohen, volunteer, eased the burden of logistical details, and Lisa J. Servon, first a graduate summer intern and then a research assistant, was a marvel at organizational expertise and a creative and tireless researcher, without whom the core aspects of the work on this exhibition would not have been accomplished. We acknowledge Barbara Bridgers, Photograph Studio; John Buchanan, Chief Registrar, and Nina S. Maruca, Associate Registrar; Emily K. Rafferty, Vice President for Development and Membership, and her staff, particularly Carol Ehler, Assistant Manager, who were extraordinarily inventive in pursuing funding for the exhibition; the Education Department, under the guidance of Kent Lydecker, notably, Helen Shannon, Associate Museum Educator, and Stella Paul, Assistant Museum Educator, for developing lively public programming in conjunction with the exhibition; and the commitment and interest of Hilde Limondjian, Program Manager, Department of Concerts and Lectures. The tireless efforts of the Merchandise Production Department, under the auspices of Lisa Cook Koch, General Merchandise Manager, and, specifically, Valerie Troyansky, Assistant General Merchandise Manager for Development and Administration, resulted in gift items that are particularly well suited to Stuart Davis's art. Michael C. Battista, Exhibition Designer, and Zack Zanolli, Lighting Designer, collaborated on the installation, which aptly complements the artist's work. John Ross, Manager, Department of Public Information, and Norman Keyes, Jr., Public Information Officer, expertly coordinated public relations for the exhibition.

For the catalogue *Stuart Davis, American Painter*, we acknowledge the essayists: Robert Hunter and Karen Wilkin, who participated in this project as part of the Stuart Davis catalogue raisonné office, and Diane Kelder, John R. Lane, and Lewis Kachur, who contributed essays and also provided helpful suggestions and advice. Malcolm Grear Designers, Inc., is responsible for the handsome design.

We wish to thank the Editorial Department at the Metropolitan Museum, under the direction of John P. O'Neill, Editor in Chief and General Manager of Publications, specifically, Helga Lose, Production Associate, and Heidemarie Colsman-Freyberger, Bibliographer, of the exhibition catalogue, as well as Gwen Roginsky, Production Manager, and Connie Harper, Budget Coordinator/Publications. We would like especially to acknowledge the efforts of Ellen Shultz, Editor, who sensitively edited the manuscripts, and also lent her expertise to decisions about the design and organization of the catalogue.

Lastly, we are grateful to our families and friends who have seen us through these past few years of seemingly endless travel and research.

Lowery Stokes Sims

Associate Curator, Department of 20th Century Art, The Metropolitan Museum of Art

William C. Agee

Exhibition Consultant, Professor of Art History, Hunter College, City University of New York

Lenders to the Exhibition

Addison Gallery of American Art, Phillips Academy, Andover, Massachusetts

Amon Carter Museum, Fort Worth

The Art Institute of Chicago

The Butler Institute of American Art, Youngstown, Ohio

The Carnegie Museum of Art, Pittsburgh

The Chrysler Museum, Norfolk, Virginia

The City of New York

The Crispo Collection

Dallas Museum of Art

Earl Davis. Courtesy of Salander-O'Reilly Galleries, New York

The Detroit Institute of Arts

Sid Deutsch Gallery, New York

Drake University, Des Moines, Iowa

Mrs. Max Ellenberg

Mr. and Mrs. James A. Fisher, Pittsburgh

The Forbes Magazine Collection, New York

Georgia Museum of Art, The University of Georgia, Athens

The Solomon R. Guggenheim Museum, New York

Henry Art Gallery, University of Washington, Seattle

Hirshhorn Museum and Sculpture Garden, Smithsonian Institution, Washington, D.C.

Honolulu Academy of Arts

Mr. and Mrs. Roger Horchow

Archer M. Huntington Art Gallery, The University of Texas at Austin

Arthur E. Imperatore. Courtesy Luhring Augustine Gallery, New York

Indiana University Art Museum, Bloomington

The University of Iowa Museum of Art, Iowa City

The Israel Museum, Jerusalem

Herbert F. Johnson Museum of Art, Cornell University, Ithaca, New York

Joslyn Art Museum, Omaha. University of Nebraska at Omaha Collection

Dr. and Mrs. Arthur E. Kahn, New York

Constance Kamens

Dr. and Mrs. Henry Kaufman

Samuel and Francine Klagsbrun

Jon and Barbara Landau, New York

The William H. Lane Collection

Edward J. Lenkin

Mr. and Mrs. Perry J. Lewis

Cornelia and Meredith Long, Houston

Los Angeles County Museum of Art

John F. Lott, Lubbock, Texas

Edith and Milton Lowenthal Collection, New York

John and Jan Mackey

Memorial Art Gallery of the University of Rochester

The Menil Collection, Houston

The Metropolitan Museum of Art, New York

Meyer Associates

Milwaukee Art Museum

Minnesota Museum of Art, Saint Paul

Munson-Williams-Proctor Institute, Museum of Art, Utica, New York

Museum of Fine Arts, Boston

The Museum of Fine Arts, Houston

The Museum of Modern Art, New York

National Museum of American Art, Smithsonian Institution, Washington, D.C.

Neuberger Museum, State University of New York at Purchase

Nevada Museum of Art, Reno

The Newark Museum, New Jersey

Norton Gallery, West Palm Beach

The University of Oklahoma Museum of Art, Norman

The Pennsylvania Academy of the Fine Arts, Philadelphia

Philadelphia Museum of Art

The Phillips Collection, Washington, D.C.

Françoise and Harvey Rambach

Phyllis and Jerome Lyle Rappaport

Michael and Elizabeth Rea, New York

The Regis Collection, Minneapolis

Rose Art Museum, Brandeis University, Waltham, Massachusetts

The Saint Louis Art Museum

San Francisco Museum of Modern Art

The Santa Barbara Museum of Art

Alice and Leslie Schreyer

Warren and Jane Shapleigh

Dr. and Mrs. Milton Shiffman

Southwestern Bell Corporation, Saint Louis

Sunrise Museums, Charleston, West Virginia

Terra Museum of American Art, Chicago

Virginia Museum of Fine Arts, Richmond

Walker Art Center, Minneapolis

Washburn Gallery, New York

Wellesley College Museum, Jewett Arts Center, Wellesley, Massachusetts

Whitney Museum of American Art, New York

Wichita Art Museum, Kansas

Yale University Art Gallery, New Haven

11 Anonymous Lenders

Diane Kelder # Stuart Davis and Modernism: An Overview

For Americans born since the end of World War II, it is almost impossible to conceive of a time when this country did not manifest a vital leadership in the visual arts. Buttressed by political and economic power, and by irresistible visions of energy, confidence, and know-how, America's cultural products captured the imagination of Europeans and stimulated emulation. In fact, the history of the art of the second half of the twentieth century offers a pattern of development that contrasts dramatically with that of the first fifty years. The early decades were marked by a dependence on the European modernist tradition and by the contradictory reactions engendered by this dependence. While an acute awareness of provincialism prompted some artists to struggle with new concepts of form and content embodied in the work of pioneering Europeans, frustration or disillusionment with those same models caused others to abandon them and embrace indigenous realist styles and overtly American subjects. No concerted critical voice supported the various efforts to create an American modernist style in the 1920s and 1930s, and the audience for advanced art remained extremely limited despite the establishment of galleries and museums dedicated to its exhibition and dissemination.

If most of the protagonists in the growth of early American modernism succumbed to the lack of a sense of common enterprise or mission, one remarkable painter, Stuart Davis, transcended the historical pattern of confusion and reticence. With formidable skill, tenacity, and courage, he proved that it was possible for an American to accept the challenge of the Europeans without relinquishing his native identity or priorities. Davis's long career paralleled this country's cultural coming of age, and the vital aesthetic, social, and political issues that informed its critical periods of maturation are brought into

sharp focus through his paintings and his incisive writings.

As with other artists of his generation, Davis's encounter with European modernist painting in the Armory Show of 1913 had a decisive effect on his development. His initial training with the realist Robert Henri had encouraged an acute sensitivity to his environment, and direct visual stimuli would always be fundamental to his method of painting. Conversion to modernism did not result in Davis's repudiation of his realist heritage, but it made him aware of the autonomous character of a work of art. "The act of painting," he later maintained, "is not a duplication of experience, but the extension of experience on the plane of formal invention."[1]

Davis's gestation of modernist concepts was longer than that of most of his contemporaries and it produced a more original assimilation. When the initial enthusiasm for European vanguard art gave way to political and cultural isolationism in the 1920s and 1930s, Davis emerged as American modernism's champion; he was the only major painter who never lost his faith in its progressive character, nor his determination to reconcile the formal and philosophic issues it raised with the quality of the American experience.

Not part of an artistic group, Davis labored single-handedly in the 1920s to develop an idiomatic Cubism that translated the dynamics of the contemporary American environment into abstract color and shape. If his approach to form and content at times seemed to parallel that of other artists who were affected by Cubism, closer examination reveals that the character of Davis's paintings is bolder, his handling of color and paint more provocative, and his pictorial syntax more distinctively vernacular. More important, he was the only painter of

his generation to penetrate the surface of the style and seek its underlying logic. Rooted in theory and tested by experience, his work manifests a rare understanding of the ideational character of painting, as well as a broad streak of native pragmatism.

By the late 1920s, Davis had thoroughly assimilated Cubist structural strategies. He intensified his efforts to develop a more original and satisfactory synthesis of color and design in the 1930s and early 1940s. The murals he executed for the Federal Art Project reveal that he was seeking alternatives to Cubist pictorial structure, prefiguring the concerns of a younger generation of artists whose explorations would radically alter the intention and character of American painting in the period after World War II. Although the ascendance of Abstract Expressionism challenged Davis's status as the country's leading modernist, it did not lessen his resolve to continue making his own kind of paintings. The emergence of Pop Art during the last years of his life accorded a contextual relevance to Davis's cool, objective approach and to his long-standing dialogue with popular culture, but the artist was disdainful of this superficial linkage, which failed to recognize his very different motivation and objectives.

If our appreciation of Stuart Davis's contribution to the later history of American modernism has been clouded by critical priorities and by the need to validate stylistic agendas, his stature in an objective survey of its development is evident. The sheer ambition and consistently high quality of his painting would be sufficient to distinguish it from the efforts of his contemporaries, but it is also invested with aesthetic continuity and intellectual integrity—larger virtues rarely encountered in Davis's own time, and sadly absent from the cynical eclecticism and self-aggrandizement that has characterized much American painting in recent years.

Davis was born in 1892, and his artistic training and early development occurred during what has been called the Era of Progressive Reform. The period was marked by a growing sense of national pride in America's manifold technological accomplishments and by an optimistic belief that a combination of scientific methodology and management would engender material and social progress. Davis's ideas about making art in America were certainly informed by this optimism. His later writings repeatedly assert his conviction that modern art was intrinsically a "reflection of the positive progressive fact of modern industrial technology."[2]

By 1909, when Davis entered Robert Henri's art school in New York, discontent with American art institutions and the slick finish of the work that emanated from them was manifest. A year earlier, Henri had joined forces with John Sloan and six other artists linked only by their anti-academic stance to organize an exhibition at the Macbeth Gallery. In challenging the stranglehold of New York's conservative National Academy of Design jury system, the "Eight" sought to advance the aesthetic pluralism evident in their own work. Many of their paintings already displayed the vigorous execution and provocative urban subject matter that would prompt hostile critics to identify them as the Ashcan School. Henri's teaching emphatically rejected academic rules and standards of beauty; it advocated experimentation and encouraged students to look for subject matter in their daily environment.

Davis roamed the city in search of motifs, and his earliest work clearly reflected the enthusiasms and techniques of his Ashcan School models. In addition to its cultivation of distinctive urban subjects, he also credited the Henri school with developing "a critical sense toward social values in the student."[3]

Davis's growing social consciousness was reinforced by his friendship with and exposure to the progressive politics of John Sloan. As the art editor of the radical monthly *The Masses*, Sloan invited Davis and other former Henri students to contribute illustrations, cartoons, and covers. Davis was actively involved with *The Masses* until 1916, when politically oriented captions were added to his submissions, prompting his resignation.

A comparison of Davis's commercial and independent efforts of the period suggests that he made no clear distinction between "low" and "high," or fine, art. Both types of works display a straightforward, basically naturalistic handling of form similar to that seen in the art of his mentors (fig. 1), while the few traces of European influence in his drawings or watercolors point to such artists as Daumier, Beardsley, or Toulouse-Lautrec— hardly in the vanguard at that time. Davis later magnified the revelatory experience of the "International Exhibition of Modern Art" of 1913. He must be taken at his word that he was unaware of advanced European art until his confrontation with it there. During his student years, the opportunities to view modern painting or sculpture in New York were, indeed, limited. The establishment of Alfred Stieglitz's Little Galleries of the Photo-Secession (commonly known as "291") in 1905 was crucial to developing and disseminating knowledge of twentieth-century European and American modernist art. Stieglitz introduced New Yorkers to the work of Rodin, Brancusi, Cézanne, and Matisse, and his maga-

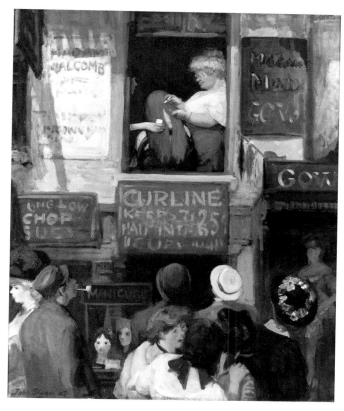

Figure 1. John Sloan. *Hairdresser's Window*. 1907. Oil on canvas. Wadsworth Atheneum, Hartford. Ella Gallup Sumner and Mary Catlin Sumner Collection

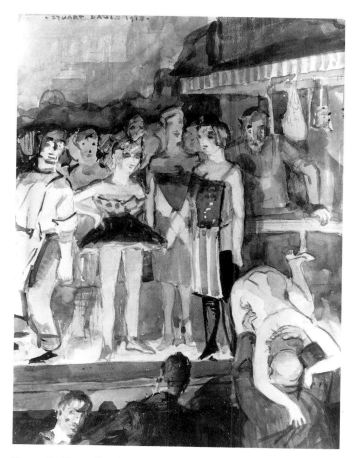

Figure 2. Stuart Davis. *Babe La Tour*. 1912. Watercolor and pencil on paper. National Museum of American Art, Smithsonian Institution, Washington, D.C. Gift of Henry M. Ploch

zine *Camera Work* (1903–17) provided unprecedented coverage of international modernist activities, reprinting reviews of exhibitions and offering translations of important theoretical modernist texts.

If Davis never frequented Stieglitz's exhibitions it would not have been surprising, given the aesthetic differences that separated Stieglitz's group of European-oriented artists—John Marin, Marsden Hartley, Alfred B. Maurer, Max Weber, Abraham Walkowitz, Arthur G. Dove—from the Ashcan realism of Henri's followers. A keen sense of rivalry bordering on outright hostility developed between the two factions during Davis's student years. Despite its democratic stance, Henri's group consisted of artists whose traditional orientation and tastes were antithetical to the avant-garde ambitions of Stieglitz and his circle. When Davis made his public debut at the Society of Independent Artists' exhibition organized by Sloan in 1910, the Stieglitz artists were conspicuously absent from what had been publicized as a survey of new American art. However, if the "Independent Artists" shows did not succeed in embracing more adventurous forms of American painting, they provided a model for the ambitious survey of modern American and European art that would eventually take place in 1913.

The Armory Show, which offered Americans their first comprehensive view of European modernism, was the most important contribution to the establishment of a native modernist tradition. Nearly sixteen hundred works in a variety of mediums were exhibited. French art, which had exerted the most palpable influence on American painting, dominated the show: Fauvism and Cubism were well documented, German Expressionism was modestly represented, and Italian Futurism was not even included. Despite omissions, visitors were offered an astonishing variety of high-quality modern art. While Marcel Duchamp's *Nude Descending a Staircase* came to symbolize the radical enterprise of the Europeans, the exhibition also included important works by Cézanne, van Gogh, Gauguin, Matisse, Braque, and Picasso that revealed the breadth of their modernist accomplishments. In this awesome context, the American presence, which included five Davis watercolors (see fig. 2), must have seemed unimpressive. Indeed, the most advanced American contributions came from artists in the Stieglitz circle (Marin, Maurer, Hartley; see fig. 3), or the Paris-based American painters influenced by recent theories of color abstraction (Morgan Russell, Stanton Macdonald-Wright; see fig. 4).

From New York, the Armory Show traveled to Chicago and Boston. When it finally closed, it had generated

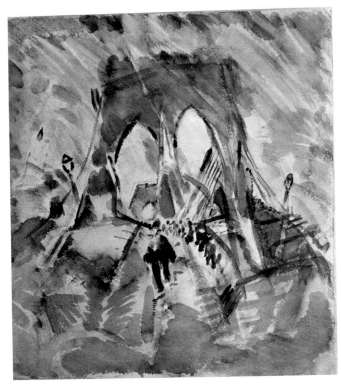

Figure 3. John Marin. *Brooklyn Bridge*. About 1912. Watercolor on paper. The Metropolitan Museum of Art, New York. Alfred Stieglitz Collection, 1949

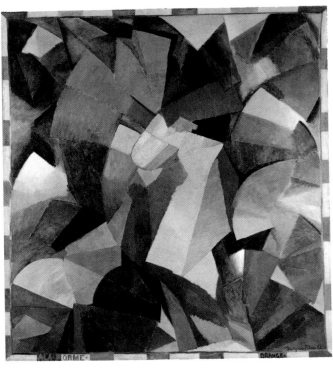

Figure 4. Morgan Russell. *Synchromy in Orange: To Form*. 1913–14. Oil on canvas. Albright-Knox Art Gallery, Buffalo, New York. Gift of Seymour H. Knox, 1958

extraordinary press coverage and an audience of about three hundred thousand. Of the 174 works purchased from the show, only a quarter were American. A significant group of serious collectors emerged—A. J. Eddy, John Quinn, Albert C. Barnes, Walter Arensberg, and Katherine S. Dreier—but far more important than its stimulus to collecting was the Armory Show's effect on artists. For those who already had been exposed to vanguard art on their European sojourns, it reaffirmed progressive attitudes; for the others, it was a sobering revelation of their own limitations and a catalyst for change. As Davis recollected, "I was enormously excited by the show, and responded particularly to Gauguin, van Gogh, and Matisse, because broad generalizations of form and the non-imitative use of color were already practices within my own experience. I also sensed an objective order in these works which I felt was lacking in my own. It gave me the same kind of excitement I got from the numerical precision of the Negro piano players . . . and I resolved that I would quite definitely have to become a 'modern' artist."[4]

Over the next six years, Davis made an all-out effort to educate himself about modernism by exploring the various options the Armory Show presented. Identifying with these formal and coloristic innovations also made Davis aware of the shortcomings of his training with Henri: "In repudiating academic rules for picture structure, new ones suitable to the new purpose were insufficiently established. The borderline between descriptive and illustrative paintings, and art as an autonomous sensate object was never clarified. Because of this, reliance on the vitality of subject matter to carry the interest prevented an objective appraisal of the dynamics of the actual color-space relations of the canvas."[5]

Davis's pursuit of progressive strategies "suitable to the new purpose" did not result in immediate stylistic transformation, nor did his experiments proceed in a clear direction. In paintings executed between 1915 and 1919, when he was summering in Gloucester, Massachusetts, he often emulated the intense palettes and simplified designs of the artists he had singled out for praise in the Armory Show. Coming to grips with new concepts of color, shape, surface, and structure forced him to work in different ways, and the quality of his painting seems uneven. Davis's attraction to van Gogh is especially evident in the vivid color and generous pigmentation of many of his landscapes and self-portraits. Yet, even in this early, patently derivative stage in his modernist explorations, Davis was beginning to assert his distinctly American identity. This becomes clear when we consider a work

Figure 5. Henri Matisse. *The Red Studio*. 1911.
Oil on canvas. The Museum of Modern Art,
New York. Mrs. Simon Guggenheim Fund

such as *Studio Interior* of 1917 (cat. no. 20). At first glance, this painting seems little more than a well-intentioned homage to Matisse's *Red Studio* of 1911 (fig. 5), which Davis had seen in the Armory Show. Appropriating the device of a monochromatic ground relieved by outlines and occasional patches of color, Davis measures his own American artist's world against that of his sophisticated European model. The hermetic unity, refinement of objects, and mat, uninflected surface of Matisse's canvas contrast with the more disjunctive space, homelier furnishings, and vigorously brushed surface of Davis's. The replacement of Matisse's stately clock with an open phonograph and a pile of records, and the prominence accorded a window view of rooftops, as opposed to Matisse's stacked or hung paintings, suggests that Davis wished to underline the different sources (jazz and the city) that were nourishing his art.

A significant shift from Fauvism is evident in a number of Davis's canvases dating from 1916 through 1918, in which he began to render landscape and architectural elements as increasingly simplified planes of subdued color. Similar in motifs and uniform in size, these paintings may have been conceived as a calculated experiment in Cubist structure. Davis abandoned the reductive and analytical treatment of landscape and returned to a literal approach in *Multiple Views* of 1918 (cat. no. 23). By juxtaposing interior and exterior Gloucester motifs, he

sought to convey simultaneity. If his goal was ambitious, the composition reveals his limitations: The discrepancy between illustrative and abstract space is evident, and the artist's attempt to assert the physical reality of the whole painted surface is unsuccessful. The formal and procedural conflicts manifested in *Multiple Views* resulted from a desire to impose a new conceptual reality on the observed world—a conceptual reality that Davis was beginning to identify with Cubism, but which he was not yet capable of implementing. The year he painted this problematic canvas, he wrote that the real subject of landscape was "a mental concept derived from various sources and expressed in terms of weight and light." Significantly, he concluded that "Cubism is the bridge from percept to concept."[6]

During the years when Davis was privately working through Post-Impressionism, Fauvism, and a tentative Cubism, the onset of World War I made it difficult for American artists to maintain contact with the European avant-garde. Stieglitz's artists and the Paris-based Synchromists, who showed in New York in 1914, were the major figures on the modernist horizon. The latter benefited from the skillful proselytizing of one of the period's most distinguished critics, Willard Huntington Wright, whose brother Stanton was the movement's leading theorist. Wright's book *Modern Painting* (1915) surveyed the history of modernism and boldly concluded that Syn-

Figure 6. Morton L. Schamberg. *Machine*. 1916. Oil on canvas. Yale University Art Gallery, New Haven. Gift of Collection Société Anonyme

Figure 7. Charles Demuth. *Machinery*. 1920. Tempera and pencil on cardboard. The Metropolitan Museum of Art, New York. Alfred Stieglitz Collection, 1949

chromism was its latest and most advanced manifestation. Yet, despite Wright's impressive arguments and a significant number of adherents (including Morton Schamberg and Thomas Hart Benton), Synchromist color abstraction never took root in the factional and unfocused New York art world. Indeed, the return of Marcel Duchamp and Francis Picabia to New York in 1915 and 1916, respectively, would effectively overshadow these and other American efforts to orchestrate the development of modernism. Both artists were taken up by Walter Arensberg, the most ambitious of the new collectors, and together they launched a propaganda campaign that would eventually establish New York Dada as a vanguard beacon for vast numbers of Americans. Duchamp's and Picabia's utilization of modern industrial and commercial images inspired John Covert, Schamberg, Man Ray, and others to follow suit. In 1917, when the Society of Independent Artists mounted their large exhibition, the native assimilation of the "machine aesthetic" was well documented in the works submitted (see fig. 6).

In the third decade of the century, the political and cultural isolation that would peak during the Depression began to assert itself. Notably absent from the League of Nations, America significantly curtailed immigration during the Harding administration. Business expanded at the expense of workers' attempts to organize, the racist Ku Klux Klan renewed its violent attacks, and there was a pervasive fear of anarchism and Bolshevism. At the same time, an unprecedented prosperity fueled the market for consumer products, leading to inevitable complacency and self-satisfaction. With few exceptions, American artists no longer looked to Europe for aesthetic direction, but rather tended to refine the insights gained from exposure to vanguard art. There were impressive defections from the ranks of modernism—Hartley, Weber, and Benton repudiated abstraction and returned to more realist styles—and there were efforts to accommodate aspects of Cubism to subjects that reflected specifically American characteristics. Bypassing the spatial complexities of Analytic Cubism, such painters as Charles Demuth, Schamberg, and Charles Sheeler simplified and flattened objects to achieve structural clarity without obliterating their identity (see fig. 7). Pristine and bold, yet eminently legible, the style of their paintings has been described as Precisionist or Cubist-Realist. Drawn to subjects (barns, grain elevators, factories, tanks, machines) whose inherent formal properties lent themselves to pictorial simplification, the Cubist-Real-

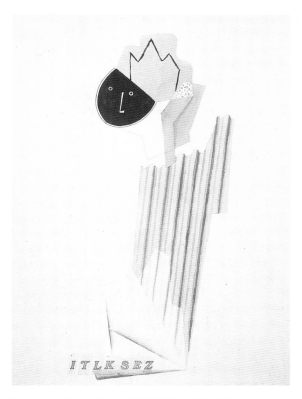

Figure 8. Stuart Davis. *ITLKSEZ*. 1921. Watercolor and collage on paper. The William H. Lane Collection

Figure 9. Stuart Davis. *Mexican Girls*. 1923. Oil on artist's board. Collection Earl Davis. Courtesy of Salander-O'Reilly Galleries, New York

ists also extolled the traditions of the rural and industrial America they symbolically evoked. Compared with European or even earlier American modernist paintings, the techniques of the Cubist-Realists seem conservative, but their identification of native architecture and technology contributed to the gradual awareness of the distinctive visual experiences that distinguished America from Europe.

In the early 1920s, when many American artists were retreating from modernist experimentation, Davis began searching for a way of integrating his new understanding of the functions of color and shape into a coherent plastic whole. Synthetic Cubism provided the formal and intellectual model. Unlike others who had superficially absorbed the "look" of Cubism, he systematically probed its pictorial structure. In order to clarify his new principles, he began writing about the art of painting on a regular basis, and his lengthy notes illuminate his contemporaneous works and provide insights into his evolving methodology: "A work of art . . . should be first of all impersonal in execution. . . . It may be . . . simple . . . but the elements that go to make it up must be positive and direct. This is the very essence of art that the elements of the medium . . . have a simple sense-perceptual

relationship. . . . The subject may be what you please . . . but in all cases the medium itself must have its own logic."[7]

In 1921, Davis made a number of collages, and paintings that simulated collage, which bear witness to his intellectual and technical grasp of Braque's and Picasso's precedents. Again, his notebooks reveal that he had been thinking seriously of the implications inherent in the French models for his own experiments. "Words can be used in paintings . . . ," he maintained. "The hint of 'JOURNAL' in cubism should be carried on."[8] The crisp, flat forms and humorous coded reference ("It Looks Easy") to Cubist practice in *ITLKSEZ* of 1921 (fig. 8) also seem to reflect the spirit of New York Dada. Davis's comments in his notebooks of about 1920 to 1922 imply that while he did not endorse the posturing and propagandizing of Picabia and Duchamp, he was intrigued by their irreverent approach to subject matter and encouraged by their example to experiment with untraditional materials. Related to the collages, and indicative of a lifelong fascination with both modern packaging and the formal potential of words, were the tobacco-label paintings of the same year. William Agee has suggested that these paintings offered Davis a "way out of his early land-

scapes," and provided "a means to start the picture, to gain a more overtly structural picture."[9] The clarity of the oversized and rearranged packaging elements and their consistent frontality also reflect the increasing emphasis Davis was placing on the two-dimensional physical reality of his canvas.

Davis's growing confidence in his ability to absorb and expand upon Cubist strategies resulted in significant changes in his approach to form and subject in the mid-1920s. The monumentality and the emphatically linear schematization of the figures in *Mexican Girls* of 1923 (fig. 9) suggest a new awareness of the work of Fernand Léger, as do the 1924 still lifes of household objects such as *Edison Mazda*, *Electric Bulb*, and *Odol* (cat. nos. 54–56). Although Davis had seen Léger's early paintings in the Armory Show, he did not have an opportunity to view the French artist's more recent work until 1925, when the Société Anonyme mounted a large exhibition in New York. Nonetheless, there is an evident affinity in the two artists' search for maximum formal clarity. Davis's admiration for Léger was due particularly to the French painter's choice of subjects and manifest fascination with the man-made environment of billboards, storefronts, and complex machines. This both paralleled and confirmed Davis's burgeoning awareness of the aesthetic and systemic implications of industrial technology for the creation of his own modern style.

The climax of Davis's efforts to master Cubist structure occurred in 1927–28, when he nailed an electric fan, a rubber glove, and an eggbeater to a table and painted them exclusively. Nearly twenty years later, Davis described his subject as "an invented series of planes.... They were a bit on the severe side, but the ideas invoked in their construction have continued to serve me.... My aim was not to establish a self-sufficient system to take the place of the immediate and accidental, but to ... strip a subject down to the real physical source of its stimulus ... so you may say that everything I have done since is based on the eggbeater idea."[10] Davis had arrived at abstraction through a process of clarification, distillation, adjustment, and synthesis, as the preparatory drawings for the paintings testify. The Egg Beater series, and the subsequent Matchbook and Percolator paintings, constituted what Davis later called formula pictures. "The formula could only be arrived at through wholesale observation ... and intellectual selection of the common denominator of varieties ... which [could] be rationalized and used over and over again with success."[11] He brilliantly demonstrated the validity of his theory in the 1940s and 1950s, when he utilized the structural matri-

ces or configurations of *Egg Beater No. 2* for *Hot Still-Scape for Six Colors—Seventh Avenue Style* (cat. nos. 68, 124) and of *Percolator* for *Owh! in San Pao* (cat. nos. 63, 146).

As the end of the 1920s loomed, Davis's investigation of Cubist syntax had reached a level of sophistication unmatched by any other American artist. His work was becoming more visible, and his reputation as a modernist painter was growing. Juliana Force, director of the Whitney Studio Club, included him in group shows and gave him a solo exhibition in 1926. He had a retrospective at the Newark Museum in 1925, and was also invited to participate in the prestigious "International Exhibition of Modern Art" organized by the Société Anonyme at The Brooklyn Museum in 1927. The same year, he began showing at Edith Halpert's Downtown Gallery, one of the few commercial galleries in New York that actively promoted American modernist art. Sales of work to Juliana Force and a subsidy from Gertrude Vanderbilt Whitney in return for future paintings provided Davis with funding for a trip to Paris in May 1928. When he embarked on what was to be a thirteen-month stay, Davis was thirty-five years old, and virtually the only American modernist who had never been to Paris. His decision to make the trip was certainly influenced by his long-standing conviction that Paris was the center of modernist culture and the focal point of continuing artistic innovation. His evident satisfaction with the Egg Beater canvases prompted him to take along two of them, doubtless with the expectation of eliciting a positive reaction from a more knowledgeable audience.

In Paris, Davis generally moved with ease in the world of American expatriate artists and writers. He was friendly with Isamu Noguchi, Alexander Calder, Niles Spencer, and Marsden Hartley, and he met Gertrude Stein and saw her legendary collection of early modernist art. Although he had hoped to visit Picasso's studio, there is no evidence that Davis ever met with him. He did, however, show his work to Léger, who "liked the Egg Beaters very much and said they showed a concept of space similar to his latest development.... He thought the street scenes I am doing here too realistic ... but said they were drawn with fine feeling."[12]

In the light of Davis's steady progression through early modernism to Cubism, it would have seemed natural for him to have engaged some of the more radical aesthetic issues then reflected in the art being shown—but that was not the case. While his letters home offer insights into his social contacts, or document his enthusiastic reaction to the life and look of the French capital, they

Figure 10. Stuart Davis. *Still Life with Saw.* 1930. Oil on canvas. The Phillips Collection, Washington, D.C. Acquired, 1946

provide no evidence of significant contact with the major practitioners of avant-garde art. Léger's remark about the Paris views prefigured the historical consensus that their selective but apparent naturalism signaled a hiatus in Davis's development of abstraction.

Two years after his return from Paris, Davis wrote that his experience there had enabled him to dispel "the disheartening rumor that there were hundreds of talented young modern artists ... who completely outclassed their American equivalents. . . . It proved to me that one might go on working in New York without laboring under an impossible handicap. It allowed me to observe the enormous vitality of the American atmosphere as compared to Europe and made me regard the necessity of working in New York as a positive advantage."[13]

Davis's work in the early 1930s reveals in many ways that he was still assessing the effects of his stay in Paris, while scrutinizing his earlier, painstaking formulation of Cubism, and coming to terms with his keenly American identity. *Egg Beater No. 5* of 1930 (cat no. 84), begun shortly after Davis's return, invites obvious comparison with his earlier canvases, but the planar austerity and acute abstraction of his work of the late 1920s has been replaced by a stylized Cubism that links this picture with Picasso's and Braque's still lifes of the previous decade. *Still Life with Saw* of 1930 (fig. 10) reveals a startling freedom in the disposition of its hybrid shapes, as well as a playfulness that suggests a delayed receptivity to the

art of Joan Miró and Surrealism that is also evident in *Salt Shaker* of 1931 (cat. no. 94). A remarkable series of lithographs (see fig. 11) done the same year incorporates seemingly antithetical Cubist and Surrealist approaches to form and space and a latent naturalism. Juxtaposing still-recognizable images of Paris, New York, and Gloucester with geometrically and organically abstracted forms, Davis created complex, sweeping patterns and rich tonal effects that daringly express the physical properties and inherent two-dimensionality of the graphic medium.

In the 1930s, Davis's productivity was deeply affected

Figure 11. Stuart Davis. *Barber Shop Chord.* 1931. Lithograph. Amon Carter Museum, Fort Worth

by the economic and social turbulence engendered by the Depression. A quarter of the labor force was unemployed by 1933, and the already marginal incomes of artists were dramatically reduced. When the United States government began to organize various relief projects to employ artists in the creation of public works Davis was among the first to enroll. He joined the Public Works of Art Project (later to become the Federal Art Project) in 1933, and remained active in the Graphic Arts and Mural Division until 1939. If Davis's enrollment in the Federal Art Project helped to alleviate his poverty and to provide him with essential materials to continue painting, he was also motivated to join because he firmly believed that the program offered artists an unparalleled opportunity to speak to a larger audience and thus to challenge the dictatorship of taste by "an economically enfranchised class."[14]

While his views about the social responsibilities of the artist were shaped initially by his exposure to the radical politics of Henri and Sloan, and subsequently informed by Marxism, his conviction that vanguard artists had an important role to play in any movement for social progress was consistent with his growing perception of the didactic character of modern art. Davis's insistence that there was a structural logic connecting modernist art with society prompted him to see the former as both an emblem of and a model for social action: "The best work of the last seventy-five years is great because it is real contemporary art which expresses in the materials of art the new lights, speeds, and spaces of our epoch. Modern chemistry, physics, electricity . . . have produced a world in which all the conceptions of time and space have been enormously expanded and modern and abstract art both reflect and are an active agent in that expansion. . . . Abstract art . . . is the actual progressive force in the art of our epoch."[15]

Despite his sympathy for Marxism, which was shared by many artists and intellectuals during the period, Davis was too independent a thinker to support the rigorous orthodoxy of Marxist philosophy. He vehemently rejected its dismissal of abstraction and its insistence that the value of the work of art was determined by the political relevance of its content. His increasing distaste for Social Realism was exceeded only by his contempt for the realism championed by the xenophobic right. When *Time* magazine published an article in 1934 praising the work of Thomas Hart Benton, John Steuart Curry, and Grant Wood, and ridiculing the American artists who had been influenced by modernism, Davis counterattacked. Writing in *Art Front*, the outspoken Artists'

Union publication, he deplored the Regionalists' vision of American life as "caricature" and "third rate vaudeville character cliché with the humor omitted."[16] He took strong exception to the magazine's condemnation of foreign influence on American art, and correctly identified the source of the article in the writings of conservative critic Thomas Craven, whose book *Modern Art* had proclaimed his anti-European, pro-American thesis just a year before. Davis's antipathy to the simplistic content and recycled realism of "American Scene" painting was hardly new, but doubtless was intensified by the popular acclaim the movement now enjoyed. For years, while simultaneously attacking European modernism, Craven had been urging American artists to utilize their native environment as subject. His condemnation of Cubism, and particularly of its American "imitators," failed to acknowledge the originality of Davis's fusion of modernist method and authentic native imagery.

Davis was already sensitive to criticism that his work was unduly influenced by French art. Four years earlier, when an otherwise enthusiastic critic chided him for his adoption of a foreign visual idiom, he retaliated by claiming that no American artist had "created a style which was unique . . . completely divorced from European models," and, while admitting the influence of Léger or Picasso, he added, "I strongly deny speaking their language."[17] The title of his 1932 exhibition at the Downtown Gallery, "The American Scene: Recent Paintings, New York and Gloucester," not only acknowledged the heated discourse of foreign versus native style and content, but signified a challenge to the Regionalists' claim to exclusive interpretation of the American experience. Davis remained the adversary of isolationist politics and aesthetics well into the 1940s, but it is clear that conservative perceptions of his work had taken their toll. Even at a decade's remove from the controversy with Benton, Curry et al., he felt it necessary to affirm his artistic provenance: "I am an American, born in Philadelphia of American stock. I studied art in America. I paint what I see in America, in other words, I paint the American scene."[18]

The four murals that Davis produced for the Federal Art Project in the late 1930s sustain his arguments that modernist art could speak directly to public needs. Their content is eminently legible, yet they are among the most complex and sophisticated works of the period. Although Davis invested much thought in their iconography, he felt that their formal statement was of paramount importance, since "the subject matter which is common to all works of art is constructive order and the achievement of

it in the material of expression."[19] Rejecting the Social Realism practiced by most of the FAP muralists, he aimed at raising the aesthetic consciousness of the public through contemplation of this new "constructive order." The extensive notes for his *History of Communications* mural, painted for the 1939 World's Fair (see cat. nos. 121–122), address the artist's problem of creating meaningful public art while at the same time respecting his own "objective aesthetic principles":

> The quality which is common to all works of fine art throughout history is the existence of real physical order in the space of the material of expression. . . . "Art order" and "real physical order" are synonymous. The work of real Art expresses nature by analogy not by similitude. . . . The social content of Art is always simply Art itself. The social meaning of Art consists at all times of an affirmation of the joy felt in the successful resolution of a problem. This expression has social meaning because it gives concrete proof of the possibility of establishing order in certain aspects of man's relationship to Nature. Such expression is a moral force and provides courage for life to those who experience it.[20]

Davis's mural style powerfully reflected his insistence that the content of abstract art seek its sources in nature —a position that was opposed to the goals of geometric purity pursued by such younger painters as George L. K. Morris, Balcomb Greene, and Carl Holty, who had established the organization known as American Abstract Artists in 1937. Influenced by various European models, including Constructivism, Abstraction-Création, and Mondrian's Neoplasticism, the generally geometric orientation of the artists in the organization was too limiting and too exclusive of the vital human experience that was fundamental to Davis's concept of abstraction.

Despite his economic, aesthetic, and political struggles, Davis's reputation as the country's premier modernist loomed large in the 1930s. Asked by the organizers of the Whitney Museum's "Abstract Painting in America" exhibition (1935) to contribute an introduction to the catalogue, he provided a succinct history and a lucid exposition of the development of the modernist tenets that had instructed his own work. His spirited advocacy of modernist art also encouraged such younger artist friends as Arshile Gorky, Willem de Kooning, and David Smith, who were just coming to terms with Cubism in their own work. Gorky was among the first to recognize Davis's constructive use of color and to applaud his affirmation of the inherently two-dimensional character of the canvas. Referring to the prevailing climate of hostility to modern and abstract styles, Gorky indicted the conservative "vultures, waiting . . . for the death of the

distinctive art of this century, the art of Léger, Picasso, Miró, Kandinsky and Stuart Davis."[21]

In the 1940s, Davis's writing continued to serve the cause of advanced painting. His articles for *Parnassus* (1941), *Harper's Magazine* (1943), and *Artnews* (1943) forcefully proclaim modern painting's unique capacity to express the dynamism of contemporary experience. He ventured the opinion that the long European tradition of modern art was coming to an end, that it was now up to American artists to discover new forms for conveying the rapid changes taking place in the environment. For Davis, these years were also marked by greater productivity, more frequent gallery shows, and official recognition in the form of a comprehensive retrospective at The Museum of Modern Art in New York (1945).

Davis's brilliant paintings of the early 1940s reveal the new concepts of color and design he brought to bear on familiar urban or landscape themes. In *Report from Rockport* of 1940 (cat. no. 123), he exploited color's capacity to advance or recede and to suggest surface or depth. Combining stylized natural forms and still-recognizable objects, such as gasoline pumps, with more freewheeling abstract shapes, rendered in blatant contrasting hues, he created images analogous to the rapid discontinuities of the modern American scene. While his surroundings still provided a direct stimulus to painting, his past work now seemed open to possibilities of revision or expansion in the light of his recent concerns. Although the structural matrix of *Egg Beater No. 2* of 1928 is still the visible point of departure for *Hot Still-Scape for Six Colors—Seventh Avenue Style* of 1940 (cat. nos. 68, 124), its discrete planes have become inundated by jagged and swirling shapes, and its subdued tones have been superseded by aggressive, pulsating color. Davis explained the thinking and procedures the painting reflected in the following statement:

> *Hot Still-Scape in Six Colors—7th Avenue Style* is composed from shape and color elements which I have used in painting landscapes and still lives [*sic*] from nature. Invented elements are added. Hence the term "Still Scape." It is called "Hot" because of its dynamic mood. Six colors . . . were used as the materials of expression. They are used as the instruments in a musical composition might be, where the tone-color variety results from the simultaneous juxtaposition of different instrument groups. It is "7th Avenue Style" because I have had my studio on 7th Ave. for 15 years.
>
> The subject matter of this picture is well within the experience of any modern city dweller. Fruit and flowers; kitchen utensils; fall skies; horizons; taxi cabs; radio; art exhibitions and reproductions; fast travel; Americana; movies; electric signs; dynamics of city sights and sounds; these and a thousand more are com-

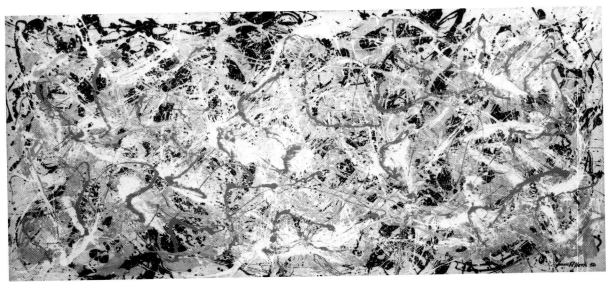

Figure 12. Jackson Pollock. *Number 27.* 1950. Oil on canvas. Whitney Museum of American Art, New York. Purchase

mon experience and they are the basic subject matter which my picture celebrates. The painting is abstract in the sense that it is highly selective, and it is synthetic in that it recombines these selections of color and shape into a new unity, which never existed in nature but is a new part of nature.[22]

Davis already had begun to seek alternatives to the characteristically centralized pictorial organization of Cubism in murals such as *Swing Landscape* of 1938 (cat. no. 114), where he dispersed forms across the entire surface of his canvas. In *Arboretum by Flashbulb* (cat. no. 131) and *Ursine Park* (fig. 57), both of 1942, and *Ultra-Marine* of 1943 (cat. no. 132), abstract color shapes are repeatedly organized to create an overall pattern, which eliminates a single focus. No part of these compositions, nor any color unit, is accorded more importance than another. Instead, our perception of the systematic adjustment or balancing of the color shapes forces us to acknowledge a new conception of painting as a totally ordered, continuous surface. John Lane has clarified the relationship of Davis's understanding of Gestalt theory to the development of his painting in the 1940s,[23] stressing its link with the new concept of pictorial design the artist called "configuration theory." Davis's goal was the creation of "an objective coherence not obtained before in painting. . . . The total quality of the design evokes a cosmological point of view for the observer. Instead of a center focus . . . all parts of the field of observation are centers of focus—serial centers. The keynote of the total quality . . . is equality."[24]

If "configuration theory" provided a system that en-

abled Davis to develop a bolder and more dynamically decorative sense of surface, the paintings of Matisse and Miró presented alternatives to Cubist space that Davis seems to have found useful. His contemporaneous notes reveal an admiration for the spatial implications of Matisse's color and for Miró's elimination of the strong central focus of Cubist composition.

While Davis was logically and systematically developing his own post-Cubist notion of picture space, such younger artists as Arshile Gorky, Adolph Gottlieb, Willem de Kooning, and Jackson Pollock were also discovering allover strategies that would transgress the spatial discourse of Cubism and make it seem irrelevant to the newly perceived issues of painting. Although their ambitions may have been similar, the motivations and procedures of these artists and those of Davis were opposite and irreconcilable. Pollock's abandonment of the planar construction of Cubism and his identification of color and line as autonomous elements no longer tied to defining shape constituted a breakthrough that pushed American painting in radical directions that were incompatible with Davis's essentially relational approach. In *The Mellow Pad* of 1945–51 (cat. no. 135; fig. 61), the underlying structure of *House and Street* of 1931 (cat. no. 92) is virtually obscured by the suffocating complexity of Davis's color-space configurations. Comparison of *The Mellow Pad* with Pollock's *Number 27* of 1950 (fig. 12) reveals a similar emphasis on surface; however, Davis's rich palette, programmed sequences of invented and calligraphic shapes, and controlled brushwork differ enormously from the opaque color, impulsive movement, and rapid, paint-

erly execution that characterize the Abstract Expressionist work. The impact of Pollock's canvas is immediate, dynamic, and palpably sensual, whereas Davis's is cumulative, deliberate, and more demonstrably logical.

Although Davis's conception of painting had undergone significant change since his conversion to modernism, it was still fundamentally rooted in the external, phenomenological world, as opposed to the work of Gorky, Pollock, and the other Abstract Expressionists, who were exploring the internal world of emotions, and whose paintings were increasingly understood as extensions and records of those emotions. Davis's aversion to the emphasis on subjective content that dominated the critical discourse of Abstract Expressionism reflected an unswerving dedication to an art of clarity and objective order. He explained his own view in the following statement:

> Whether it is good or bad, I regard the mood I am in a part of the subject, and both as completely irrelevant to the piece of work I plan to do. The doing of the work, regardless of the mood or subject, is a completely new experience which does not transmit the character of either. . . . Making a painting is an architectural discipline from the purchase of the stretcher to the precise instruments used to execute it. . . . When it is understood that painting is completely disassociated from the experience in subject matter and psychological attitude that preceded it, it becomes possible to talk about an absolute, universal art.[25]

Abstract Expressionism isolated Davis from the mainstream of American modernism, and, in the 1950s—the decade of its greatest influence—he increasingly withdrew from contact with other artists to engage in an introspection that prompted critical reassessment of his earlier ideas and achievements. While returning to previous compositions for clarifications or focus was a periodic *modus operandi*, Davis had never before been so preoccupied with his own past, his own art as subject. *Tournos* of 1954 (cat. no. 119) recapitulated in strong color and lively patterns the successive evolutions of a 1932 notebook sketch (fig. 13) in the paintings *Landscape* of 1932 (The Brooklyn Museum, New York) and *Shapes of Landscape Space* of 1939 (cat. no. 118). Two years later, in 1956, he provided the configuration with additional linear elements and a fresh palette in *Memo* (cat. no. 120). In the last decade of his life, Davis's composition acquired an increased economy and monumentality. Responding to the stylistic challenge of Abstract Expressionism, he pointedly reaffirmed his artistic heritage in *Colonial Cubism* of 1954 (cat. no. 152), which recast, in brighter color and more emphatic shapes, the formal relationships first examined in the 1922 painting *Landscape, Gloucester* (cat. no. 42; fig. 14).

Shortly before his death, the emergence of Pop Art appeared to give Davis's oeuvre an unexpected currency. His early interest in packaging, advertisements, signs, and mass communication was cited as a precedent for the works of Andy Warhol, James Rosenquist, Roy Lichtenstein, and others. Davis was irritated by this association, which failed to recognize that he had always utilized popular culture and common objects as points of departure for formal inventions that transformed their identities and significance.

From the vantage point of the 1990s, Stuart Davis's idiosyncratic paintings seem as distant from the Cubist models that were their principal inspiration as they are

Figure 13. Stuart Davis. Sketch from a notebook. 1932. Collection Earl Davis. Courtesy of Salander-O'Reilly Galleries, New York

Figure 14. Stuart Davis. *Landscape, Gloucester.* 1922. Oil on canvas. Collection John F. Lott, Lubbock, Texas (see cat. no. 42)

from the Abstract Expressionist works that historically have overshadowed them, or the Pop Art that has claimed superficial allegiance with them. Early in his career, Davis decided that painting was a matter of order, structure, and relationships. He dedicated himself to a sustained investigation of the physical "facts" of the medium in order to establish its objective character and its "logic." At the same time, he presciently identified vital manifestations of contemporary American experience—popular music, technology, transportation, communication—as his subject matter. He once remarked that jazz was the first native expression of modernism, and he saw it as offering a structure and a system that might instruct his own efforts to create a modern style.[26] While he initially based this style on Cubist methods, he repeatedly tested them against his particular, American situation. In the process, the stately syntax of Cubism acquired a signal, vernacular energy.

Stuart Davis sought to engage the vital aesthetic, social, and political issues of his time in his paintings and writings. Both proclaim his conviction that human experience could be objectified, clarified, and expanded through the system and structure of art. In its fundamental concern with conveying meaning through constructive order, Davis's painting aspired to the tradition of the universal and classical—but it did so on its own "concretely topical"[27] terms. Davis's instinctive feeling for his environment invested synthetic forms with the genuine aura of the New York streets, the waterfronts, or the New England town squares that initially inspired them. The remarkable continuity of their aesthetic ambition and their pictorial resolution ultimately distinguishes Davis's paintings from those of his modernist predecessors and contemporaries and secures their privileged place in the history of American art.

Notes

I should like to thank Barbara Rose, Allen Rosenbaum, and Daniel Berger for their helpful criticism of my manuscript, and Lowery S. Sims for her patience and support.

1 Stuart Davis, "What About Modern Art and Democracy?" *Harper's Magazine* 188 (December 1943); reprinted in Diane Kelder, ed., *Stuart Davis*. New York, Washington, and London: Praeger, 1971, pp. 134–35.

2 Stuart Davis Papers, September 30, 1937. Harvard University Art Museums, Fogg Art Museum, Cambridge, Massachusetts.

3 Stuart Davis, in "Autobiography." New York: American Artists Group Monographs, 6, 1945, n.p.; reprinted in Kelder, op. cit., p. 19.

4 Ibid. pp. 23–24.

5 Ibid., p. 23.

6 Stuart Davis Papers, 1918, op. cit.

7 Stuart Davis, Notebook: December 30, 1922; see Kelder, op. cit., pp. 33–34.

8 Quoted in John R. Lane, *Stuart Davis: Art and Art Theory* (exhib. cat.). New York: The Brooklyn Museum, 1978, p. 96.

9 William C. Agee, *Stuart Davis (1892–1964): The Breakthrough Years, 1922–1924* (exhib. cat.). New York: Salander-O'Reilly Galleries, 1987, n.p.

10 James Johnson Sweeney, *Stuart Davis* (exhib. cat.). New York: The Museum of Modern Art, 1945, p. 17.

11 Stuart Davis, Daybook: 1932; see Kelder, op. cit., p. 60.

12 Letter from Stuart Davis to his father, September 17, 1928, quoted in Lewis Kachur, *Stuart Davis: An American in Paris* (exhib. cat.). New York: Whitney Museum of American Art at Philip Morris, 1987, p. 6.

13 Stuart Davis, "Self-Interview," *Creative Art* 9 (September 1931), p. 211.

14 Stuart Davis, "Letters from Our Friends," *Art Front* 1, 1 (November 1934), p. 2; reprinted in Kelder, op. cit., p. 151.

15 Stuart Davis, "Abstract Painting Today," previously unpublished article commissioned for Art for the Millions (1940); see Kelder, op. cit., p. 120.

16 Stuart Davis, "The New York American Scene in Art," *Art Front* 1, 3 (February 1935), p. 6.

17 Letter from Stuart Davis to Henry McBride, reprinted in *Creative Art* 6 (February 1930), suppl. pp. 34–35.

18 Sweeney, op. cit., p. 23.

19 Stuart Davis, "Mural for Studio B, WNYC (Working Notes) (1939)"; see Kelder, op. cit., p. 93.

20 Stuart Davis, "Mural for the Hall of Communications, New York World's Fair (Working Notes and Diagrams) (1939)"; see Kelder, op. cit., pp. 81, 84–85.

21 Arshile Gorky, "Stuart Davis," *Creative Art* 9 (September 1931), p. 213.

22 Statement by Stuart Davis written in September 1940. Collection Earl Davis.

23 Lane, op. cit., chapter 6.

24 Ibid., p. 57.

25 Statement by Stuart Davis written on November 3, 1952, at the request of Alfred H. Barr, Jr., in conjunction with The Museum of Modern Art's acquisition of the painting *Visa*; see Kelder, op. cit., p. 102.

26 For sensitive discussion of Davis and jazz see Brian O'Doherty, *American Masters: The Voice and the Myth in Modern Art*. New York: E. P. Dutton, 1982, pp. 52–53, 56, 60, 91–92.

27 Stuart Davis, artist's statement in *Forty American Painters 1940–1950* (exhib. cat.). Minneapolis: University of Minnesota Art Gallery, 1951, p. 19.

The Rewards and Disappointments
of the Ashcan School:
The Early Career of Stuart Davis

Robert Hunter

First and Second Generations

Stuart Davis's first identity as an artist was as a member of the Ashcan School—the radical group of realists, led by Robert Henri, who changed the course of American art during the early years of this century. An examination of Davis's role in this movement provides not only an improved understanding of his art as a whole, but also a new perspective on the movement itself. Davis, it becomes clear, was an important figure within the group. He helped to define and expand the Ashcan style in its full development, as it flourished (if only briefly) among a generation of younger artists. Moreover, his art was influential in crystallizing public and critical response to the movement, and, in addition, Davis even played a role in the naming of the Ashcan School.

As an artist seeking his way within this movement Davis had many advantages—not the least of which was a formidable talent. This is seen, for example, in the complex relationships of line and texture in *Park Avenue Bridge*, a sketchbook drawing of November 1909 (see fig. 15), dating from his first days as an art student. Born December 7, 1892, he was not yet seventeen years old and had received little formal art training at the time the drawing was made.[1] Stuart Davis literally grew up within the Ashcan movement. During Stuart's childhood, his father, Edward Wyatt Davis, a Philadelphia newspaper artist and art editor, was an active participant in the artistic explorations of a small circle of newspaper illustrators, out of which the movement took form. As a young artist, Stuart Davis enjoyed the friendship and support of John Sloan, perhaps the strongest talent the movement produced in its initial phase. Most importantly, from 1909 to 1911 Davis studied with the Ashcan group's charismatic founder and guiding spirit, Robert

Henri. Davis soon surpassed his teacher in ambition and achievement. *Consumers Coal Co.* (cat. no. 1; fig. 16), dated January 12, 1912, can be seen as a kind of graduation piece and personal declaration of independence—a challenge to Henri's own earlier urban snow scenes (see fig. 16). The fact that Henri's *The Snow* had been purchased by the French government for the Musée du Luxembourg in 1899 was well known to his students, and it provided them with a prestigious example to emulate.[2] In *Consumers Coal Co.*, Davis treats with dignity the Ashcan theme of everyday urban life. He applies the paint as richly and knowingly as Henri, with broad strokes of the brush and palette knife. In composition, Davis entered new realms. He uses the planes of the buildings and pavement depicted to organize the space, and, within this larger pictorial structure, three lampposts, and railings, to demarcate space intervals and im-

Figure 15. Stuart Davis. *Park Avenue Bridge*. 1909. Pencil on paper. Collection Earl Davis. Courtesy of Salander-O'Reilly Galleries, New York

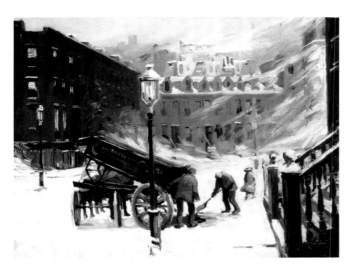

Figure 16. Stuart Davis. *Consumers Coal Co.* 1912. Oil on canvas. Sunrise Museums, Charleston, West Virginia. Gift of Amherst Coal Co. (see cat. no. 1)

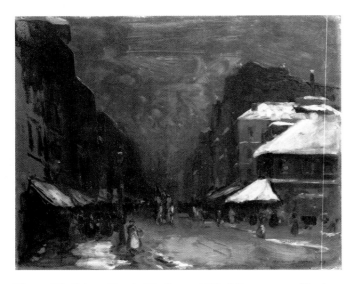

Figure 17. Robert Henri. *The Snow.* 1899. Oil on canvas. Musée d'Orsay, Paris

plied angular planes. The human figures and the repeated window and door openings create interaction and movement on another scale. In his later art, while retaining his allegiance to vernacular subject matter, he developed and refined this structural sensibility within a Cubist idiom (see figs. 18, 19). *Fish Market* of 1912 (cat. no. 7), for all its dark and foreboding mysteriousness, is a further example of the artist's early command of structural organization.[3]

We are accustomed to thinking of the Ashcan School in a restricted way, confining the term to the older, Philadelphia-born artists in the group. Two generations of the Ashcan School are not commonly defined, but it is

useful to do so—and necessary, in fact, if we are to give the younger artists their due. Davis himself supported this division between the two generations. In discussing the Ashcan School by name, he distinguished between "the founders—Henri, Luks and so on," and the "generation after the founders," referring specifically to Glenn Coleman and George Bellows, and by inference to all their contemporaries and near contemporaries, himself included.[4] The first generation, of course, consisted of Robert Henri and the small group of his colleagues who established their artistic identities in the 1890s in Philadelphia: John Sloan, George Luks, Everett Shinn, and William Glackens—all of whom relocated to New York at about the turn of the century.[5] The second generation —far larger—was made up of Henri's numerous students in New York. For roughly a decade, from about 1902 to 1913—the peak years of Henri's influence on this generation—an exciting movement flourished. Among the second generation of Ashcan artists who were to gain lasting prominence within their lifetimes were George Bellows, Edward Hopper, and Rockwell Kent. There were many more, however, whose fame was brief, or who only attained recognition belatedly. Some of the high-spiritedness and excitement of this group as a whole is captured in a luridly titled but respectful article of the period, "New York Art Anarchists. Here is the Revolutionary Creed of Robert Henri and his Followers." The article summarized Henri's call for an "art that would reflect the actual life and character of the people," and described how his followers "have taken rooms in tenements down on the lower east side, over on the west side around Sullivan and Thompson street [*sic*], and through old Greenwich Village, and are absorbing and studying the different classes of life as earnestly and enthusiastically as though they were in Latin Quarter studios."[6]

These young artists of the second generation dominated the famous 1910 "Exhibition of Independent Artists," which was many times larger than the groundbreaking "Eight" show and had an even greater public impact. Of the approximately ninety-three painters in the 1910 exhibition, no fewer than thirty-nine can be considered second-generation Ashcan artists, in that they studied with Henri in New York; four of the five first-generation Ashcan artists exhibited as well.[7] Stuart Davis was represented with five canvases, his first public showing, after only about three months' experience with oil painting.[8]

Despite the initial attention it received, and its later importance to the development of realism in America from the 1910s up to the present, the Ashcan School

Figure 18. Stuart Davis. Untitled sketchbook drawing, no. 6–2. 1926. Watercolor, ink, and pencil on paper. Collection Earl Davis. Courtesy of Salander-O'Reilly Galleries, New York

Figure 19. Stuart Davis. *Building and Figures*. About 1931. Gouache and pencil on paper. Collection Mr. and Mrs. Roger Horchow, Dallas

never really achieved a coherent artistic vision. Although Henri and his earliest followers were trying to create an art that would be valid in the modern world, they never fully understood—and thus did not accept—one of the basic premises of modern art in their time: that a painting was in some ways an autonomous object that was validated to an important extent by its own internal formal and expressive dynamics, not just by the accuracy of its references to external, visual reality. In spite of this, these artists could not help but be affected by modern European art. Even in the Ashcan School's Philadelphia beginnings, stray hints of expansive Parisian modernism infiltrated and undermined its more narrowly focused program of reportorial realism. The approach, in short, was self contradictory. Nevertheless, the extended Ashcan School, in its largeness and exuberance, had a genuine integrity and vitality. Moreover, it served as a first step in breaking the hold of the National Academy of Design and other restrictive art institutions on the cultural life of America. Thus, it was a rude shock that, while still in a burgeoning stage, full of fresh life and excitement, the movement was fatally weakened by the Armory Show of 1913, and the overwhelming revelations of past and current European modernism that the exhibition provided. Despite the authentic creative energy of the Ashcan School, the Armory Show brutally exposed the basic provincialism of American aims and

achievements in comparison to the power and diversity of the art of Europe. Stuart Davis, like many others, responded very strongly: "After the Armory Show . . . I was impressed by . . . the realization that the Henri school, . . . this American free naturalism [,] wasn't the answer, that all kinds of new areas were opened up. I wasn't the only one in the school who reacted to the Armory Show . . . there were others."[9] Davis later explained, in succinct modernist terms, the basic flaw for him in Henri's approach: "The borderline between descriptive and illustrative painting, and art as an autonomous sensate object, was never clarified."[10]

Henri's followers reacted with confusion and with diverse explorations of new artistic directions. Subsequently, during the social and cultural upheavals wrought by World War I and its immediate aftermath, the Ashcan School was much diminished as a distinct and vital force, and its vanguard role was effectively ended. The art of its continuing adherents merged with the broader international conservative trends that dominated, in quantity anyway, the period between the two world wars. Much of the work of the second generation is today unknown or neglected—even that produced by those now recognized to be major artists. This neglect is due in part to the fact that, as the best of these artists went on to even greater achievements, many of them repudiated if not their origins, then the art of their origins.

Stuart Davis did exactly this. In his later comments on his early years, he always praised the teaching of Henri, but he consistently disparaged his own early art.[11] Nevertheless, measured against its own standards and against the not inconsiderable achievements of the first-generation Ashcan School, the art of the second generation has significance and deserves attention. For the most part—and this was the case with Davis—the contribution of the younger artists to the Ashcan style was precisely their infusion of hints of what were still only dimly perceived modern trends. The best artists of this generation produced early work of high merit, and became painters of prominence and importance in the world of American art. Some of them maintained their standing up to and even through the Abstract Expressionist period. Edward Hopper, for example, persisted in pursuing his early direction, and achieved an important place for himself and for the continuing realist tradition. Others who also remained realists, but who had less talent or possibly fewer opportunities, made significant contributions but never perhaps surpassed their early achievements. Among this group are George Bellows, Rockwell Kent, Guy Pène du Bois, Glenn Coleman, Carl Sprinchorn, Rex Slinkard, and Henry Glintenkamp.

Near the end of his life, on the occasion of the fiftieth anniversary of the "Exhibition of Independent Artists," Davis was asked about some of his old companions who were by then mostly forgotten by the art world. Answering in his characteristic pithy, deadpan manner, he nevertheless gave a serious response, coupling the promise of the early days with the drearier realities of the passing years: "Scott Stafford was a man of enormous talent and virtuosity as a painter. He never became known and may have abandoned Art for some reason. Arnold Friedman was an individual creator who worked in the Post Office. . . . [James H.] Daugherty was a successful illustrator. [Glenn] Coleman has never received the status he deserves in American art history as a first-class talent. Glintenkamp was an accomplished painter at an early date who later took to wood-cuts for some reason. Julius Golz was a good artist who became a teacher in Ohio."[12]

There were a select few who produced noteworthy early work, and later made major contributions to American modernism. Stuart Davis, along with Arnold Friedman and Patrick Henry Bruce, belongs in this group. That Bruce—whose early paintings have mostly been lost to us—was recognized initially as an accomplished Ashcan artist we learn from Sprinchorn: "A portrait [of Warren Hedges, a fellow student] . . . painted by Bruce

. . . hung on the wall in the life class [, a] cynosure of all eyes and an example of the . . . highest accomplishment . . . of any Henri pupil."[13] Morgan Russell, Andrew Dasburg, and Arthur B. Frost were prominent among those who studied with Henri, and, like Bruce, immediately thereafter went to Paris and became deeply involved in French modernism. There were, in addition, other practitioners of advanced art who (based on the little we know now of their early work) perhaps failed to attain noteworthy personal achievements, but still contributed to a developing modernist culture—for example, A. S. Baylinson and John Pandick. These two classmates of Davis's at the Henri School were producing, exhibiting, and attracting notice for innovative work even before Davis, during the tumultuous post-Armory Show period.[14] There were myriad other young artists, including Amy Londoner and Hilda Ward, who were favorably received at the time, but who are virtually unknown to us today. Having studied with Henri, all of these artists exhibited in the many group shows he promoted at his school, at the MacDowell Club, and in other artist-organized events of the period.[15]

In these exhibitions Davis received important notice, although not all of it was entirely flattering. Guy Pène du Bois reviewed Davis's first one-man show held at the Henri School after Davis had studied there only a year: "He has ideas to express and seeks to put them forth, and does put them forth, with a wild and impetuous eagerness that causes him to soar to glorious heights or else to fall to the ground, an incoherent and inexplicable mass. His work is never mediocre. It is bad or good."[16] The critic Joseph Chamberlin was very responsive also: "Some of the very best work of the 'new men' in this city is [being] shown . . . not futurist work, but work that the future will have to reckon with. The highest place in it is taken by the pictures of George Bellows, Stuart Davis and Randall Davey."[17] At another time he wrote: "Glenn Coleman's and Stuart Davis's scenes in and around big cities are full of pathos and power."[18] Davis was characterized as "a young leader of the 'don't care' school of art."[19] His work was called "alternatively repellently horrible, amusing and lovely."[20] The perceptive and influential critic Henry McBride was an early champion: "The wicked Stuart Davis . . . overtop[s] all his confreres."[21]

The second generation—diverse, dynamic, and numerous—was responsible for the Ashcan School's broad public impact and ongoing recognition. The first generation, however, has come to represent the entire movement. In part, this is because—as noted above—some of

the artists in the second generation, like Davis, virtually disowned the work of their Ashcan phase as they adopted more radical means of expression. By the same token, the tamer but more clearly established artistic identities of the first generation, and their persistence in maintaining their styles, have made them, in retrospect, the dominant personalities of the Ashcan School. However, it was Henri's many New York students, with Davis prominent among them—the second-generation Ashcan artists—who established the movement as a broad-based enterprise and focused public attention on it.

Disappointments: Stuart Davis, *The Masses*, and the Naming of the Ashcan School

The second-generation artists of the Ashcan School clearly had a greater influence on American art than has generally been acknowledged: They, in fact, were responsible for the Ashcan School having acquired its peculiar name, and Stuart Davis played a major part in the sequence of events that brought this about. It is widely accepted that the name *Ashcan School* originated in Art Young's attack in 1916 on the art of some of his fellow contributors to *The Masses* magazine.[22] An examination of the background of that incident reveals a specific art source for Young's use of the term *ash can*; more importantly, it helps to define better certain aspects of the Ashcan School and, especially, the contribution of its second generation.

The Masses, which was cooperatively produced by its contributing artists and writers, billed itself as "a *popular* Socialist magazine—a magazine of pictures and lively writing," and, further, as "a magazine with a sense of humor and no respect for the respectable; frank, arrogant, impertinent . . . a magazine whose final policy is to do as it pleases and conciliate nobody, not even its readers."[23] As it turned out—and, not surprisingly, considering the belligerent agenda—*The Masses* did not even please or conciliate its own board members.

The magazine had been a drab and moribund political journal on the verge of closure, but by early 1913 it was revived and transformed. Under the guidance of Stuart Davis's mentor, John Sloan, its appearance was forthrightly remodeled after the example of the radical satirical German and French magazines *Jugend*, *Simplicissimus*, *L'Assiette au Beurre*, and *Gil Blas*, which were then much admired for their pictures, if not for their texts, in progressive circles. Sloan brought to *The Masses* a talented group of young Henri followers, Stuart Davis chief among them. George Bellows and

Davis's close friends and sometime studio mates Henry Glintenkamp and Glenn Coleman were also included; Maurice Becker, another former Henri student, was already working for the magazine. (Sloan was a committed and active Socialist, who, in 1913, made an unsuccessful bid for the New York State Assembly on the Socialist ticket.) These artists, like their European counterparts, purposefully attacked conventional values and taste on a broad front in both the style and the content of their work. In style, the sketchy crayon drawings produced by most of the *Masses'* artists were considered "unfinished" and mere "smudges" by contemporary standards. Their subject matter emphasized class distinctions, gleefully satirizing the wealthy and powerful and depicting the poor not sentimentally, but as economically and socially disadvantaged. This in itself was enough to have the drawings branded "offensive" and "vulgar." Stuart Davis and others in the Ashcan faction further compounded this offensiveness by creating images of the more tawdry aspects of the lives of society's outcasts—the working poor, hoboes, derelicts, prostitutes—and by showing an obvious delight in doing so. There was an element of superior, participatory bohemianism in their attitude, and an absence of moral, Socialist uplift.

Cartoonist Art Young and a majority of the literary editors of the magazine did not entirely agree with this orientation of the Ashcan contributors. They considered it self-indulgent and politically irresponsible. Some of them, like Young, seem to have been as offended as the magazine's bourgeois targets. They favored a more positive, pragmatic, and politically effective program. Floyd Dell, assistant to managing editor Max Eastman, indicated that there had been an ongoing disagreement, and explained: "The squabbles between literary and art editors were usually over questions of intelligibility and propaganda versus artistic freedom; some of the artists held a smouldering grudge against the literary editors, and believed that Max Eastman and I were infringing the true freedom of art by putting jokes or titles under their pictures."[24] Max Eastman, without going into specific details, later observed: "Hell had to break loose. . . . It was a quarrel, essentially between art and propaganda, poetry and practical effort. . . . In more personal terms, it was a war of the Bohemian art-rebels against the socialists who loved art."[25]

As we shall see, Stuart Davis had, from the beginning, been at the center of this discontent, and was the chief instigator of the final confrontation. When the tensions finally broke out into open conflict there were numerous stories in the press, with headlines like "Clash of Classes

Stirs 'The Masses'." One article gave the following account, which has the virtue of being a contemporary report, unlike the later recollections cited above: "Day before yesterday the editors of The Masses had a row. In fact there had been a bit of a row for some time. But yesterday the art editors rebelled. They said they wanted to pick the pictures that were to be used. And, furthermore, they didn't want any literary editors explaining their pictures. It was true, they admitted, that ordinary folks couldn't always understand them without help, but The Masses wasn't meant for ordinary folk."[26] Clearly, there had been a long-standing, simmering conflict within the editorial board. We will examine that conflict, and Stuart Davis's central role in it, in greater detail as we proceed. It is evident from Art Young's angry comment, quoted below, and from additional evidence, that not only the public but some of the board members, too, were offended by the vulgarity of the magazine's art.

Young's consequential and now-famous phrase on the occasion of the "split" is contained in a hastily written statement for the press, which read in part: "The dissenting five artists were opposed to 'a policy'. They want to run pictures of ash cans and girls hitching up their skirts in Horatio street [sic]—regardless of ideas—and without title. . . . For my part, I do not care to be connected with a publication that does not try to point out [sic] the way out of a sordid materialistic world. And it looks unreasonable to me for artists who delight in portraying sordid and bourgeois ugliness to object to 'a policy'."[27]

When Art Young used the term ash can he was referring to second-generation Henri followers—specifically to Davis, Coleman, Glintenkamp, and Becker, as well as to Sloan. They were the dissenting artists. Max Eastman asserts that it was Davis and Davis's best friend, Coleman, who were "the strike leaders."[28] Sloan had already disassociated himself almost completely from the magazine; he came to the culminating confrontational meeting at the behest of the younger artists to support them and act as a spokesman for their position.[29]

What has never been noted before is that when Art Young made his remark he was referring to a specific work of art. He was not the first to use the term ash can in reference to the work of these artists; his immediate source was the title *Disappointments of the Ash Can* that accompanied a 1915 newspaper reproduction of a George Bellows drawing (see fig. 20). The drawing depicts three hungry hoboes appraising their find from a close-at-hand garbage can. The cartoon's caption has one of the hoboes making the pronouncement: "Dey's woims in it."[30] Given Young's violent objection to the sordid and ugly subjects

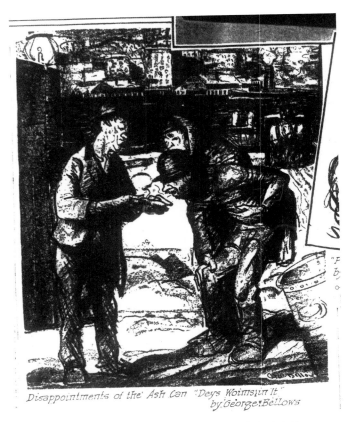

Figure 20. George Bellows. *Disappointments of the Ash Can.* About 1913. Drawing reproduced in the *Philadelphia Record*, April 25, 1915, Sunday magazine section, p. 4

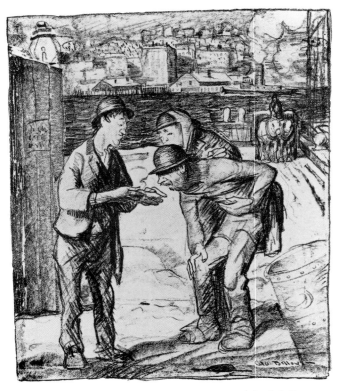

Figure 21. George Bellows. *Disappointments of the Ash Can.* About 1913. Drawing reproduced in *The Masses* 5, February 1914, p. 18, with the title "Real Tragedy" and the caption "DEY'S WOIMS IN IT!"

favored by the Henri followers on the staff, the title *Disappointments of the Ash Can* may well have taken on an ironic twist for him, signifying his ongoing disappointment with the artists who chose to depict such subjects. In any case, it was this drawing and its title that led to the naming of the Ashcan School—and Stuart Davis played a direct part in an evolving sequence of events that brought this about.

Bellows's drawing had received a lot of exposure and was well known to the *Masses'* staff. In fact, it had first been published in *The Masses* in February 1914 (see fig. 21).[31] It did not have the *Ash Can* title then, but was called *Real Tragedy*. The caption with the hobo's words was the same, however. The occasion for the drawing's subsequent publication in the newspaper in 1915 was its inclusion in the exhibition "The American Salon of Humorists,"[32] which received wide, generally favorable publicity. More than half of the twenty-five artists represented were contributors to *The Masses*. Davis exhibited thirteen works, including a selection of drawings that had previously been published in *The Masses*. Art Young also participated in the show, and could have renewed his acquaintance with the offending Bellows drawing there. Afterward, *The Masses* published an extended commentary on the exhibition, concentrating on its own artists.[33] It is clear from their allusions to it that both Art Young and Max Eastman, by the time of the split, considered that this particular drawing epitomized the art of the younger members to which they objected. It is apparent that the drawing had, indeed, come to typify that art, even before the exhibition brought it renewed publicity.

Davis also played a role in this process. In a column that would have been written more than a month prior to the exhibition, Eastman relates the following anecdote: "Stuart Davis was walking in a downtown street with a friend the other day, and saw some pitiful Belgian of the industrial war making for the interior of a garbage can, in search of a bite of food. 'Look—he knows I'm a *Masses* artist!' said Davis, with that peculiarly *Masses* humor of his."[34] Davis and Eastman are referring specifically to the Bellows cartoon. The quip and the drawing have the same theme—hungry beggars looking for food in a refuse can. Bellows's picture was the only such explicit rendition of the subject to appear in the magazine, and Davis clearly had it in mind when he made his remark. In fact, this is one of those not infrequent examples of life emulating art—at least in the eyes of the beholder. In this case Davis, as the beholder, and in his spoken response, is seizing on the image of the refuse can as a paradigm of

Figure 22. George Bellows. *A New York Street before Dawn.* About 1907. Drawing reproduced in *Harper's Weekly* 58, September 6, 1913, p. 21

the art of *The Masses*, and, by extension, of the art of the entire second generation of Henri followers. Young, in flinging the term *ash can* at the artists, was, in effect, following Davis's lead.

Much later, long after the heat of battle had passed and the Ashcan School had won the day and taken an honorable place in the history of American art, Max Eastman was proud to acknowledge his association with it and, he seems to suggest, with the adoption of its name. Writing in his memoirs, he claimed that "we were coarse enough . . . to play a role in creating the 'Ash-can School' of art. Indeed George Bellows' revolting [drawing] . . . of two [*sic*] bums picking scraps out of a refuse can was the *ne plus ultra* of that school."[35]

An earlier, directly related precedent in Bellows's art for the "ash-can" theme is a drawing entitled *A New York Street before Dawn* (fig. 22), which was reproduced in *Harper's Weekly* in 1913. It, too, elicited a reference to "ash cans" in what is, to my knowledge, the earliest such published use of the term in connection with a work by one of these artists. The drawing in question was described in a contemporary critique: "Bellows essays a New York subject with an elaborate use of his imagina-

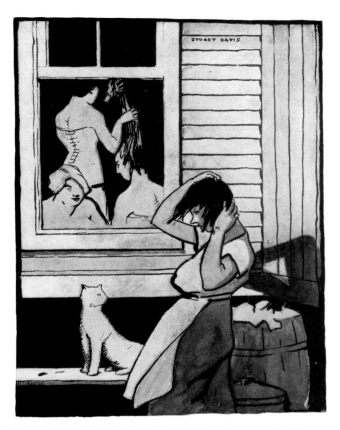

Figure 23. Stuart Davis. *Cats.* 1913. Drawing reproduced in *Harper's Weekly* 58, September 6, 1913, p. 9

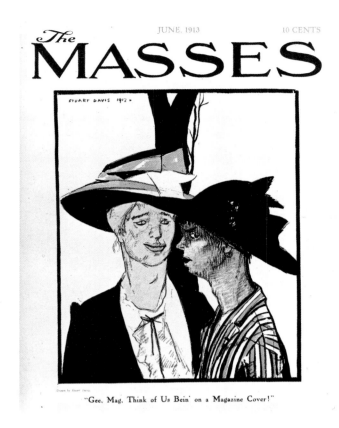

The MASSES

"Gee, Mag, Think of Us Bein' on a Magazine Cover!"

Figure 24. Stuart Davis. *"Gee, Mag."* 1913. Drawing reproduced on the cover of *The Masses* 4, June 1913

tion in 'A New York Street Before Dawn,' showing dogs preying on ash cans and gutter heaps."[36]

It should be noted that this drawing also has a direct connection to *The Masses.* The venerable *Harper's Weekly* at this time was emulating the more radical new magazine whose lively graphics had been attracting a lot of attention in progressive circles. For a brief period in the fall of 1913, *Harper's Weekly*, in what proved to be a lamentably misguided attempt to update its image, published drawings by the *Masses'* artists—those very same individuals who were later to be at the center of the *Masses* controversy: Davis, Bellows, Sloan, Coleman, and Becker. Davis's *Cats* (fig. 23), for example—which, incidentally, includes a trash barrel and a garbage can—appeared in the same issue as the Bellows drawing;[37] it presents an intimate view of young women of dubious reputation. Their possible status is suggested in the not too subtle allusion, by means of the title and the presence of a rangy alley cat, to a cat-house—a popular term for a house of prostitution. Needless to say, this experiment on the part of the popular mainstream magazine met with an instant public outcry, and soon ended. The drawings elicited such reader comments as, "Your 'shredded wheat' style of illustrations are [*sic*] horrid," "The pic-

tures are daub [*sic*]!" and, "It is a poor promise for the future if we are to judge by the so-called cartoons by Stuart Davis, which have absolutely nothing to recommend them, and are about as inane a products [*sic*] of decadent art as can be found in contemporary publications."[38]

Max Eastman took delight in reprinting from *Collier's* magazine yet another attack on the illustrations by the *Masses'* artists as they appeared in *Harper's Weekly*—an abusive, extended denunciation, linking Davis and Bellows. The overwrought prose joins their works so closely that it seems to combine the two images into one. The writer makes explicit references to both Davis's *Cats*, which is aptly characterized, and to the Bellows drawing: "Many of the stern young moralists who are winning fame by their pictures in our magazines seem (to paraphrase a homely proverb) to have the same bad smell up their nostrils. Their people are gawky, greasy, febrile, and mean; they are doing contemptible things in a graceless, animal sort of fashion; their backgrounds are dingy, tawdry, and slovenly or unsanitary. Life is shown in the guise of the thriftless seeker after low pleasures. And yet these artists are intelligent, educated, alive, with the artist's deft hand and trained eye. They proved it by drawing a revolting bunch of cats and dogs prowling about some

overturned garbage cans!"[39] There are no human figures or cats in Bellows's drawing although, admittedly, his dogs have a feline aspect. The writer's description of figures and his reference to "a revolting bunch of cats" must relate, however confusedly, to the Davis drawing. Indicative of the nascent conflict within the *Masses*' staff, Eastman—writing over a year before the big confrontation—concedes that the argument of the *Collier's* writer has some merit: "It may, indeed, be true that freedom to see and sing [the realities of life] has turned the heads—or the hearts—of some poets and artists. They may have fallen a little in love with the sordid for its own sake."[40] Young's later statement loudly echoes this assessment. It is clear that the tensions that divided the staff existed well before the dramatic split.

As has been noted, the problem existed from the beginning, when John Sloan introduced to the magazine the young second-generation Ashcan artists who were to transform its appearance. Stuart Davis was at the center of controversy from the start. With his first major illustration for *The Masses*, he initiated a minor version of the later confrontation. His first cover drawing, of two homely women with the caption, "Gee, Mag, Think of Us Bein' on a Magazine Cover!" (fig. 24),[41] printed in an unflattering blue-green, brought him and the magazine much notice at the time—and is today his best-known contribution to *The Masses*—but it almost did not get published. This early skirmish is vividly described by the poet Louis Untermeyer in his memoir of the period. When the drawing was submitted at a monthly staff meeting, there was "an immediate outcry." During an angry and heated argument two (unnamed) editors "threatened to resign if the drawing ever appeared in the magazine." Untermeyer, who describes Davis as "savagely independent," suggests that the drawing was his protest against not only the conventional, romanticized magazine illustrations of the day, but also "against our own fondness for the sweet and slick redeemed by a sharp caption."[42] Art Young was one of the violent objectors to the Davis drawing. Later, in his autobiography, Young rather sheepishly explained his objection: "I voted against the Davis drawing. I was older than many of the rebellious artists and had a hang-over of bourgeois taste that I never completely abandoned and perhaps never will."[43] In addition, we have Davis's own unapologetic, straightforward reference to the meeting: "Last night we had a stormy session where everybody got personal and started saying nasty things about each other. I got my cover accepted which they have previously been afraid to print and it will appear in the next number."[44] This pivotal meeting expanded the limits of what would be accepted for publication from the second-generation Ashcan artists on the staff, and thereby helped determine the content and appearance of the magazine in its then still new, more radical format. Davis's cover, which generated publicity for the magazine while helping to establish its new identity, was called "the best magazine cover of the year" by one critic.[45] The favorable response solidified the position, for a time, of the Ashcan faction within the *Masses*' staff.

Art Young's style was very different from that of Davis and the other Ashcan artists on the magazine's staff. A member of an earlier generation, Young had solid experience in standard newspaper cartoon work. He used mostly pen and ink, and his drawings had a clean, crisp look, with sharp contrasts of black against white. (See, for example, his cartoon [fig. 25] that, aptly for our discussion, mocks the younger artists' propensity for depicting the sordid and ugly in magazine illustrations.)[46] Young displayed a rather buoyant, sunny disposition, taking obvious delight in skewering the top-hatted, tail-coated, overfed symbols of capitalism that were his frequent targets. His work was influenced by the boisterous, life-affirming artists of the English graphic-arts tradition, such as Thomas Rowlandson and George Cruikshank. Young's cartoons always made a clear and specific political point. In all of these qualities, he differed markedly from the second-generation Ashcan contributors to *The Masses*, who, in their preference for the dark, expressive tonalities of crayon drawing, and in their more cynical and even pessimistic outlook, followed the more

Figure 25. Art Young. Cartoon. 1914. Drawing reproduced in *The Masses* 6, November 1914, p. 6

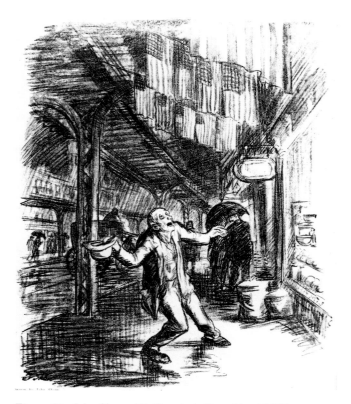

Figure 26. John Sloan. *His Country's Flag*. About 1912. Drawing reproduced in *The Masses* 4, December 1912, p. 4

Figure 27. Stuart Davis. Untitled. 1913. Crayon, ink, and pencil on paper. Collection Earl Davis. Courtesy of Salander-O'Reilly Galleries, New York

modern French tradition of Honoré Daumier, Jean-Louis Forain, and Théophile-Alexandre Steinlen. John Sloan shared Young's generally optimistic and positive approach, but he also looked with favor on the modern French tradition. As the chief art editor of the magazine, he was the one who most affected its appearance. Having personally invited Davis and the other Henri followers to join the staff, he vigorously supported them when controversy arose.

There were precedents by these artists for the unobtrusive inclusion of refuse containers in the dismal urban settings of the social outcasts who were their subjects. Ash cans and other trash receptacles served as mute symbols of society's human rejects. Such usage occurs, for example, in John Sloan's first contribution to the magazine —the depiction of a drunken derelict—and in drawings of prostitutes by Glenn Coleman and Stuart Davis (see figs. 26, 27).[47] Davis made his drawing specifically to accompany a poem by Louis Untermeyer, basing its general layout on his painting of 1912 entitled *Bleecker Street* (cat. no. 2). Significantly, both of Davis's works depict identifiable sites—locations of recognized former gentility and social distinction that had declined into shabbiness and dereliction.[48] Thus, Davis's gritty, realistic treatment of subject and site served both to celebrate

the Ashcan style and also to underline its distance from the respectable world of those with more conservative tastes. The Ashcan School's attack on the National Academy of Design, for example, was not just an attack on its genteel style, but, more broadly, the message was that gentility itself could fade and was, indeed, fading already.

Davis's enigmatic bedroom scene *The Front Page* (cat. no. 9), which he exhibited in the Armory Show, and its more obvious alley-cat analogue *Two Cats* (cat. no. 8), both from 1912, are indicative of the provocative sensibility that the artist brought to *The Masses*. Davis's drawing of prostitutes to illustrate Untermeyer's poem was of the type that Art Young had in mind when, in his denunciation of the Ashcan artists, he referred to "girls hitching up their skirts in Horatio street [*sic*]."[49] His specific reference, however, must have been to John Sloan's *Putting the Best Foot Forward* (fig. 28), the depiction of a destitute, peg-legged beggar and an attractive young prostitute, each soliciting in his or her own way.[50]

As noted, Davis, in his quip about the hoboes and the refuse can, recognized Bellows's drawing of the subject as a paradigm of the art of *The Masses* and of the second generation of Henri's followers who were its major contributors. *The Masses* had a reputation for vulgar depic-

Figure 28. John Sloan. *Putting the Best Foot Forward.* 1913. Drawing reproduced in *The Masses* 6, June 1915, p. 4

Figure 29. Stuart Davis. *The Dog.* About 1915. Drawing reproduced on the back cover of *The Masses* 8, September 1916, with the caption "The Dog: 'What Are Those Strange Creatures Doing?'"

tions of the lower strata of society, and this particular drawing by Bellows came to stand for all the sordidness that such pictures might imply. With Bellows the refuse can moved from background setting—its role in Davis's, Sloan's, and Coleman's drawings, for example—to foreground participant. In the process, the ash can became emblematic of the dominant strain in the art of *The Masses*—specifically, that produced by second-generation Henri disciples—and it was then adopted as a symbol for the entire movement, as a result of Art Young's angry remark.

The *Masses* split was quite dramatic, but, for all that, it did not constitute a permanent rupture among the staff artists and writers. Two additional drawings by Davis appeared in the magazine before it ceased publication in 1917, and he contributed to its successors, *The Liberator* and the *New Masses*. *The Dog* (fig. 29), one of these last *Masses* illustrations,[51] presents a startling view from a rooftop. Davis's well-articulated canine is a descendant, via those of Toulouse-Lautrec, of Bellows's savage pack of mongrels. The picture's complex formal and psychological layering of observation and reflection redeems the squalor in the Bellows drawing, and its integration of realism and pictorial construction helps to lift the Ashcan style from too close a dependence on its reportorial role.

Rewards

In the immediate aftermath of the *Masses* split, Davis went to Gloucester, Massachusetts, and, as if freed from certain Ashcan realist obligations, during the summer of 1916 he created his most advanced paintings to date—for example, *Gloucester Beach/A Cove (Rockport Beach)* and *Sketch—Church Tower* (cat. nos. 16, 18). In these works, he went beyond his initial cautious responses to the modern art of the Armory Show, as witnessed in the *Portrait of a Man* of 1914, *The Back Room* of 1913, and *Hillside near Gloucester* of about 1915–16 (cat. nos. 4, 6, 15). These earlier paintings are good and strong, with lessons learned from van Gogh, Cézanne, and Matisse, respectively. However, in the work that Davis produced in the summer of 1916 there was a heightened striving for a more unified personal vision as the artist intensified his efforts to forge an amalgam of his realist origins and his newer modernist aspirations. His allegiance to these origins remained strong, as evidenced by his 1917 painting *Last Trolley—Gloucester* (cat. no. 21), which, despite its severe generalizations of form and color, conveys a somber realism and an implied but inexplicit narrative.

In 1918, a difficult year because of wartime disruptions, during which Davis did very little painting, he

reasserted his Ashcan origins even more strongly in *Multiple Views* (cat. no. 23). He composed the painting in a setting in which he was literally surrounded by other Ashcan artists—Sloan, Luks, and Coleman among them. Painting over a period of several days in a competition held at the basically conservative Whitney Studio Club, with which he was associated, Davis chose to recapitulate some of his imagery of the last few years. For example, *Gloucester Beach /A Cove (Rockport Beach)* and *Garage* (cat. nos. 16, 22) are repeated in a more naturalistic guise at the upper center and lower right of *Multiple Views.*[52]

Davis's 1919 self-portraits and landscapes painted in Tioga, Pennsylvania, and in Gloucester more successfully combine Ashcan realism and modernist expressiveness (see cat. nos. 24–29). It was a time of deep introspection for the artist—who had almost died in the great influenza epidemic of 1918—and for the nation as a whole; World War I had brought to an end the era of optimism and reform that had given rise to the Ashcan School. Davis forthrightly returned to the certainties of his realist beginnings and refounded his art on them. At the same time, he attempted to explore a range of expressive realism deriving from the European modern tradition extending from Courbet to van Gogh. Thus, he reaffirmed his origins as he also prepared for the profound advances of the next few years. In his paintings of 1919 and in his Matisse-inspired watercolors of early 1920, he began to assimilate in a more systematic way the lessons of the modern masters, going beyond Robert Henri's visual transcription of reality and espousing a modernist vision of manipulating reality for pictorial, expressive effect. Davis's later works retain this vital connection with everyday reality. *Salt Shaker* of 1931 and *Visa* of 1951 (cat. nos. 94, 144), for instance, succeed because they are vibrant, witty Cubist transformations of common objects—a simple kitchen item on the one hand, and a matchbook cover on the other.

Stuart Davis's artistic origins were formed by the Ashcan School, and throughout his life he remained rooted in that vital American experience. In his later years, looking back from the vantage point of a long and successful career, Davis reflected: "My basic attitude toward art was established by my father's close association with the Philadelphia newspaper artists of [the] 1890s, who later formed the core of the group called 'the Eight.' . . . The subject matter of that kind of realism has rapidly changed in its physical and psychological content without changing my attitude toward its significance."[53]

Notes

For their invaluable assistance in the preparation of this study I would like to thank Helen Farr Sloan, Earl Davis, Lawrence B. Salander, Sam Hunter, and William C. Agee.

[1] Stuart Davis created confusion with his claim that he was born in 1894. This is the date that has usually appeared in the critical and art-historical literature of the last fifty years. However, with my discovery of his birth certificate, which was misregistered in the Philadelphia Department of Records under the name "Davies" by the physician attending his birth, we now know with certainty that he was born December 7, 1892.

[2] Both Henry Glintenkamp and Carl Sprinchorn, for example, executed large-format urban snow scenes: *Street Scene in Winter* of c. 1910, and *A Winter Scene on the East Side* of 1906, respectively; at 30 by 40 inches, they were the same size as Davis's.

[3] Davis's early affinity for compositional concerns and for a mild generalization of color and form is partially the result of his intimate familiarity in his youth with the abstracting patterns of the Poster Style, the art of Aubrey Beardsley and Théophile-Alexandre Steinlen, and other Post-Impressionist developments.

[4] "Stuart Davis Reminisces," interview by Harlan B. Phillips, 1962, p. 53. Unpublished transcript. Collection Earl Davis.

[5] It is also useful to make a clear distinction between the Ashcan School and The Eight. The latter was a temporary association of the first-generation Ashcan group with three very different artists, Arthur B. Davies, Maurice Prendergast, and Ernest Lawson, for one exhibition only, in 1908.

[6] Izola Forrester, "New York Art Anarchists; Here is the Revolutionary Creed of Robert Henri and his Followers," *New York Herald*, June 10, 1906. Clipping in the John Sloan Archives, vol. 2, The Museum of Modern Art, New York.

[7] My figures are based on data in *The Fiftieth Anniversary of the Exhibition of the Independent Artists in 1910* (exhib. cat.). Wilmington: Delaware Art Center, 1960, pp. 13–20. Luks was the absent first-generation member.

[8] In addition to the four paintings listed in the catalogue of the 1910 "Exhibition of Independent Artists," Davis exhibited *The Music Hall* (Collection Earl Davis), which he completed only after the catalogue had gone to press.

[9] "Stuart Davis Reminisces," op. cit., p. 103.

[10] Stuart Davis, in "Autobiography." New York: American Artists Group Monographs, 6, 1945, n.p.

[11] Examples abound of Davis's later dismissive attitude toward his early art. In his autobiographical essay he explains: "In this early period of riding, walking, and gadding about all over the place, *it seems* that a great many drawings and paintings were made. *I have no idea what became of most of them.* . . . My ability to draw life in the raw, *as far as it went*, made me a candidate to join the staff of *The Masses. . . . Whatever the merit* of these drawings [for *Harper's Weekly*], they fitted in with the 'liberal' kick on which the magazine was oriented" (Ibid., italics mine). Davis's disparagement of his early work and his ongoing, persuasive accounts of his own life story colored most subsequent critical commentary on his art.

[12] Stuart Davis, in a letter to Bruce St. John, director of The Wilmington Society of the Fine Arts, Delaware, May 6, 1959. Copy in the collection of Earl Davis.

[13] Carl Sprinchorn Papers, Archives of American Art 3011, frames 34ff. Lent by the Folger Library, University of Maine, Orono. Bruce's sitter, Warren Hedges, soon after went to California, where he taught the young Stanton Macdonald-Wright, the future Synchromist, at the Art Students League of Los Angeles.

14 Baylinson and Pandick exhibited with Davis in a group show, "Paintings on Exhibition," New York, Liberal Club, January 31–February 13, 1916 (brochure in Stuart Davis Scrapbooks, Archives of American Art N584, frame 92). The conservative critic Royal Cortissoz characterized them as "ultramodern," while calling Davis and the other exhibitors merely "modern." "Some of the pictures are quite companionable, while others are as shocking to the nerves as the blowout of an automobile tire. John Pandick shows two so-called portraits in lurid reds and smoky blues. It is difficult to see any resemblance to the human countenance, and they remind one of nothing so much as a burning pile of rubbish." Davis's realistic and slightly stylized *Back Yard* (Collection Earl Davis) of 1916, by contrast, is seen as "not bad in design" (Royal Cortissoz, "Random Impressions of Art in Current Exhibitions," *New York Tribune*, February 6, 1916, sect. 3–4, p. 3). Another critic was more accepting of Pandick's "cubistic effusions" and of Baylinson's "nice pattern of colors," but the critic still distinguished between these "violently revolutionary painter men" and the realists John Sloan, Glenn Coleman, and Stuart Davis, the last of whose work he found "original and very amusing" (H. C. R., "Art and Artists . . . Revolutionary Artists at the Liberal," *New York Globe*, February 8, 1916, p. 10). The other exhibitors were Homer Boss, Maurice Becker, Henry Glintenkamp, Eugene Higgins, and Paul Koechl—all Henri followers.

15 For example, Glenn Coleman, Julius Golz, Jr., and Arnold Friedman organized a show of the work of Henri's students in 1908: "Exhibition of Paintings and Drawings by Contemporary American Artists," New York, Harmonie Club, March 9–31, 1908 (cited in Gail Levin, *Edward Hopper: The Art and the Artist* [exhib. cat.]. New York: W. W. Norton and Co. in association with the Whitney Museum of American Art, 1980, n.p.). The exhibition included work by some of the best of Henri's students of the period. In addition to the organizers, among the thirteen exhibitors were Edward Hopper, George Bellows, Guy Pène du Bois, Rockwell Kent, and Carl Sprinchorn. The "Exhibition of Independent Artists," New York, April 1–27, 1910, was the largest and most spectacular of such exhibitions and was a direct precursor to the Armory Show. In 1911, Rockwell Kent organized a show inspired by the "Exhibition of Independent Artists" and apparently intended as a follow-up to it: "An Independent Exhibition of the Paintings and Drawings of Twelve Men," held at the Gallery of the Society of Beaux-Arts Architects, New York, March 26–April 21.

16 Guy Pène du Bois, Untitled review of exhibition, *New York American*, October 31, 1910, p. 19.

17 Joseph Edgar Chamberlin, "Good Pictures at MacDowell Club: A Refreshing and Promising Show by Some of the Younger Artists," *New York Evening Mail*, January 24, 1914, p. 6.

18 Joseph Edgar Chamberlin, "Artists at MacDowell Club: An Exhibition Which Includes the Work of Some Promising Painters," *New York Evening Mail*, December 8, 1911, p. 10.

19 Emanuel Julius, "Humor in American Art," *The New York Call*, May 2, 1915, sect. 2, p. 1.

20 William B. McCormick, "MacDowell Club's Excellent Show Heralds Passing of the Art Jury," *New York Press*, May 11, 1913, sect. 2, p. 6.

21 Henry McBride, "What Is Happening in the Art World," *New York Sun*, January 25, 1914, sect. 7, p. 2.

22 William Innes Homer discusses early usage of the term. It apparently first appeared in print in Holger Cahill and Alfred H. Barr, Jr., *Art in America in Modern Times*. New York: Reynal and Hitchcock, 1934, p. 31 (William Innes Homer, *Robert Henri and His Circle*. Ithaca: Cornell University Press, 1969, pp. 280–81).

23 The first quotation is from *The Masses* 4 (December 1912), p. 3; the second is from *The Masses* 4 (July 1913), p. 2. Rebecca Zurier provides an excellent account of the magazine in *Art for The Masses: A Radical Magazine and its Graphics, 1911–1917* (exhib. cat.). Philadelphia: Temple University Press, 1988.

24 Floyd Dell, *Homecoming*. New York: Farrar and Rinehart, 1933, p. 251.

25 Max Eastman, *The Enjoyment of Living*. New York: Harper and Brothers, 1948, p. 548.

26 Unsigned, "Editorial Split Mars Harmony on the Masses," *New York World*, April 7, 1916, p. 5.

27 Unsigned, "Clash of Classes Stirs 'The Masses'," *New York Sun*, April 8, 1916, p. 6. In the final analysis, the controversy may have been more the product of personality disputes than hardcore political or artistic beliefs. The magazine published far more untitled, non-political drawings after the split than it ever had before—for example, purely poetic reveries by Frank Walts, Hugo Gellert, and even Arthur B. Davies. It may be that the editors saw this work as a healthy antidote to the "sordid and bourgeois ugliness" of the Ashcan faction.

28 Max Eastman, op. cit., p. 549; Eastman gives further details on the confrontational meeting on pages 548–55. Davis, Coleman, Becker, and Sloan resigned. Glintenkamp, ignoring Coleman's purported role, later indicated that it was Davis and he who initiated the revolt (Henry Glintenkamp, "Art Young," *Direction* 7, April–May 1944, p. 12). George Bellows chose not to participate in the controversy. Mary Heaton Vorse, a writer for the magazine, indicates the long-standing nature of the squabble and Davis's central role in it in a letter written to her family the previous year: "Later drifted in a few of the others, mostly of the dissenting group who think that the salary list is too large, Davis and Carlton Brown [a writer and close friend of Davis] and Coleman. They grumbled in their sleeves and when Max asked them what ailed them seemed unable to tell where they had gotten their grouches . . . " (Mary Heaton Vorse Papers, March 10, 1915. The Archives of Labor History and Urban Affairs, Wayne State University, Detroit, Michigan). The literary editors, Eastman and Dell, were the only salaried workers. Davis and his friends thought that the salaries should be eliminated and that the artists and writers, as independent groups, should each decide on their own contributions. In her published memoir, Vorse emphasized the writers' discomfort: "Nothing more horrible can be imagined than having one's piece torn to bits by the artists at a *Masses* meeting" (Mary Heaton Vorse, *A Footnote to Folly*. New York: Farrar and Rinehart, 1935, p. 42).

29 According to Mrs. John Sloan, in an interview with this author on December 8, 1972, her husband stopped going to the *Masses* meetings by mid-1914, although his name was retained on the masthead.

30 Bellows's drawing, with the caption "Disappointments of the Ash Can," appeared in E. W. Powell, "Art in Serious and Comic Phases," *Philadelphia Record*, April 25, 1915, Sunday Magazine Section, p. 4. This new information, and additional material presented below, confirms the conjecture of William Innes Homer (op. cit.) that Bellows's depictions of ash cans may have contributed to the creation of the name Ashcan School. It should be noted that, strictly speaking, "ash can" refers to a refuse container for ashes and cinders from wood and coal—the common fuels of the day. As is clear here, however, the name was used interchangeably with "garbage can." (The term appears as two words in connection with the Bellows drawing and as used by Young—not as one word, as in some but not all of the later literature on the Ashcan School.)

31 *The Masses* 5 (February 1914), p. 18.

32 The exhibition was held at the Folsom Galleries, New York, April 17–May 1, 1915. The drawing was number 13 in the cata-

logue, where it was titled *Worms*. Several of the titles were clearly concocted specifically for the exhibition—but perhaps not by the artists themselves. As in this case, some titles can be read as insulting double entendres. Therefore, without corroboration, this particular title cannot be taken as definitive.

33 Edmond McKenna, "Art and Humor," *The Masses* 6 (June 1915), pp. 10–12. Bellows's *Disappointments of the Ash Can* is not mentioned.

34 Max Eastman, "Knowledge and Revolution," *The Masses* 6 (April 1915), p. 5. "Belgian" as used here means victim. Belgium was much in the news as the innocent sufferer in the warfare between France and Germany. Davis himself had done a cartoon on the subject, "She Gets it Coming and Going," which accompanied an article by John Reed, "Notes on the War: By Our European Correspondent," *The Masses* 6 (November 1914), p. 14.

35 Max Eastman, *Love and Revolution*. New York: Random House, 1964, p. 19. Actually, Eastman refers to the work as a lithograph. The exact medium of several of Bellows's contributions to *The Masses* is in dispute. Zurier identifies some works as transfer lithographs with added drawing, whereas Myers and Ayres suggest at least one is a monoprint with added drawing (Zurier, op. cit., p. 200; Jane Myers and Linda Ayres, *George Bellows: The Artist and His Lithographs 1916–1924* [exhib. cat.]. Fort Worth: Amon Carter Museum, 1988, p. 20). As the whereabouts of the work are unknown, I have chosen simply to use the term *drawing*. We cannot assume that Eastman possessed special knowledge on this matter, although he may have.

36 Bellows's *A New York Street before Dawn* was reproduced in *Harper's Weekly* 58 (September 6, 1913), p. 21. The quotation is from a harsh critique of the magazine's illustrations by James Britton, "Art: American Illustration A La Mode," *The Hartford Daily Courant*, September 19, 1913. (My thanks to Garnett McCoy of the Archives of American Art for calling this article to my attention.) Britton writes of one of Davis's contributions: "The pen drawing frontispiece by Stuart Davis proved a mere travesty, lacking even the merit of frank caricature." The writer attacked all the *Masses* artists featured in *Harper's Weekly*, and went on to conclude: "It is earnestly to be hoped that these clever chaps will soon cease posing, drop the methods of the French and other European caricaturists, and settle down to express themselves, the more puritanically the better." The Bellows drawing, which dates from about 1907, is now entitled *Hungry Dogs*, and is in the collection of the Boston Public Library. It is the source for the artist's first lithograph, of the same title, which he made in 1916 (Lauris Mason and Joan Ludman, *The Lithographs of George Bellows: A Catalogue Raisonné*. Millwood, New York: KTO Press, 1977, no. M.1; see also Myers and Ayres, op. cit., pp. 32–33, 160–61).

37 *Harper's Weekly* 58 (September 6, 1913), p. 9. During August and September 1913, *Harper's Weekly* published a total of six drawings by Davis. Davis based *Cats* on a watercolor of the previous year (reproduced in Karen Wilkin, *Stuart Davis*. New York: Abbeville Press, 1987, p. 8, as *Woman Washing Hair* [Collection Earl Davis]). It was one of a series of at least three watercolors depicting the same setting and group of women. See also *Servant Girls* (cat. no. 10). One of these works, as yet unidentified, was exhibited in the Armory Show.

38 *Harper's Weekly* 58 (October 11, 1913), pp. 30–31.

39 Max Eastman, "What Is the Matter with Magazine Art," *The Masses* 6 (January 1915), p. 16. Eastman stated that he was quoting from *Collier's*.

40 Ibid.

41 *The Masses* 4 (June 1913), cover illustration.

42 Louis Untermeyer, *From Another World*. New York: Harcourt, Brace and Company, 1939, p. 45.

43 Art Young, *On My Way*. New York: Horace Liveright, 1928, p. 287.

44 Stuart Davis, undated letter [late April 1913] to Hazel Foulke. Collection Earl Davis.

45 Franklin P. Adams, "Always in Good Humor," *New York Evening Mail*, May 22, 1913, p. 10. Another writer contrasted the cover favorably with the conventional covers of Charles Dana Gibson and Howard Chandler Christy that it satirized, and observed, "Most cover designs don't mean anything. But this one does" (Unsigned, "Books of the Week," *New York Globe*, May 24, 1913, p. 6).

46 *The Masses* 6 (November 1914), p. 6.

47 *The Masses* 4 (December 1912), p. 4; 4 (July 1913), back cover; and 5 (October 1913), p. 15.

48 I am grateful to Dr. Jan Seidler Ramirez, Curator of Painting and Sculpture at the Museum of the City of New York, for helpful discussion on this subject. Untermeyer's poem is titled "Any City." In *Bleecker Street*, the "J.COLP PHARMACY" sign can be identified with Joseph Colp, a druggist, whose business was located at 209 Bleecker Street, at the corner of Minetta Street. In the untitled drawing, the sign "CHAS S. LOW CHINESE RESTAURANT" locates the site at 514 Sixth Avenue, just south of Thirty-first Street (*Trow's Business Directory of Greater New York*. New York: 1912, 1913).

49 See note 27.

50 Horatio Street, like Bleecker, is in a section of Greenwich Village that had fallen from its former fashionable status into disrepute. Young, in citing it, was making a punning reference to "whore"—the drawing's subject, to which he so strongly objected. Sloan based the drawing on a more decorous version of the theme, his 1910 etching *Girl and Beggar*, which he exhibited at the Armory Show in February 1913 (Peter Morse, *John Sloan's Prints: A Catalogue Raisonné of the Etchings, Lithographs, and Posters*. New Haven: Yale University Press, 1969, no. 150).

51 *The Masses* 8 (September 1916), back cover. As evidence that the consequences of the *Masses* split were not irreparable, one should note that Max Eastman selected two works for its successor, *The Liberator*, precisely because of their Ashcan offensiveness. One of the works was the 1912 watercolor on which the *Harper's Weekly* illustration *Cats* was based. Eastman reproduced it with the title *Feline*; his commentary on it echoes—now entirely favorably—the anonymous critique from *Collier's* on *Cats* that he had published previously: "[Davis] chooses to have somewhat the character of an alley cat. His art lives among the same squalid and strong-smelling and left-out objects, and it goes its sordid way with the same suave dirty muscular self-adequate gracefulness of power" (Max Eastman, "Portrait of a City," *The Liberator* 1 [August 1918], pp. 22–23).

52 For a discussion of the Whitney Studio Club competition, see Avis Berman, *Rebels on Eighth Street*. New York: Atheneum, 1990, pp. 150–53.

53 Stuart Davis Papers, March 23, 1954. Harvard University Art Museums, Fogg Art Museum, Cambridge, Massachusetts. William Agee kindly alerted me to this passage.

Karen Wilkin "Becoming a Modern Artist": The 1920s

When the 1920s began, Stuart Davis was twenty-seven and a far more sophisticated painter, with more adventurous tastes and a broader understanding of European modernism, than the young man who had exhibited in the 1913 Armory Show. His urban, vernacular subject matter remained unchanged (as it would for most of his life), but he no longer aspired to the sketchy realism of his first American teachers; instead, he aimed at the formal daring of his new European heroes. By the end of the decade, Davis the artist was essentially formed, entrenched in the territory he would explore for the rest of his career—an American brand of Cubism unmistakably his own. The evolution that he called "becoming a Modern artist" was complete.

It was a tortuous and complicated process, even for Davis, whose commitment to modernism was wholehearted, long-lasting, and, all things considered, made with remarkable speed. Still, his course was not a tidy, linear progression, but a series of advances, side steps, and apparent retreats. At times, it seems as if he could have been an entirely different painter than the one we know had he chosen to pursue notions that he had embraced briefly and then discarded. Davis's path in the 1920s was particularly erratic. This is the period when he painted some of his last naturalistic pictures and his first fully realized abstractions—but not in that order, and when he made some of his most atypical works, as well as the first that wholly anticipate his most characteristic mature paintings.

The variousness of Davis's work of the 1920s is proof that these were still formative years, but they were also among the most eventful, professionally and personally, in his long career. Enlightened viewers were beginning to regard him as a painter worth noting. He had his first exhibition with the legendary Edith Halpert, the dealer who would represent him for most of the rest of his life; his first one-man exhibition in a museum; and his first retrospective. He enjoyed the first (and for a long time, only) major sale of his work and, for the first time, traveled outside of the eastern United States, where he had grown up. At the end of the decade, he married.

January 1920 found Davis and a close friend from his days at Robert Henri's school, Glenn Coleman, in Cuba —an obvious choice for young painters with virtually no income. Close, cheap, and exotic, Cuba offered new, exciting subject matter and, no less important for residents of Prohibition Era America, a liberal attitude toward alcohol. Davis's recollections of his two-month stay include knife fights, a bathtub with a resident pig, importunate young women, and wild misunderstandings over language.[1] His descriptions of Havana at the start of the 1920s, as seen by a sharp-eyed young man with a taste for local color and low life, are echoed in a series of vivid, rapidly executed watercolors.

At first acquaintance, pictures such as the 1920 *Dancers on Havana Street* (cat. no. 30) seem like throwbacks, at least in subject, to Davis's early views of Hoboken alleys and Harlem saloons, made under Henri's tutelage. He recorded whatever emphasized Havana's difference from New York: tropical vegetation, details of architecture, the Cubans themselves. After 1913, once he had resolved to "become a Modern artist," his work frequently was rather simple, with little or no anecdotal detail, yet he seems to have found the inhabitants of Havana's streets and the surrounding countryside irresistible—as compelling as the New York parade he had studied ten

Figure 30. Stuart Davis. *Gloucester Terraces*. 1916. Crayon and ink on paper. Collection Earl Davis. Courtesy of Salander-O'Reilly Galleries, New York

years earlier. The Cuban pictures are full of graceful women, imposing policemen, dandies in sharp-brimmed hats, horse-drawn carriages, dogs, roosters, and the like.

What truly distinguishes the Cuban watercolors is their palette—luminous pinks, clear blues, and odd mauve-browns, punctuated by snappy yellows and greens—and the way Davis deployed these hues in bold, thin patches. Nothing in the acid Fauvist color of his early New York streetscapes or Gloucester townscapes (fig. 30) anticipates this. The transparency and clarity of these pictures may owe something to the characteristics of watercolor, but they also suggest that Davis filtered his first experience of a tropical country through what he knew of Matisse's work, finding justification for heightened color and exaggerated shapes and patterns in his Caribbean surroundings, just as, a few years earlier, he had filtered the cornfields of Pennsylvania through his admiration for van Gogh.

Generally speaking, the Cuban watercolors are unlike anything that preceded or—except in color and surface— followed them, yet they offer clues to patterns in Davis's approach to his work. New places often affected him as Cuba did, engaging him with their specifics and appar-

ently diverting him from his modernist impulses, until he could find ways of making the particular mesh with larger considerations of color, space, and structure.

Soon after his return from Cuba, Davis shifted gears —not once, but several times. Over the next few years, he probed a range of possibilities (none overtly related to what he had done in Cuba), just as he had in the previous decade, testing modernist variables. By 1921, a burgeoning interest in Cubism took precedence over the modified naturalism of his watercolors, along with—among other things—a flirtation with Picabia-like "machine" images. A series of extraordinarily original "still lifes" with themes related to packaging and smoking, appreciably unlike either Cubism or the art of Francis Picabia, also dates from this period. Cubist notions had attracted Davis as early as 1916, although then he seemed merely to "find" Cubist images in the angles of Gloucester shacks and rooftops, rather than to reconstruct appearances with invented planes. Yet, by 1921, he was producing pictures such as *Garden Scene* and, a year later, *Three Table Still Life* and *Still Life with "Dial"* (cat. nos. 37, 43, 44), whose articulate structures and spatial pulse demonstrate a sure grasp of Cubism, visually and intellectually. That these pictures are indebted to Picasso and Braque is obvious (fig. 31), yet Davis's versions of the classic Cubist *guéridon* are very much his own: The pale, intense lavenders and pinks of the Cuban watercolors found their way into his Table still lifes, whose delicate pastels are more reminiscent of Davis's images of Havana than of Picasso or Braque's resonant, subdued pictures of café tabletops.

Davis's rapid assimilation of Cubist concepts was perhaps inevitable—the result of growing ambition and greater firsthand experience of the advanced European art he wished to emulate. Exhibitions of truly current work were still rare in New York, but a handful of galleries was dedicated to the avant-garde, and it is evident that Davis made an effort to keep himself informed. (Like others of his generation, he seems to have been less interested in what he knew of American modernism, perhaps because he felt that even the most adventurous Americans stood in the same relationship to advanced European art that he did.)

The Russian-born painter, connoisseur, theorist, and mystic John Graham may have served as a catalyst. Graham had arrived in New York in 1920, via Paris, where he had gotten to know many of the French vanguard, including Picasso and the Surrealist painters and writers. Since he returned often to Europe, Graham was an invaluable source of news about the latest radical art and

Figure 31. Georges Braque. *The Table* (*Le Guéridon*).
1921–22. Oil on canvas. The Metropolitan Museum of
Art, New York. Partial Gift of Mrs. Bertram Smith, in
honor of William S. Lieberman, 1979

ideas, for his New York friends. Graham's influence on a
generation of forward-looking young New York artists in
the 1920s and 1930s is well documented, so it is quite pos-
sible that he fostered Davis's nascent interest in Cubism.
It is not known, however, exactly when they met. Davis's
friend John Sloan could have provided a link in the early
1920s, since Graham studied with him at the Art Stu-
dents League, but all that is certain is that by the end of
the 1920s, Graham and Davis were good friends; in 1929,
Graham introduced Davis and Arshile Gorky and they
all became so close that they were known as "The Three
Musketeers."

It has been suggested, too, that Davis was encouraged
to follow his Cubist leanings by the poet William Carlos
Williams, a passionate follower of American avant-garde
painting and a close friend of many of its practitioners.[2]
Since Davis and Williams saw each other only a few
times and never seem to have become friends, it is dif-
ficult to know what role—if any—the poet played in
Davis's maturing grasp of Cubism. In 1920, Williams
asked permission to reproduce one of Davis's "multiple-
view" drawings of 1916 as the frontispiece to a collection
of poems, praising the work for its "impressionistic view
of the simultaneous."[3] The drawing, an amalgam of self-
contained vignettes, bears witness to Davis's habit, at
the time, of composing by bringing "drawings of different
places and things into a single focus."[4] In a sense, this is
a primitive version of the Cubists' efforts to incorporate
notions of time and memory into what had been an art of
the single, transfixed moment. It is a long way from the
coherent, breathing structure of planes of the Table still
lifes of 1922, but the notion that is at the heart of Cubism,
of conflating many aspects of the visible world and orga-
nizing them into a new, autonomous relationship, is al-
ready there. Did Williams's enthusiasm for the drawing
make Davis reevaluate its implications?

We know that Davis found Williams's poetry provoca-
tive. He wrote: "To me it suggests a development of word
against word without any impediments of story, poetic
beauty or anything at all except clash and sequence"[5]—
a description that could easily apply to the series of To-
bacco still lifes Davis began in 1921 (about the same time
that he painted the spatially complex Cubist landscapes),
after his introduction to Williams's poetry. The Tobacco
pictures are flattened, geometric constructions, "clashes
and sequences" of a fragmented actuality, assembled
without regard for narrative or for the "real" relationship
of parts. At first sight, paintings like *Lucky Strike* of 1921
(cat. no. 32) seem related to Cubist collage, since they ap-
pear to incorporate wrappers and labels from cigarette

Figure 32. William Harnett. *The Artist's Letter Rack.* 1879. Oil on canvas. The Metropolitan Museum of Art, New York. Morris K. Jesup Fund, 1966

Figure 33. Stuart Davis. Untitled. 1921. Pencil and collage on paper. Collection Earl Davis. Courtesy of Salander-O'Reilly Galleries, New York

papers, cigarettes, and loose tobacco, yet, in fact, they are not collages at all, but meticulously painted. The American tradition of trompe-l'oeil still life goes back at least to the end of the nineteenth century—to those uncanny canvases of overflowing letter racks and hunters' trophies meant to fool the viewer, momentarily, into thinking that he was seeing an assortment of real objects against a real wall (see fig. 32).[6] Davis's Tobacco still lifes recall this tradition in a highly abstracted way, although their illusionism is strictly one of surface and texture, not of space; the papers and labels Davis imitates on an enlarged scale would have been just as tightly pressed to the surface, had they been real.

There is a precedent for this, too, of course. Braque and Picasso often resorted to mimicry, although only as adjuncts to a larger, *painted* context. Had Davis misunderstood the nature of collage? If he had been dependent solely upon photographs of Cubist examples this might be plausible, but he wasn't, and his journals of the 1920s affirm that he speculated about making a new kind of picture by combining a variety of materials.[7] Some of the Picabia-like watercolors of 1921 even play illusions of collage against actual pasted elements (see fig. 33). The illusionism of the Tobacco still lifes must have been deliberate.

In comparison to the generously scaled Table still lifes, with their eccentric planes and unstable spaces, the Tobacco still lifes seem a little stiff. In their clarity and abstractness, however, they are closer to Davis's later concerns than any of the Table still lifes, good as they are. *Three Table Still Life* (cat. no. 43), for example, may be more ambitious and more spatially complex than *Lucky Strike* (cat. no. 32), but it is about things placed on a horizontal surface in a logical way, while *Lucky Strike* is about wholly abstract relationships. Its component elements retain the patterns, textures, and texts of actual objects, but they are detached from their original forms and reincarnated as discrete, flat shapes, perfectly congruent with the surface of the canvas. For all its radical invention, though, *Lucky Strike* seems jammed and somewhat airless, without the spatial play typical of Davis's best work and already present in *Three Table Still Life.* Nonetheless, the Tobacco still lifes anticipate a paramount aspect of Davis's mature art. They embody the independent reality he always strove for: The fact of the new painted image rather than the reflection of something preexisting. (Curiously, it is not the still lifes but the Cubist landscapes, with their spotted and dotted planes, that most directly prefigure Davis's later work, in everything but color; the configuration of *Garden Scene*

[cat. no. 37], in fact, is the basis of some of his most important and inventive paintings of the 1940s.)

No matter how abstract paintings like *Lucky Strike* may be, their subject matter is obviously important. For all Davis's later insistence that "ANY" subject would do, the accoutrements of smoking seemed to have special appeal. They recur frequently in his work, full of the "roll your own" machismo and Jazz Age sophistication of the days before the Surgeon General's warnings. For Davis, a lifelong heavy smoker, cigarette papers, wrappers, and loose-tobacco pouches—he particularly liked a brand called "Stud," whose emblem was a rearing stallion—were casual, habitual companions, but he also seems to have attached other meanings to them, possibly even equating smoking with maleness itself. The cigar store, along with the barbershop and the gas station, all traditionally male preserves, inhabit his sketchbooks and paintings. The most spectacular—and unequivocal—manifestation of male/tobacco iconography (complete with Stud pouch, barber pole, and gas pump) is the mural Davis executed in 1932 for the men's lounge of Radio City Music Hall, significantly entitled *Mural (Men without Women)* (cat. no. 100).

Davis was fascinated by labels and packaging, in general. In a journal of the early 1920s, he declared, not wholly ironically, that the advent of packaging—as opposed to old-fashioned bulk barrels—was evidence of high civilization.[8] Labels, like street signs, provided him with a lexicon of letters and words that could be richly associative and, at the same time, make the picture more self-sufficient. He was aware of the Cubists' use of letters as both formal elements and bearers of content, but, initially, the meaning of legible messages seems to have interested him most. They helped him to avoid the anonymity of the geometric abstraction he disliked so much. "The lettering," he wrote in 1923, "introduces the human element."[9] Davis used signs and lettering in some of his earliest pictures as naturalistic elements of the streetscape. In the Tobacco still lifes, we are meant to read and respond to words and letters, but typography is wrenched free from rational explanation to become, as it would in Davis's later works, at once a carrier of associations and a key structural element. The meanings, both literal and punning, and the sounds of Davis's words and titles always count, but, as he wrote toward the end of his life, they had other functions as well: "Letters LOCK Scale/Letters LOCK Color."[10]

During the mid-1920s, Davis shifted his attention from packaging to ordinary domestic objects, lifting them from their familiar surroundings, as he had cigarette packs, and isolating, enlarging, and altering them. Again, he was taking his cue from the European artists he admired. In the 1920s, using ordinary, mass-produced objects as subjects for painting was still radical—a declaration of independence from tradition. Still-life painters of the past had delighted in exotic fruits, fine glassware, silver, and the spoils of the hunt in humble kitchen copper and earthenware. Davis, like his Cubist heroes, simply painted what was at hand, current and ordinary. Picasso and Braque focused on the musical instruments and wine bottles in their studios and favorite cafés; Davis extolled the twentieth-century kitchen, with

Figure 34. Stuart Davis in New Mexico, 1923. Photograph courtesy of Earl Davis

its light bulbs, percolators, eggbeaters, and matchbooks (see cat. nos. 54, 63). Some years later, he suggested that his use of "unesthetic material, absurd material, non-arty material,"[11] owed something to Marcel Duchamp's example, but for Davis, selecting unlovely, everyday objects as still-life material was also an extension of the training he had received at Robert Henri's school. Like Léger's and Picabia's machine imagery, Davis's domestic hardware was both subject and metaphor, a portable equivalent of his principal theme—modern urban life in all its manifestations—just as the contemporary city was his substitute for traditional landscape.

Davis's response to the celebrated landscape of New Mexico, where he spent three or four months of the summer and fall of 1923 with his younger brother, Wyatt, and the John Sloans, is testimony to this attitude (see fig. 34). Because of Sloan's enthusiasm, Davis's expectations were high, yet he found little to engage him in the non-urban setting of the mountains, desert, and brilliant light that entranced so many of his colleagues. "I don't think you could do much work there except in a literal way," he wrote, "because the place is always there in such a dominating way. You always have to look at it."[12]

Davis produced a respectable number of paintings during his stay in Santa Fe, most of them fairly "literal" and respectful of the particulars of a place new to him, just as the Cuban watercolors were. The best manage to subvert New Mexico's obvious beauties by translating them into modernist language. In *New Mexican Landscape* (cat. no. 49), Davis turned a travel-poster view of distant mountains, luminous sky, and cottony clouds into a series of sharply defined, relatively uninflected planes. Calligraphic drawing suggests landscape details, but sometimes breaks free of description to set up independent rhythms. Undulating painted borders heighten the sense of artifice. Unlike the more typical, clean-edged inner frames of Davis's later paintings, which simultaneously isolate the picture and mediate between it and the rest of the world, the wavy borders of *New Mexican Landscape* seem like allusions to the traditional vignette. At the same time, they have irresistible associations with the ripply white edges of snapshots of the period.

As if in defiance of the vaunted scenery around him, Davis painted a series of near-monochrome "portraits" of extraordinarily unprepossessing objects while he was in Santa Fe: a naked light bulb on its chain, a giant saw, a monstrous eggbeater (see cat. nos. 50, 51). They are peculiar pictures, difficult to account for, since these every-day objects are presented *verbatim*—not used as

Figure 35. Stuart Davis. Sheet from Sketchbook 6. 1926. Pencil on paper. Collection Earl Davis. Courtesy of Salander-O'Reilly Galleries, New York

springboards for formal invention. Each is isolated, drawn with uncompromising clarity, poised at its most recognizable angle. They may be much more than genial nose-thumbing at a too-picturesque environment. Davis commented on how struck he was by the relics of New Mexico's ancient Indian civilizations, how aware he was of the region's prehistoric past: "Then there's the great dead population. You don't see them but you stumble over them. A piece of pottery here and there and everywhere. It's a place for an ethnologist not an artist."[13] Davis's "portraits" of twentieth-century objects may be tributes to his own civilization's artifacts.

The artist's final word on Santa Fe was one of dismissal: "Not sufficient intellectual stimulus. Forms made to order, to imitate. Colors—but I never went there again."[14] Paradoxically, the paintings that he made in reaction to the New Mexico landscape proved seminal; for the next four or five years, the spoils of the hardware store and the five-and-ten all but replaced the street as Davis's primary territory. This is not to say that he lost interest in his surroundings. A New York sketchbook of 1926 documents his continuing, acute observation of the "hardware" of the urban landscape. Lampposts, railings, signs, skyscrapers under construction, and the ubiqui-

Figure 36. Gerald Murphy. *Razor*. 1922. Oil on canvas. Dallas Museum of Art. Foundation for the Arts Collection. Gift of Gerald Murphy

tous girders of the El provided Davis with the material for rapid sketches (see fig. 35). Increasingly, though, he was more preoccupied by objects that could be brought within reach of his hand; percolators, mouthwash bottles, matchbooks, radio tubes, light bulbs, and eggbeaters engaged him profoundly. There is a surprising likeness in spirit between these pictures and some of the few surviving works of the American expatriate Gerald Murphy. Murphy's giant razors (fig. 36) and cogs were painted in the south of France, more or less concurrently with Davis's oversized New York coffeepots and light bulbs, but the two men were probably unknown to each other.

A common interest in Fernand Léger may provide a connection. Murphy knew Léger well and frequented his studio; Davis had seen some of Léger's early work in the Armory Show, but he had to wait until 1925 for a New York exhibition that offered a comprehensive view. For Davis, who responded quickly to good modernist painting, in general, and had a particular sympathy for Léger's themes of contemporary life filtered through the omnipresent machine, the 1925 show must have had considerable impact, but the echoes of Léger in Davis's paintings of the 1920s often appear to be a function of affinity rather than of direct influence (see fig. 37). Davis,

Figure 37. Fernand Léger. *Tree*. 1925. Oil on canvas. Sprengel Museum, Hannover

for example, rarely modeled or shaded forms as Léger did at this time, preferring to abut more or less unbroken color planes. When Davis did, atypically, experiment with modeling, he never attempted—or achieved—the delicacy or subtlety of Léger's tonal shifts.

In his notebooks, Davis ranked Léger high: "Léger is good because he came to grips with the subject matter of contemporary life in its industrial aspects,"[15] but despite Davis's respect and interest, he was cautious about Léger's approach. Léger's view of the world around him as machinery was specific and eccentric enough to attract notice, but it also represented an outer limit that was perilous to cross. Just beyond Léger, according to a Davis notebook entry, lay "Geometric Art,"[16] with its insistence on the right angle and its disdain for the irregularities of the workaday world that so delighted Davis.

Superficially, the monochrome "hardware portraits" Davis made in New Mexico and soon after his return—before the 1925 Léger show in New York—are among the most Léger-like of his works. As Léger, too, had done in the 1920s, Davis relied on scaling-up, frontality, and simplification to create a kind of industrial naturalism. These pictures are less abstract than the Tobacco still lifes, as though Davis had, once again, taken a side road in his pursuit of modernism. A few elegant landscapes of the mid-1920s, such as *Early American Landscape* and *Town Square* (cat. nos. 61, 62), suggest even greater withdrawal (and the possible influence of Léger), but by 1927, in pictures like *Percolator* (cat. no. 63), he began to dissect his enlarged, isolated subjects and present them as constructions of hard-edged planes. Clear, pale, subtly nuanced color forces these planes apart, adding a kind of visual pulse absent from the congested Tobacco still lifes. For almost the first time, Davis seems to build his paintings according to what he came to call "color-space logic" —his phrase for his intuitive but disciplined method of using prismatic juxtapositions of color relationships to suggest spatial relationships. It is as though he realized that the neutrality of inanimate objects allowed him to investigate space and structure in new ways.

"The culmination of these efforts," Davis wrote, "occurred in 1927–28, when I nailed an electric fan, a rubber glove and an eggbeater to a table and used it as my exclusive subject matter for a year. The pictures were known as the *Eggbeater* series and aroused some interested comment in the press, even though they retained no recognizable reference to the optical appearance of their subject matter." In Davis's words, "The 'abstract' kick was on."[17]

It was abstraction based on distillation (not on "simultaneity," in William Carlos Williams's sense), as Davis's careful preparatory drawings show. Their relationship to the paintings derived from them provides a key to Davis's working methods and explains, in part, his pictures' uncanny way of looking at once effortlessly improvised and absolutely immovable. The drawings bear witness to meticulous adjustment of shapes, to weighing of angles and densities, to fine tuning and tinkering with what appears, on canvas, to be a spontaneous, sure departure from observed reality. All evidence of hesitation, doubt, change, and evolution is barred from the finished painting, but the final drawn configuration was not just a preparation; it was a complete, self-sufficient work of art. Davis later insisted that "A Drawing is the correct title for my work."[18]

Color, however subtle, rich, or bright, only clarified the spatial perception that had provoked the original image, and it was mutable in a way that the drawing was not. In the Egg Beater series, the color that animates and aerates the structure of planes varies greatly from picture to picture, while the basic drawn configurations of the series are intimately related. Each version explores slightly different ways of faceting illusory space, but the variables have to do with how the layered planes are described, whether they are bounded by curves or straight lines, whether they overlap or abut. The general layout remains intact, and details, such as the hand grip of the beater, are repeated.[19]

By the late 1920s, paintings like the Egg Beater series established the thirty-five-year-old Davis as a leading exponent of American modernism, in the eyes of the avant-garde's handful of supporters, but his work was still not received with unqualified enthusiasm. A review of his first show at Edith Halpert's Downtown Gallery, in 1927, declared *Percolator* (cat. no. 63) "quite incomprehensible."[20] The audience for vanguard art remained small, and Davis, like most of his colleagues, sold almost nothing. Yet, something extraordinary happened at his 1928 exhibition at the Valentine Gallery. As Davis described it in his autobiography: "In May 1928, Mrs. Juliana R. Force, then of the Whitney Studio Club, bought several of my pictures. Having heard it rumored at one time or another that Paris was a good place to be, I lost no time in taking the hint. With one suitcase, I hopped a boat and arrived in the center of art and culture in the middle of June."[21]

Davis settled in a borrowed studio in Montparnasse for something over a year.[22] As he had been in Havana, he was enthralled by everything that struck him as unlike America, everything that gave Paris its flavor. His notebooks record anything that seemed to him particu-

Figure 38. Stuart Davis. *Horse's Head (Child's Drawing)*. 1928. Pencil on paper. Collection Earl Davis. Courtesy of Salander-O'Reilly Galleries, New York

Figure 39. Stuart Davis. *La Cressonee*. 1928. Pencil on paper. Collection Earl Davis. Courtesy of Salander-O'Reilly Galleries, New York

Figure 40. Stuart Davis. *La Toilette*. 1928. Pencil on paper. Collection Earl Davis. Courtesy of Salander-O'Reilly Galleries, New York

Figure 41. Stuart Davis. *Paris Scene*. Sheet from Sketchbook 7. Pencil on paper. Collection Earl Davis. Courtesy of Salander-O'Reilly Galleries, New York

larly French: shop signs, syphon bottles, café tables, balcony railings, even a Turkish toilet (see figs. 38–40). Davis's letters home describe his pleasure in even the most ordinary Parisian buildings, his terrified awe of the skills of Parisian taxi drivers, his delight in a way of life that included prolonged sitting in public places. Like most Americans in Europe for the first time, he was deeply impressed by the age of the city, the evidence of continuous habitation; as a connoisseur of urban life, he capitulated entirely to the seduction of 1920s Paris. "Over there," he wrote, "the actuality was so interesting I found a desire to paint it just as it was."[23]

At first glance, Davis's French streetscapes suggest he did just that (see fig. 41). They seem conventional, with their traditional perspective and myriad details, in contrast to his adventurous still lifes of the previous few years. In the Egg Beater pictures, he had virtually disassembled his subject matter, until it became all but unrecognizable and the spatial relationships ambiguous. In his images of Parisian streets, he kept everything more or less intact, as though the character of the city were so powerful that he was unable to eliminate or shift any portion of what he saw. Yet, longer study reveals paintings like *Rue des Rats No. 2* or *Place Pasdeloup* (cat. nos. 78, 82) to be quite daring. Underlying the wealth of drawn motifs dear to the tourist are economical constructions of brilliantly colored planes that exist almost independently of their nominal subject matter. Rather than being literal transcriptions of postcard views, the Paris streetscapes prove to be inventive attempts to translate the urban fabric into a highly colored and personal version of Cubism.

A passing reference in Davis's autobiography suggests what he was after: "There was so much of the past, and the immediate present, brought up together on one plane."[24] This could describe his own early attempts to make a range of places and events coexist on the same canvas—for example, the "simultaneous" Gloucester pictures—as well as the Cubist habit of forcing a variety of perceptions into a new, unified image. However, Davis's Paris streetscapes do not read altogether as Cubist pictures. Instead of being arrangements of fluctuating planes, all related to a single surface plane—as Cubist works are—Davis's Paris pictures seem to exist in terms of two, not-quite-integrated spatial concepts: a relatively traditional urban landscape, and a superimposed abstract layer of extraordinary color, texture, and pattern, the whole bound uneasily together by a sharply defined painted border. The abstract superstructure is a brilliant, flat—if interrupted—surface, independent of the

illusionistic street scene. Drawn patterns emphasize the flat surface, but since they are derived from the richly specific linear elements of Davis's sketchbooks, they also reinforce naturalistic illusion. Far from knitting the past (the urban fabric of Paris) into a seamless whole with the present (modernist attitudes toward imagery), Davis forced them into a visually unstable association.

The "official" version of Davis's stay in Paris, his autobiographical notes of 1945, implies that throughout 1928 and 1929, he remained apart from other artists, concentrating on his own work. Perhaps this was a canny defense against conservative American critics; Davis always insisted that the best American art, including his own, was deeply indebted to French innovations, and complained later that "American artists who sought to continue the discoveries of Paris were denounced as un-American."[25] Davis's letters reveal that, despite his lack of French, he was less isolated from the world of advanced Parisian art than his public recollections maintain. The crusty surfaces and clear shapes of *Rue des Rats No. 2* are evidence enough that he was aware of what Picasso and especially Braque were doing at the time, but in addition to looking at the art around him Davis knew many of the artists. He quickly connected with the expatriate members of the avant-garde and a few who weren't expatriates. His old friend Elliot Paul, a founder of the experimental magazine *transition* and a fixture of 1920s Paris, arranged for Davis to visit Gertrude Stein's collection and Léger's studio. (A promised invitation to Picasso's studio apparently never materialized.) Léger came to see Davis's work. "He liked the Egg Beaters very much," Davis wrote home, "and said they showed a concept of space similar to his latest development and it was interesting that 2 people who did not know each other should arrive at similar ideas. He thought the street scenes I am doing here too realistic for his taste but said they were drawn with fine feeling. He invited me to send something to a show he is organizing in January."[26]

The simplification of some of Davis's Paris pictures, such as *Adit No. 2* (cat. no. 81), may have been a response to Léger's criticism, but this cannot be proven. Léger's still lifes of the period, with their large geometric planes and schematic profiles, are very different from Davis's small-scale urban landscapes. Davis's pictures did not become as spare or as generously scaled as Léger's until the 1950s. Again, it is difficult to establish direct influence; affinity, or at least *informed* affinity, seems closer to the mark.

Davis's autobiography gives the impression that he was alone in Paris, but he had a companion, Bessie Cho-

sak. His family disapproved of her and refused to acknowledge her existence, so his letters home are not informative on the subject. Nonetheless, Bessie Chosak and Stuart Davis were married in Paris in 1929, and, having exhausted the funds provided by the sale of his pictures to Juliana Force, the couple sailed for New York that August. Davis never returned to Europe. A few years later, he wrote that his stay in France enabled him "to spike the disheartening rumor that there were hundreds of talented young modern artists in Paris who completely outclassed their American equivalents. . . . It proved to me that one might go on working in New York without laboring under an impossible artistic handicap. It allowed me to observe the enormous vitality of the American atmosphere as compared to Europe and made me regard the necessity of working in New York as a positive advantage."[27]

Notes

[1] Unpublished interview conducted by Harlan B. Phillips for the Archives of American Art, 1962. For discussion of Stuart Davis in Cuba, see Karen Wilkin, "Stuart Davis: The Cuban Watercolors," *Latin American Art* 2, 2 (Spring 1990), pp. 39–43.

[2] See Dickran Tashjian, *William Carlos Williams and the American Scene, 1920–1940* (exhib. cat.). New York, Berkeley, Los Angeles, and London: Whitney Museum of American Art, in association with the University of California Press, 1978, pp. 62ff.

[3] Ibid., p. 62.

[4] Diane Kelder, ed., *Stuart Davis*. New York, Washington, and London: Praeger, 1971, p. 26.

[5] Tashjian, op. cit., p. 62.

[6] Davis's dealer, Edith Halpert, exhibited work by William Harnett (1848–1892), one of the best known of the trompe-l'oeil painters.

[7] John R. Lane, *Stuart Davis: Art and Art Theory* (exhib. cat.). New York: The Brooklyn Museum, 1978, p. 96.

[8] Ibid., p. 94.

[9] Stuart Davis Papers, March 13, 1923. Harvard University Art Museums, Houghton Rare Books Library, Cambridge, Massachusetts.

[10] Ibid., May 2, 1962, op. cit.

[11] Rudi Blesh, *Stuart Davis*. New York: Grove Press, 1960, p. 17.

[12] James Johnson Sweeney, *Stuart Davis* (exhib. cat.). New York: The Museum of Modern Art, 1945, p. 15.

[13] Ibid.

[14] Ibid.

[15] Stuart Davis Papers, September 1941, op. cit.

[16] Ibid., March 1942.

[17] Kelder, op. cit.

[18] Stuart Davis Papers, October 31, 1954, op. cit.

[19] The similarity between the Egg Beater paintings and Picasso's works of the late 1920s has often been noted. Davis, like many of his contemporaries, paid close attention to Picasso, but knew his work chiefly from reproductions. Picasso's pictures of this type were not shown in New York until Davis was well into the Egg Beater series. As well, striking similarities exist with Arshile Gorky's work of about 1930.

[20] *Chicago Post*, November 29, 1927.

[21] Kelder, op. cit.

[22] For discussion of Davis in Paris, see Lewis Kachur, *Stuart Davis: An American in Paris* (exhib. cat.). New York: Whitney Museum of American Art at Philip Morris, 1987; Karen Wilkin, *Stuart Davis*. New York: Abbeville Press, 1987, chapter 3.

[23] Sweeney, op. cit., p. 20.

[24] Ibid., p. 19.

[25] Stuart Davis Papers, August 1941, op. cit.

[26] Stuart Davis, in a letter to his father, September 17, 1928. Quoted in Wilkin, op. cit., 1987, p. 120.

[27] Stuart Davis, "Self-Interview," *Creative Art* 9 (September 1931), p. 211.

Stuart Davis in the 1930s: A Search for Social Relevance in Abstract Art

Lowery Stokes Sims

Although Stuart Davis had espoused a political philosophy grounded in Progressive and Socialist agendas since his youth, it was not until his return from Paris, when he was thirty-seven years old, that his political views became more ideologically focused. As Richard Pells has observed, the onslaught of the Depression signaled for reformist American thinkers that the environment was ripe for the start of a long-awaited new social order.[1] Several decades of theorizing were to result in action. In Davis's case, this situation seemed to create a disconcerting dichotomy between his art and his politics. Davis was adamant that a commitment to social and political action was the artist's duty. At the same time, as the most prominent proponent of abstract art in America, he insisted that art making should remain free of propagandistic concerns. While Davis scholars have tended to discuss these two aspects of his career separately, a reconsideration of Davis's approach to art making during this period does, in fact, demonstrate a continuing commitment to popularist ideals. Davis's subject matter as well as the different styles he adopted must be examined from this point of view in order to comprehend his unique approach to social and political commentary in his art.

In 1932, Davis contributed a work of art to the exhibition of mural projects by American painters, sculptors, and photographers organized by Lincoln Kirstein at The Museum of Modern Art in New York. This exhibition was intended to showcase the talents of American painters in the arena of public art, prior to the founding of government-sponsored projects in this country.[2] Although critical response to the exhibition at the Modern Museum was less than enthusiastic, the show led to Davis's first official mural commission—from Donald Deskey, the designer of the Radio City Music Hall in the newly built skyscraper complex, Rockefeller Center. *Mural* (also known as *Men without Women*; cat. no. 100) was installed in the men's lounge (see fig. 42). The commonplace location and the random and indeterminate audience—cutting across a wide spectrum of (male) society—required that Davis create this imagery with a "non-art" audience, the masses, in mind. This opportunity afforded him perhaps the first instance in his mature career to present a composition, based on what he called "uniquely American" subject matter, to an audience outside of the rarefied circles of the art world.

In *Mural*, Davis arranged an assortment of objects, irrespective of scale, within the composition. These included props for what were then considered exclusively male interests—for example, smoking, card playing, and grooming—as well as such motifs as the schooner and its mast and sails, the car and garage, and gas pumps, all of which, by then, were familiar within Davis's oeuvre. The composition seems to be curiously Gatsbyesque in feeling, like a lingering souvenir of the sybaritic 1920s, and certainly compatible with the location of the mural. Davis restricted his palette to black, olive green, white (now discolored), and brown or maroon. Despite the fact that each element is clearly recognizable, familiar narrative conventions are not operative. Davis conceived a spatial and temporal interaction of symbolic elements, which he described in 1939: "In composing a picture each step of development is dependent on visualization of a specific set of directions, sizes, shapes and tones, which represent the new object. This visualization is then re-

lated . . . to the already existing adjacent object. The super-space shapes develop inductively in this way."[3]

In the 1920s, Davis had first described the distinction he made between narrative and form. Determining that the real subject matter of painting was not the object, figure, or scene depicted, but its plastic components, Davis blazed a unique trail through the domains of realism and abstraction that was distinct from that of the Ashcan School—the circle within which Davis's talent was first nurtured. The Ashcan artists had employed a stylistic vocabulary inspired by seventeenth-century Dutch and nineteenth-century German painting to depict urban life and its social tensions. Although Davis was particularly close to John Sloan and had studied with Robert Henri, by the early 1920s, Davis dismissed narrative and anecdotal elements in art as "sentimental," noting that the subject matter is of "secondary importance from the standpoint of the artist."[4] It merely "starts the machinery of execution to work . . . consequently . . . [it is] . . . no greater than abstract ideas."[5] In *Mural*, for example, the various objects and vignettes are juxtaposed without regard to their actual scale or continuity. The spaces between the specific undulations of line (which convey the familiar contour of an object) maintain the pictorial balance within the assembly of shapes. All expression is to be rendered by means of color: for example, area, planar balance, and texture. "Only through the employment of color shapes and scales would

one get the closest approximation of the strength of emotion originally felt by the artist."[6]

Although he had declared the primacy of formal elements in the creation of the work of art, Davis confused issues by steadfastly rejecting the label "abstract." His sense of realism was centered on "real" things—actual objects in an actual space.[7] In 1927, he wrote: "In the first place my purpose is to make realistic pictures. I insist upon this definition in spite of the fact that the type of work I am now doing is generally spoken of as abstraction. . . . People must be made to realize that in looking at abstraction they are looking at pictures as objective and as realistic in intent as those commonly accepted as such."[8]

In weaving a syntactical relationship between avant-garde modernism and political or social purpose, Davis used the conventions of realism in a non-empirical, abstracted way. He seemed to provide a means of mediating the dichotomy between his will to abstraction and his realist posture when he described the process of his image making: "Let the shapes be impersonal and arbitrary . . . [they] . . . could be familiar forms such as a head, an ink bottle, a wheel, etc. . . . [used] . . . to represent size, and in no sense to represent the object of the subject." Familiar shapes "could be obliterated by drawing say the outline of a head and then filling the space with a tobacco label."[9] Davis envisioned that this imagery would provide a new subject matter that would ap-

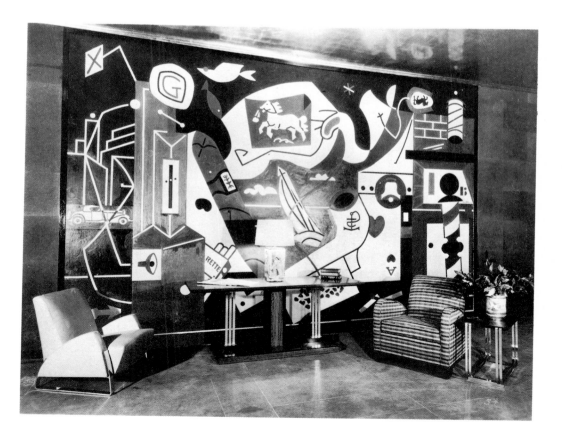

Figure 42. Stuart Davis. *Mural (Men without Women) in situ* in the men's lounge, Radio City Music Hall, New York (see cat. no. 100). Photograph courtesy of Earl Davis

peal to a mass audience, and would embody the concept of America celebrated by such poets as Carl Sandburg, William Carlos Williams, and Walt Whitman, noting: "I want direct simple pictures of classic beauty expressing the immediate life of the day."[10] Davis felt that his 1921 paintings based on tobacco products set the direction for the new kind of art. In addition, his "uniquely American" subject matter would be drawn from advertising, the media, and jazz.

In the 1930s, Davis pursued a stylistic approach that complemented the new imagery. Drawing was to be the key to that art. Between 1932 and 1934, he purged his work of its painterly aspects in favor of the logic he found in drawing. For Davis, line was to be the primary agent for creating spatio-temporal tensions in a "good" composition.[11]

The modular-unit areas created by the successive crossing of lines (angles) were seen as more specific than color tones in defining a composition. (Yet, despite this systematic, mathematical jargon, Davis stressed the fact that the composition would ultimately be created "emotionally.")[12] A group of the black-and-white works that he executed at this time treats themes and motifs from Gloucester. Schooner rigging and masts, set against the sky, not only illustrate Davis's dynamic, angular units, but also suggest the rudiments of his color-space coordinates.[13] Despite his disavowal of narrative, Davis was concerned about the "readability" and accessibility of his imagery: "I will . . . [my art] . . . to be simple and easy to remember."[14] In his subsequent fusion of line with color and pattern, Davis provided recognizable elements as entry points for the viewer, while simultaneously focusing attention on factors such as the organization of color, shape, and line. This device would serve to elicit a purely emotional, intuitive response from the spectator, which he considered to be of a higher order than the work's reflected or self-evident meanings.[15]

As Davis's work evolved stylistically, he constantly considered the audience for his art. During the 1930s, that audience became specifically identified with the working man, and Davis began to focus on government support of the arts.[16] The issue of accessibility was realigned from earlier assertions that his art should be "self supporting," as it had "nothing in common with the trade in art of the galleries." It "should be sold in stores like newspapers and magazines . . . [as] . . . large colored reproductions . . . for 5 or 10 dollars."[17] Davis also theorized that the very nature, or "form," of this socially viable art "always results from the choice made by an artist. This choice is socially determined, because his whole life

is socially determined."[18] The advent of government support was supposed to free artists from financial concerns and allow them to concentrate on furthering the cause of the working classes. The WPA programs were widely regarded as a sign that the "golden age" of federal support for the artist had arrived, for this official sanctioning was an important gesture for the American artist still struggling to gain acceptance and find support in this country.

It "demonstrated to the country as a whole the essential role that art played in people's lives. Artists could now consider themselves useful members of society, especially since the chasm between artists and their fellow men was clearly disappearing."[19] Davis would lobby for continued government support of the arts through the forums of the Artists Union (he served as president in 1934) and its magazine *Art Front* (which he edited in 1935–36), as well as through the American Artists Congress (which was inaugurated in 1936 and elected Davis as chairman in 1937). Although Davis enrolled in the easel section of the WPA in 1934, he did not complete his first mural project under these auspices until 1938. *Swing Landscape* (cat. no. 114) was commissioned in 1938 for the newly constructed public-housing project in the Williamsburg section of Brooklyn.

Davis's commitment to reconcile abstraction and figuration was dictated by the fact that, as John Lane has noted, he had to address the "skepticism about the relevance of modern art to the times"[20] in order to establish the political credibility of abstract art. Davis's public-mural work was the obvious format within which his political and social mission would be best achieved, but as Karen Wilkin points out, while "[t]he murals . . . admirably fulfill their mandate to address public issues, . . . [t]hey are . . . [n]either uplifting narratives nor heroic allegories [;] they are light-hearted declarations of his preoccupations with form and color."[21] Davis's studio works also need to be examined to clarify how he accommodated a more broadly defined audience while addressing his belief in the absolute freedom of the artist to experiment with new forms. Davis defined social purpose in art in the broadest terms: Not only was it "a certain type of painting," but it also included the work of "all artists who in whatsoever way are willing to direct their art toward progress, and who oppose war and reaction."[22] He was emphatic that this did not mean that the artist would ignore all the new technical advances in painting. "The task of the artist above all was to fight for the right for individual artists to practice art in all categories that existed."[23] Davis grappled with social content in his art in

three different approaches to subject matter. In the first, he employed themes culled from the consumer, media-inflected urban culture of America; in the second, he attempted to conceptually correlate his formal theories with dialectical reasoning; and in the third, he reintroduced the figure into his work in order to express more overt political commentary.

Davis's presentation of commonplace motifs from the grocery store, from magazines, and from the streets of America parallels the Cubists' and Dadaists' interjection of found elements in their work through the techniques of collage and of appropriation. Yet, the differences in Davis's work are telling: "the full product label, the signature package and even the advertising slogan are pointedly defined. The French Cubist artists, in contrast, occasionally included the brand name of an aperitif or brandy, but more frequently showed a nameless bottle of wine or a generic bottle labeled *vin*. Within the American compositions the product image is fully displayed in all its promotional splendor, envisioned as a commodity shaped and supported by advertising. The paintings display the salient American tendency to view the everyday world in terms of commercial brand-name products."[24]

During the 1930s, the brand names Davis incorporated in his work became more abbreviated, and even symbolized, than in his 1921 tobacco paintings and in *Odol* (cat. no. 56). For example, the packet of tobacco, once the central focus of the Tobacco series of the 1920s, took the form of increasingly shortened references. This is apparent in *New York—Paris No. 1* of 1931 (cat. no. 90) where Stud tobacco is merely one of many visual elements in the composition, and in *Mural* of 1932 (cat. no. 100), where the stallion, which accompanied the name Stud in the 1931 composition, suffices to identify the product. Perhaps Davis felt that, within the development of his work, a trademark image or a logo would evoke content in the same way that the barber pole in *Mural* identifies the type of business depicted. The effectiveness of this strategy would depend on the fact of a general agreement and consistency in the use of signs, words, or names to designate phenomena in specific contexts in the empirical world.[25] It also complements the schematization of form that Davis introduced to enhance the readability of his art. References to recognizable locales, as seen in *New York—Paris No. 3*, and *House and Street* (cat. nos. 91, 92), and urban terminology, such as *hotel*, *garage*, and *telephone*, serve a formal as well as a directional function. On one occasion, in *New York—Paris No. 3*, Davis inserts the name of a restaurant, TICINO, on a street sign for special effect. Davis's repertoire of popularist references grew to include cigars and magazines (as in *Magazine and Cigar* of 1931; fig. 92) and everyday objects (as in *Salt Shaker* and *Radio Tubes*; cat. nos. 94, 95), and the ubiquitous gas pumps bore the name of the newest gasoline on the market (see cat. no. 99).

The influence of Dada and Surrealism can also be detected in these works. "Even though Davis denounced the motivation behind Dadaism, he acknowledged that the Dadaists' free association of diverse objects was partially responsible for freeing him from the idea that subject matter must have a linear or narrative logic."[26] Likewise, Surrealism effected the "coming of age" of the object "weaned from its source and left to seek out relations other than familiar ones . . . [and to] . . . reveal unexpected affinities."[27] This is Davis's special achievement in such works as his New York—Paris pictures and the Radio City *Mural* (cat. no. 100). In these paintings, Davis approaches René Magritte in having set up a "Hegelian dialectic of contradictions, in which a union of opposites operated as the mainspring of reality."[28] The subtlety of the relationship of one object to another in Davis's work can easily be dismissed as frivolous or non-contextual unless the symbolic and resonant potential of the object is taken into account. In addition, it is necessary to consider the "plural significance of experience in which spatio-temporal measurement is seen as the relation between observer and phenomena . . . [and] . . . corresponds to Einstein's theory of relativity . . . which abolished the 'absolute' space and time of Newtonian theory."[29] Like the Russian artist Kazimir Malevich, Davis heralded the appearance of this new space in his paintings by setting the objects against a continuous, neutral background.[30]

The question is whether this strategy in and of itself can effect a viable political and social contact with society at large, void, as it tends to be, of polemical editorializing. If, as Davis thought, art created from such sources would find its own natural audience outside the exclusive art circles, it would find its life by evoking a response from that audience. This type of subject matter was a potent agent for initiating communication with working-class ethics by evoking the social cohesion that resulted from the development of what Daniel Boorstin has called "communities of consumption."[31] Davis's evocation of familiar trademarks, brand names, and the like traded on the propensity of modern society to define itself according to its loyalty to specific products or stores or pastimes. In dealing with this subject matter, Davis must have been keenly aware of the pitfalls of kitsch. His dilemma was stated in a 1939 article in which Clement Greenberg castigated contemporary political regimes that repudiate

the avant-garde in order to pander to the intellectual resistance of the "peasant" or the "proletariat." "[T]he peasant [read "worker"]," Greenberg noted, "finds no 'natural' urgency within himself that will drive him toward Picasso [read "abstract art"] in spite of all difficulties. In the end the peasant will go back to kitsch . . . for he can enjoy kitsch without effort."[32] While Davis maintained his commitment to creating art with a broad-based popular appeal, he would not descend to the level of kitsch to do so. At the same time that his choice of subject could have an appeal to the masses through its references to familiar things, places, and experiences, instead of diluting classical modernist or traditional forms, Davis simply selected a subject matter that had its own distinct rules and criteria, and created his art according to communicative techniques he appreciated and adapted from advertising and publishing.[33]

Davis's correlation of his color-space theory with the systems of dialectical materialism represents one of the most fascinating and complicated aspects of the artist's attempts to promote abstract art as a social and political agent. Although abstraction had been almost synonymous with the vision of a new world order in Europe in the period just before and after World War I, by the 1930s this situation was changing. The alliance between the revolutionary regime in Russia and the advocates of Suprematism and Constructivism was aborted when the government repudiated modernism in favor of so-called Stalinist Realism in 1934. Similarly, the repression of the Bauhaus School and modernist art, and the promulgation of a classicist aesthetic, which accompanied the rise of Nazism in Germany during the 1930s, indicated a bleak future for the acceptance of abstraction and avant-garde tendencies within a specifically political context. Davis, however, like most progressive American intellectuals in the 1930s, did not focus on the realpolitik within the Soviet Union, but chose to perpetuate the idealistic dreams of the Russian revolution. Within the context of the political reality of the world, Marxist Russia was distinguished from Fascist Germany and Italy.[34] Yet, in the final analysis, Davis was far from a doctrinaire Marxist. He "shied away from Marxism when political agendas dominated too powerfully. For Davis, scientific materialism and a dialectical . . . method were more fundamental truths than . . . specific uses. . . . Indeed Davis's understanding of . . . [these] . . . processes was probably as deeply influenced by American Pragmatism as by Marxism. Diane Kelder has pointed out, in considering Davis's relationship to Marxist aesthetic theories that 'the

broader influence of Pragmatism and its climate of ideas should be reconsidered.' "[35]

As Davis developed and clarified his color-space theory, he suggested a fascinating relationship between it and dialectical thought. Davis's color-space theory was based on "an intuitive measuring system for color that would parallel and complement his already well conceived methods of optical geometry."[36] This optical geometry was based on the principle "that every time you use a color you create a space relationship. . . . They . . . have . . . always and automatically, a positional relationship to some necessary, basic, coordinative referent."[37] Dubbing the means by which he figured out the spatial relationships on the picture plane "dialectical," Davis explained: " 'It starts with the presence of two opposing space systems which establish a specific planal [sic] relationship. . . . The dialectical elements, whose contradictory simultaneous experience creates the aesthetic form, are as follows: length, area, color-tone.' More importantly, modern art, according to Davis, was engaged in a dialectical relationship with reality. . . . '[I]n its internal form and in its external relation to reality, modern art could stimulate radical change in the political and economic structure of America.' "[38] In this conceptualizing of a parity between dialectical materialism and his color-space theory, Davis situated the social function of art on a more intuitive, even subliminal, level. The subject matter of art, although cast in abstract means, and focusing on the formal elements noted above, would be able to inspire a psychological and intellectual uplift or stimulus through the viewer's intuitive response to the formal characteristics of a given work. Indeed, as has been discussed, in the mural *Swing Landscape* (cat. no. 114), originally designed for the Williamsburg Public Housing Project, Davis achieved an incredible synthesis of realism and abstraction, color and form, and space and flatness, which he would pursue according to his color-space theory in the works of the 1940s. In *Swing Landscape*, Davis camouflaged a three-part composition of Gloucester themes within his cogently conceived arrangements of color shapes. It is as if the artist deliberately calculated the assignment of color to the shapes to counteract the expected perspectival reading (present even within the riotous pointillism and chromatics of a Fauve painting). This strategy of camouflage allowed Davis to maintain his stance as a "realist," while advancing the abstractionist impulse of his color-space theory. Compared with the easel painting *Landscape with Garage Lights* (cat. no. 102), executed in 1932, the anecdotal

elements in *Swing Landscape* have been submerged within the overall scheme of Davis's juxtapositions of color shapes, which create spatial interactions distinct from the picture's more evident perspectival conventions.

This approach to form and color was compatible with the goals that Burgoyne Diller envisioned for the abstract art commissioned for the Williamsburg housing complex. In place of rigorous depictions of workers ascending the parapets to take control of the factories, and striving to better their situation, Diller "reasoned that aesthetically pleasing forms might be more appealing after a hard day's work than images of factories, city streets, and allegories of class struggle."[39] His ideas reflect the idealism inherent in Suprematism, de Stijl, and the Bauhaus that the masses could be educated to appreciate abstract art. This issue was discussed in a number of forums in New York during the 1930s. The positions taken encompassed both the issue of artistic freedom and invention on the part of the artist, as well as the visual literacy of the public. In this dialogue, Davis and his abstractionist colleagues were pitted against the so-called "Paint America" tendency—a broadly conceived trend, better known as the "American Scene" movement— whose exponents embraced the revival of interest in American culture and its intrinsic system of values, aesthetics, and philosophy.[40] Artists as divergently positioned as the Regionalists and the Social Realists shared a common antagonism—even a hostility—toward abstract art.[41] The proponents of this aesthetic point of view, such as the critic Thomas Craven, hearkened to the notion of shared memories and innate expression to achieve the American cultural renaissance that they envisioned, and it was artists like Thomas Hart Benton who captured that resurgent idea of America in his paintings.

Davis emerged as a witty and cogent participant in this debate over what constituted American art, an art for the American people. He positioned himself squarely and adroitly in the middle, criticizing both the realist and abstractionist camps. For Davis, non-objective art was misguided and socially irresponsible, yet he countered this philosophy by affirming the democratic nature of abstraction, and—as an aside to the "Cravenists"—reiterated his belief in the ability of abstract art to express a commonly comprehended experience. "The . . . conception that . . . 'non-objective' painting is 'absolute' is . . . a general misconception regarding the meaning of abstract art by most people. . . . The general misconception regarding abstract art is that it is different in kind from the great tradition of realistic art through the centuries.

Such a conclusion has no more basis in fact than the idea of the Baroness [Hilla Rebay] that a painting of the general space-light relations of a human head is 'relative,' and that a painting of colored soap bubbles, confetti and streamers a la [Rudolf] Bauer is 'absolute.' . . . To regard abstract art as a mysterious irrational bypath on the road of true art is like regarding electricity as a passing fad."[42] Davis challenged the position of the Cravenists by asserting the inherently realistic nature of abstraction, which determines its significance and content. "Meaning is [an] objective process, a real happening, which is proved by its social communicability. Meaning is a quality found only in association with experience common to many people. For an event to have meaning for us, we must have had experience with the objective elements that compose it. Abstract art is realistic and has meaning because it expresses common experience."[43]

Davis utilized this formalist argument as a springboard from which to challenge his favorite antagonist, Thomas Hart Benton, on the latter's presumptions of the inherent validity, even primacy, of realist techniques.[44] In a vigorous rejoinder to Benton's 1935 comments "On the American Scene,"[45] Davis attacked the hegemonic position of mimetic styles and a focus on the anecdotal as expressions of a truly American art. "I, too, think great art will come out of the Middle West, but certainly not on the basis of Benton's presumptions. It will come from artists who perceive their environment, not in isolation, but in relation to the whole. . . . Regional jingoism and racial chauvinism will not have a place in the great art of the future."[46] Davis continues his critique, singling out elements such as Benton's depictions of specific figures (he found Benton's representations of African and Jewish Americans particularly racist and inflammatory), and even the artist's painting techniques, which Davis asserted resulted in unstable and fugitive surfaces, thus discrediting the pretensions to grandiose cultural values of the "Paint America" movement.[47]

In this exchange and in others waged in the pages of the daily newspapers and the art press throughout the 1930s, Davis effectively dispensed with the notion that experience and reality are ultimately encapsulated in imitative realism. He alternatively pointed out the emotive and connotative values of form—not just "pure" form, but form grounded in the sensations of daily life, which is accessible to all people. In this manner he reiterated his conviction that the formal elements of painting took precedence over the specificities of subject matter—an idea that he had articulated in the early

Figure 43. Stuart Davis. *Men and Machine*. 1934. Oil on canvas. The Metropolitan Museum of Art, New York. Gift of Mr. and Mrs. Jay R. Braus, 1981

1920s. As we have seen, however, this did not preclude anecdotal references in Davis's work. Indeed, at various times during the 1930s, Davis's interest in certain subjects occasionally coincided with the "American Scene" sensibility. This is seen particularly in his depictions of the environs of Gloucester, Massachusetts. Images of this New England fishing town dominated his art from 1915 to 1934. In the course of the 1930s, Gloucester itself became increasingly abstracted formally in Davis's work, and after 1934, it was more abstracted emotionally and conceptually. In *Red Cart* of 1932, *Waterfront* of 1935, and *Gloucester Harbor* of 1938 (cat. nos. 103, 110, 113), Gloucester motifs appear as isolated elements in the compositions, and color and pattern take precedence over anecdotal details. This progression culminated in the 1939 *Mural for Studio B, WNYC, Municipal Broadcasting Company* (cat. no. 115), in which Davis again reworked familiar Gloucester motifs (schooner rigging, mast, ropes, and sky) along with musical notations and urban typography. However, vestiges of contextual references are frustrated by Davis's abrupt juxtapositions of variant thematic elements within their own "islands" or "auras," which float against a neutral beige background. They are connected by the most contrived of devices—for example, by the rope from the rigging, which reaches from the area of the mast to the strip of municipal graphics. In writing about this work, Davis asserted that its subject matter was concerned with music, electronics, and physics. This strategy of de-emphasizing artistic issues was utilized—as we shall see—by other proponents of abstraction to defuse arguments about the validity of abstract art. It also accommodated the general public by providing analogies with familiar concepts, objects, or places in contemporary American society and everyday life.[48]

Davis's forthright assumption that his public would come around to his way of seeing reflected his conviction that artists should be leaders in society. John Graham likewise urged artists "not to cater to the masses, but to educate them to higher standards."[49] Fernand Léger, who visited New York several times,[50] also contributed to this debate in an article published in the February 1937 issue of *Art Front*. "Léger railed against those who believed that the Masses could not understand the new art, claiming it was only necessary to give workers leisure and access since modernist art reflected their times and the products they manufactured."[51] This concept of a "new realism," comparable to that described by Davis, comprised the very real attempt of abstract artists to contend with the hostility toward abstraction. In this context, it should be noted that both Léger and Davis tended to abstract forms based on their own perceptions of the natural world. This method was distinct from that of non-objective artists, who approached abstraction from a purely formal standpoint. These artists, Davis felt, isolated the "artistic function from its social mission"— the progression of historical materialism.[52]

Several works of the 1930s, which feature more specifically narrative scenarios, should be reevaluated in this context. These works are generally regarded as less

successful, largely because of the inclusion of figures, which Davis had eliminated from his art in the early 1920s.[53] While Davis's figures have been criticized for their lack of resolution, their indeterminate quality provides a more open engagement of the content.[54] The most elaborately conceived of these paintings is *Abstract Vision of New York: a building, a derby hat, a tiger's head, and other symbols (New York Mural)* of 1932 (cat. no. 99). As interpreted by Bruce Weber, this work is an homage to Al Smith, the Progressive politician. Through an intricate iconographic program, Davis refers to Smith's failed presidential campaign and his improbable incarnation as an agent for the newly constructed Empire State Building. Davis also tackles Tammany Hall, and evokes the work of one of the best-known political cartoonists, thus firmly and formally anchoring his own Progressive leanings within a visual icon of contemporary culture. Here, Davis employed a particularly crisply defined linear style, avoiding the heavy hand associated with the genre of propaganda by means of an exploitation of formal and compositional devices from Cubism and Surrealism—for example, fluctuant space and non-realistic scale relationships. In the two earlier works *House and Street* and *Trees and El* (cat. nos. 92, 93), Smith's name actually appears, spelled out in oversized letters as on some ill-fated campaign poster.

In *American Painting* (cat. no. 104), also begun in 1932, Davis presents another complexly coded iconography of American cultural politics. Lewis Kachur has outlined the main motifs in this work, which, in its original state (see fig. 111, cat. no. 104), include a hand holding a pistol, a top-hatted man of the sort that would frequent café society, four male figures, an architectural element, an airplane with the words LITTLE JOE—a reference to a turn of dice—emblazoned on its side, and a stylized, quirky head, with only one strand of hair.

Davis's use of a stylized linearity in *Abstract Vision of New York: a building, a derby hat, a tiger's head, and other symbols (New York Mural)* and in *American Painting* emphasized the two dimensionality of their designs and their similarity to cartoon art. He later painted over the original composition of *American Painting* in 1951, and in that state it served as the basis for the composition of *Tropes de Teens* (cat. no. 105), executed in 1956. Davis may be evoking the kind of disjointed, overlapping imagery used as transitional sequences in movies. Certainly, his four male figures are reminiscent of the proverbial bad-boy-turned-thug characters that populated 1930s films (this is complemented in the painting by the hand with the pistol). The awkward face gives rise to associations with Tod Browning's film *Freaks*, which was released in 1932. Written at the upper left of *American Painting*, along the side of the architectural element, is a riff from a Duke Ellington song, "*It dont mean a thing/If it aint got that swing*," evoking jazz—the art form Davis thought particularly analogous to the type of American painting he wanted to create.[55] "Jazz has been a continuous source of inspiration in my work from the very beginning for the simple reason that I regard it as the one American art which seemed to me to have the same quality of art that I found in the best modern painting."[56] The structure of jazz was seen by Davis as a means by which he could utilize an American art form to liberate his own creativity from provincialism.[57] This attempt to meld "American-ness" with modernity contradicted prevailing attitudes, and, given the context in which this picture made its debut—the Whitney Museum's "First Biennial of Contemporary American Painting"—this was an important point for Davis to make.[58]

The title of the 1934 painting *Men and Machine* (fig. 43) may have been inspired by a series of articles enti-

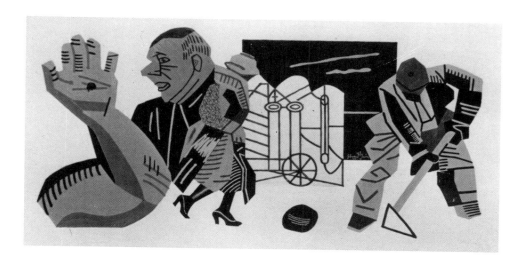

Figure 44. Stuart Davis. *Contemporary Street Scene.* 1934. Oil on canvas. Whereabouts unknown

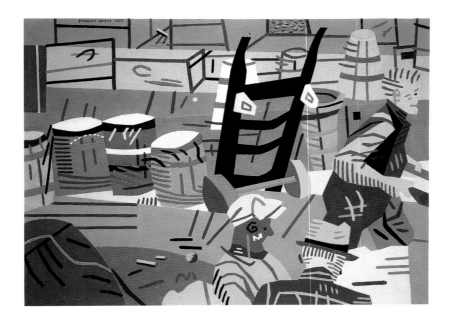

Figure 45. Stuart Davis. *The Terminal.* 1937. Oil on canvas. Hirshhorn Museum and Sculpture Garden, Smithsonian Institution, Washington, D.C. Gift of Joseph H. Hirshhorn, 1966

tled *Men and Machines*, published in 1929 in *The New Republic* by the Progressive author Stuart Chase, that dealt with the influence of modern technology on American society. Chase focused explicitly on the danger of automated employment: "[While] . . . in the past technological discoveries had opened up new opportunities for employment . . . since 1921 this process appeared to have ended. . . . Even the middle class was suffering some kind of proletarianization as their jobs became mechanized. With production growing more efficient, purchasing power remained stagnant and surpluses piled up. Technology, in Chase's view, was now introducing the specter of mass unemployment."[59] In the painting by Davis, the relationship between the two men is not specifically defined. Perhaps some commentary on class is indicated by the differences in their attire, but otherwise they stand with their backs to us contemplating the scene. In the oil painting *Contemporary Street Scene,* of 1934 (fig. 44), Davis makes a more pointed class distinction between the fashionably clad woman walking down the street and the man she approaches, who wears a suit but is aggressively attacking the asphalt with a sledgehammer. At the left, a bespectacled bureaucrat is confronted by the muscular arm of a worker. Three years later, in *The Terminal* of 1937 (fig. 45), Davis again presents a dockside labor scene, this time focusing on three longshoremen hauling cargo off a dock. The artist has framed the painting so that the specifics of locale are edited, and, as in *Men and Machine*, there is no attempt to manipulate our emotional and political feelings through the presentation of circumstantial events that we know had confrontational elements. In *The Terminal*, the figures are composed of

broad areas of color, with texturing added to provide some sense of space (in addition to that achieved through the overlapping of forms) and visual interest.

It is in his 1936 gouache entitled *Artists against War and Fascism* (fig. 46) that Davis presents the most specifically propagandistic image within his oeuvre. This is a blunt depiction of political oppression. Two uniformed soldiers drag a bloody figure between them. Instruments of confinement are present in the form of an interrogation lamp and barbed wire. In the distance, we see a formidable building with a huge studded wheel attached to it, and, above, a smoking cannon announces an overrun by the military. At the bottom, a fallen sign reading *Libre* provides a poignant note. While the scene is not specific, it could well refer to the German occupation of the Rhineland, or the outbreak of the Spanish Civil War, which occurred the same year. Davis used the cannon motif in other compositions in the 1930s; for example, in *Sunrise* of 1933 (fig. 47), it sits above a bifurcated view of a cove in Gloucester and the town's familiar towers and masts. It is rendered in black and white, contrasting with the color of the scenes below, and, as such, seems suspended like a portent of the subject depicted in *Artists against War and Fascism*.

The 1941 gouache *Ana* (cat. no. 130) may be considered in this context, as it seems to provide a natural conclusion to this discussion. Davis casts the theme of labor as an allover profusion of industrial haul and scrap material. A black person, anachronistically dressed in nineteenth-century homespun and sporting the remnants of recently broken chains, can barely be made out at the lower left corner of the composition. The juxtaposition of the figure against the panoply of industrial

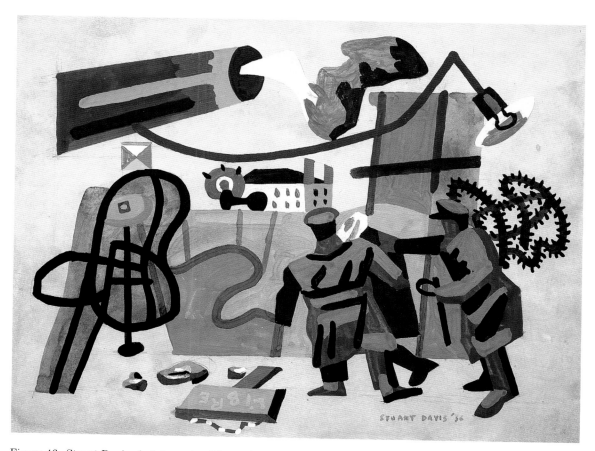

Figure 46. Stuart Davis. *Artists against War and Fascism.* 1936. Gouache on paper. Collection Fayez Sarofim

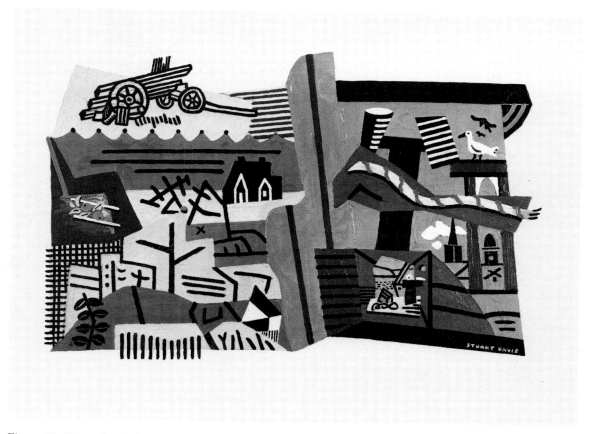

Figure 47. Stuart Davis. *Sunrise.* 1933. Oil on canvas. Collection Mrs. Holger Cahill

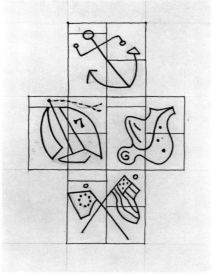

48

49

50

51

Figure 48. Stuart Davis. Fabric design: Nautical motifs. About 1934. Ink, over pencil, on paper. The Metropolitan Museum of Art, New York. Gift of Mrs. Stuart Davis, 1981

Figure 49. Stuart Davis. Textile. About 1938. Printed linen. The Brooklyn Museum, New York. Gift of Mrs. Stuart Davis, 76.25.2b

Figure 50. Stuart Davis. Fabric design: Liquor and Prohibition motif. About 1934. Ink, over pencil, on paper. The Metropolitan Museum of Art, New York. Gift of Mrs. Stuart Davis, 1981

Figure 51. Stuart Davis. Textile. About 1938. Printed linen. The Brooklyn Museum, New York. Gift of Mrs. Stuart Davis, 76.25.2c

Figure 52. Advertisement for the Franklin Simon department store, New York, showing dresses made from fabrics designed by Stuart Davis. *The New York Sun*, April 12, 1938

52

scrap and machinery seems to symbolize the transition of American society from a rural, agrarian culture to an industrial one—a transition that went through its final throes during the period between the wars.[60] The imagery of *Ana* also upholds Davis's assertion that modernist art was the embodiment of an industrial democracy, "a reflection of progressive modern technology, and a contribution to knowledge of materialistic reality."[61] "The future of painting is clear, is historically determined and . . . built on the solid foundation of modern art. . . . [It] looks toward improving the lives of the workers by giving them more money, more leisure, more education, and more culture. Such a program can only be conceived in view of modern technological development through the materialism of science."[62] Modern art was a means for capturing the abstract qualities of the American industrial landscape. This is seen in the black-and-white renditions of sections of pipes and rigging, and in the celebration of newly built modern architecture in the 1930s—such as the Empire State Building —in *Abstract Vision of New York: a building, a derby hat, a tiger's head, and other symbols* (*New York Mural*) (cat. no. 99). That materialistic reality would be manifest—in the words of Davis—in " 'the products of the machine . . . includ[ing] American architecture, factory-made domestic furniture and tools, advertisement printing, labels and electric signs.' "[63] Davis then extended his own participation in that reality through several excursions during the 1930s and 1940s into commercial art, adapting his modernist vocabulary to fabric designs, tapestries, ceramics, and album and book covers.

Davis's dealer, Edith Halpert, organized the exhibition "Practical Manifestations in American Art" in 1934

at her Downtown Gallery to demonstrate how modern art could be applied to commercial design.[64] Davis's contributions to this exhibition included the oil painting *House and Street*, an ink study for *Mural* and photographs of the work *in situ* in the men's lounge at Radio City Music Hall, and designs for dress fabrics (see figs. 48–51).[65] His work was also shown in the exhibition "Modern American Art in Modern Room Settings" at the Modernage Furniture Company in New York in 1935.[66] Davis continued to create designs for Samuel Kootz Associates in the later 1930s, and some of them were used for fabrics for Easter dresses, which were advertised by the Franklin Simon department store (see fig. 52). Davis later designed a rug, *Flying Carpet*, which was woven by Stanislav V'Soske (see fig. 53), and he adapted his black-and-white compositions of the early 1930s to designs for china plates for Castleton China. These experiences left their mark on Davis's work as he increasingly applied the means of creating designs to the service of his unique, mature art style. As a result, the graphic elements in his paintings gradually took on the role of formal as well as informational references (see cat. nos. 141, 163).

The year 1940 marked the end of any overt political expression on Davis's part. Like many of his contemporaries, Davis was becoming disillusioned with Progressive political philosophies and with the limited response of Americans to art—specifically, to modern (abstract) art. The basic estrangement of art from the general public seemed to lie in the failure to resolve what was to be an American art, and what the role of art and artists would be in relation to that public (the masses). For American Socialists and Progressives, the invasion of

Figure 53. Stuart Davis. Study for *Flying Carpet*. 1942. Gouache on paper. Collection Earl Davis

Finland by the Soviet Union marked a definitive rupture with Communism. During this period, Davis also reconciled with his longtime dealer, Edith Halpert (with whom he had broken ties in the mid-1930s over a dispute about money), which indicates that he had come to the realization that neither the working classes nor the government could support artists in the natural and logical way he had envisioned. From this period on, his color-space theory found a full flowering in a series of compositions that both revisited past works (for example, *Feasible #2* and *Arboretum by Flashbulb*, cat. nos. 48, 131), and responded to the present (*Ultra-Marine* and *The Mellow Pad*, cat. nos. 132, 135), both in terms of his personal artistic development and that of the emerging Abstract Expressionists group. This would be the pattern in Davis's work until the end of his career (see the essay by William Agee, pages 82–96).

While the specifically political nature of Davis's equation of democracy with abstract art might have seemed a bit strained within the dogmatism of the 1930s, by the end of World War II its pertinence was quite clear. "As America increased its involvement in international political and military affairs, it also actively engaged in foreign aid and international trade to promote the superiority of the free enterprise system. The exporting of American taste, American products, and more generally the American way of life advanced America's influence and image, particularly as these exports offered a marked contrast with the Soviet economic system, products and way of life."[67] Davis's own reputation became more widespread after World War II, in the midst of the rise of Abstract Expressionism and, subsequently, of Pop Art. Indeed, he was one of the few artists, so strongly identified with abstract art during the 1930s, who was able to make the transition from social activist to éminence grise in American life and culture in the 1950s.

Notes

1 See Richard H. Pells, *Radical Vision and American Dreams, Culture and Social Thought in the Depression Years*. New York, Evanston, San Francisco, and London: Harper & Row, 1973.

2 See Judith Tannenbaum, "Yun Gee: A Rediscovery," *Arts Magazine* (May 1980), p. 165.

3 Diane Kelder, ed., *Stuart Davis*. New York, Washington, and London: Praeger, 1971, p. 83.

4 Stuart Davis Papers, December 30, 1922. Harvard University Art Museums, Fogg Art Museum, Cambridge, Massachusetts.

5 Ibid.

6 Ibid., March 5, 1923.

7 This "reality" was progressively supplanted and embellished by the use of words, as Davis's work evolved during the last two decades of his career. In Lewis Kachur's essay (see pages 97–108), he deals with the issue of words in Davis's oeuvre and how they function compositionally, establishing parallels with Cubism, collage, modern advertising, and the like. What is also interesting is how Davis asserts a manipulation of representation and designation, and the relativity of their interaction—a position that would have intrigued Ludwig Wittgenstein (1889–1951). What we may now recognize as an engagement of semiotic and simulationist strategies is most obviously seen in such compositions as *Premiere* of 1957 (cat. no. 158).

8 Stuart Davis, in a statement addressed to Edith Halpert, cited in John R. Lane and Susan C. Larsen, eds., *Abstract Painting and Sculpture in America, 1927–1944* (exhib. cat.). Pittsburgh and New York: Museum of Art, Carnegie Institute, and Harry N. Abrams, Inc., 1983, p. 10.

9 Stuart Davis, Notebook: 1920–22, December 4, 1920. Private collection.

10 Ibid., March 29, 1921.

11 Kelder, op. cit., pp. 55–59.

12 Ibid., p. 63.

13 Wayne L. Roosa, "American Art Theory and Criticism During the 1930s: Thomas Craven, George L. K. Morris, Stuart Davis." Ph.D. diss., Rutgers–The State University of New Jersey, 1989, p. 330.

14 Kelder, op. cit., p. 81.

15 See Clement Greenberg, "Avant-Garde and Kitsch," in *Art and Culture: Critical Essays*. Boston: Beacon Press, 1961, p. 14.

16 Stuart Davis Papers, March 17, 1936, and August 26 and September 29, 1937, op. cit.

17 Stuart Davis, Notebook: 1920–22, March 29, 1921. Private collection.

18 Stuart Davis Papers, September 20, 1937, op. cit.

19 Matthew Baigell, *The American Scene: American Painting of the 1930's*. New York and Washington: Praeger, 1974, p. 50.

20 John R. Lane, *Stuart Davis: Art and Art Theory* (exhib. cat.). New York: The Brooklyn Museum, 1978, p. 35.

21 Karen Wilkin, *Stuart Davis*. New York: Abbeville Press, 1987, pp. 146–47.

22 Stuart Davis Papers, July 5, 1936, op. cit.

23 Ibid.

24 Sidra Stich, *Made in U.S.A.: An Americanization in Modern Art, the '50s and '60s* (exhib. cat.). Berkeley, Los Angeles, and London: University of California Press, 1987, pp. 89–90.

25 See Suzi Gablik, *Magritte*. London: Thames and Hudson, 1970, p. 141.

26 Roosa, op. cit., p. 327.

27 Gablik, op. cit., p. 104.

28 Ibid., p. 123.

29 Ibid.

30 See Wilkin, op. cit., p. 134.

31 Daniel J. Boorstin, *The Americans: The Democratic Experience*. New York: Vintage Books, 1973, pp. 145–48.

32 Greenberg, op. cit., p. 18.

33 The suggestion that advertising imagery could constitute an integral art form, or, at least, a means of expression, with its own criteria, may counter its being classified as "low" art by Kirk Varnedoe and Adam Gopnik in *High & Low: Modern Art, Popular Culture* (exhib. cat.). New York: The Museum of Modern Art and Harry N. Abrams, Inc., 1990, pp. 15–16.

34 Stuart Davis Papers, August 26, 1937, op. cit.

[35] Roosa, op. cit., p. 314.

[36] Lane, op. cit., p. 41.

[37] Ibid.

[38] Cecile Whiting, *Antifascism in American Art.* New Haven and London: Yale University Press, 1989, pp. 75–76.

[39] Lane and Larsen, op. cit., p. 23.

[40] Baigell, op. cit., pp. 18–23. "American Scene" is a broad description that Matthew Baigell uses to describe the "Paint America" trend. He includes Regionalists, Social Realists, Stuart Davis, and Ben Shahn, but excludes the next generation working in the spirit of the Ashcan School (such as Reginald Marsh, Kenneth Hayes Miller, and Isabel Bishop, sometimes known as the "14th Street School"), Precisionists, Charles Burchfield, and Edward Hopper. Additionally, Susan Larsen ascribes the purpose of capturing a "native expression rooted in time and place" to the work of such artists as Marsden Hartley, Georgia O'Keeffe, and Charles Sheeler. This suggests that the dichotomy between the "American Scene" group and the Stieglitz circle has been framed too extremely (see Lane and Larsen, op. cit., p. 15). Baigell also distinguishes among the agendas of the realist proponents, noting the conflicts that arose between the Regionalists and Social Realists over issues of nationalism and aesthetic value in art. While the Social Realists felt that the Regionalists' espousal of an American art based on an "American" experience was comparable to the Nazi agenda, the Regionalists castigated the Social Realists for painting "symbolic" figures for propaganda sake, rather than "real people" (see Baigell, op. cit., p. 61). Such veiled allusions do not hide the truth, which was that the conflict was between the values and conditions of an "older" America of the so-called "heartland" (the Regionalists) and a "newer" America of immigrant populations in urban centers on both coasts (the Social Realists). Whereas the Regionalists wanted to create an art from a set of conditions, the Social Realists wished to change the nature of those very conditions (ibid.).

[41] In hindsight, it may be recognized that the divergent efforts of the "American Scene" group, who asserted the primacy of American art within the history of world art, and the abstractionists, who nurtured revolutionary ideals in their painting, contributed to the genesis of Abstract Expressionism, and the leadership role that the United States played in the post-1945 art world. However, between the two world wars, abstractionist stances were considered neither politically, emotionally, nor financially viable.

[42] Stuart Davis, "Abstraction Is Realism: So Asserts Stuart Davis in New Letter on Non-Objective Art Controversy," *The New York Times* (October 8, 1939), sect. 9, p. 10.

[43] Ibid.

[44] Davis's "formalism" could easily be associated with Clive Bell's "significant form." Davis, however, found Bell's concept "too vague to have much value" (Kelder, op. cit., p. 85).

[45] Thomas H. Benton, "On the American Scene," *Art Front* 1, 4 (April 1935), pp. 4, 8.

[46] Stuart Davis, "Davis's Rejoinder," *The Art Digest* 9, 13 (April 1, 1935), pp. 12–13.

[47] Ibid., p. 13.

[48] See Edward Alden Jewell, "Abstraction and Music: Newly Installed WPA Murals at Station WNYC Raise Anew Some Old Questions," *The New York Times* (August 6, 1939), sect. 9, p. 7. Jewell, himself, was skeptical about the analogies drawn, in this case, between music and abstract art: "I suppose the artist [Hans Wicht] could to some extent substantiate an assertion . . . that his design possesses, as does a musical fugue, counterpoint. . . . Yet it somehow takes more than this to make counterpoint in a sense that could interchangeably apply both to painting and to music." About Davis's mural Jewell wrote: "If Mr. Davis here painted a symphony, it must be esteemed in no way analogous to any symphony—at least any good one—that I have listened to in the concert hall."

[49] Lane and Larsen, op. cit., p. 12.

[50] Léger met Davis in Paris in 1928, and later visited New York in 1931, 1935, and 1938. Davis interceded on Léger's behalf in 1935 to secure him employment on a WPA project (Stuart Davis Calendars, October 10, November 14, November 20, 1935. Archives of Earl Davis).

[51] Lane and Larsen, op. cit., pp. 12–13.

[52] Stuart Davis Papers, 1936, op. cit.

[53] See Wilkin, op. cit., p. 139.

[54] It is interesting to compare Davis's figurative style with that of Jacob Lawrence in the same period. Both artists similarly employed flat areas of color to create their figures. Lawrence, however, was willing to exaggerate and manipulate the proportions of the limbs, as well as the spatial orientation in his compositions, to suit his narrative task (see, for example, the Toussaint l'Ouverture series of 1937–38). Davis, on the other hand, seems curiously conventional in the organization of forms in space within this body of his work.

[55] See Roosa, op. cit., p. 323.

[56] John Lucas, "The Fine Art Jive of Stuart Davis," *Arts Magazine* 31, 10 (September 1957), p. 33.

[57] Brian O'Doherty, *The Voice and the Myth: American Masters.* New York: Universe Books, 2nd ed., 1988, pp. 77–78.

[58] Davis particularly played up the "American-ness" of his work in 1932. For example, his exhibition that year at the Downtown Gallery was entitled "American Scene: Recent Paintings, New York and Gloucester . . . " Pictures such as *Landscape with Garage Lights* (cat. no. 102) display an anecdotal quality that Donald Keyes has attributed to the influence of Edith Halpert, who encouraged Davis to accommodate the current trend in the art world—the celebration of the American scene—in his own work (see Donald D. Keyes, "Stuart Davis: *Snow on the Hills,*" *Georgia Museum of Art Bulletin* 12, 2 [Winter 1987], pp. 5, 23).

[59] Pells, op. cit., pp. 27–29.

[60] Ibid., pp. 88, 199–200.

[61] Lane and Larsen, op. cit., p. 12.

[62] Stuart Davis Papers, November 29, 1937, op. cit.

[63] Whiting, op. cit., p. 75.

[64] See the exhibition catalogue *Practical Manifestations in American Art: Davis, Fiene, Hirsch, Kuniyoshi, Laurent; Nakian, Shahn, Sheeler, Zorach.* New York: The Downtown Gallery, 1934. This exhibition attracted widespread attention in both the art and the general press. Critics observed ironically that artists evidently had learned that creating with the public in mind was not detrimental to their talent (see Edward Alden Jewell, "'Practical' Artists Hold an Exhibition," *The New York Times* [December 18, 1934]), and that art is not necessarily "aloof and mysterious" but can be a part of daily life. See also Melville Upton, "Artists Turn to the Useful," *The New York Sun* (December 21, 1934).

[65] Samuel Kootz later opened an art gallery in New York, and was instrumental in promoting artists of the nascent New York School during the 1940s and 1950s. Davis refers to his dealings with Kootz in his calendars: see, for example, notations for November 8, 1937, and January 21 and 26, 1938.

[66] See the exhibition catalogue *Modern American Art in Modern Room Settings.* New York: Modernage Furniture Company, 1935.

[67] Stich, op. cit., p. 12.

Stuart Davis in the 1940s

Trauma

The decade of the 1940s was a period of crisis for Stuart Davis, then in his fifties—a time characterized by his agonized determination to retain the position he had heretofore confidently occupied in the forefront of American artistic enterprise. New York's escalating importance as an international art center compelled him to renew his ideas about picture making and the content of art in the face of the challenge from younger artists and new, inimicable aesthetic positions. Despite respect from the critics, growing support from collectors, and attention from museums (including a retrospective organized by James Johnson Sweeney at The Museum of Modern Art in New York in 1945), Davis's suffering—personal and professional—remains palpable. Largely disengaged from life outside his studio and experiencing great difficulty in completing work (there are only about ten major paintings from the period, but a disproportionate number of them are among his finest works), from 1943 to 1949 his drinking—which had always been heavy—seemed to offer the principal escape from his problems.

Event by traumatic event, in late 1939 and early 1940, the art world in which Davis had played a central role for the past decade came apart. On August 18, 1939, he calendared his termination from the WPA Federal Art Project, ending the period of modest economic security he had enjoyed since 1933; three days afterward, he noted the shocking news that would further exacerbate his growing reservations about the directions culture and politics on the Left were taking: "Announcement of a pact between Germany and Russia—non-aggression. Confirms Gen. Krintsky articles in Sat. Eve Post."[1] Less than two weeks later, Germany stormed Poland, initiating the chain of occurrences that would soon draw all of Europe into World War II.

Davis was deeply committed to the American Artists' Congress, a Popular Front organization in which art-community members from a broad spectrum of the political Left joined together in opposition to war and Fascism.[2] Shortly before Christmas 1939, the Soviets invaded Finland, and early in the new year the increasing internal factionalism the Artists' Congress was experiencing came to a head when Davis raised the issue with the Executive Board of what stand would be taken on the Russo-Finnish War.[3] After its doctrinaire Communist members—effecting a Stalinist takeover of the Congress—succeeded on April 4 in having accepted a report rationalizing the invasion, a devastated and bitterly discouraged Davis[4] initiated a wave of resignations[5] and began a wrenching reevaluation that would thoroughly reorient his personal priorities and significantly alter his artistic convictions. At the height of his activism in 1935, Davis believed that he and his fellow artists had serious social and leadership responsibilities, and he summoned them to the "arena of life problems."[6] Now, however, he would once again accept the relationship that, historically, more typically has abided between the avant-garde artist and his educated, middle-class patrons, stating, "For great art to exist there must be a great audience, consisting of at least one person."[7] Davis reembraced the position of modernist elitism he had held before being radicalized during the Depression, remarking, "There's nothing like a good solid ivory tower for the production of art,"[8] and he reaffirmed the centrality of aesthetics to the modernist artistic enterprise, writing in one instance, "The question of what is good or bad art in painting is not exclusively a matter of personal taste. The quality of works of art varies with the individuals who make them and with historical epochs, but the quality of art itself is an objective constant."[9] On another occasion he noted:

This informed usage of the word "art" refers to nothing else but the artist's abstraction of the color-space of a subject, entirely separate from its political, economic, or domestic meaning and utility; and his reconstruction of that abstraction in the material of his art. Thus all real art has always been and will always be essentially abstract, regardless of changes in subject matter, material, and technique. . . . The validity of a work of art stands in no proportionate relationship whatever to the cogency of its ideological content, and vice versa. If any care to call this viewpoint "art for art's sake," let them make the most of it. I call it art for society's sake. A society which cannot afford such an art is poor indeed.[10]

The marriage of Socialist humanism and the formalism inherent in modernist art had, in any event, never been an easy one, and it was a source of frustration that, during the 1930s, abstract art had little or no discernible impact on social or political conditions. This, coupled with shattered faith in the ideals of peace and social progress resulting from the disillusioning political behavior of the Soviet Union, drew the American avant-garde to refocus on those internal artistic matters it could control. Davis's friend George L. K. Morris and the newly emergent writer Clement Greenberg, whose important contributions were published in the *Partisan Review*,[11] were articulate voices, as artists and critics turned from the public quest for an art of social utility to the private search for a post-Cubist visual vocabulary (the case with painters such as Davis, who also were interested in formal matters) and a personal, expressive content (the concern of Mark Rothko and Barnett Newman, who wished to expand the possibilities for new subject matter Surrealism had raised).

Report from Rockport *and* Hot Still-Scape . . .

As engaged an activist as he was, Davis had, in fact, only concentrated his art and his aesthetic thinking on social issues for a few years in the mid-1930s. Late in the decade, and well before he changed his political allegiances, he had become preoccupied with developing a measuring system for color to parallel and complement the already well-conceived methods of drawing, which he called "optical geometry," that he had articulated in the early 1930s. This new combination of color and drawing created what he called "color-space." Although not contemporary with the formulation of the concept, Davis's clearest definition of the idea was expressed in 1957:

As far as the term "color-space" goes, it is simply a phrase I invented for myself in the observation and thought that every time you use a color you create a space relationship. It is impossible to put two colors together, even at random, without setting up a number

of other events. Both colors have a relative size: either they are the same size or they are not. And they are either the same shape or they are not the same shape. They also have, always and automatically, a positional relationship to some necessary, basic, coordinative referent. So the notion that thinking of color as a thing by itself seemed inadequate. For my own personal use I simply called the things that happen when you use two colors, and the process of drawing and painting, a color-space event.[12]

Davis's researches led him, in the spring of 1940, to create what he called a "Color-Field Space Cube" (see fig. 54), in which he depicted the advance and retreat of colors with respect to value change and relative warmth and coolness of hue. He desired, through the general theory of "color-space," to rationalize control of as many of the elements that affected the picture as possible, but he insisted that this discipline of color relationships be intuitively rather than technically practiced.

The first painting in which Davis utilized the newly crystallized color-space idea was *Report from Rockport* (cat. no. 123; figs. 55, 56), begun in March 1940—a picture in which there is an especially taut relationship between color and line and surface and depth that speaks for the dualism of flatness and illusionistic space that

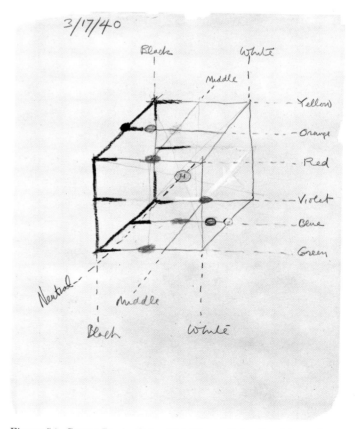

Figure 54. Stuart Davis. *Color-Field Space Cube.* Graphite and colored crayon on paper. March 17, 1940. Harvard University Art Museums, Fogg Art Museum, Cambridge, Massachusetts. Gift of Mrs. Stuart Davis

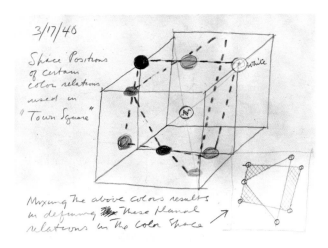

Figure 55. Stuart Davis. Color Relations Study for *Report from Rockport*. March 17, 1940. Graphite, colored crayon, and white chalk on paper. Harvard University Art Museums, Fogg Art Museum, Cambridge, Massachusetts. Gift of Mrs. Stuart Davis

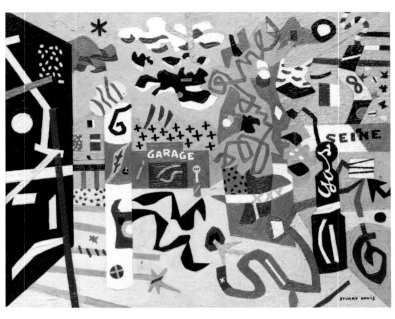

Figure 56. Stuart Davis. *Report from Rockport*. 1940. Oil on canvas. Edith and Milton Lowenthal Collection, New York (see cat. no. 123)

characterizes the best modernist paintings.[13] The subject is the town square of Rockport, Massachusetts, and, like another notable painting of 1940, *Hot Still-Scape for Six Colors—Seventh Avenue Style* (cat. no. 124), in it the artist combines a regional visual reference to the American scene with a sophisticated formal construction. Of the content of *Hot Still-Scape . . .* he wrote:

> [It was] the product of everyday experience in the new lights, speeds, and spaces of the American environment. And it is important to note that our environment includes modern art as a living element, as well as negro-boy hitching posts, white iron vases on green lawns, trotting horses, oyster houses, carriage wood carving and fitting, New England blue skies and waters, superhighways, the proportions of 100 story buildings, gasoline pumps, taxis, billboards, cigarette packages, garages, neon tubes, music through radio, motion picture juxtapositions, skywriting, etc. . . . My painting is the record of 100,000 impressions and experiences which include the paintings of Van Gogh and Picasso (fortunately a part of the American scene) as well as . . . schooners and dories, well kept and well painted homes, Indian pots and blankets, the honest landscape of New Mexico, and the civilized gadgets of the five and ten cent store.[14]

Davis's invention of a vernacular Cubism—his masterful synthesis of specifically American subject matter and European modernist style—represents not only the culmination of his artistic endeavors in the 1930s but also the highest contribution to the art of the period made by an American painter. Now, however, there were urgent, new issues alive in the dynamic cultural climate of New York, posing questions that were deeply provocative to

an artist such as Davis, who was accustomed to occupying a position of leadership.

Ultra-Marine and For Internal Use Only

In 1943, Davis predicted the end of European painting's oppressive hegemony, and alleged that America had freed itself from the shackles of this tradition.[15] He wrote, "The development of modern art in Europe is probably at an end. Indeed, its strength seems to have been sapped for some years past. During its regime it broke down traditional concepts of composition unsuited to contemporary expression. . . . But enormous changes are taking place which demand new forms, and it is up to artists living in America to find them."[16] He considered himself to be a leader in the vanguard that sought to forge a new formal vocabulary to transcend the venerable Synthetic Cubist style that was identified with Picasso.[17] *Report from Rockport* (cat. no. 123) displays an elaboration of decorative motifs and an emphasis on the constructive properties of color. This development accelerated during the next few years, in part under the influence of the Gestalt psychologists at The New School for Social Research in New York, where Davis had begun teaching in 1940.

Gestalt theories—which hold that the process of vision integrates significant structural patterns, and that images can be extensively abstracted and still retain their affiliation with reality—encouraged further abstraction in Davis's art. They also provided him with a

foundation for what he called "configuration theory,"[18] the goal of which was to create an allover pictorial scheme to which the response would be a complete experience rather than a sum of discrete reactions to the parts. This was a post-Cubist objective, and, in *Ultra-Marine* (cat. no. 132), Davis achieved the tenets of his "configuration theory." In this 1943 painting, the invented decorative vocabulary overwhelms the structure, and every detail is brought to near-equal visual intensity. Irregularly shaped and abruptly truncated color planes push with dynamic vigor against the edges of the canvas, colors collide everywhere on the pictorial surface, and flat planes refuse to open up into illusionary depth. Davis's 1940s style found support in the art of Fernand Léger and Joan Miró—especially in the abundance of pictorial incident that characterizes Miró's work—and, in a more general sense, in the paintings of Matisse, although the Cubist structural foundations of Davis's new style clearly persisted.

During the late 1930s, when varieties of geometric abstraction were gaining popularity among artists in New York, Davis had remained one of the most eloquent proponents of the tradition of realism in late Cubism. He represented the notion of an art based on observation of the natural world and then abstracted from those perceptions, as opposed to those artists who maintained that true abstract art could not be referential but must be the exclusive product of invented forms. Although, during the 1930s, Davis had argued persuasively that all subject matter must find its source in the natural world and common experience, his study of Piet Mondrian's writings during the early 1940s—particularly, of two statements published in 1942, "Toward the New Vision of Reality"

and "Pure Plastic Form"[19]—led Davis to significantly modify that position and helped him to rationalize the practice of inventing forms for his own increasingly abstract art. He summarized his position, contrasting present and past practice, in 1943:

> My early landscapes showed enthusiastic emotion about the color-texture-shape-form of associative entities such as sky, sea, rocks, figures, vegetation. The purpose was to make a record of things felt and seen so that the total associations of the moment could be experienced. Today I disassociate the painting experience from general experience and attain a universal objective statement that transcends the subjectively particular. The emotion is given an intellectual currency beyond time and place.[20]

Although *Ultra-Marine* (cat. no. 132)—the first of Davis's paintings to be composed exclusively of his new, abstract "art forms"—signaled his departure from subject abstractions such as *Report from Rockport* (cat. no. 123), he was still concerned with *Ultra-Marine*'s expressive effect. Correctly, he felt that, despite his efforts, the picture continued to allude to nature although it was the least referential of the three major paintings in his "park" series (which also includes *Arboretum by Flashbulb* [cat. no. 131] and *Ursine Park* [fig. 57], both of 1942). In order to counteract this effect and resolve the conflict between form and content, in his theoretical writings in the mid-1940s he committed himself to concentrate more rigorously on an agenda addressing formal problems, evolving a notion of the "neutrality of subject matter." Davis explained this concept, saying that his initial response to the stimulus of natural subject matter was not neutral because he was conscious of what he considered to be the irrelevant associational meanings generated by the sub-

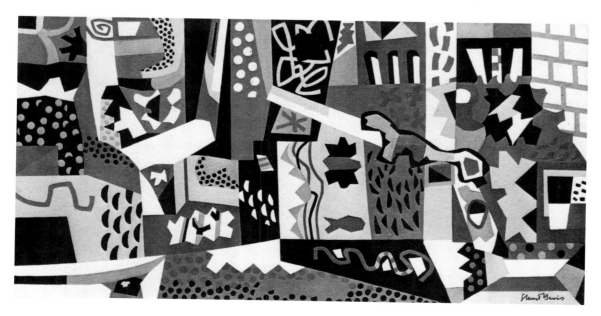

Figure 57. Stuart Davis. *Ursine Park*. 1942. Oil on canvas. Whereabouts unknown

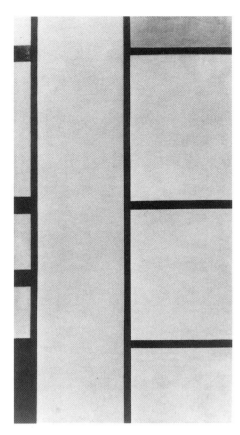

Figure 58. Piet Mondrian. *Composition.* 1935–42. Oil on canvas. Private collection

Figure 59. Piet Mondrian. *Broadway Boogie-Woogie.* 1942–43. Oil on canvas. The Museum of Modern Art, New York. Given anonymously

ject. He believed that this was a "non-art" reaction and that only through the act of painting were the emotions resulting from his perceptual experience neutralized by their transformation into "art forms" completely independent of the original subject.[21]

For Internal Use Only (cat. no. 134), painted in 1944–45, was the first major picture to be completed after *Ultra-Marine.* Davis seems to have borrowed from Mondrian the grid of two tall, black lines, and the vertical orientation that the Dutch artist had selected for his three so-called "Gothic" paintings, which were started in Europe and completed in New York in 1942 (see fig. 58). Davis also seems to have been inspired by the predominantly yellow *Broadway Boogie-Woogie* of 1942–43 (fig. 59), for he adopted its color-within-a-color blocks. When Emily and Burton Tremaine visited Davis in his studio in New York in the spring of 1945 to consider the purchase of *For Internal Use Only*, Mrs. Tremaine asked the artist if the picture had anything to do with Mondrian. Davis replied that it had been painted with the late master in mind and that the title had to do with his recollections of Mondrian and how he missed their experiences listening to jazz together. Davis pointed out that the picture contained the abstracted marquee of a New York jazz club and the abstracted piano keys, bow tie, and black face of one of Mondrian's favorite boogie-woogie pianists.[22] Besides being an homage to Mondrian, *For Internal Use Only* also illustrates Davis's continuing reservations about the limitations of the latter's formal means by contrasting them with his own rich vocabulary of abstracted forms, his allusions to the urban landscape's brick walls and signs, and his expansive palette of more than a dozen colors. In spite of the impact of Mondrian's ideas on Davis's own theories about abstraction, which led him to distance himself conceptually from natural subject matter, and even in the light of Mondrian's own statement that Davis was "the most abstract . . . of the young Americans,"[23] the fact is that in paintings as abstract as *Ultra-Marine* and *For Internal Use Only,* Davis's art still retains a vivid, readable relationship with the natural world.

The Mellow Pad

The central focus of Davis's work, in the second half of the decade, was *The Mellow Pad* (cat. no. 135; figs. 60, 61). Begun in earnest on June 11, 1945, and—after several campaigns resulting in a great many sketches in his notebooks, and a number of related smaller paintings—only completed in 1951, *The Mellow Pad* actually was

Figure 60. Stuart Davis. Study for *The Mellow Pad*. January 2, 1947. Ink on paper. Harvard University Art Museums, Fogg Art Museum, Cambridge, Massachusetts. Gift of Mrs. Stuart Davis

Figure 61. Stuart Davis. *The Mellow Pad.* 1945–51. Oil on canvas. Edith and Milton Lowenthal Collection, New York (see cat. no. 135)

first laid out in the summer of 1940 when the artist noted, "Drew in 26 × 42 House & St. (1931)," [24] citing the source for the picture's composition in one of his important paintings of the early 1930s. *House and Street* (cat. no. 92) depicts an abstracted stretch of a New York block seen from beneath a set of curves on the elevated rapid-transit line. A proliferation of embellishment disguises *The Mellow Pad*'s basic structure, but the underlying design and a number of details from *House and Street* may be discerned. In the later picture, Davis replaced the reference to the politician Alfred E. Smith in the 1931 composition with the new painting's title, THE MELLOW PAD. The brick wall that, in the 1931 work, adjoined the word SMITH remains in *The Mellow Pad*, as does an abstracted allusion to the two ladders and, in the right-hand section, hints of the glass-grid building located in the background of the earlier picture.

Among *The Mellow Pad*'s new elements are a number of inscriptions that impart aspects of the complex content of Davis's art of the late 1940s. The letters X, N, and an inverted C stand for the idea of "X and N relations," [25] the notion of neutrality of subject matter, and configuration theory, respectively. Their presence reveals Davis's invention of a powerful new way to reconcile form and content in his art by taking the subject matter for his paintings from his own theoretical ideas and creating an iconography in which his abstract-art-theory concepts are symbolized by concrete shapes, and the formal art ideas on which the work was based are represented visually on the surface of the painting. [26] The inscription

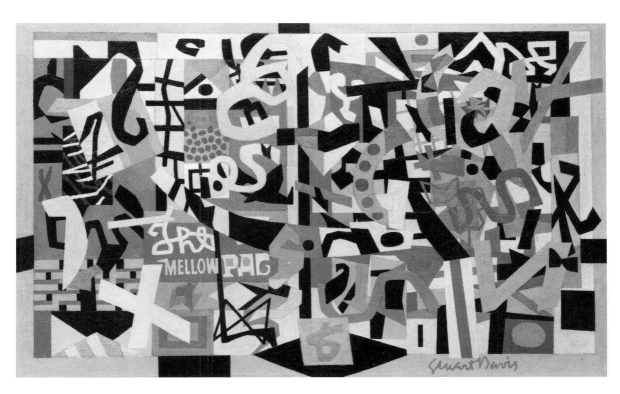

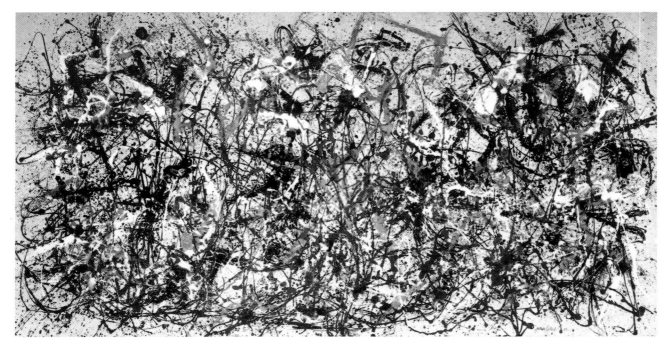

Figure 62. Jackson Pollock. *Autumn Rhythm*. 1950. Oil on canvas. The Metropolitan Museum of Art, New York. George A. Hearn Fund, 1957

The MELLOW PAD means a personal space with a mellifluous and genial emotional tenor in jazz jargon. Further indicating the painting's visual analogies to jazz, Davis noted on March 3, 1951, "Worked on Hell's Corners of Mellow Pad with terrific results in bringing consciousness of Logic onto the plane of the Topical Subject in a Psychosomatic Jazz Iconographic context. This day was probably the most powerful objective Art realization of my life."[27] *The Mellow Pad* declares Davis's deep involvement with jazz, widely accepted as perhaps America's most original cultural contribution and one that captured the vitality and sophistication of its modern urban life. This musical form paralleled Davis's own efforts to fuse modernist style with American subject matter into a new vernacular. He was too aware of the differences between the formal materials and expressive potential of art and those of music to try to achieve the same effects in paint as the jazz musicians did in sound. However, in *The Mellow Pad*—based on *House and Street* —the fact that floating forms of remarkable variety, signifying vibrant activity, dance atop the underlying structure of the preexisting composition's New York cityscape suggests parallels with improvisational jazz. Rather than attempting specific technical or procedural concordances, Davis instead incorporated verbal and iconographical references to jazz in his pictures. In a more general way, he shared with many jazz musicians a philosophy of artistic freedom that insisted on the artist's liberty to transform source material, emphasizing the

prime importance of innovative formal relations. This main concern was accompanied by his intention to express the vital condition of contemporary American city life.[28]

The enrichment of the surfaces of *Ultra-Marine, For Internal Use Only*, and *The Mellow Pad* overpowered the regularity of their underlying structures, causing Davis's art to seem to him liberated from late Cubism. While his work was not as loose as that of some of the younger painters of the New York School, whose art was informed by Surrealism, Davis remained in the stylistic vanguard until 1947, when Jackson Pollock's first drip paintings achieved the sought-after breakthrough from School of Paris conventions. The affinity between Davis's sources and ambitions and those of the developing Abstract Expressionists is unmistakable, as are, to a certain extent, the pictorial results of Pollock's allover painting and Davis's own configurational art. A drip canvas by Pollock (see fig. 62) and *The Mellow Pad* share such characteristics as edge-to-edge evenness; shallow, illusionistic depth; and emphatic surface. There are, however, very great differences between the large scale, limited color, and rapid, painterly handling in Pollock's work and Davis's exhaustive preparatory studies, traditional easel-sized canvases, elaborate palette, and careful application of relatively uniform and only moderately textured brushstrokes. Furthermore, Pollock abandoned the planes and grids of Cubism, freeing line and color from their traditional duties of defining shape and allowing

Figure 63. Fernand Léger. *The City*. 1919. Oil on canvas. Philadelphia Museum of Art. The Louise and Walter Arensberg Collection

them to function as autonomous pictorial elements. In contrast, Davis still prescribed a compositional structure like that of *The Mellow Pad*, in which a surface intricate with decorative sequences is superimposed on a grid provided by the simple underlying design of *House and Street*, producing a visual parallel to the artist's dictum, "Art is . . . a Dynamic Event, an Act. At the same time it is an Event within the Law."[29]

In contrast to such works as *Report from Rockport* and *Hot Still-Scape* . . . (cat. nos. 123, 124) from early in the decade, in which there is a kind of cheerful, almost naïve celebration of the American scene, *The Mellow Pad* shows the city the way Davis's Ashcan realist mentors Robert Henri and John Sloan had taught him to think about it forty years before—as gritty, complex, infinitely diverse, and unforgiving, yet vital, ripe with possibility, and the only place on earth one would wish to be. Davis had been an astute student of the greatest French Cubist paintings of a metropolis—specifically, of Léger's *The City* of 1919 (fig. 63)—and, employing the language of early-twentieth-century modernism, Davis brilliantly defined American urban life and the optical, philosophical, social, and psychological space it occupied. *The Mellow Pad* may be the best painting by a member of the second generation of American abstractionists, but the conditions it describes really had passed. To the emerging third generation of American modernists, the Abstract Expressionist artists, New York was no longer a place that could be accepted uncritically and art was not necessarily a positivist enterprise defining a more perfect world. They explored the psyche of modern man, and what they found in that subconscious interior mindscape was often not reassuring.

Retreat, No Surrender

In 1949, the dealer Samuel Kootz and the critic Harold Rosenberg organized an exhibition called "The Intrasubjectives," which included William Baziotes, Willem de Kooning, Arshile Gorky, Adolph Gottlieb, Hans Hofmann, Robert Motherwell, Jackson Pollock, Ad Reinhardt, Mark Rothko, Mark Tobey, and Bradley Walker Tomlin. Kootz wrote in the catalogue:

> We have had many fine artists who have been able to arrive at Abstraction through Cubism: Marin, Stuart Davis, Demuth, among others. They have been the pioneers in the revolt from the American tradition of Nationalism and of subservience to the object. Theirs has, in the main, been an objective art, as differentiated from the new painters' inwardness.
>
> The intrasubjective artist invents from personal experience, creates from an internal world rather than an external one.[30]

Rosenberg, who originated the term *Action Painting* to describe the work of the gestural abstractionists, and argued that the governing impulse for their painting was not a formal dialectic with late Cubism but existential anxiety, became a dominant voice in the critical discourse of the early 1950s, and was the source of the

Figure 64. Henri Matisse. *Cirque*: Plate II from *Jazz*. 1943. Painted and cut-paper collage, mounted on canvas. Executed in pochoir, 1947. The Metropolitan Museum of Art, New York. Gift of Lila Acheson Wallace, 1983

widely publicized ideas about Abstract Expressionism's subjective content that Davis found so odious.

Andrew C. Ritchie, curator at The Museum of Modern Art in New York, invited Davis to participate in a symposium held on February 5, 1951, in association with "Abstract Painting and Sculpture in America." That major exhibition included the full range of the abstract enterprise, and, because it placed Davis and other artists who favored subject abstraction or geometric abstraction into the same context with the Abstract Expressionists, Davis regarded the symposium as an important opportunity to draw the battle lines and speak out forcefully against an art he did not approve of. Conspiring with others of his generation who shared his artistic convictions (he was then fifty-nine), particularly George L. K. Morris and Ralston Crawford, Davis persuaded Ritchie to invite Morris also to be a panelist,[31] while working to influence the order of the speakers so that "the Intrasubjectives should not have the last word."[32] Davis put a great deal of effort into preparing his remarks, intending them as a kind of manifesto articulating his values in the face of the challenge of the younger Abstract Expressionists. The panel consisted of Ritchie, Davis, Morris, de Kooning, Alexander Calder, Fritz Glarner, and Motherwell. Davis reported, "A sell-out audience and very important occasion. My paper in support of Art as an Objective Art, an Absolute Art as against Subjective Art, regardless of Idism was enthusiastically rec'd and many people congratulated me on it."[33] Among his pointed comments were the following thoughts:

I think of Abstract Art in the same way I think of all Art, Past and Present. I see it as divided into two Major categories, Objective and Subjective. Objective Art is Absolute Art. Subjective Art is Illustration, or communication by Symbols, Replicas, and Oblique Emotional Passes.

. . . Its [Objective Art's] Universal Principle is the Sense of Freedom.

Subjective Art is a "Horse of Another Color," to use the current Bop phrase; as it refers to shots of "Horse," or Heroin, which come in different colors to suit the Esthetic Taste and Poetic Mood of the client.

. . . Over thirty years ago, Learned Proponents for Expressionism variously identified its Content as a "Psychic Discharge"; "Soul-Substance"; and a "Belch from the Unconscious," communicating the Distress of the Suffering Artist, as a sort of Moral Cathartic.

. . . Art is not a Subjective Expression to me, whether it be called Dadaism, Surrealism, Non-Objectivism, Abstractionism, or Intra-Subjectivism. But when paintings live up to these Advance Agent Press Releases, I turn on the Ball Game.[34]

While, in the early 1940s, Davis had some intellectual, professional, and social contacts with other vanguard artists, by late in the decade he had turned inward, and increasingly isolated himself from external influences.[35] In the 1920s and the 1930s, he invariably had allied himself with the most advanced tendencies in American culture, and his recorded statements at the time ring with faith in the future, but the position he took at The Museum of Modern Art's symposium in 1951 in opposition to Abstract Expressionism is articulated in the dismissive and defensive terms of a former progressive now finding himself a conservative. Typical of his responses that year to the younger New York School artists was, "Saw Ad Reinhardt's show at Parsons—very slight content. Also 1 Newman and 1 Rothko very elementary in Purpose. The one objectively positive thing in these people is the large size canvas which constitutes an idea in itself."[36] About the Gorky retrospective at the Whit-

ney Museum of American Art, he commented, "Talented, Endlessly Mimetic, Immature. Always a Pose and Grande Gesture. But has the merit of desire for the best and it was a good idea to hold the show. He was essentially a man without a country—no topical subject."[37]

In 1948, Davis had written: "Going to strange places and doing things is no longer meaningful because such places are sick from the materialistic world plague. It therefore becomes necessary to create one's own values through the Method and language of Art in which the given Subject-Logic is Neutral to the Esthetic creation."[38] Yet, his kind of self-examination was very different from the Abstract Expressionists' introspection, since it took the form of a nostalgic review of his artistic past —particularly, that of the late 1920s and early 1930s. As he wrote to Edith Halpert in 1953: "I am strictly a European (French, that is) man myself, altho forced by birth and circumstance to live in the American Art Desert as exile. And then of course the 'Europe' I mentally dwell in no longer exists in actuality."[39]

Trends in contemporary painting continued to move in directions Davis did not condone, and he no longer chose to renew his art by either a theoretical or a stylistic change of vocabulary based on a stimulating confrontation with current issues. This does not mean that he slipped into a state of quiet resignation; on the contrary, his continued vitality manifested itself in the form of a high-art decorative style and a spirited wit—a change in his art that occurred about 1950 and reflected a setting aside of many of the principles behind his ultimately unsuccessful pursuit in the 1940s of a formal syntax that would transcend late Cubism. Davis's new, fifties style is manifest in a painting based on a matchbook advertisement for Champion brand Little Giant spark plugs: *Visa* of 1951 (cat. no. 144). Taking inspiration, as he had numerous times earlier in his career, from commercial graphic design, probably looking at the 1940s work of Matisse (fig. 64),[40] and shifting his primary means of artistic expression from line to vibrant color, he achieved breadth and ease in *Visa* by relaxing the intensity of the formal inquiry that is so conspicuous in *The Mellow Pad*. The result in *Visa* is a pictorial space that is more akin to that of *Report from Rockport* and the Egg Beater series, in which stage-set-like elements define a shallow perspective.

Even if some of the passion that so fervently inhabits Davis's complex work of the 1940s is absent in this new painting, it is nonetheless more obviously directly engaged with popular culture. The artist noted, "Kootz, Greenberg, Barr, Janis, etc., represent Art Ideas which are oriented toward progress," but, he added, "I like popular art, Topical Ideas, and not High Culture or Modernistic Formalism. I care nothing for Abstract Art as such, but only as it evidences a contemporary language of vision suited to modern life."[41] The problem, however, was that the aspects of popular culture that Davis was interested in no longer helped trenchantly to define the current state, or to predict the future, of urban America. From the outset, Davis's art had been streetwise, and it was this embrace of the legacy of Baudelaire's call for a "painter of modern life," who captures the space and sensations of the city, that Davis took from Henri (rather than the Ashcan School's conservative style) and that served as an essential ingredient in his development as a modernist. Gradually, Davis became quite isolated and far more interested in his television set than in contacts with the progressive art world, and his paintings acquired a once-removed quality that in part comes from mediated experience rather than active participation. In their tone, his pictures seem out of step with the most progressive art of the 1950s and early 1960s because they are nostalgic and uncritically positive in their tone. With the emergence of the United States, in the postwar period, as the world's foremost political, economic, and cultural power, the attributes of complexity, ambiguity, sophistication, and moral compromise wrestled with simplicity, clarity, innocence, and integrity to define accurately the nature of America. The younger artists who most perceptively examined popular culture as a source for their art—Jasper Johns, Roy Lichtenstein, Claes Oldenburg, Robert Rauschenberg, and Andy Warhol—created work that reflected these ambivalences. While the Abstract Expressionists explored the mindscape of contemporary urban man and the Pop Artists looked unblinkingly at the city's offerings of visual banalities, Davis continued to depict the metropolis with a Machine Age modernity, vulgarity, and glamour that dated to the 1920s and 1930s, and existed then only in his recollections. Clement Greenberg, discussing Mark Tobey and Bradley Walker Tomlin, put his finger on the trouble with the late work of Davis: "The art that results does not show us enough of ourselves and of the kind of life we live in our cities, and therefore does not release enough of our feeling."[42] Davis was no longer telling us so much about ourselves, and his achievements after the 1940s—as good-looking as they are—remain, in the end, limited by his attachment to a prewar comprehension of American culture and a connection to the formal vocabulary that gave his 1954 painting *Colonial Cubism* (cat. no. 152) its name.

Notes

The preceding discussion has been developed from my broader study, *Stuart Davis: Art and Art Theory*, published in association with the exhibition of the same title organized by The Brooklyn Museum in 1978. That catalogue has been the principal source for my subsequent published writing on Davis. I am grateful to The Brooklyn Museum for permission to draw extensively on that text.

1 Stuart Davis Calendars, August 21, 1939. Archives of Earl Davis. The artist recorded meetings, social engagements, and quotidian events in some detail in these calendars, but his notation of milestones was very limited.

2 See Cecile Whiting, *Antifascism in American Art*. New Haven and London: Yale University Press, 1989, for a thorough study of the cultural politics of the 1930s and early 1940s that includes a detailed analysis of Davis's participation. Whiting's discussion of Davis in the 1930s, focusing on the Popular Front as it applies to his modernist art and democratic Socialist politics, is a valuable contribution to the Davis literature. However, while her description of Davis's change of political position about 1940 to that of "an anticommunist liberal rather than an independent Marxist" (p. 68) is accurate, her assertion that "he continued to develop a relationship between his art and the politics of antifascism throughout the Second World War" (p. 68) is not supported by the facts of Davis's public undertakings, his writings, or his art; nor is there evidence that either his art or his ideas about art and culture after 1940 reflect active political concerns. As Ad Reinhardt put it in his November 27, 1945, *New Masses* review of the Stuart Davis retrospective at New York's Museum of Modern Art, "[He] has always known the value of group activity . . . and was once conspicuous in the organized combating of Fascism, bigotry, narrow political and aesthetic ideas. His present political inactivity and his lack of relation to the artists' groups is regrettable for a painter of his integrity and stature." Whiting's analysis of the form and content of Davis's paintings of the 1940s, arrived at from a political perspective, is, in my view, essentially mistaken.

3 Roselle Davis Calendars, February 8, 1940. Archives of Earl Davis.

4 Interview with Roselle Davis, New York, December 1974.

5 Roselle Davis Calendars, April 5, 1940. Davis wrote a letter of resignation on April 5, along with a press release. The Artists' Congress accepted his resignation on April 11.

6 Stuart Davis, "A Medium of Two Dimensions," *Art Front* 1, 5 (May 1935), p. 6. Marxism was the primary political and intellectual stimulus for Davis, as it was for many artists in the Depression years. Reproached by respected voices on the Left, who criticized modernist artists for what was claimed to be their irrelevant concentration on the development of personal styles, their preoccupation with formal problems, and their shirking of responsibility for effecting social change, Davis developed an elaborate (and rather tortured) defense of the validity of abstract art as a vehicle for conveying meaningful social content. He was convinced that if modernists could be leaders in aesthetic matters, they could also be in the vanguard of social progress, which he defined in Marxist terms. He was never willing to compromise the formal values in his art. Rather, in his search for greater objectivity in the use of materials of expression, he frequently described the role of the modernist artist seeking to advance the art of painting in terms similar to that of a researcher pursuing the conquest of nature through science, both contributing to the knowledge of materialistic reality (Stuart Davis Papers, July 21, 1937. Harvard University Art Museums, Fogg Art Museum, Cambridge, Massachusetts).

7 Stuart Davis Papers, May 27, 1940, op. cit.

8 Ibid., June 2, 1940.

9 Stuart Davis, "Art in Painting," in *Marsden Hartley, Stuart Davis* (exhib. cat.). Cincinnati Modern Art Society, 1941, pp. 7–8.

10 Stuart Davis, "Abstract Art in the American Scene," *Parnassus* 13 (March 1941), p. 102.

11 On Morris, see Melinda A. Lorenz, *George L. K. Morris: Artist and Critic*. Ann Arbor, Michigan: UMI Research Press, 1982. For an excellent study of Clement Greenberg, see Robert Storr, "No Joy in Mudville: Greenberg's Modernism Then and Now," in *Modern Art and Popular Culture: Readings in High and Low*. Kirk Varnedoe and Adam Gopnik, eds. New York: The Museum of Modern Art and Harry N. Abrams, Inc., 1990, pp. 160–90.

12 Quoted in H. H. Arnason, *Stuart Davis* (exhib. cat.). Minneapolis: Walker Art Center, 1957, p. 44.

13 For a detailed, illustrated discussion of Davis's exploration of color theory, and a close formal analysis of its practice in the painting *Report from Rockport*, see John R. Lane, *Stuart Davis: Art and Art Theory*, op. cit., chapter 4; the development in the early 1930s of his drawing theory is discussed at length in chapter 2.

14 Stuart Davis Papers, September 2, 1940, op. cit.

15 Ibid., January 3, 1943.

16 Stuart Davis, "The Cube Root," *Artnews* 41, 18 (February 1–14, 1943), p. 34.

17 Stuart Davis Papers, January 7, 1943, op. cit.

18 For a detailed discussion of Davis's configuration theory, see John R. Lane, *Stuart Davis: Art and Art Theory*, op. cit., chapter 6.

19 Both of these essays are reprinted in Piet Mondrian, *Plastic Art and Pure Plastic Art*. Preface by Robert Motherwell; introduction by Harry Holtzman. New York: Wittenborn, 1945, pp. 10, 13–15.

20 Stuart Davis Papers, July 1943 [?], op. cit.

21 Ibid., July 7, 1947.

22 Telephone interview with Emily Hall Tremaine, September 9, 1977. Roselle Davis made a notation of the visit on May 29, 1945, commenting that the painting, wet and unfinished, had been bought by the Tremaines. Davis completed and signed it June 10, 1945 (Stuart Davis Calendars). According to Virginia Pitts Rembert's interview with Mrs. Tremaine, the club was Spec's Place ("Mondrian, America, and American Painting," Ph.D. diss., Columbia University, 1970, p. 307). *For Internal Use Only* is based on *G & W*, a small painting of 1944 (cat. nos. 133, 134). Mondrian died February 1, 1944—an event noted by Roselle Davis in the Stuart Davis Calendars. Davis was suffering from a knee injury sustained in a fall and could not attend the memorial services on February 3, but Roselle Davis went. (Davis had first met Mondrian at the residence of their mutual friend, the painter and writer Charmion von Wiegand, on May 22, 1941; they had little personal contact, next meeting on July 5, 1942, when Harry Holtzman took the Davises and Mondrian to the Paramount Theater and Billy's, a nightclub, to hear jazz; after the Dutch artist's death and at Holtzman's invitation, Davis went to see Mondrian's studio on April 3, 1944 [Stuart Davis Calendars].)

23 Jay Bradley, "Piet Mondrian 1872–1944: Greatest Dutch Painter of Our Time," *Knickerbocker Weekly* 3, 51 (1944), p. 16.

24 Stuart Davis Calendars, June 28, 1940.

25 "X and N relations" refers to Davis's compositional theory for establishing the topography of his paintings. The "X" (external) relations paralleled the natural environment only in the broadest terms, including perspective, color, and the relative size and position of shapes. The "N" (internal) relations corresponded to the more specific characteristics of perceived natural objects and spaces, such as tactile appearance, light and shade, particularized shape, and solidity (John R. Lane, *Stuart Davis: Art and Art Theory*, op. cit., p. 57).

26 The earliest indication that an iconography of Davis's art theory was being incorporated into his pictures is contained in a study for *The Mellow Pad* dated January 2, 1947 (Stuart Davis Papers, op. cit.), in which the words *neutral* and *Subject-Logic* appear. Lewis Kachur's Davis research has been gradually revealing the nature of the artist's interest in words. Davis mentions little specifically on the subject. He did attend a lecture on semantics by the popularizing linguist S. I. Hayakawa at The New School for Social Research in New York on April 22, 1947 (Stuart Davis Calendars). Davis was introduced to Hayakawa by Harry Holtzman, himself enthusiastically involved in semantics studies at the time and quite frequently in touch with Davis in the late 1940s.

27 Stuart Davis Calendars, March 3, 1951.

28 Davis noted on December 9, 1951 (Stuart Davis Calendars), that he had had a discussion with Bob Reisner and Marshall Sterns about a recent article by Reisner comparing modern art and jazz, and that he had taken Reisner a photo of *The Mellow Pad*. From the context, it is quite clear that Davis approved of what Reisner had written—an example of which follows:

The stimulating relationships within the two fields heighten the pleasure of each and both begin to make cultural sense to us, sense because they express an over-all picture of our age.

Here in the uninhibited outpourings of creative artists we find similar aims and attitudes, similar responses to a keyed up civilization. (By uninhibited outpourings we do not imply chaotic spewings or mere therapeutic emotional release, but an attempt to be free of the bonds of classicism and academism [sic], although complete freedom of formalized elements is impossible in any art form) (Robert George Reisner, "Writer Compares Modern Art and Jazz," *Downbeat*, November 16, 1951, p. 6).

29 Stuart Davis Papers, March 2, 1946, op. cit.

30 Samuel Kootz and Harold Rosenberg, *The Intrasubjectives* (exhib. cat.). New York: Samuel M. Kootz Gallery, 1949.

31 Stuart Davis Calendars, December 4, 1950.

32 Stuart Davis Calendars, January 22, 1951.

33 Stuart Davis Calendars, February 5, 1951. On March 9, Davis and Morris began organizing an April sequel to The Museum of Modern Art's forum and they got as far as lining up Holger Cahill to chair a panel consisting also of Dorothy Miller, Clyfford Still, Robert Motherwell, Josef Albers, and Ad Reinhardt. Davis revealed the agenda: "We agreed that the Forum should leave no doubt about Art as a direct continuity of thought about common experience today, as opposed to Mystical or Arty ideas" (Stuart Davis Calendars, March 22, 1951). Postponed until November to improve advance-publicity possibilities, the forum was never held.

34 Stuart Davis, "What Abstract Art Means to Me," *The Museum of Modern Art Bulletin* 18, 3 (Spring 1951).

35 In 1942, Davis was represented in "American and French Paintings," an exhibition organized by John Graham that included, among the younger artists, Willem de Kooning, Lee Krasner, and Jackson Pollock. The same year, Davis participated in a large show Samuel Kootz arranged for Macy's, as well as in "Masters of Abstract Art" at Helena Rubinstein's New Art Center. His work appeared in Howard Putzel's "67" Gallery exhibition, "40 American Moderns," in 1945. This was the last year that Davis exhibited with the "new" generation other than in large and generalized modernist shows, such as the 1951 "Abstract Painting and Sculpture in America" at The Museum of Modern Art in New York. Davis did not frequent Abstract Expressionist or expatriate Surrealist social circles in New York. (His position on Surrealism was determined in the 1930s, and he was unwavering in his conviction that the movement neglected the material world in favor of idle fantasy couched in the language of psychoanalysis and that its involvement with dreams and the unconscious was pathological, pessimistic, and reactionary [Stuart Davis Papers, 1936 (?), op. cit.].) Neither did he develop a relationship with Hans Hofmann. Gorky and Davis had drawn apart by the mid-1930s, and he and Graham had a falling-out in 1941. In his calendars Davis records talking with Pollock only twice—once on October 4, 1945, and again on January 16, 1951; this paucity of contact was typical as he was not socializing with any of the most progressive figures on the New York art scene any longer, and there are hardly any notations of meetings with Abstract Expressionist artists. During the 1940s, the Davises' closest friends were Holger Cahill and Dorothy Miller, Louis and Ann Guglielmi, George L. K. Morris and Suzy Frelinghuysen, Niles Spencer and Dorothy Dudley, and George Wettling. The Davises also saw quite a lot of Ralston Crawford, Robert Goldwater and Louise Bourgeois, Carl Holty, Harry Holtzman, Walter Quirt, and Charmion von Wiegand. There was occasional contact with Alfred H. Barr, Jr., Romare Bearden, Paul Burlin, Paul Gaulois, Henry Glintenkamp, Balcomb and Gertrude Greene, Edith Halpert, Samuel Kootz, Yasuo Kuniyoshi, Jacob Lawrence, Julian Levi, Edith and Milton Lowenthal, Loren MacIver, Romany Marie, Jan Matulka, Abraham Rattner, Meyer Schapiro, James Johnson Sweeney, and Edgard Varèse, among others.

36 Stuart Davis Calendars, June 7, 1951.

37 Stuart Davis Calendars, January 16, 1951.

38 Stuart Davis Papers, July 1948, op. cit.

39 Stuart Davis, in a letter to Edith Halpert, August 11, 1953. Edith Halpert Papers, Archives of American Art, Smithsonian Institution, Washington, D.C.

40 Davis generally can be counted on to reveal his sources somewhere in his writings, but there are—to the best of my knowledge—no specific references to Matisse's *Jazz* or to the cutouts. These Matisse works of the 1940s would, nevertheless, seem to provide the most significant external high-art precedent for Davis's late style.

41 Stuart Davis Papers, December 17, 1950, op. cit.

42 Clement Greenberg," The Present Prospects of American Painting and Sculpture," *Horizon* (October 1947), reprinted in John O'Brian, ed., *Clement Greenberg: The Collected Essays and Criticism*, Volume 2: *Arrogant Purpose, 1945–1949*. Chicago and London: University of Chicago Press, 1986, p. 166. A preference for long-held enthusiasms also pertains to Davis's other artistic interests: For instance, he named his son George Earl Davis after the pianist Earl Hines and the drummer George Wettling; both musicians found their sources in 1930s swing style, rather than in the hermetic, abstract, bebop style that defined the advanced practice of jazz in the 1940s and early 1950s and is generationally associated with the Beat poets and the Abstract Expressionist artists. Davis noted in his calendar on February 24, 1951, that hearing the swing trumpeter Roy Eldredge's records " makes all current Jazz trends sound Intrasubjective."

William C. Agee # Stuart Davis in the 1960s: "The Amazing Continuity"

The late paintings of Stuart Davis, dating from 1960 to his death in June 1964, have received relatively little attention—less perhaps than his work from any other period. This has been to Davis's detriment, for without considering the output of these years, we would overlook important aspects of his art and of his life. We would miss, for example, the full impact of the phenomenon that, earlier, he had termed "the Amazing Continuity"[1] —and which characterized his art throughout his career. Certain ideas and techniques that had absorbed him all his life were explored in the 1960s with a new freshness. His work of the last years, thought by many to be out of date, bears what may seem a distinct relevance to the newer art of the 1960s, even beyond its oft-noted relationship to Pop Art. Finally—and most importantly—to disregard Davis's late paintings is to ignore some of his greatest and most monumental achievements.

It is not surprising that we do not know well Davis's work of the 1960s, for until the occasion of the 1991–92 retrospective organized by The Metropolitan Museum of Art in New York, the late paintings have been viewed— or published—only once in any detail.[2] In addition, the brevity of the period, in the context of Davis's unusually long career, has made it appear unlikely that there would be anything from then worthy of study. "Late," in terms of Stuart Davis, has always been taken to mean his work after 1950, when he returned to a broad, planar Cubist style of high-keyed color.[3] While it cannot reasonably be said that Davis forged a new and unique style in the 1960s, the work does have specific qualities that distinguish it from that of the 1950s. In fact, it is a mark of Davis's career that, from the start, his style in each decade had its own distinctive characteristics and patterns —and the 1960s were no exception.

In the 1960s, Davis was no longer highly visible. Beset by ill health, which isolated him in his studio, he had one major show—the 1962 exhibition of recent work held at the Downtown Gallery in New York. Yet, while he remained the slow and laborious worker he had been since the 1940s, in retrospect we can see that he continued to move ahead, and that he was more active and more productive in the 1960s than the facts would indicate.

Davis himself was widely respected after 1950, but his art seemed somewhat passé and out of kilter with the painterly and expressionist efforts of the younger artists of the New York School. True, Davis's paintings—especially those of the 1920s—were regarded by some as a source for the emerging Pop Art. However, this only had the effect of further consigning him to the position of a historical figure—a kind of early-modernist novelty, rather than a living, working artist, whose painting had any relevance for that time. Because his perceived connection to the commercial images of Pop Art has persisted in diverting most of our attention, it is only now that we understand to what extent his art did, in fact, influence and partake of contemporary developments well beyond Pop Art.[4]

We have, for example, virtually failed to notice the great flowering of Cubist-based art that was produced during the early and mid-1960s. The resurgence of that seminal movement engaged Davis, Hans Hofmann, and David Smith, as well as Burgoyne Diller and the still little-known George L. K. Morris. The mature work of these artists constitutes one of the great achievements of modern art in the United States, and makes a study of Davis's late pictures obligatory, if for no other reason. Furthermore, Davis has been widely admired by two generations of younger artists, including Ray Parker, Donald Judd, Al Held, George Sugarman, David Novros, Paul Mogensen, and Mark di Suvero, to an extent that we can only now appreciate. As early as 1957, when Kenneth Noland and Al Held, among others, were seeking a

more stable, less painterly kind of art, Davis's work presented a prime example of a clear and open style that was abstract and contemporary. Davis's relevance for younger artists was soon stated eloquently by Donald Judd, then a critic for *Arts Magazine*, who, as much as anyone, recorded the emergence of a new aesthetic in the late 1950s and early 1960s. In his review of Davis's 1962 exhibition at the Downtown Gallery, Judd declared his admiration by stating that "there should be applause."[5] Judd's review bore visible and cogent witness to the esteem in which Davis and his late work were held, and underscored the importance of the color, scale, clarity, and power of Davis's painting as a precedent for the best new art of the 1960s. However, as these artists were not yet well known, their praise went largely unnoticed, and, sadly, Davis died before this recognition became more widely accepted. His reputation seemed to slip back into history, and, consequently, the late work has been considered hardly more than a quiet playing out of a long career, without real direction or focus.

In fact, Davis's late work is rich and complex—the decisive summary of a lifetime of art making. The 1960s paintings are marked by greater size, scale, and monumentality, and a reduced palette of ever more intense color. There is a new economy of means, with a starker clarity in the drawing and design, and, thus, a heightened sense of directness.[6] These qualities represented the culmination of a long search for a type of painting that would be an "autonomous sensate object" —a goal Davis first established for himself when he left Robert Henri's school in 1912.[7] These were the very aspects of his work that appealed to younger artists like Judd, and that helped both to define and to confirm the direction that their own art would follow.

Of course, these stylistic qualities did not appear overnight in 1960; their evolution can be traced to the 1950s, when Davis's work began to take on a new scope and a consistently larger format. Even before, his art bore a closer relation to that of the New York School than had been supposed. As early as 1940, Davis's paintings had displayed a pronounced, allover surface density, which is evident in two of his masterpieces, *Report from Rockport* and *Hot Still-Scape for Six Colors—Seventh Avenue Style* (cat. nos. 123, 124). These paintings foreshadowed and helped bring about the movement toward an allover style of painting developed in the early 1940s by Jackson Pollock, Arshile Gorky, and Willem de Kooning. Davis later rejected what he perceived as Pollock's unbridled flow of creative energy from the unconscious ("A Belch from the Unconscious") as the source of his art, in favor of a more calculated conception and his own geometric, hard-edged technique.[8] Yet, despite their obvious stylistic differences, Davis remained closer to more of the salient aspects of Abstract Expressionism than has been realized. In addition to creating an allover surface pattern, Davis began to increase the size and scale of his work in the early 1950s, paralleling one of the most important innovations of the New York School, while also embracing the power and directness of Abstract Expressionist drawing. In his small but incisive paintings *Town and Country*

Figure 65. Stuart Davis. *Town and Country*. 1959. Oil on canvas. Collection Aaron Fleischman, Washington, D.C.

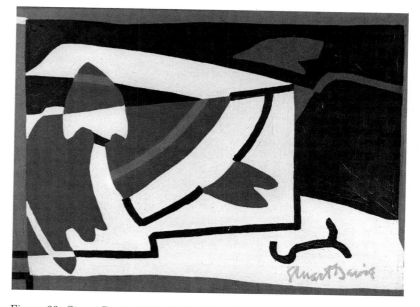

Figure 66. Stuart Davis. *White Walls*. 1959. Oil on canvas. Collection Mr. and Mrs. Irving Brown, Brooklyn, New York

and *White Walls* (figs. 65, 66), both of 1959, Davis's source was the drawn outlines of paintings by de Kooning and Franz Kline, respectively; he also made drawings after paintings by Mark Rothko and William Baziotes. Davis had always liked to draw, and enjoyed working in black and white. He equated drawing with painting, and, following Cézanne's dictum, he believed that to paint was to draw, and to draw was to paint.[9] In the 1950s and 1960s, Davis increasingly put a premium on large-scale drawing, which explains the emergence of the large, black-and-white painting/drawings that were previously—and erroneously—identified as unfinished studies. In fact, these were separate and independent works that in some cases actually postdate the versions in color.[10] Davis may have been influenced by the power of Picasso's 1912 Cubist drawings, which read as full-blown paintings. *Town and Country* and *White Walls*, as well as the densely impacted drawing in *The Paris Bit* of 1959 (cat. no. 162), may be seen as more studied and calculated equivalents of the linearity that characterized the works of Pollock, de Kooning, and Kline. The intensity, and density, of Davis's use of rich blacks and whites can also be interpreted as a rejoinder directed at the black-and-white paintings of Pollock, de Kooning, Kline, and Motherwell, which accounted for much of the best Abstract Expressionist painting.

For all of these reasons, *Ready to Wear* of 1955 (cat. no. 154), for example, seems perfectly at home installed among the Art Institute of Chicago's Abstract Expressionist paintings. Conversely, when *Semé* of 1953 (cat. no. 148) was hung with works by Charles Sheeler and other earlier American modernists in the pre-1945 gallery at The Metropolitan Museum of Art, the picture

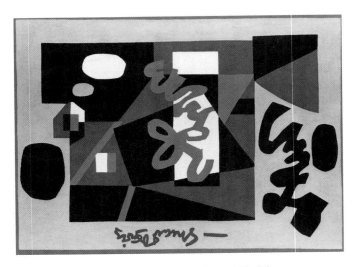

Figure 68. Stuart Davis. *General Studies*. 1962. Oil on canvas. Krannert Art Museum, University of Illinois, Champaign. Purchase

looked constricted and out of place; it clearly belonged in the contiguous—and simultaneously visible—gallery with the larger and more expansive paintings of Gorky, de Kooning, and Pollock.[11] In important ways, then, Davis's position in the 1950s established his relevance to the 1960s, for the size, scale, and power of Abstract Expressionist art were among the characteristics that Noland, Judd, Frank Stella, and others took as their starting point. There has been something of a perception that Davis's style remained static after 1950,[12] yet his art continued to evolve, and in the 1960s these qualities were intensified in his own work. Thus, he both learned from and in turn contributed to the new developments in the art of the 1950s and 1960s, continuing the pattern he had established early in his life: In the 1910s he had borrowed from and then added new elements to the realism practiced by the Ashcan School, and, in a similar fashion, in the 1920s and 1930s he expanded the range and vocabulary of Cubism in the United States.

It is not difficult to see in detail just how Davis's art relates to that of the 1960s. His color, for example, which was always strong and vibrant, became even more intense. In this regard, Judd singled out *Unfinished Business* (cat. no. 171), noting that in it the color was "hotter and therefore more dense," which for Judd meant that there was an additional degree of physicality to the picture.[13] Judd also noted that Davis was working on a consistently larger scale, as in *Standard Brand* of 1961 (cat. no. 163), which is 60 × 46 inches. From 1962 to 1964, Davis finished his largest easel paintings, *Contranuities* (fig. 97) and *Blips and Ifs* (cat. no. 164), which measure 68 × 50 inches and 71⅛ × 53⅛ inches, respectively. Because of their size and the sheer power of the color, these

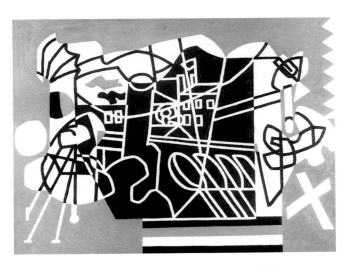

Figure 67. Stuart Davis. *Ways and Means*. 1960. Oil on canvas. Private collection

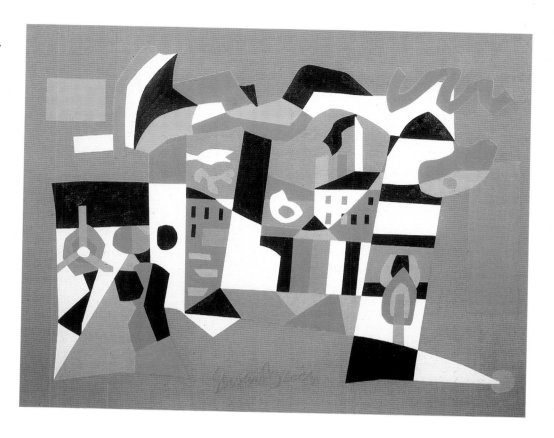

Figure 69. Stuart Davis. *Midi.* 1954.
Oil on canvas. Wadsworth Atheneum,
Hartford, Connecticut. The Henry
Schnakenberg Fund

paintings easily could have been considerably enlarged, to good effect. Judd understood this, and he suggested that Davis "should again increase the scale."[14] He reported that one visitor to the show thought Davis "should just write his name across a canvas billboard size."[15]

If Davis's palette became hotter, it also underwent a reduction, so that he never used more than five—and sometimes only four—hues in a single work. This perhaps stemmed, at least in part, from a conversation that he had on January 6, 1954, with the art historian Meyer Schapiro, whom he would consult on technical and art-historical matters. It was Schapiro who assured Davis that five hues would define any "complex of colors."[16] Throughout Davis's career, he enjoyed investigating all aspects of a type of painting, or of a technical or conceptual problem, often reversing or radically changing the precepts of a given picture in a later version. Thus, in the 1960s, as earlier, he could dazzle the viewer with high-keyed color, or else he could work with a dark, deliberately restricted palette. In *Schwitzki's Syntax* of 1961 (cat. no. 145), Davis limited himself to four hues—red, green, black, and white—in what we may read as an answer not only to the hot color of the 1960s, but also as an attempt to counter the florid tones of his two earlier versions of compositions featuring the word CHAMPION: *Little Giant Still Life* of 1950 and *Visa* of 1951 (cat. nos. 141, 144). Despite—or perhaps because of—this restriction, *Schwitzki's Syntax* does have a fullness and a depth to it

that are not found in the early versions, which are far more optical.

Another type of pictorial economy that appealed to 1960s taste was the broad, open planes of such paintings as *Standard Brand* (cat. no. 163). With this work, Davis had entered the last phase of his ever-evolving Cubist syntax, which had informed his art since 1921. (It is not enough to term Davis an "American Cubist," for his brand of Cubism and the art he produced significantly differed in each decade of his career.) Donald Judd remarked how words and letters make Davis's pictures less spatial and the forms more interlocked; the white "seemed negative, but was obviously positive."[17] The observation of this effect accounted in part for the qualities of unity and singleness that Judd sought in his own art. "It is all subtle and complex," Judd concluded.[18]

The art of Stuart Davis needs no justification or explanation outside of its own merits, so that any discussion would be meaningless if it did not illuminate the special qualities of that art. A closer look at its evolution in the 1960s demonstrates how the "Amazing Continuity" developed during Davis's fifty-five years as a painter. After 1940, he invariably reworked old themes, updating them in light of his current stylistic and conceptual concerns.[19] This practice began with the Art Space series (see cat. nos. 125–128), the first of the 1940s, which was based on the 1924 drawing in watercolor and crayon *Gloucester Harbor* (cat. no. 58). For Davis, if something was a good

idea twenty or even thirty years before, then it remained a good idea always.[20] He would hold to this same belief until his death, and it is reflected in the title of the 1963 work *Contranuities*: "against the new it is."[21] One of the apparent paradoxes that abound in Davis's art and in his life is that what seems so fresh and novel often has a long and detailed history of ongoing revisions. Yet, *Contranuities* was fresh and new despite its title, and even if the underlying design was not; for Davis, it was ultimately the quality of the art itself that carried the painting and made up its content.

Davis began the decade of the 1960s by recycling earlier subjects in *Ways and Means* of 1960 (fig. 67), *Schwitzki's Syntax* and *Anyside* of 1961 (cat. nos. 145, 165), and *General Studies* (fig. 68) and *Unfinished Business* (cat. no. 171) of 1962. The strong and expansive drawing evident in *Ways and Means*—a little-known painting—continued the linear network employed in *The Paris Bit* of 1959 (cat. no. 162), and paralleled the drawing style of the Abstract Expressionists with which Davis felt a kinship. *Ways and Means* recalls the strong graphic qualities of Davis's work of the early 1930s, and even brings to mind the searching, probing drawings of Henri Matisse—an artist closely identified with Davis since 1914, but always in relation to color. The immediate sources of Davis's 1960s pictures, however, were his own works—for example, *Composition No. 5* of about 1932–34 (cat. no. 107) and a somewhat modified version of it, *Midi*, of 1954 (fig. 69). *Composition No. 5* was one of the best of Davis's series of pivotal black-and-white ink paintings and drawings of 1932 in which pure drawing was raised to the level of full and independent painting. In these pictures

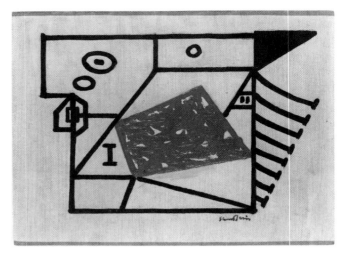

Figure 71. Stuart Davis. *Composition with Red Polygon.* 1932. Oil on canvas. Collection H. L. Bernard, New York

—both on paper and on canvas—Davis worked out his "angle theory," which was the basis of the linear, open Cubist format that was fundamental to his work thereafter.[22]

In the 1932–34 *Composition No. 5,* drawing predominates; in the 1954 painting *Midi*, color reigns supreme; and in *Ways and Means*, Davis united the two elements, achieving a remarkable synthesis. By thickening the black and the white lines, they became, simultaneously, color planes and shapes, as well. In later versions of the composition, Davis also reversed the original colors in places, so that what were once black lines became white ones, and what, in 1932, had been the white surface of the paper or canvas (in the center), in the 1960 painting became a dense black field. Here, the interchangeability of solid and void and positive and negative demonstrates how Davis, even at the end of his career, continued to find "ways and means" to invigorate his original but always evolving Cubist vocabulary.

Anyside of 1961 (cat. no. 165) was adapted from a 1956 gouache, *Water Street* (Private collection), which, in turn, may have been based on, or at least partly suggested by, the right side of the 1931 painting *House and Street* (cat. no. 92). The configuration of *House and Street* is not the same as that of *Anyside* and *Water Street*, but when the right and left sides of *House and Street* are reversed—and here the meaning of "anyside" is significant—the three pictures share similarities. *House and Street* was a seminal painting, and the source for *The Mellow Pad* of 1945–51 (cat. no. 135), as well as for the idea of the bipartite format that recurs in *For Internal Use Only* of 1944–45, *Deuce* of 1951–54, and in several of Davis's 1960s works, including *Fin (Last Painting)* (cat. nos. 134, 150, 175). *House and Street* presents a view of Lower Manhat-

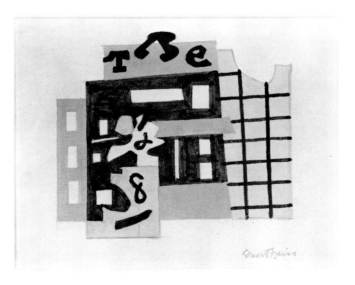

Figure 70. Stuart Davis. *Park Row.* 1953. Gouache on paper. Milwaukee Art Museum. Gift of Mr. and Mrs. Harry Lynde Bradley

tan, showing Front Street, which is close to Water Street. While not identical to these later works, *House and Street* certainly provided the source for the grids of buildings, as well as for the way in which the various elements of a street scene were condensed into a sequence of overlapping planes. The grid, an essential pictorial element in *House and Street*, also figures in the 1961 *Municipal* (cat. no. 166)—another urban scene, this one derived from the 1953 gouache *Park Row* (fig. 70). The use of the grid was an acknowledgment of Piet Mondrian, whose art Davis had admired since the early 1930s, and which was an especially important influence on Davis's works of the 1960s.

The large diagonal planes at either side of *Anyside* (which some have seen as recalling stage-set flats) lead the viewer into the picture—a device Davis first employed in the Paris paintings of 1928–29. These works usually—and erroneously—have been regarded as a sentimental interlude of no real importance for Davis's art, either at the time they were made or later.[23] Yet, they are highly accomplished and sophisticated paintings, the complexity of their Cubist syntax camouflaged—deliberately—by their romantic subject matter, which has been trivialized by the thousands of nostalgic "postcard" scenes churned out for the tourist by insignificant Sunday painters. Davis turned the inspiration of Paris into serious art of a high order, transforming the planar, geometric Cubist designs of the hermetic 1927–28 Egg Beater series (cat. nos. 65–76) into expansive urban views.[24] He had transformed the mundane before—and as early as 1911—when he developed stock, Ashcan School themes into fresh works of art, charged with high pictorial and psychological drama. In *Anyside*, it can be fairly said that Davis adapted the methodology of his comfortable, discreet views of Paris to the urban, industrial sprawl of Lower Manhattan—as filtered through his formal and iconographic concerns of the early 1960s.

The importance Davis placed on his 1932 black-and-white linear works was revealed once more when he returned to them as the sources for two major paintings of 1962, *General Studies* (fig. 68) and *Unfinished Business* (cat. no. 171). The 1932 oil *Composition with Red Polygon* (fig. 71) provided the design for *General Studies*, as it had for *Pad #4* of 1947 (cat. no. 139). In *General Studies*, Davis converted areas that had been entirely defined by line into crisp planes of bright color. The large element at the center of *Unfinished Business*, based roughly on an X, is first seen in a 1932 sketchbook drawing (Collection Earl Davis) and later in the central section of *Allée* (cat. no. 156), Davis's 1955 mural for Drake University in

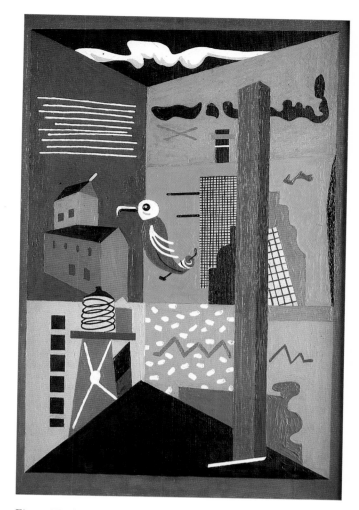

Figure 72. Stuart Davis. *Summer Twilight*. 1931. Oil on canvas. Montgomery Museum of Fine Arts, Montgomery, Alabama. The Blount Collection

Iowa. The continuity of this one element—seen in much of his work—clearly demonstrates that, for Davis, art making was an ongoing, cumulative exercise, never a finality but a continual process of thought and experimentation, of "unfinished business." In this instance, what had begun as an unremarkable, unassuming black-and-white drawing finally became a powerful "field" painting of intense hues, which, some thirty years later, fits in comfortably among the body of Davis's 1960s color abstractions.

The most dramatic re-use—and transformation—of an earlier theme may well be found in the 1963 *Contranuities* (fig. 97), for which Davis appropriated as his source a 1931 picture entitled *Summer Twilight* (fig. 72).[25] The latter is something of an odd picture—a mélange of what appear to be disparate elements from Gloucester, including a parrot and a building, arranged according to the methods of Surrealist juxtaposition, which captured Davis's attention at that time. Davis was not satisfied with the picture and revised it sometime before 1940—a practice that became common for him after

1952, when he reworked several of his small Cubist paintings dating to 1922. Davis transformed *Summer Twilight* into one of his most monumental, complex, and, hence, greatest paintings. First, the size and scale were enlarged dramatically, then the color and texture were made dense and rich, and surface incident was increased so that the design and the material are so alive as to seem almost to pulsate. The resulting *Contranuities* is not quite the largest of Davis's easel paintings, but because it is breathtaking in impact and scope, it reads as much larger than it is. It is so good and so strong that, if we did not know better, *Contranuities* conceivably could be the work of an artist half Davis's age, of another generation altogether. Davis took the daring step of changing *Summer Twilight* into an abstract painting by inverting it, so that in *Contranuities* we see it upside down. He had done this before, in 1955, when he used as the source for *Ready to Wear* and *Cliché* (cat. nos. 154, 155) a small, 1922 painting, which he first inverted and then reworked. Thus, once more in 1963, Davis held true to his earlier claim of 1927 that he was not an abstract artist, but, in fact, a painter of Realist pictures. Even when his art appears abstract and, at first glance, illegible, there is always a source—either a known site, or an earlier work—for its specific content. Often, the content is a composite of an actual scene and Davis's art theory, which served as the basis for re-exploring old themes. Therefore, Davis can be said to have achieved a paradigmatic style of painting: truly abstract, but with an actual, verifiable subject. It is precisely this phenomenon that captured the attention and respect of David Novros, then a very young but highly promising artist, and now one of our most accomplished abstract painters.[26]

Davis did not always have to reach as far back as the 1920s or 1930s to find works that could provide ongoing inspiration for him in the 1960s; he had only to look to the recent past—to 1956 and 1957—to find a suitable theme and format. Three of his best paintings of the 1960s incorporate elements of commercial packaging—which had been important to Davis since 1921—that reappeared in *Package Deal* of 1956 (see fig. 73) and in *Premiere* of 1957 (cat. no. 158), after their initial re-emergence in *Little Giant Still Life* and *Visa* of 1950 and 1951, respectively (see cat. nos. 141, 144). *Package Deal* had been prompted by *Fortune* magazine, which commissioned seven artists to create still-life paintings of ordinary products found in a supermarket. Davis's design—which he enlarged a year later in *Premiere*—was based on a four-part Cubist grid within which were located the words BAG, LARGE, *100%*, CAT, JUICE, NEW, Cow, and FREE,

all taken from labels and reordered in flat, emblematic planes. In two small gouache studies related to *Package Deal* (figs. 74, 75)—but probably done after it, not before—Davis focused in on, and enlarged, details of the pictorial field. In the first study, Davis concentrated on the lower center of *Package Deal*, so that CAT became the central element; in the second gouache study, he shifted the focus to the left section of the original painting, so that LARGE appears off center at the left, and CAT and NEW are cropped at the bottom and the right, respectively. In the large painting entitled *International Surface No. 1* of 1958–60 (cat. no. 159), Davis continued both the label and the package theme, as well as the process of enlarging and cropping the original design, by focusing on the lower right section and blowing up the words NEW, CAT, and *100%*. In addition, the high-pitched color of *Premiere* was toned down to a more reserved palette of green and red, with large areas of black and white.[27]

Davis's process of focusing on a specific area of an original source work and enlarging some of the words was radically expanded in his 1961 painting *Standard Brand*, and culminated in the monumental *Blips and Ifs* of 1963–64 (cat. nos. 163, 164)—the latter, one of Davis's final paintings, and certainly among the most powerful. In *Blips and Ifs*, Davis altered the words and their context significantly from their customary associations with consumer goods and the supermarket, with only *Pad* and *Any* remaining from the original composition. For his references, the artist had drawn upon the private worlds of his art theory, his art itself, and his life, but these were nevertheless presented in a format that calls to mind the large, blaring billboard evoked in *Premiere* (cat. no. 158), thus underscoring the fact that there can be no doubt that these two paintings should be viewed as part of the same series. Words had played a prominent role in Davis's work since 1912; in *Blips and Ifs* and *Standard Brand*, they carry the picture. ("Words are a form, an analogue, of physical architecture / Words have meaning in reference to objective forms and acts / Words can refer to a precedent form or they can create one," Davis noted, on October 27, 1960.[28] In *Standard Brand*, only three words—the vertical *Any* at the left, Pad, and COMPLET, aside from *Stuart* in the upper right corner—are enlarged enough to fill the painting, and are responsible for its impact. The same type of four-part Cubist grid as in *Premiere* is the basis for this work, but it was clarified and expanded to cover the full surface of the canvas.

Davis's focus on the words and the surfaces of his paintings was as intense as his focus on his life. The large, vertical *Any* had been present in many of his

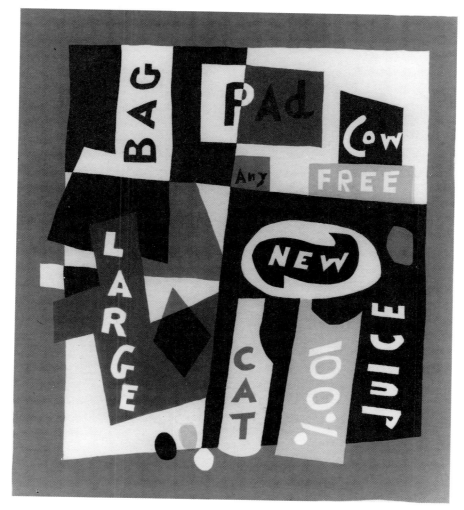

Figure 73. Stuart Davis. *Package Deal.* 1956. Gouache on paper. Private collection
(see also figs. 118–121)

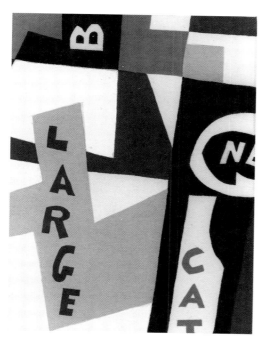

Figure 74. Stuart Davis. Detail Study No. 1 for
Package Deal. 1956. Gouache on paper. Collection
Leo S. Guthman, Chicago

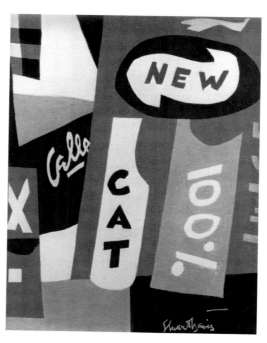

Figure 75. Stuart Davis. Detail Study No. 2 for
Package Deal. 1956. Gouache on paper. Private
collection, Washington, D.C.

Figure 76. Photograph clipped from *The New York Times* by Stuart Davis

Figure 77. Stuart Davis. Drawing for *Bois* (shown horizontally). 1960. Pencil on paper. Collection Earl Davis. Courtesy of Salander-O'Reilly Galleries, New York

Figure 78. Stuart Davis. *Bois*. 1960. Gouache on paper. Collection Jonas Aarons, South Orange, New Jersey

Figure 79. Stuart Davis. *Château*. 1960. Gouache on paper. Collection Ross S. Rapaport, Stamford, Connecticut

works, but never before had it been quite so prominent as in *Standard Brand*.[29] For Davis, it was a way to neutralize the obvious subject matter, to establish that "any" subject is as good as "any" other—that the meaning stems from the way the art is made. Davis was most comfortable in his "Pad" (as in *The Mellow Pad* of 1945–51) —namely, in the picture itself—and with the process of making art; the large COMPLET seems to announce that not only is the picture now full and complete, but so, also, is Davis's art and his very existence. This can be confirmed by the importance attached to his signature, although here he used only his first name, and it is all but illegible. To be sure, Davis had often made his signature an intrinsic structural element in his paintings after 1945, when it first appeared prominently in *For Internal Use Only* (cat. no. 134), but in his notes for April 26, May 6, and June 27, 1961,[30] he dwelled more specifically on the signature's function. He wrote movingly of how it was the symbol of completion, the "psycho-physical content of complet." Earlier, on March 25, 1961, he had noted that "Completion must be understood as the economical use of past accomplishment, not a redoing of it. Hence, signature is enough."[31] Thus, for Davis, the signature represented the act of completing a process, a painting, and, ultimately, with it a lifetime of making art.

In *Blips and Ifs*, Davis emphatically insisted on this message by bringing us literally face-to-face, by means of his own "zoom lens," with the radically enlarged compositional elements. (The typically wry Davis title refers to radar—a blip is a mark on the screen, and IFS are the intermediate frequencies of the radar's impulses—and it may be said his concentration on his art and on the

Figure 80. Stuart Davis. *Closed Circuit.* 1962. Casein on paper. Private collection. Courtesy of Barbara Mathes Gallery, New York

details of his life was as relentless as radar tracking its target.) We are pulled into the midst of this powerful, looming painting, which demands our attention. So unrelenting is the focus on the words that COMPLET is cut off in the middle of the L. Perhaps this is a premonition of how Davis's artistic activity and his life would be curtailed in the few months before his death—although he chose to assert his presence by placing his full signature prominently at the top of the canvas. *Blips and Ifs* is a truly inspiring painting, one of Davis's great accomplishments in the 1960s, both for its formal power and

beauty and for its significance as a most personal biographical statement. There should be applause, indeed.

Davis's late work, as one might guess, is full of other unsuspected surprises as well. Typically, just when we are sure that there are no freshly invented themes to be found in his paintings, Davis introduces a new one—as he did in 1960. For good measure, he established this new motif as a recurring thread throughout his work of the 1960s and, in fact, it was the basis of his last paintings. This final series—his largest—consists of more than twenty-five oil paintings, gouaches, and drawings, yet it has remained all but unnoticed. It was based on a small photograph of a view of the medieval town of Carcassonne in France (fig. 76) that Davis had clipped from *The New York Times.* The photograph is surprisingly unremarkable, showing a tree in the center and, past it, the crenellated walls of the town, with a turret at the left and two archways at the right. The clipping was found among Davis's papers, apparently without other documentation to explain just why he had been so attracted to it.[32]

A small pencil drawing, a study for *Bois* (fig. 77), probably from 1960, does provide some clues: The central element is a tree, which defines and anchors the space, and divides the picture in half. Davis had used a tree in a somewhat similar manner as the central image and a spatial divider as early as 1919 in *Autumn Landscape* (cat. no. 26) and again in 1921 in the series of Cubist landscapes, such as in *Tree* (cat. no. 36). These

Figure 81. Stuart Davis. *Terrace.* 1962. Oil on gesso panel. San Diego Museum of Art. Gift of Mr. and Mrs. Norton S. Walbridge

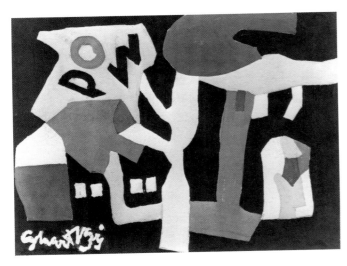

Figure 82. Stuart Davis. *Emblem*. 1963. Casein on paper.
Collection Mrs. Harold Diamond, New York

works, in turn, became prototypes for Davis's two-part pictures, which first emerged with the 1931 *House and Street*. This was followed by *For Internal Use Only* of 1945, *The Mellow Pad* of 1945–51, and *Deuce* of 1951–54. A like division of the composition also occurs in *Bois* and in *Château* (figs. 78, 79), both of 1960, and part of this last series; in the two versions of *Punch Card Flutter* (see cat. no. 174), as well as in *Closed Circuit* and *Terrace* (figs. 80, 81), all of 1962; in *On Location* (cat. no. 173) and *Emblem* (fig. 82) of 1963; and, finally, in *Fin* (*Last Painting*) of 1964 (cat. no. 175). The division of the composition seems to aid and abet two of Davis's cryptic aims, which he jotted down on that small pencil drawing (see fig. 77): "Method—Content—simultaneous" and "Disappearance of the Identification Image"; both com-

ments indicate Davis's desire to submerge the subject in the process of making the picture. By dividing a painting in half, Davis created, in a sense, two separate paintings, each of which becomes removed from the overall design and from the known and familiar image of the subject. This was one method Davis used to make a painting more abstract and to focus the spectator's attention on the process of art making as the content of the work.

More often in this series, however, Davis did not bisect the composition but utilized it to explore the possibilities of a free-flowing, cursive type of drawing, which could serve to counter, or set in relief, the pronounced rectilinearity of a painting's Cubist-based grid. This is apparent in *Anyside* and *Municipal* (cat. nos. 165, 166), and especially in *Standard Brand* and *Blips and Ifs* (cat. nos. 163, 164). A tree is frequently at the core of the drawing. Sometimes it is seen in full profile, as in *Punch Card Flutter*; at other times, as in *Twilight in Turkey* (fig. 83) and *Evening in Istanbul* (cat. no. 172), Davis might show an enlarged, close-up section of the tree and a wall. The scene depicted therefore is sometimes easily recognized, as in *Bois* and *Château*, or it can be condensed and camouflaged, as in *Terrace* and *Closed Circuit*. These paintings vary in size from small to full-scale canvases; some are dense and full, others loose and open, with the main image centered amidst empty expanses of the picture surface. As an example, Davis painted a full-color and a black-and-white version of *Punch Card Flutter*, to illustrate just how utterly different two paintings of the same composition could be.

In sum, we have the sense that Davis exercised a full

Figure 83. Stuart Davis. *Twilight in Turkey*. 1961.
Oil on canvas. Collection Earl Davis. Courtesy of
Salander-O'Reilly Galleries, New York

command over all aspects of the technique of drawing, which helps to explain his deep, lifelong admiration for the work of Georges Seurat (1859–1891). During Davis's last years, Seurat was his favorite artist.[33] However, Davis's esteem had little or nothing to do with Seurat's use of color, but centered on the French painter's skill in drawing and in rendering space. For Davis, Seurat's prime lesson was how areas of a painting could become synonymous with space, as opposed to the works of most artists, who, instead, defined the shapes and areas of a composition as merely existing in space. Davis's late paintings summarized a love of drawing that spanned a lifetime, as is evident in his earliest extant works—the drawings of Newark and its surroundings from the fall of 1909, when Davis had just begun to study with Robert Henri. In the black-and-white version of *Punch Card Flutter*, Davis's early faith in drawing reached its summit, and his confidence enabled him to realize a large-scale drawing in the form of a painting.

In 1961–62, Davis introduced another new theme into his work in a mini-series of three paintings, beginning with the 1961 *Graves End* (fig. 84). Its source is unclear, although the painting appears to depict a half-domed building at the right, which is joined to a wall at the left center. This configuration calls to mind Davis's 1928 gouache, painted in Paris, of the Institut de France (see fig. 85). In *Isle of Dogs* (Whereabouts unknown), also of 1961, Davis focused in on and enlarged the central section of the gouache and inverted his signature, thus transforming it into an abstract shape. The motifs in these paintings, in turn, were inverted, becoming the basis for one of Davis's major works, *Letter and His Ecol* of 1962 (cat. no. 168). The latter is among Davis's most enigmatic paintings, not only for its cryptic title, but also because of the nearly illegible word fragments in the balloon at the top center. Lewis Kachur has suggested that these truncated words may represent the first parts of *Institut* (at the top) and *École* (at the bottom)—an example of Davis's use of words as shapes and signifiers within a painting.[34] If the letters are, indeed, abbreviations of these French words, the 1928 gouache of the Institut de France becomes even more plausible as the possible source of *Graves End*, for the latter, too, appears to revive Davis's old connection with France.

As in many of Davis's late paintings, the strong and inventive color in *Letter and His Ecol* brings to mind that of Matisse. Davis had admired Matisse's work since the Armory Show in 1913. The influence of Matisse's use of color first became evident in Davis's work as early as 1914, and it would remain an inspiration throughout

Figure 84. Stuart Davis. *Graves End*. 1961. Oil on canvas. Collection Mr. and Mrs. Robert C. Levy, Chicago

Davis's career. It is not just the high pitch and intensity of Davis's palette that relates it to that of Matisse, important as these qualities are, but the sheer novelty of the hues and the inventiveness of Davis's placement of color areas are equally striking. In *Letter and His Ecol*, the passages of color are juxtaposed and locked together with a clarity and sureness of technique that recalls Matisse's famous tract on color construction, the *Notes of a Painter* of 1908.[35] Davis placed a color alongside another (here, he uses two primaries, red and yellow, and a secondary color, green, in concert with black and white) so that each is altered, in turn, by the position of the adjoining color area, until the surface is tightly knit into a mosaic of rich tones. "Letters LOCK Scale / Letters LOCK Color . . . ," Davis noted on February 5, 1962,[36] in reference to *General Studies* (fig. 68). The late work and its color embody the art of painting at its highest, and it is all the more brilliant because its wide range of chromatic effects is produced by only five hues. The verve of Davis's color and its handling is present throughout his oeuvre, often at the most unlikely points in his career—as in the series of little-seen gouaches of 1931–32, such as *Sand Cove* (cat. no. 96). Not until the concentric-circle paintings of Kenneth Noland, of 1958–62, do we encounter the same feel for and breadth of color.

The renewed intensity and boldness in Davis's use of color after 1950 suggest the influence of Matisse's late cutouts, which had attracted wide attention in this country when they were included in the retrospective of the French artist's work at The Museum of Modern Art in New York in November 1951.[37] Furthermore, besides the rich color, the way Davis's compositions are con-

Figure 85. Stuart Davis. *Institut National de France*. Gouache on paper. Private collection, Scarsdale, New York

structed, with each shape having its own, autonomous identity and position—as if placed *in* as well as *on* the canvas—also brings to mind Matisse's cutouts. It is an apparent contradiction in Davis's art that, while he chose to pursue a highly structured, hard-edged type of painting, he always retained his early love of painterly surfaces and textures. This has gone virtually unnoticed because it is not visible in printed reproductions of his work, but a careful examination of his art—and especially of the late paintings—consistently reveals a pronounced surface texture, with distinct brushwork patterns throughout, subtly granting every area of a canvas its own special character. This recalls the similar effect of the monumental, purist still-life paintings of Patrick Henry Bruce (1881–1936) of the 1920s.[38] By introducing texture, Davis gives the passages of color substantial body, increasing the overall materiality of his work and, thus, making it all the more memorable.

Davis also endowed black-and-white pictures with this same quality, as in the two versions of *Letter and His Ecol* (cat. nos. 169, 170). These two black-and-white paintings take his long-standing practice of creating different works from the same design even further. Davis altered the mood and feeling of each painting by varying the width and type of line, so that the touch of the brush and its relative emphasis become determining factors in the final effect. These paintings represent the culmination of Davis's long preoccupation with working exclusively in black and white, which can be legitimately traced to his earliest efforts—the drawings of 1909.

Given the course of the "Amazing Continuity" of Da-

vis's artistic production, it is not surprising that his final work, *Fin (Last Painting)* (cat. no. 175), is both a complex and a dramatic conclusion to his art and his life. It is his largest work, measuring 73 × 51 inches, and is not only powerful but compelling. As with *Contranuities* (fig. 97), at first its verticality appears to make it difficult to read, and it can even seem like an abstract compendium, but Davis was ever the realist—and, in fact, the painting was based on the horizontal motif of tree and walls at Carcassonne, here turned and presented as a vertical. This process of altering the orientation of a motif from one picture to another served to neutralize the subject matter—always a prime concern for Davis, as we have seen. He had employed the device in *G & W* of 1944 and in *For Internal Use Only* of 1945 (cat. nos. 133, 134), laying in the motif horizontally and then orienting each painting vertically so that the motif became less identifiable. In a still more radical vein, Davis completely inverted the source painting for *Contranuities*, as he had for *Ready to Wear*, *Cliché*, and *Letter and His Ecol* (cat. nos. 154, 155, 168).

Fin (Last Painting) was on Davis's easel at his death on June 24, 1964. It has always been regarded as unfinished, which no doubt is so, but perhaps not for the reasons generally assumed—namely, the presence of the masking tape. It is unfinished because, otherwise, Davis would have strengthened the painted areas with additional color. I believe that he intended to paint over the raw masking tape and to make it part of the completed picture. The configurations formed by the tape at the upper left and the lower right correspond to the divisions he drew in on the last of a series of small ink sketches (see fig. 86) for the painting. These divisions created a four-part grid, which corresponds to those in *Standard Brand* and *Blips and Ifs*; within the grids, Davis added elements that further defined the space, especially at the upper left, where an even more elaborate grid was introduced.

An important clue to Davis's intentions is provided by *Schwitzki's Syntax* (cat. no. 145), which contains a strip of masking tape, with a painted band through it, across its surface. This painting has also been considered unfinished—and it, too, may well be—not because of the tape, however, but because the paint application, especially at the bottom, is thin, and Davis typically would have created a richer surface. It is likely that he felt that the tape gave the painting a new, more material reality that made it more abstract and more of an "autonomous sensate object"[39]—the pictorial goal he had sought since his exposure to European modernism in

Figure 86. Stuart Davis. Study No. 3 for *Fin (Last Painting)*. 1964. Oil, casein, wax emulsion, and masking tape on canvas. Collection Earl Davis. Courtesy of Salander-O'Reilly Galleries, New York

1913 at the Armory Show. He must have meant for the masking tape to stay.

The tape also suggests another chapter in Davis's long-standing relationship to the art of Mondrian. That relationship, like Davis's connection with Abstract Expressionism, runs deeper than one might suppose. Not only could Davis not accept the art of Pollock and the unconscious; apparently he also rejected the work of Mondrian as too rigid and too polemical.[40] It is certainly true that Davis was another kind of artist, but, more importantly, he had a deep and abiding respect for Mondrian and his art. Davis particularly admired the Dutch painter for his integrity and uncompromising directness; his way of seeking the absolute and the irreducible in the painting and picture-making process; and for the concreteness of his art.[41] Mondrian had used colored tape to plan some of his last paintings, and it remained on the canvases after his death. Davis surely knew these paintings,[42] and he must have liked the hard-edged quality that the tape added to them. Consequently, Davis planned to use it in his own paintings—sparingly in *Schwitzki's Syntax* and extensively in *Fin (Last*

Painting). Davis had known of Mondrian since at least 1928, but there is no mention of him in Davis's writings until 1935, perhaps after he saw Mondrian's work at Albert E. Gallatin's Gallery of Living Art at New York University.[43] Thereafter, Mondrian's paintings were of major significance for Davis. In *G & W* and *For Internal Use Only*, he paid homage to Mondrian while simultaneously critiquing the Dutch artist by distorting Mondrian's use of the grid and by basing the internal elements in his pictures not on Mondrian's utopian concept of universal truth, but on two panels of a Sunday comic strip of Popeye and Wimpy from a New York newspaper.[44] The geometric design of Davis's 1955 mural *Allée* (cat. no. 156) clearly suggests the example of Mondrian, as does the upper portion of *Memo* of 1956 (cat. no. 120)—which may have been, in part, a prototype for the grid in *Municipal* of 1961 (cat. no. 166)—as well as Davis's preference for playing off black and white against two or three strong primary hues in a single painting.

Fin (Last Painting), in a very real sense then, picks up formal and thematic elements from *G & W* and *For Internal Use Only*. Its multi-part grid, for example, unmistakably calls to mind the late pictures of Mondrian painted in New York. Here, too, Davis made the grid "impure" by breaking it up at the lower right, and letting it intrude into the black border. Within this highly structured composition, he introduced intensely personal elements that would have been unthinkable to Mondrian.[45] Davis knew his life was almost at an end, and, as an acknowledgment of this, he added the word FIN—suggested by the end of a French movie he had seen on his ever-present television set—at the top left. For Davis, the end was not pleasant. He recorded his reaction with a painful OWH—as he had done, in a far different context, in the title of the 1951 picture *Owh! in San Pao* (cat. no. 146). Davis marked the completion of the design of the painting—and of his art and his life —by adding his nearly indecipherable signature at the upper left, and connecting it to FIN. Thus, while Mondrian addressed what he believed to be the universal, Davis interjected the most personal and painful autobiographical elements into his work.

The painting is, therefore, a fitting close to Davis's career: rich, compelling, and far more complex than one would suppose it to be from its outward appearance. Filled with an allusive network of difficult and private references, but still clear and powerful, it marked the end of a long life of art making by one of this century's greatest artists.

Notes

1 The phrase appeared in Davis's 1951 painting *Visa* (cat. no. 144). In a letter of November 3, 1952, to Alfred H. Barr, Jr. (reprinted in Diane Kelder, ed., *Stuart Davis*. New York, Washington, and London: Praeger, 1971, p. 100), Davis explained that "amazing" was the kind of painting he wanted to look at, and "continuity" was a "definition of the experience of seeing the same thing in many paintings of completely different subject matter and style."

2 In the exhibition "Stuart Davis: Motifs and Versions," held at the Salander-O'Reilly Galleries, New York, November 2–December 27, 1988. See also the catalogue with foreword by William C. Agee, introduction by Lawrence B. Salander.

3 See John R. Lane's seminal work *Stuart Davis: Art and Art Theory* (exhib. cat.). New York: The Brooklyn Museum, 1978, pp. 75 ff. The exhibition and Lane's catalogue have been the basis for all subsequent Davis studies. (I wish to acknowledge the importance of Jack Lane's work to my own research and thinking about Davis.)

4 Only Brian O'Doherty and Lewis Kachur have, to any degree, discussed Davis's significance for the 1960s. See Brian O'Doherty, "Stuart Davis: Colonial Cubism," in *American Masters: The Voice and the Myth in Modern Art*. New York: E. P. Dutton, 1982, pp. 47–95; and Lewis Kachur, "Stuart Davis: A Classicist Eclipsed," *Art International* 4 (Autumn 1988), pp. 17–21.

5 Donald Judd, "In the Galleries: Stuart Davis," *Arts Magazine* 36, 10 (September 1962), p. 44.

6 See Karen Wilkin, *Stuart Davis*. New York: Abbeville Press, 1987, pp. 203–7, where some of these qualities are outlined.

7 See Davis's comments in James Johnson Sweeney, *Stuart Davis* (exhib. cat.). New York: The Museum of Modern Art, 1945, p. 9.

8 Stuart Davis, "What Abstract Art Means to Me," *The Museum of Modern Art Bulletin* 18, 3 (Spring 1951), p. 15.

9 Davis's comments on drawing appear in much of his writing and fill numerous sketchbooks. Many of his most cogent remarks have been published by William C. Agee and Karen Wilkin in *Stuart Davis: Black and White* (exhib. cat.). New York: Salander-O'Reilly Galleries, 1985. However, some dates in that catalogue are now invalid due to documentary material subsequently released by Earl Davis after that exhibition.

10 See note 9, and also Davis's calendar entries. His writings prove that in several cases he undertook the black-and-white paintings after the color versions, and that they were sometimes conceived of as autonomous works.

11 Davis's paintings appeared strong in relation to these works in Henry Geldzahler's exhibition at The Metropolitan Museum of Art in New York, "New York Painting and Sculpture: 1940–1970."

12 See, for example, Lane, op. cit., pp. 75–83.

13 Judd, op. cit.

14 Ibid.

15 Ibid.

16 Stuart Davis Calendars. Collection Earl Davis.

17 Judd, op. cit.

18 Ibid.

19 Lane, op. cit., was the first to point out just how extensive this practice was.

20 Tape recording of a television interview with John Wingate, date uncertain (probably 1957), at the time of Davis's retrospective exhibition.

21 First pointed out by Lewis Kachur in a lecture at the Museum of the City of New York, January 1986.

22 See the artist's 1932 sketchbooks, and Stuart Davis Papers, 1932, reproduced in Lane, op. cit., pp. 23–25.

23 See, for example, Lane, op. cit., p. 21, and O'Doherty, op. cit., pp. 69–71.

24 Davis discussed precisely how the Paris pictures continued the structural ideas of the Egg Beater series in Sweeney, op. cit., pp. 17–18.

25 Kachur, 1986 lecture, op. cit.

26 David Novros, in conversations with this author from 1987 on.

27 The enlargement in *International Surface No. 1* was noted by H. H. Arnason in his important exhibition catalogue *Stuart Davis Memorial Exhibition*. Washington, D.C.: National Collection of Fine Arts, Smithsonian Institution, 1965, pp. 47–48.

28 Stuart Davis Papers, October 27, 1960. Harvard University Art Museums, Fogg Art Museum, Cambridge, Massachusetts.

29 See Lane, op. cit., pp. 65–67.

30 Stuart Davis Papers, April 26, May 6, and June 27, 1961, op. cit.

31 Ibid., March 25, 1961.

32 The photograph was discovered by the artist's son, Earl Davis, but there is no indication of what material may have accompanied the photograph.

33 Davis's admiration for Seurat appears throughout his notebooks of 1923 (microfilm, Collection Robert Hunter), and was expressed in an interview with William Homer shortly before Davis's death in 1964: see William Innes Homer, "Stuart Davis, 1894–1964: Last Interview," *Artnews* 63, 5 (September 1964), pp. 43, 56.

34 Kachur, 1986 lecture, op. cit. However, in the Stuart Davis Papers of 1962 and 1963, op. cit., the artist refers to the word *Ecology*, which in several places he shortened to *Ecol*.

35 Reprinted in Jack D. Flam, ed., *Matisse on Art*. New York: E. P. Dutton, 1978, pp. 35–40.

36 Stuart Davis Papers, February 5, 1962, op. cit.

37 On November 23, 1951, Davis recorded in his calendar that he saw the show.

38 There is no evidence that Davis knew Bruce, but Davis was in Paris in 1928–29, while Bruce was living there. See William C. Agee and Barbara Rose, *Patrick Henry Bruce, American Modernist: A Catalogue Raisonné*. New York and Houston: The Museum of Modern Art and The Museum of Fine Arts, 1979.

39 See note 7.

40 Stuart Davis Papers, October 5, 1943, op. cit.

41 Ibid.

42 Davis frequently visited the Sidney Janis Gallery in New York, where Mondrian's work was often shown. For example, in his calendar for November 21, 1953, Davis noted that he saw the exhibition "50 Years of Piet Mondrian."

43 See Stuart Davis, "Memo on Mondrian," *Arts Yearbook* 4 (1961), pp. 66–68.

44 Mrs. Burton Tremaine, the former owner of the painting, told Lane (op. cit., pp. 52–53) that Davis had said the picture contained abstracted piano keys, a bow tie, a black face, and an abstracted marquee of a New York jazz club. However, a photograph found among Davis's papers shows that he worked from a Sunday comic strip of Popeye and Wimpy, from which the composition derives exactly, in a schematic fashion.

45 However, a recent article shows that Mondrian was interested in Walt Disney's *Snow White*. See Els Hoek, "Mondrian in Disneyland," *Art in America* 77, 2 (February 1989), pp. 136, 143, 181. I am grateful to Michelle White, a graduate student at Hunter College in New York, for calling this to my attention.

Lewis Kachur **Stuart Davis's Word-Pictures**

During the latter phase of Stuart Davis's career, the formalist school of art criticism was ascendant, and its exponents saw each of the arts tending to self-definition, toward "the irreducible working essence of art and of the separate arts," in Clement Greenberg's view. For these critics and their supporters, the essential issue in pictorial art proved to be "flatness and the delimitation of flatness."[1] Thus, theatrical or literary concerns were considered extraneous to the rigorous essence of painting.

Stuart Davis, however, had already worked through these issues as a young artist in the 1920s. Contrary to the practice of formalist artists, Davis increasingly incorporated words and linguistic associations in his works from 1949 on. Not surprisingly, therefore, as the hegemony of formalist criticism consolidated, Davis's reputation waned, and his ambition to combine language and image in art has remained largely unrecognized. With hindsight, we now realize that Davis's word-pictures are unique among his generation of American artists, separating him first from his Ashcan School contemporaries, then from the Stieglitz group of American modernists, and, finally, from the emergent New York School of the postwar era. This was neither a monolithic development nor a consistent one on his part, yet it became a vital basis for the unique quality of his ultimate artistic achievement. Since John R. Lane published his pioneering study on Davis in 1978, we know that the dialogue of word and image in Davis's oeuvre was buttressed by a massive quantity of theoretical writings—perhaps the aspect of Davis's artistic legacy that is of greatest relevance and interest to the growing ranks of art-and-language artists today.

Davis's "art-theory papers" are integrally tied to the peregrinations of words in his pictures. Indeed, his earliest preserved writings date from just before his first important word-pictures: the Tobacco paintings of 1921. In the earliest preserved notebook, Davis bravely asserted, "As in Apollinaire poetry encroaches on painting, so let painting encroach on poetry. . . . The hint of 'Journal' in cubism should be carried on."[2] This forward-looking ambition was one that, initially, Davis was able to live up to only sporadically. He also recognized that to "use literature as well as visualization" would fall outside the boundaries of traditional fine art, yet he deliberately decided not to limit himself to the "problems of painting as such." Instead, he vowed, "where words or a word is necessary, they will be used."[3] Thus began five decades of melding word and image. Writing, or calligraphy, bridged the sister arts, and suggested that painting and language functioned analogously as systems: "Script in writing, the free sequence of written letters is the equivalent of the visualization and drawing of a shape."[4]

Davis's landmark Tobacco pictures boldly explored a variety of contemporary typographies. A comparison with the cigarette packaging and advertising of the time indicates how far Davis's art was from true trompe l'oeil. As a smoker, he was keenly aware of the sleekness of the new, mass-market advertising graphics and, for instance, of the richness of the Lucky Strike package's deep red-and-green hues. *Sweet Caporal* of 1922 (fig. 88) is a prime example of how Davis suggested current graphics while abstracting their specific images. In terms of lettering, the elegantly scripted K and B are prominent elements in the picture, but only when we examine contemporary cigarette packs (see fig. 87) do we realize that Davis distilled the typography quite directly from the manufacturer's name, Kinney Bros., as it appears on the wrappers. So, too, the multicolored, stitched pattern at the upper left of *Sweet Caporal* is a stylized setting

Figure 87. Sweet Caporal cigarette packs. The Metropolitan Museum of Art, New York. Burdick Collection

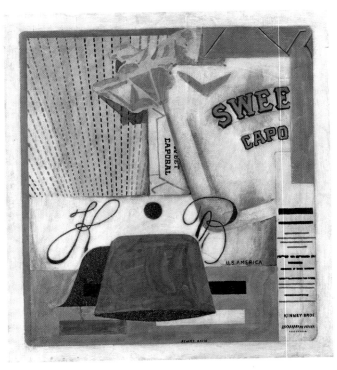

Figure 88. Stuart Davis. *Sweet Caporal*. 1922. Oil and watercolor on canvas board. Thyssen-Bornemisza Collection, Lugano

sun, while the red, bell-like shape in the foreground derives from the fez on the actual pack. In a similar way, the blue bands—one with a "false" 1910 date—in *Lucky Strike* (cat. no. 32) are adaptations of the tobacco-tax stamps, bearing the year of the relevant legislation, affixed to cigarette packs.

Davis thought of smoking in a historical context, writing of the advance of individual packaging over the bulk barrels of tobacco of the previous century as "the nature of the present days." This new, urban "nature" included "photographs and advertisements, Tobacco cans and bags and tomatoe [*sic*] can labels."[5] Besides anticipating Andy Warhol's Campbell's soup paintings, this attitude also led Davis to an important blending of low culture and fine art—a self-avowed consolidation of "the popular picture."[6] Too close to advertising and design sources to be "pure" fine art, but too fragmentary and abstracted for commercial posters or trompe l'oeil—yet with elements of each—these hybrid pictures resist easy categorization.

Although Davis produced only a handful of Tobacco pictures, the advertising logo became part of his visual vocabulary, which he would continue to exploit. Later works that include trademarks, such as the iconic *Odol* of 1924 (cat. no. 56) or the compositions containing the word *Champion*—from a brand of spark plugs Davis saw advertised on a matchbook as late as 1949—are among some of the artist's most impressive images. Thus, he far

surpassed his Ashcan School origins, for in those earlier works words and signs functioned merely as an aspect of the urban streetscape rather than as independent elements in the composition.

One notable exception is *Garage* of 1917 (cat. no. 22), essentially an Ashcan word-picture and therefore, as Karen Wilkin notes, particularly prophetic.[7] Spatially, it is quite shallow, as if Davis wished to suggest the flatness and clarity of the printed page. This canvas would prove to be especially significant for, the following year, Davis appropriated part of *Garage* as the major typographic element in *Multiple Views* (cat. no. 23).

Concurrent with the Tobacco paintings, Davis produced a large-scale wall decoration for the Nut Shop in Newark owned by his friend the artist Gar Sparks (see fig. 89). Although the final result is more aptly regarded as advertising rather than fine art, this environmental "mural" was a new experience for the painter. No imagery appears on the store's four walls, only "letters of every color, letters of every shape and size, looking at first like a pied form in a lunatic's print shop." Oversaturated by innovative typography as we now are, it is difficult to appreciate just how radical this "weirdness of alphabet," as it was described in one journalist's report, seemed at the time.[8]

The effect of the Newark wall-painting experience gradually filtered into Davis's work. In an early note-

Figure 89. Soda fountain in Gar Sparks's Nut Shop, Newark, New Jersey, showing Stuart Davis's first public wall decoration (1921; now destroyed). Photograph courtesy of Earl Davis

book, he planned his first true word-picture (see fig. 90): the capital letters GAR isolated on "a beautiful background of cream-colored stucco. Some handsome clapboards painted yellow...."[9] The first three letters of *garage* make a nice pun on the unusual name of Davis's patron-friend. Yet, in the sketch as executed, the word is shortened to GA, evoking still a third possible interpretation: the initials of the French poet Guillaume Apollinaire, whose *Calligrammes* are referred to in the same notebook in which this drawing appears. If the allusion to Apollinaire is valid, it would be appropriate, since his innovative image-poems were regarded by Davis as exemplars of a new, hybrid form of expression somewhere between art and language. Although apparently never realized, the "GAR" project heralds the full-blown development of the word-picture in Davis's oeuvre in the late 1940s.

In pursuit of Gallic culture, Davis first immersed himself in the French language during his trip to Paris, Apollinaire's city, in 1928. In his Paris paintings, Davis in many ways reverted to the Ashcan approach to the urban scene, only now grafted onto an unreal, planar space. The words in the Paris works are in basic French and, in some cases—particularly, in *Rue Lipp* (cat. no. 79)—begin to take on a life of their own. This title, too, is more literary than literal, for no such street exists; it refers, instead, to

Figure 90. Stuart Davis. *"GAR."* 1922. Ink on paper. Stuart Davis Notebook: 1920–22. Private collection

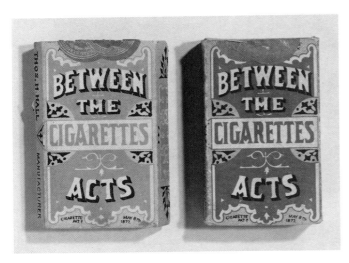

Figure 91. Between the Acts cigarette packs. The Metropolitan Museum of Art, New York. Burdick Collection

the well-known Brasserie Lipp, on the Left Bank, frequented by artists and writers. In *Rue Lipp*, Davis also incorporated into the streetscape a personal, biographical allusion, via the poster at the right, to the poems of his friend the writer Bob Brown, who would soon visit Paris. Brown's "optical poems," published in his *1450–1950*, were lighthearted extensions of Apollinaire's *Calligrammes*, and re-ignited Davis's interest in the verbal-visual nexus. Davis unleashed his first visual pun in *Rue Lipp*—the top hat within the beer mug on the table that he labeled *biére hatt* [sic] lest the viewer miss the double image.[10] Davis would eliminate the words and express this pun solely in terms of color in the 1959 variant on this painting entitled *The Paris Bit* (cat. no. 162). This odd juxtaposition of images is primarily significant as a type: an attempt to transpose a purely literary device (the pun) into visual form.

After his return to New York, Davis would allude to Paris in his correspondence with Brown, recalling their beer-drinking bouts at the Brasserie Lipp,[11] and his New York paintings, such as *The Barber Shop* (1930; fig. 114), would take on something of the quality of Parisian streetscapes, the Parisian *tabac* even transformed into a cigar store, replete with several varieties, including LeRoy and Garcia Grande. The cropped poster at the right in *The Barber Shop*, captioned BETWEEN THE ACTS, at first glance seems to be an internal reference to the composition's empty, stage-like space, but is, in fact, the brand name of cigarettes and cigars as well (see fig. 91). When Davis painted a second version of *The Barber Shop* in 1941, *New York under Gaslight* (cat. no. 129), the inclusion of words was meant to heighten the conceptualized unreality of the image. Thus, Davis went beyond

what could be viewed as recognizable street typography, although his wit has worn rather thin here. Most interestingly, in *New York under Gaslight* he eliminated the words BETWEEN THE ACTS, perhaps because they had recently gained quite a different association as the title of Virginia Woolf's last novel, and replaced them with a self-referential sign underscoring the fact that the image is an illusion. The use of non-referential language, even if strained, here attains a new level, and the poster alluding to gin and jazz interjects other personal enthusiasms of the artist into a densely "inscribed" image.

If Davis was intrigued by the poetry of Apollinaire, or even "the thing that Whitman felt," the vernacular, too, became a recurrent strain in his literary preoccupations. The painting *Magazine and Cigar* (fig. 92), like Davis's mural for the Radio City Music Hall men's lounge (cat. no. 100)—which also focused on masculine pastimes—introduces the detective story into his range of subjects. Such pulp fiction was becoming a popular staple at the time, and was also turned out by another of Davis's writer-friends, Elliot Paul. Perhaps in connection with the controversy in the art world over what constituted the "American Scene," Davis turned increasingly to his version of Americana, including popular culture. It is likely that no other painting is more polemical in this regard than the suggestively titled *American Painting* of 1932–51 (cat. no. 104).

American Painting was a major effort for Davis, created specifically for a historic occasion—the first biennial exhibition of contemporary American painting at the newly opened Whitney Museum of American Art in New York. The work practically jumps out of the pages of the plates section of the Whitney catalogue, which is clogged with conservative, Realist art. This clean-lined and schematic composition was a conscious attempt to telegraph what American painting could or should be in 1932—hence its title. Davis was not alone in this aim: Consider, for instance, Charles Sheeler's *Americana* (1931; Edith and Milton Lowenthal Collection, New York), an even cleaner-lined, photographic version of modernism, exhibited in the same premier Whitney Biennial. For Sheeler, Shaker furniture was emblematic of a quintessentially pure American cultural product, as jazz was for Davis. Thomas Hart Benton's *America Today* murals (1930–31; formerly The New School for Social Research, New York) were another contemporary bid for the distillation of native experience, as was the coloration of Georgia O'Keeffe's *Cow Skull: Red, White and Blue* (1931; The Metropolitan Museum of Art, New York).

100

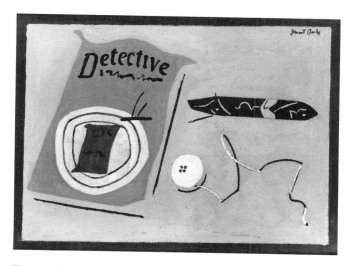

Figure 92. Stuart Davis. *Magazine and Cigar*. 1931. Oil on canvas. Richard York Gallery, New York

In this context, one would expect a work entitled *American Painting* (fig. 111) to manifest a similar definition of native art. Indeed, the couplet at the left edge of the canvas, "*It dont mean a thing / If it aint got that swing*," does so. This Duke Ellington lyric is clearly analogized to the fine-art realm, which should "swing" with the bounce and rhythm of popular music. Specifically, Davis had a lifelong regard for jazz, considering it an authentic American art form that could appropriately grant a parallel authenticity to painting. "Real jazz, that is to say Jazz as an Art, is characterized by complete freedom in its expression."[12] A post-Lindbergh, Prohibition America plagued by gangsterism may also be the source of the outlined, inconsistently scaled airplane and the hand with a pistol in the composition, but this does not account for the atypical presence of figures in a Davis painting. Perhaps the artist aimed for ambiguity and a rather surreal sense of juxtaposition.[13]

The phrase LITTLE JOE on the fuselage of the airplane does provide a visual and conceptual center for a number of the disparate elements in the picture. In American slang, the expression refers to the number four in the game of dice.[14] Thus, the four dots next to the phrase become one face of a die—another optical pun recalling the beer/hat of *Rue Lipp*. "Fourness" extends as well to the unusual group of standing males behind the airplane. Could they be schematic allusions to those Davis felt would lead American painting forward?

Certainly, the men have never been identified, yet the images could still refer to a loose artistic alliance of Davis, John Graham, and Arshile Gorky, who were known as "The Three Musketeers."[15] One artist who recalled this group, Willem de Kooning, may himself be the

fourth "Musketeer"; Jan Matulka is another possibility.[16] Such an alliance would be analogous to the three musketeers in the Alexandre Dumas novel who are joined by a fourth swashbuckler. Two sketchbook drawings of 1932, identifiable as heads seen in front of cityscapes, tend to support this interpretation.[17] More portrait-like than the gang of four in *American Painting*, one can be identified as Gorky and the other as a self-portrait. These drawings were not published until after the artist's death; Davis undoubtedly turned away from their specificity in the final canvas, which was earmarked as a more public work.

An indication of the import of *American Painting* in Davis's oeuvre is its later overpainting. Davis often redid compositions—indeed, theme and variation are the core of the late paintings—but *American Painting* is the unique canvas that was taken up again and reworked after being finished and publicly exhibited. As such, it is an unequaled palimpsest of Davis's shifting concerns, from the 1930s to the 1950s. Davis's notes on art theory reveal that he was very busy in the fall of 1948 revising the composition of *American Painting*. He does not write directly of his intentions, but he did make an exceptional number of studies for the picture—seventeen within the three-week period from September 10 to 30, 1948—followed by a few sporadic sketches in subsequent months, into 1949. It is clear from these studies that September 1948 was the major period in Davis's rethinking and reworking of the earlier canvas. The writings accompanying these sketches speak of the neutralization of the "subject cliché": "The C[olor]-Art concept makes all subject matter immediately available by neutralizing it."[18] Nonetheless, there remains a "continuity of subject meaning," even after changes are made: "Such ideological sequences contain repudiations and erasures of themselves as part of their continuity."[19] Just what aspect of the subject is "erased" by Davis's addition of the word *Eraser* in the center has not been posited. The death of his old friend Arshile Gorky on July 21, 1948, surely prodded Davis to think about what American painting had been in the thirties, and soon after (in September) sent him back to *American Painting*, his sixteen-year-old canvas. The exceptional decision to overpaint it was therefore particularly motivated by the desire to update the four-figure group.

Most suggestive in this regard is Davis's compositional sketch (fig. 93) of September 21, 1948, executed exactly two months after Gorky's suicide. The second figure from the right encloses a linear doodle within its outline —a tangled script that is more legible in other sketches

Figure 93. Stuart Davis. Study for *American Painting*. Ink on paper. September 21, 1948. Harvard University Art Museums, Fogg Art Museum, Cambridge, Massachusetts. Gift of Mrs. Stuart Davis (see cat. no. 104; fig. 111)

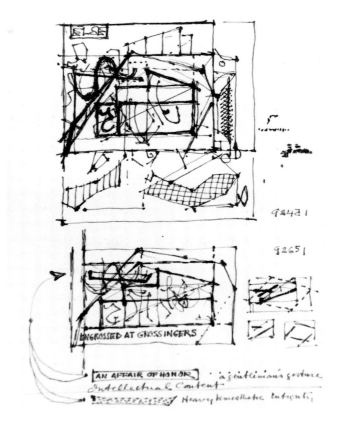

Figure 94. Stuart Davis. Study for *American Painting*. Ink on paper. September 24–26, 1951. Harvard University Art Museums, Fogg Art Museum, Cambridge, Massachusetts. Gift of Mrs. Stuart Davis (see cat. no. 104; fig. 111)

as the word *Eraser*. It begins with a horizontal capital *E* at the bottom, and proceeds up to a thickened *r* before becoming unreadable. As the word is entirely within the outline of the figure, it is clear that he is the one "consigned to the dimension of memory."[20] Davis thus achieves a public "neutralization" of a highly charged recollection that, nonetheless, is buried within the "continuity" of the canvas's meaning. Furthermore, the process of reworking *American Painting* led to the development of the concept of "the Amazing Continuity" —one of the theoretical bulwarks underlying Davis's late 1940s transition to his monumental, final style.

Three years later, Davis began yet another campaign of repainting, interspersed with the beginning of work on the new canvases *Visa* and *Owh! in San Pao* (cat. nos. 144, 146). His art-theory sketches of September 24–27, 1951 (see fig. 94), introduce the alliterative title ENGROSSED AT GROSSINGERS for the reworked *American Painting*. Although striking primarily for its pure alliteration, this phrase brings to mind both Grossinger's bakery on Columbus Avenue in Upper Manhattan, as well as the renowned Catskills resort hotel. Over the heads of the four men, he also inserted the word ELSE, as

in "somethin' else." Davis further posited, "Else is the 4th dimensional Eraser"—in other words, *Eraser* in another dimension, somewhere else. At this point, *Eraser* itself had shifted from the "dimension of memory" (implying Gorky) to that of "obsolescence." (Davis never felt he had to be consistent about his homespun definitions, and their meanings often evolved over time.) A few days later, on September 29, Davis leapt beyond the fourth dimension, when he defined "the Amazing Continuity" as "a Shape of 5 dimensions." This meta-concept encapsulates the constants in the artist's experience of this canvas over two decades.

In *American Painting*, as it was left in 1951 and appears today, ELSE has become a black bar over the head of the third, "*Eraser*" figure. The other words added to the composition neutralize or cancel out the old subject on a conceptual level, while still leaving large parts of the original linear structure visible. Thus, NO stands for "the Idea of No Idea," and *Any* for "any subject matter."[21]

Davis continued to toy with this motif in his art-theory papers: imagining the top-hatted man and the woman from the 1932 version of *American Painting* in front of a television with rabbit-ear antennas (February 21, 1952),

writing about the subject of the 1932 *American Painting* (March 1, 1952), making an "Eraser" sketch (May 21, 1952), changing the word *Eraser* to *Every* (February 18, 1952 ff.). On April 20, 1953, he drew the composition two more times. Then, almost a year later (April 13, 1954), he drew a jewelry-like design, labeled *Ornaments*, extracted from the configuration of the woman's eyes and nose. Finally, a new, yellow-ground version of *American Painting* (*Tropes de Teens* of 1956; cat. no. 105) seemingly brought the theme to a conclusion. Yet, as late as mid-1962, Davis told an interviewer that he was still considering repainting the original *American Painting*, which he had placed on his easel. Although he termed it "not resolved," he apparently did not further alter this palimpsest of three decades of his life and career.

The Late Works

With the inclusion of the Champion matchbook cover in *Little Giant Still Life*, followed by *Visa* (cat. nos. 141, 144), Davis returned to the smoking-related subjects of his early career—particularly to the Tobacco series of 1921, as well as to works such as *Matches* of 1927 (cat. no. 64). The last painting, while identical in subject to those later pictures, contains no lettering, and thus relates to strictly planar Cubist compositions like the contemporaneous Egg Beater series. In his theoretical writings on art, Davis typically emphasizes his formalist approach, which downplays content, citing the "book of matches with printing on it" as notable only for its "lack of interest."[22] At the same time that he views the content of *Visa* as "my Unconcern with the Meaning of this Subject,"[23] Davis is nonetheless cognizant that such lowly, commercial subject matter has its own agenda, which he "champions": "The Cunning of the Commercial Designer of Match Box Covers, Cigar Box labels . . . must be loved."[24] In this way, he was implicitly opposing the "high culture" of the new American painting and its grand and weighty subjects, the "tragic and timeless." With *Champion*, as he first called *Visa*, Davis ironically crowned himself the proponent of the lowly, humble, and quotidian.

Visa is a further emboldening of Davis's word-pictures. The letters of CHAMPION are entirely flat, and the pictorial space becomes that of the printed page. Davis stakes the entire composition on letter images, or what he speaks of as "the manufacture of the Word-Shape."[25] Once established, the "Word-Shape" continued to develop as a major innovation in Davis's late works.

An important forerunner of Davis's word-pictures was the work commissioned by the Container Corporation of America, which chose a group of artists to depict each of the forty-eight states in their "United States" series of advertisements beginning in 1946. Unlike the others who were commissioned, Davis incorporated the name of the state—his native Pennsylvania—in his design, along a zigzag vertical axis (see fig. 95). The banderole containing the word *Pennsylvania* echoes the configuration of the familiar crack in the Liberty Bell, shown at the lower left. Between the banderole and the bell is a tricorne—a less familiar symbol, and therefore discretely labeled W.PENN after William Penn, the Quaker founder of Pennsylvania, for whom the state was named. (A monumental statue of Penn, sculpted by Alexander Milne Calder [1846–1923], stands atop Philadelphia's City Hall, his three-cornered hat until recently the highest point in the city.) The role of the word *Pennsylvania* in the gouache is not as dominant or dramatic as that of CHAMPION in such paintings as *Little Giant Still Life* (cat. no. 141), although it is a vital, calligraphic component of the composition; its inclusion, however, is quite unusual in the context of the rest of the series of advertisements, which generally features typical scenes of each state, also done by a native artist. Few of the artists commissioned used typographic elements in their designs. An interest-

Figure 95. Stuart Davis. *Pennsylvania.* 1946. Gouache and pencil on paperboard. National Museum of American Art, Smithsonian Institution, Washington, D.C. Gift of Container Corporation of America

ing exception is fellow Downtown Gallery artist Jacob Lawrence, who lettered the names of the cities to identify his various scenes of New Jersey. These Container Corporation advertisements were published monthly in *Fortune*; Davis's design appeared in October 1946, and Lawrence's that December. *Fortune* itself commissioned and published Davis's apotheosis of commercially based word-pictures, *Package Deal* (1956; figs. 73, 118), exactly a decade later.[26] Davis took such commissions seriously, and his approach demonstrates that he did not subscribe to an exclusivist notion of fine art. For him, not only were the lines between "high" and "low" art blurred, as with so many other modernist artists, but he believed that the ordinary "topical subject" is actively prized by the "real" or "hip" artist for its raw freshness and unpretentious directness: "The Most Artist . . . accepts the Banal and gives it a Bust in the Nose."[27] This "punchy" banality undermines the traditional conception of the fine-art subject. Davis's notes clearly indicate that he was fully aware of the implications of such choices: "I like popular Art, Topical Ideas, and not High Culture or Modernistic Formalism."[28] Thus, over a decade before the emergence of Pop Art in America, Davis foresaw that popular culture was a way out of the dead end of "modernistic formalism."

The terse title *Visa* gives another inflection to the CHAMPION motif, implying the crossing of borders and relating to Davis's ambition to paint canvases of international import. Two years earlier, Davis had written of his "Neutral Subject-Logic concept" as a "passport of finesse."[29] Now he confidently asserted, "The Amazing Pads are Absolute Universal Expression. . . . They are an International Currency."[30] Then, in a surprising prediction of the transformation of art into a multi-national commodity, he explained that such pictures were "an Internationally accepted market security. This Stock is called Pad, Inc. The Artist-Broker is not emotionally attached to his shares."[31] In critiquing the Action Painters, Davis comes out sounding clear-eyed and contemporary: "A Great Picture is not a special revelation of transcendental mood. . . . It is a product of routine work in realistic logic which includes its Social Use and Distribution through Retailers."[32] Thus, for Davis this "Amazing" canvas was cleared for international travel, as well as for the global art market.

The proliferation of large, international exhibitions of contemporary art in the 1950s seems to have contributed to Davis's cosmopolitan outlook. These included the Venice Biennale, revived after World War II—Davis's work was shown there in 1952—as well as the São Paulo

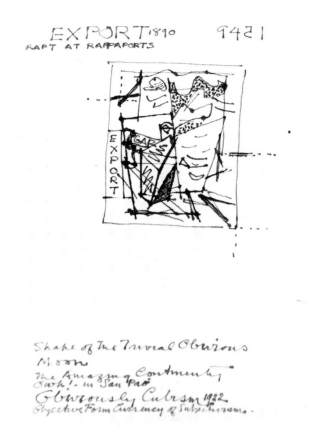

Figure 96. Stuart Davis. Study for *Rapt at Rappaport's*. Ink on paper. September 4, 1951. Harvard University Art Museums, Fogg Art Museum, Cambridge, Massachusetts. Gift of Mrs. Stuart Davis (see cover; cat. no. 147)

Bienal, founded in 1951. The initial American representation in the latter comprised a sizable group of works selected by a jury of museum curators and overseen by René d'Harnoncourt of The Museum of Modern Art in New York. *Visa* was, appropriately, one of Davis's three "envoys." Notes in his desk calendar reveal that he was working against a deadline of August 15, 1951. *Visa* was finished and picked up on August 13, but *Motel*, another painting in progress, was still being worked on as of mid-August.[33] It was apparently not completed in time for the Bienal, and Davis incorporated his likely disappointment in his choice of a new title for the picture: *Owh! in San Pao*.

The Amazing Continu-ity., which appears at the far right in *Visa*, is an oft-repeated phrase in Davis's theoretical writings at the time that went through many permutations, from the personal to the social. With sly humor, the last word is, in fact, not continuous, but hyphenated onto a second line. On one level, the phrase obviously refers to the consistency within the artist's development and, in particular, to his conceptualization of art—for instance, in "its contradictions, the inexorable casualness of its idiom."[34] As we have seen, Davis's sense

104

of "continuity" was undoubtedly heightened by his contemporaneous retouching of *American Painting*—a canvas begun in 1932 but overpainted in the 1940s and again in the early 1950s. As Davis reassured himself, "Art is Nows [sic] in the Dimension of Continuity which makes all Nows Equal."[35] Or, "The Amazing Continuity is the New Idea that a New Idea is Any Idea which is Complete."[36] He also takes the phrase beyond art into the social sphere: "The Amazing Continuity is the Hip Phrase which Erases the Square Phrase 'Freedom',"[37] and he goes further, devising one of his best-turned definitions, "Society is the Amazing Continuity between the Subjective Individual and the Display Window of History."[38]

Nonetheless, in keeping with Davis's developed sense of paradox, this concept can also be seen as its opposite —discontinuity—where the only constant is "the experience of Change" itself.[39] Similarly, somewhat later he writes, "The Amazing Continuity is not an Order of Likeness but a system of Unlikeness"[40]—or, as contemporary theorists would put it, of difference.

In explaining the new title of *Motel* (the painting contemporary with *Visa*), *Owh! in San Pao*, Davis claimed that he modified *ouch*—a reflection of painful "reality" —so it would rhyme with the name of the locale for which the work was originally intended.[41] The "pain" may have been the disappointment of not being able to exhibit this new canvas after all in the Bienal.

This uniquely named composition also includes the unusual phrase *We used to be*–NOW. Now is linked to *Owh* phonetically, but also conceptually: "The Plenitude of Now,-Ouch! Alliteration changes the 'Ouch' to 'Owh'."[42] This also may be a reflection of how "now" or up-to-date Davis felt in the art world. Although this canvas was soon shown at the Whitney Annual of 1951, Davis had not been represented there the previous two years, when the younger Abstract Expressionists were first presented in force. Davis was well aware of this development, but while he critiqued Robert Motherwell's paintings, he nevertheless made simplified sketches after works by Mark Rothko and William Baziotes. Did Davis sense that the New York School was pushing the older generation of modernists out of the limelight?

The vertically aligned ELSE at the left side of *Owh! in San Pao* links that painting to *Visa*, in which the same word appears at the lower center. In some early sketches for the latter composition, this place had been reserved for *visa*, but the word eventually migrated to the title instead. Thus, there is a certain interchangeability in the pictures of this period between the words on the canvases and the titles. We have already seen ELSE in studies for the revised *American Painting*, over the head of the "Eraser" figure. In many ways, then, these works of the early 1950s form a cluster—sharing interrelated and reciprocal themes—that can only be understood when the individual pictures are analyzed as a group.

Davis considered the title *Engrossed at Grossingers* in connection with sketches for the revision of *American Painting*, as well as for the composition that became *Rapt at Rappaport's* (cat. no. 147), a similarly alliterative appellation. This last picture is also based on a 1920s motif—an example of the "Amazing Continuity" phenomenon again—a landscape with a building alongside a body of water.[43] In the studies for *Rapt at Rapport's* (fig. 96), Davis also developed the "International Surface" concept—a further reference to the global market for paintings. He also writes of "pairs of colors" and the "switch" or "diad quanta," which appears to be a term for a binary system. The "diads" seem to be the pairs of new versions of old compositions.

The 1952 painting *Rapt at Rappaport's* has a pendant, *Semé* (cat. no. 148), from the following year. *Semé* is a French word defined in Davis's notes as "scattered, dotted, powdered."[44] The status of these two canvases as a "color pair"—or a so-called "diad quanta"[45]—is underscored by the inclusion in the upper left corners of a plus sign and a minus sign, respectively. With these symbols Davis signals a binary opposition, like positive and negative electrical charges, even though the dominant background color in both pictures is green (albeit different shades).

These works may be regarded as strictly dialectical pendants—"Opposites in total sequence continuity is properly called the Theory of Pairs"[46]—but, nonetheless, they sometimes represent less of an opposition than theme and variation. In fact, almost all Davis's works of the early 1950s are pendants, such as *Something on the 8 Ball* (cat. no. 149) and *Medium Still Life* (The William H. Lane Collection), and *Colonial Cubism* and *Memo No. 2* (cat. nos. 152, 153), among others. These "diads" are all based on 1920s motifs, and thus are, appropriately, examples of the "Amazing Continuity": "The principle of Continuity is recognized by this concept of comparative Pairs. . . . Continuity of Pairs in Space-Time."[47] In one case Davis even combines a pair of views on a symmetrically divided canvas whose title, *Deuce* (cat. no. 150), emphasizes its diptych-like quality.

As the designation *Deuce* suggests, beginning with the wonderfully alliterative *Report from Rockport*, Davis bestowed on his pictures some of the most inven-

tive appellations in American art of the 1940s and 1950s. During this time, against a flood of numerically titled or even untitled works by the New York School, Davis gave his considerable thought, and began to blend English with French in increasingly complex plays on language. As he affirmed, "The idea of an interesting Name for a painting is an important part of the Shape of Art Content."[48] Later, discussing the centrality of titles, he explained, "Titles in art are important because they are integral with the visual image and enrich it."[49] Some of his most interesting, such as *Tropes de Teens* or *Letter and His Ecol* (cat. nos. 105, 168), have remained undeciphered; others, such as *Contranuities* (fig. 97), seem to coin new English words.

Among American modernist artists, perhaps Davis, above all, had "something on the ball," yet, historically, he found himself "behind the Eight ball" when it came to the growing recognition of American art. Davis combined these two expressions in the catchy title *Something on the 8 Ball* (cat. no. 149)—a 1953–54 revision of *Matches* of 1927 (cat. no. 64). The artist introduced a new word-concept: "Facilities is the control power of the Delegated Power of Free Decision."[50] In *Something on the 8 Ball*, Davis split up the word *Facilities* on two lines, creating an elaborate pun, "Facile-it-is," that also referred to the "ease" of "free choice." In part, this means the artist is free to use any subject matter, or *any* IT, as he wrote in his notebooks and across the upper left part of the painting itself,[51] including "any" one of his own old motifs. The title *Something on the 8 Ball* was first recorded on July 25, 1953, but sketches for the actual composition were not made until a month later. The word *Facilities* first appears in a sketch of August 26, 1953, which Davis accompanied by studies for splitting it up. Like his earlier "Eye-ideas" pun, it is doubtful that "Facile-it-is" was understood by much of the public during the painter's lifetime.

A similar pun, the title *Contranuities*, has resisted decoding until now. With "Contra-new-it-is," Davis originated a title manifesto for his own recidivist compositions, implicitly denouncing the cult of the "new" that was beginning to overtake the art world. The forms in the 1963 *Contranuities* follow quite closely those in the 1931 canvas *Summer Twilight* (fig. 72)—a painting Davis no longer owned—turned upside down. Oriented thus, the central bird becomes a black-and-white abstract shape. In this case, Davis may have appropriated the image from Eugene C. Goossen's 1959 monograph on Davis, or from a photo of the earlier, 1931 work. The "Contra-new" is literally a demonstration of Davis's be-

lief in the viability of his old configurations, as well as a critique of novelty for its own sake.

Tropes de Teens (1956)—yet another unique and puzzling title that seems to come from Davis's special bilingual dictionary—is a play on the words *Teen-Tropes*. Davis zoomed in on the central portion of the original composition of *American Painting* in this variant. There are also a number of changes in detail: the Duke Ellington lyric is rendered as illegible calligraphy; the artist's signature appears toward the middle of the canvas, below the first *r* of the word *Eraser*; and, at the lower left, a blue *X* was added. On the most obvious level, the title appears to refer to teenagers' figures of speech, or to their slang expressions, however Davis's notes of 1956 reveal another, more obscure personal association: the "Voices used like Trumpets/Real Crazy Syncopation" of the medieval music of Guillaume Dufay.[52] Thus, *Teens* alludes to this "jazzy" counterpoint of the fif*teen*th century, while *Tropes* not only signifies "figures of speech" but also, according to Webster's dictionary, "phrase[s] or verse[s] added as an embellishment or interpolation to the sung parts of the mass . . . during the medieval period." That Davis may have intended to convey a third meaning is possible when one recalls that the title *Tropes de Teens* superseded *Teen-Tropes*, and that among the literal tropes in our century are Guillaume Apollinaire's imagistic *Calligrammes*, or poems, dating from the 19*teens* (1918).

Titles of this type represent a split in the public and private spheres of Davis's artistic persona. More often, he culled the most up-to-date references from contemporary life: from the space age and unidentified flying objects (*UFO*, Private collection), fashions (*Ready to Wear*, cat. no. 154), and the new computer technology (*Punch Card Flutter*, cat. no. 174)—the only interests the unpretentious Davis acknowledged publicly, in his gruff style. Therefore, in the past, few viewers of Davis's works would have been aware of the allusions in the titles to historic figures such as Dufay or Apollinaire.

In his notes about art from the last few years of his life, Davis wrote increasingly cryptically about "the Letter"; for instance, "the Letter is 2/front and back," or "the Letter and his Read-Ecol."[53] "The Letter" seems to emerge as a distilled symbol of the pictorial aspect of language. *Letter and His Ecol*, the title of a small canvas of 1962 as well as of two black-and-white versions identical in size (see cat. nos. 168–170), is an overlooked word-picture whose bilingual title, like *Tropes de Teens*, has remained mystifying. Included prominently at the

Figure 97. Stuart Davis. *Contranuities*. 1963. Oil on canvas. Private collection

top of the composition are *Inst* and *Ecol* in nearly illegible calligraphy, both words cut off at the right by the rounded edge of their black field. If French, the first word could be an abbreviation of *Institut* [*de France*], the subject of an earlier gouache Davis painted in Paris, and the seat of the Académie des Beaux-Arts. If English, an entry among Davis's art-theory papers gives the most likely explanation: "Letter is Ident[ity] of Instant Formula"[54]—suggesting the first word is short for *Instant*. This is Davis's self-defined term for the all-at-once impact of a picture, similar to the "punch-card" concept. With the title *Letter and His Ecol*, Davis seems to have wanted to affiliate himself with a "school" (or *école*) of Lettrism—with those who would use language in pictures for its visual impact as well as for its verbal associations. At the time, he continued to make the important claim—reinforced by the multicolored ANY at the lower right of *Letter and His Ecol*—that "words & phrases, and their Meaning, are part of the Form-Shape of Drawing even if they appear only in the title. They are integral with the unanalyzed Given Any content."[55]

Such letter-paintings as *Lesson I* of 1956 (cat. no. 151) suggest the kind of "lesson" given in Davis's *Ecol*. A large, white *X* cancels out the right side of a simplified Gloucester landscape, with boats painted in red, black, and green—the "Given Any content." At the lower right, the word *Speech* in red asserts the strongest visual suggestion that, for Davis, language parallels painting as a system of signification; letters (like the *X*) are the basic units of words and of speech, just as colored shapes are the building blocks of images.

With the wit of Davis's alliterative titles and puns, it is possible to lose sight of the deeply serious side of his plays on words. The artist staked his later career on continuing the *peinture-poésie* tradition, which placed him in opposition to Abstract Expressionist action painting. Indeed, by the fall of 1954, Davis would define art as, "the Shape of Language"[56] (not an arena in which to act). Later, he told an interviewer, "Physically words are also shapes."[57] His commitment to the physicality of the word in the thousands of pages of his own theoretical writings on art was not a separate activity, but an integral part of the process of creating form.

Thus, words and letters for Davis were not embellishments, but rather a touchstone—a system parallel to visual art or, at times, the subject itself of that art: "The Alphabet Syntax and Language of Color-Space Method become the Object . . . as they take the place of Subject as Given."[58] Davis has always been touted as an all-American precursor of the Pop Artists, but, however improbable it may seem, his work can also be seen as a harbinger of the profusion of language-involved art forms that have evolved since the late 1960s.

Notes

Research for this essay was completed with the support of a Chester Dale post-doctoral fellowship at The Metropolitan Museum of Art, New York, during the 1989–90 academic year. I would like to thank William C. Agee, Earl Davis, John R. Lane, and Lowery S. Sims for their assistance and helpful suggestions.

1 Clement Greenberg, "After Abstract Expressionism," *Art International* 6 (October 1962), p. 30.

2 Stuart Davis, Notebook: 1920–22, March 12, 1921, p. 19. Private collection.

3 Ibid.: May 1921, p. 35; May 29, 1921, p. 38.

4 Stuart Davis Papers, September 5, 1952. Harvard University Art Museums, Fogg Art Museum, Cambridge, Massachusetts.

5 Stuart Davis, Notebook: 1921–23, March 11, 1921, no. 40. See also John R. Lane, *Stuart Davis: Art and Art Theory* (exhib. cat.). New York: The Brooklyn Museum, 1978, no. 7.

6 Stuart Davis, Notebook: 1920–22, June 1, 1921, no. 41. Private collection.

7 Karen Wilkin, *Stuart Davis*. New York: Abbeville Press, 1987, p. 70.

8 Unsigned, "Even in Grinnich There's Nothing as Odd as Emblazoned Walls of 'Nut Shop' Here," *Newark Evening News*, May 16, 1921; clipping preserved in Stuart Davis, Notebook: 1920–22, p. 33. Private collection.

9 Stuart Davis, Notebook: 1920–22 [after September 22, 1922], p. 55. Private collection. A similar sketch and plan for another mixed-media work, "8th AVE," appears above on the same sheet.

10 This picture is discussed at length in Lewis Kachur, "Stuart Davis and Bob Brown: *The Masses* to *The Paris Bit*," *Arts Magazine* 57, 2 (October 1982), pp. 70–73.

11 Letter from Stuart Davis to his friend the image-poet Bob Brown, September 25, 1929. Robert Carlton Brown Papers, Special Collections, Morris Library, Southern Illinois University at Carbondale. Davis gives the formula "8 McSorleys Ales = 5 or 6 Demi Lipps."

12 Stuart Davis Papers, March 5, 1949, op. cit. In his notes of March 8, Davis refers specifically to American jazz.

13 Contemporary reviewers of the Whitney Biennial do not discuss the painting's imagery, but several classify it as "Surrealist." See, for instance, Ralph Flint, "Whitney Museum Opens Its First Biennial Show," *Artnews* 31, 9 (November 26, 1932), p. 4.

14 Unsigned, *American Notes and Queries* 1 (April 1941), p. 7. In an important parallel, Davis's friend Bob Brown also used the phrase *Little Joe* as a reference to dice in his slightly earlier and equally American story "National Festival: G.W., 1732–1932," in *American Mercury* 24 (December 1931), p. 405: "Roll them bones, Little Joe!"

15 John Graham alludes to the group in a letter to Duncan Phillips of December 28 [n.d.], pp. 2–3, in the Phillips Collection Archives, Washington, D.C.: "Stuart Davis, Gorky and myself have formed a group and something original, purely American is coming out from under our brushes. It is not the subject matter that makes painting American or French, but the quality, certain quality which makes paintings assume one or the other nationality." Thus, even the Russian-born Graham associates this confederation with uniquely American art.

16 James T. Valliere, "De Kooning on Pollock," *Partisan Review* 34 (Fall 1967), p. 603. Patterson Sims (in *Jan Matulka 1890–1972* [exhib. cat.]. Washington, D.C.: National Collection of Fine Arts, Smithsonian Institution, 1980, pp. 27–28) presents some evidence that Davis organized an exhibition at the Art Students League of New York in 1930 or 1931–32 that included works by these three artists plus Matulka.

17 Stuart Davis, Sketchbook: 9–21, illustrated in Diane Kelder, ed., *Stuart Davis*. New York, Washington, and London: Praeger, 1971, p. 62 lower right.

18 Stuart Davis Papers, September 14, 1948, op. cit.

19 Ibid., September 16, 1948.

20 Lane, op. cit., no. 80, p. 155.

21 Ibid.

22 Stuart Davis Papers, October 20, 1949, p. 3, op. cit.

23 Ibid., December 26, 1950, p. 7.

24 Ibid., October 9, 1951.

25 Ibid., November 1, 1951. Davis soon would define the "Word-Shape as Subject" and stress its calligraphy, "drawn freely in an invented shape which carries the mood of the doing" (November 20, 1951 ff.).

26 Unsigned, "Still Life from the Supermarkets," *Fortune* 54, 3 (September 1956), p. 140. The "United States" series is documented in *Art, Design, and the Modern Corporation: The Collection of the Container Corporation of America* (exhib. cat.). Washington, D.C.: National Museum of American Art, Smithsonian Institution, 1985, p. 58.

27 Stuart Davis Papers, October 21, 1951, op. cit.

28 Ibid., December 17, 1950. (On December 25, Davis elaborates on this in relation to *Lucky Strike* [cat. no. 32].)

29 Ibid., September 28, 1948.

30 Ibid., August 14, 1950.

31 Ibid., August 22, 1950.

32 Ibid., July 14, 1951.

33 Stuart Davis Calendars, July 17 and 23, and August 13–16, 1951. Copies kindly supplied by Earl Davis.

34 Stuart Davis Papers, November 19, 1951, op. cit.

35 Ibid., August 2, 1952.

36 Ibid., November 17, 1951.

37 Ibid., October 19, 1951.

38 Ibid., September 4, 1951.

39 Ibid., October 14, 1951.

40 Ibid., November 1, 1951.

41 Lane, op. cit., p. 168. According to entries in Davis's calendars, the work was originally titled *Motel Cadillac* or *Motel Pad* (July 11, 1951), just *Motel* (August 17, 1951), *Motel Detroit* (August 26), and finally, in an unusual full-page note, "Title for Motel/ Owh! In San Powh [*sic*]" (August 31). Davis's notations for Tuesday, July 17, 1951, indicate he was to phone Andrew C. Ritchie of The Museum of Modern Art "next Monday [to ask] whether Motel can be available." As mentioned above, *Visa* was collected by the shippers on August 13, while Davis continued to work on *Motel* after that date.

42 Stuart Davis Papers, January 19, 1952, p. 2, op. cit.

43 This painting is incorrectly titled [*Landscape with Saw*] in *Stuart Davis (1892–1964): Motifs and Versions* (exhib. cat.). Foreword by William C. Agee; introduction by Lawrence B. Salander. New York: Salander-O'Reilly Galleries, 1988, colorplate 7.

44 Stuart Davis Papers, January 1951, op. cit.

45 Ibid., August 31, 1952, and September 3, 1952.

46 Ibid., December 3, 1953.

47 Ibid., March 25, 1954 ff., and April 7, 1954.

48 Ibid., September 27, 1951.

49 Ibid., October 27, 1960.

50 Ibid., January 1, 1953 ff. "Free Decision" is further described there as "the gift of free choice."

51 Ibid., August 10 or 25, 1953: "ANY IT is Constantly Given. E[nvironment] itself is seen as an IT."

52 Ibid., December 7, 1956 [?]. This sheet comes after July 1956, but not in the sequence of the December 1956 papers. The complete edition of the works of Guillaume Dufay (1400–1474), who is noted for composing the first cyclical Masses, was published beginning in 1947. Dufay may have been brought to Davis's attention by his friend Meyer Schapiro, the art historian and medievalist. Davis goes on to relate Dufay's "syncopations" to "Earl Hines['s] 'Trumpet Style' idea."

53 Ibid., n.d. [following February 1963 and March 22, 1963, respectively].

54 Ibid., following January 5, 1963. The title *The Letter & his Ecole* [*sic*] appears with a sketch on the next page.

55 Ibid., n.d. [1963–64]; undated group of pages at the beginning.

56 Ibid., September 27, 1954.

57 Katharine Kuh, *The Artist's Voice: Talks with Seventeen Artists*. New York: Harper & Row, 1960, p. 52.

58 Stuart Davis Papers, June 6, 1960, op. cit.

Consumers Coal Co. 1912

Oil on canvas, 29½ × 37½ in. (74.9 × 95.3 cm.)
Sunrise Museums, Charleston, West Virginia.
Gift of Amherst Coal Co.

Bleecker Street. 1913

Oil on canvas, 38 × 30 in. (96.5 × 76.2 cm.)
Collection Earl Davis. Courtesy of Salander-O'Reilly Galleries,
New York

Consumers Coal Co. demonstrates Stuart Davis's deft interpretation of the energetic brushwork and urban themes of the Ashcan School of painting. Almost incidentally, we are made aware of Davis's interest in signs and typography, and his propensity for skillfully organizing the compositions of his paintings. The scene seems to end in a cul-de-sac. We are first drawn into it by means of the perspective of the stoop at the right, after which the diagonal of the tilted coal wagon calls our attention to the dark building at the left, and then to the dominating horizontal of the lighter, beaux-arts structure that encloses the scene in the distance. The streetlamp in the front contains our view in the foreground, and reinforces the passageway down which a lonely female figure is making her way. This lamppost visually concretizes our sense of distance within the composition, particularly as it is lined up with a second lamppost just beyond the figure. This conceit of framing the composition with diagonal perspectival elements at each side and focusing the viewer's

Entries have been written by
Lowery S. Sims (LSS),
Lisa J. Servon (LJS),
and Lewis Kachur (LK)

attention on a point in the distance that is parallel to the picture plane may also be seen in the artist's *Town Square* of 1925–26 and *Place des Vosges No. 1* of 1928 (cat. no. 62; fig. 104).

Consumers Coal Co. is dated January 12, 1912, on the canvas, and has been identified as a New York scene.[1] A New York locale does seem most likely, for although sometime in 1912 Davis moved to Hoboken, New Jersey—where he shared a studio with Henry Glintenkamp—the exact date of Davis's move is uncertain. In any case, he would probably have done a sketch of the scene and translated it into a painting in the studio.

Just a year later, in 1913, the young artists left Hoboken and returned to New York. Their departure even received notice in the local paper.[2] *Bleecker Street*, painted that same year, demonstrates the changes that had taken place in Davis's work. While the loose brushstrokes of *Consumers Coal Co.* are still in evidence, Davis organized the composition so that we are confronted with the darker areas in the buildings to the upper left, and the street occupies the lower right, where some sunlight illuminates the scene even though it is a rainy day. Our eye is riveted on the woman in the extreme lower-right corner. As in his 1912 *Self-Portrait* (cat. no. 3), Davis engages us psychologically with this lone figure, who here rather pointedly makes eye contact with us. Her bright red coat is complemented by the brilliant green with touches of yellow and orange of the vegetables and fruit, which stand out from the shadows in front of the darkened buildings that emit no light or life. There are a few other anonymous figures carrying umbrellas in mid-composition, and we can certainly see the influence of America's Luminist painters in the peculiarly atmospheric quality of this overcast scene. The space opens at the right side, directly behind the woman in red, to reveal the tenement buildings and the El station in the distance. The J. COLP PHARMACY sign once again indicates Davis's interest in advertising.

LSS

1 See Bruce Weber, *Stuart Davis' New York* (exhib. cat.). West Palm Beach: Norton Gallery and School of Art, 1985, p. 11.

2 The notice in the *Hoboken Inquirer* of September 21, 1913, reads: "Art circles in Hoboken will receive a severe blow in the departure of Henry J. Glintenkamp and Stuart Davis, who occupy a studio in the Terminal Building. . . . All the lovers of art in the city made this studio their meeting place, and many celebrities of the world of art have met there. Both these artists, who hold a high place among the followers of the impressionistic school, have taken a larger studio at 1931 Broadway, New York, with Glenn Coleman, one of the best-known artists in America. The increased demand for the work of Glintenkamp and Davis made it imperative for them to move to New York where they will be in direct touch with the art editors of the various magazines" (Downtown Gallery Papers, Reel ND58, Archives of American Art, Smithsonian Institution, New York).

3

Self-Portrait. 1912

Oil on canvas, 32 × 26 in. (81.3 × 66 cm.)

Collection Earl Davis. Courtesy of Salander-O'Reilly Galleries, New York

This riveting self-portrait was executed in 1912, the year that Stuart Davis's association with the Robert Henri School of Art concluded. Already we can see how the student has taken off in another direction from the master. This portrayal is a tour de force of psychological tension. The artist faces the viewer, but his thoughts are

elsewhere, presumably on the woman forlornly making her way across the street from where the artist is standing. Davis does not turn his head toward her; his eyes are simply diverted, as if he were looking up at some unidentified spot. The slight frown—or scowl—on his face indicates that his thoughts are not easy; the brooding expression of the male and the downcast posture of the female suggest that either some altercation has occurred between the two, or that their relationship has not progressed as either one foresaw. We see a similar confrontation between a man and a woman in such watercolors as *The Front Page* (cat. no. 9) and *The Doctor* (Elvehjem Museum of Art, University of Wisconsin, Madison). Davis relies on an artful posing of the figures and the skillful depiction of facial expression and body posture to add some rather forthrightly combative nuances to the most intimate of relations.

In spite of the anecdotal nature of this work, Davis has organized the composition along specific formal guidelines. The foreground, middle ground, and background are established through a succession of dark, light, and more hazy horizontal elements that coincidentally conform to the character of the street and the architecture in the painting. Oddly enough, the focus of the composition—the artist—is shrouded in shadow, while the strongest light falls on the center of the picture, on

113

the street where the young woman is walking. In the distance is what seems to be a portion of an elevated subway, which had been a part of the New York skyline since 1904. At this time, Davis was living in Hoboken, New Jersey, where he shared a studio with his lifelong friend Henry Glintenkamp in the Terminal Building on Hudson Street.

LSS

4

Portrait of a Man. 1914

Oil on canvas, 30 × 23¾ in. (76.2 × 60.3 cm.)
The Regis Collection, Minneapolis

The garish green of the face and the strong black outlines attest to the immediate effect of the Armory Show of 1913 on Stuart Davis's work. This is only one of several half-length portraits that Davis completed in 1914. Critic Charles Caffin, writing

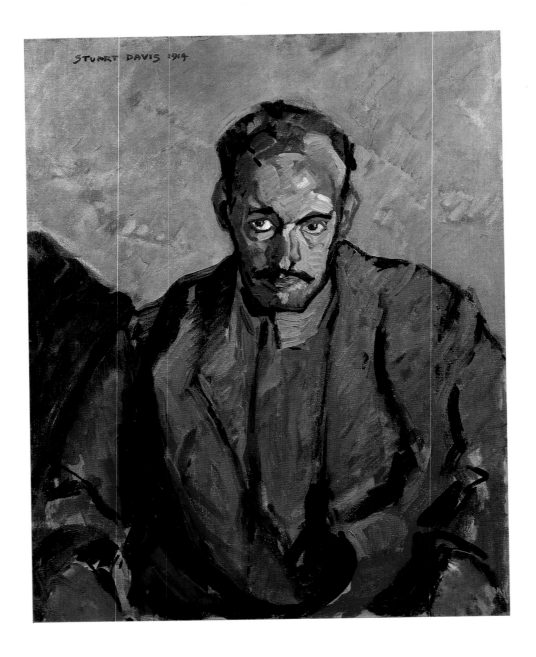

in the *New York American*, recognized the influence of Robert Henri on Davis's work: "In a 'Portrait' he reflects his master's cleverness of technique, and also the latter's tendency to use it for purposes of little or no significance. Does Davis really believe that art is only or even mostly a monkey shine of technique?"[1] While Caffin takes Davis to task for the stylistic bravura that was the hallmark of the Ashcan artists, as well as of academic masters such as William Merritt Chase, Davis was already looking to the European modernists for ways to bring his technique in line with his subject matter: "I . . . responded particularly to Gauguin, Van Gogh, and Matisse, because broad generalization of form and the non-imitative use of color were already practices within my own experience. I also sensed an objective order in these works which I felt was lacking in my own."[2]

LSS

[1] Quoted in Stuart Davis, "Autobiography." New York: American Artists Group Monographs, 6, 1945, n.p.

[2] Stuart Davis, "Autobiography" (1945), in Diane Kelder, ed., *Stuart Davis*. New York, Washington, and London: Praeger, 1971, p. 23.

5

Babette. 1912

Oil on canvas, 30¼ × 38¼ in. (76.8 × 97.2 cm.)

Collection Earl Davis. Courtesy of Salander-O'Reilly Galleries, New York

During the late nineteenth and early twentieth century, the theme of the performer became firmly entrenched within the modernist idiom. Artists such as Degas, Toulouse-Lautrec, Signac, Renoir, and Picasso had captured the pathos, hustle, and artifice of the life of performing artists—be they ballerinas, saloon singers, vaudevillians, or circus performers. In an earlier Stuart Davis composition entitled *Music Hall* (1910; Collection Earl Davis), a singer, stalwartly performing for a rather disinterested audience, is seen from the perspective of the orchestra pit, as in Degas's composition *The Orchestra of the Opera* (c. 1870; Musée d'Orsay, Paris).

In *Babette*, Davis presents a more panoramic view of the stage, again down at audience level, but this time farther back in the orchestra section of what is obviously a hall of substantial size. The musicians, with their illuminated music stands, can be made out at mid-composition. Our focal point for gauging our position is the large head of a man, which breaks our view of the spotlight that falls on Babette, the opening act of the revue. She stands, stage right, wearing a bright green dress and cloche, which contrast with her bright red hair and lips. Behind her swirl several dancing couples and single women, who create a vignette of street life in front of a rather imposing stage set of a building façade decorated with streetlamps.

The complexity and scale of the scene would seem to have been a rather ambitious project for the then twenty-year-old Davis, who successfully leads us through the composition in a very logical manner, displaying a convincing command of scale, lighting, anecdotal detail, and figuration. There is some irony in Davis's depiction of staged street life, which could only mirror the real life in the streets of New York that Henri encouraged his students to observe as a source for their art.[1]

This painting was most likely executed in Davis's Hoboken studio. A 1912 watercolor entitled *The Vaudeville Show* (Private collection) includes a woman similarly dressed, and in a slightly more exaggerated pose than Babette, on stage with dancing figures and an elaborately wrought arcade with classical details behind her. In *Babe La Tour* (1912; fig. 2)—one of the watercolors Davis exhibited in the Armory Show in 1913—he presents a more raucous scene in which one of the female performers has been pulled offstage and is being hoisted onto the shoulders of an obviously enamored customer. Again, the stage setting mimics an urban street with a variety of characters who satirize types from all walks of life.

LSS

[1] Davis wrote about his studies at the Henri School of Art: "We were encouraged to make sketches of everyday life in the streets, the theater, the restaurant, and everywhere else. These were transformed into paintings in the school studios. On Saturday mornings they were all hung on the wall at the Composition Class. Henri talked about them, about music, literature, and life in general. . . . Coleman, Henry Glintenkamp and myself toured extensively in the metropolitan environs. Chinatown; the Bowery; the burlesque show; the Brooklyn Bridge; McSorley's Saloon on East 7th Street; the Music Halls of Hoboken; the Negro Saloons; riding on the canal boats under the Public Market . . ." (Stuart Davis, "Autobiography." New York: American Artists Group Monographs, 6, 1945, n.p.).

6

The Back Room. 1913

Oil on canvas, 30¼ × 37½ in. (76.8 × 95.3 cm.)
Whitney Museum of American Art, New York.
Gift of Mr. and Mrs. Arthur Altschul, 69.114

The Back Room is one of the few oils that Stuart Davis executed in the saloons and jazz bars that he frequented in the early 1910s; drawings and watercolors make up the majority of these works. The place depicted in *The Back Room* is most likely identical to that in *Barrel House—Newark* (cat. no. 11) of the same year. The rows of barrels and the similarly posed piano player are featured in both works. In *The Back Room*, unlike *Barrel House—Newark*, Davis carves out a definite space in the center of the painting, implicating the spectator as a participant in the scene. The sharply receding floorboards and ceiling beams also draw the viewer into the work.

The main players in *The Back Room* are the dancing couple who occupy the center of the painting. The remaining figures are grouped around this pair, on whom the overhead light shines directly. Like many of Davis's works from this early period, the moment captured is rather strange, and is not definitely readable. The

dancing woman appears to be supporting her partner, who seems to slump despite his rigid posture. The man directly behind and to their left moves forward with arms outstretched, as if coming to their aid. The activity of this man contrasts sharply with the rest of the figures, who remain rooted in place. Most of the faces are blurred or obscured by shadows and hats, adding to the cryptic quality of the work. The subdued palette and greenish quality of the skin tones further the mysterious aura.

The Back Room is also intriguing because it depicts blacks and whites in the same social space. African-Americans found themselves increasingly marked off and defined during this period of urban growth; therefore, these clubs, although always owned and operated by whites, must have been among the few settings in which the two races could interact.

LJS

7

Fish Market. 1912

Watercolor on paper, 11 × 15 in. (27.9 × 38.1 cm.)
Collection Dr. and Mrs. Henry Kaufman

8

Two Cats. 1912

Watercolor and graphite on paper, 10⅞ × 14¾ in. (27.6 × 37.5 cm.)
Philadelphia Museum of Art. Anonymous gift

The watercolor of two cats on a city street captures an easily missed moment, forcing us to notice the dynamics of this feline encounter. Stuart Davis's attention to such details as the ornamental cast-iron fence and its reflection on the damp sidewalk documents his careful observation, and, in addition, gives the painting a

solid structure, creating a rhythm that moves evenly across the composition. The lettering on the door in the background, advertising the whitewashing and chimney-sweeping services of someone named John Baker, demonstrates Davis's early interest in the decorative quality of signs at the same time that it ties the painting to a particular time and place.

In *Two Cats*, Davis acknowledges debts to two influential forces, one from the past and one contemporary. The influence of Robert Henri is inherent in the focus on the incidental aspects of city street life. The subject and composition of *Two Cats* relate closely to Édouard Manet's 1868 lithograph entitled *The Cats' Rendezvous*, which depicts the meeting of a black and a white cat on a city rooftop. The contrasting colors and opposing positions of the cats in both works suggest moral overtones, but leave the viewer uncertain as to the specific message. This enigmatic quality characterizes much of Davis's early work, in which seemingly benign genre scenes are infused with complex undertones.

Fish Market (which is certainly an appropriate pendant to *Two Cats* by virtue of its subject matter alone) presents a similar examination of the rhythmic aspects of the elements of a building façade. Here also one sees the partially obscured lettering —in this case of FISH MART—that again is an early example of the type of generic sign that was to be a distinguishing feature in Davis's work throughout his career. The frontality and the prominence of the lettering is comparable to that seen in *Garage* (cat. no. 22), which was painted in 1917. Within the complex organization of rectilinear elements and horizontal and vertical relationships in *Fish Market* is a diagonal element, originating in the lower left, which serves to focus our attention on the two male figures just off-center in the middle ground, and subsequently on their companion, who is isolated at the far left.

LJS

9

The Front Page. 1912

Watercolor, gouache, and graphite on paper, 11 × 15 in.
(27.9 × 38.1 cm.)

The Museum of Modern Art, New York. Purchase

The Front Page, alternately titled *The Musician*, explores the darker side of male/
female relationships. In this painting of a pre- or postcoital moment, Stuart Davis
endows the woman, a prostitute, with power. Her greater control derives from her
more aggressive posture and her fixed stare. Instead of submitting to the male's
gaze, a theme that dominates the history of art, she challenges it. The position and
the countenance of the man in the painting communicate withdrawal. The place-
ment of his left hand and arm operates to deflect the woman's gaze and to block the
viewer's access to him. Davis's juxtaposition of strong vertical and horizontal com-
positional elements combines with the bright lights and deep shadows to reinforce
the psychological tension of the work.

Contemporary artists painted similar subjects in which traditional male and fe-
male positions underwent reversal. One example is William Glackens's illustration
for *The Little Tin Bank* (1912; Collection Mr. and Mrs. Ira Glackens), in which the
woman, dressing after a sexual encounter, remains composed and in control while
the man assumes a dejected pose. In these works, the woman, often nude, was usu-
ally portrayed thus; however, her ability to escape the conventional role reserved
for her by art-historical tradition rested on her occupation as a prostitute. Such
paintings continue a modern trend that began in 1863 with Édouard Manet's
Olympia and provide a stark contrast to the assumed physical and psychological
dominance of the male, as seen in Edgar Degas's provocative composition *Interior
(The Rape)* of about 1868–69 (Philadelphia Museum of Art. The Henry P. Mc-
Ilhenny Collection).

Davis first exhibited *The Front Page* at the New York Watercolor Club in 1912.
A periodical called *Pagan*, in which Davis published several works, reproduced it in
January 1918.
 LJS

10

Servant Girls. 1913

Watercolor on paper, 15 × 11 in. (38.1 × 27.9 cm.)

Munson-Williams-Proctor Institute, Museum of Art,
Utica, New York

Stuart Davis's 1913 watercolor of domestic laborers demonstrates the condition of working women in the early twentieth century. Grouped in a tightly knit composition, the four women remain isolated, however, each absorbed in her own thoughts. The pose of the standing figure at the left communicates the freedom conferred by the economic independence women gained by working outside the home. On the other hand, the expression of the seated female on the right illustrates the fatigue resulting from exploitative working conditions, such as the twelve- to thirteen-hour day women were expected to work. That these women are seen in front of the house belonging to their employer symbolizes their social exclusion and the rigid stratification that still existed in American society. The large dark void of the window reinforces this sense of social impenetrability.

Davis's choice of subject matter reflects his own political orientation. His father was editor of the *Philadelphia Press* and later of the *Newark Evening News*, and was instrumental in hiring artists such as John Sloan, William Glackens, and George Luks, who were associated with the group known as the Ashcan School. They focused on themes that illustrated the turmoil of turn-of-the-century urban life, with its social conflicts and economic devastation. Davis himself had studied with Robert

Henri, the guiding force of the group, between 1910 and 1912, and the present watercolor exhibits affinities with the work of these artists in both style and subject matter. The ash can at the lower left of the composition is perhaps an example of Davis's penchant for punning and may well refer to this connection.

This watercolor was one of five that Davis exhibited at the Armory Show of 1913. Only twenty-one years old at the time, he regarded this experience as one of the turning points in his life and in his art.

LJS

11

Barrel House—Newark. 1913

Pencil on paper, 20 × 15⅞ in. (50.8 × 40.3 cm.)
Collection Earl Davis. Courtesy of Salander-O'Reilly Galleries, New York

Barrel House—Newark documents the scene at one of Stuart Davis's jazz-bar hang-outs in Newark, New Jersey. Reproduced in *The Masses* in February 1914, this drawing bore the caption, "Life's Done Been Gettin' Monotonous Since Dey Bu'ned Down Ou'ah Church." Smaller print near the bottom of the page explained that, "The destruction of churches where negroes are said to become 'wrought up' is one of the latest ways of defending Christian civilization in the South."[1] *The Masses*, published from 1911 through 1917, was a radical magazine with a novel policy established by its freethinking editorial board. All contributions remained anonymous until they were debated and their fate decided upon by the board, which consisted mainly of the artists and writers themselves. Captions, also the product of these collective meetings, worked to enhance the overall impact of a drawing. The focus on urban lowlife constituted a rebellion against the more prevalent conservative periodicals.

The title of the present work may have been taken from the establishment depicted. The term *barrelhouse* also refers to a type of American blues music of the early twentieth century. It was later blended with the New Orleans style to form the hybrid known as barrelhouse jazz. The word *barrelhouse* was also a slang term used to describe something rough or crude.[2]

Although *Barrel House—Newark* looks technically crude, its composition is actually carefully constructed. The receding curve formed by the heads of the four figures draws the spectator into the work and we confront each one in succession. While the figures inhabit a small area and occupy a public, social space, two of them turn their backs on the viewer, and the four make no eye contact among each other. The only exception is the man in front, who looks menacingly out of the painting and acts as a barrier to the viewer's entry. The overall effect is to heighten the sense of alienation that many people, particularly African-Americans, experienced in American cities during this period.

LJS

1 Rebecca Zurier, *Art for The Masses (1911–1917): A Radical Magazine and its Graphics* (exhib. cat.). With contributions by Earl Davis and Elise K. Kenney. New Haven: Yale University Art Gallery, 1985, p. 156.

2 Paul Oliver, in *New Grove Dictionary of Jazz*, ed. Barry Kernfeld. New York: Macmillan, 1988, pp. 74–75.

11

12

12

Negro Dance Hall. 1915

Crayon and ink on paper, 21¼ × 16⅝ in. (54 × 42.2 cm.)

Collection Earl Davis. Courtesy of Salander-O'Reilly Galleries, New York

Both this drawing of 1915 and one from 1912 with the same title, *Negro Dance Hall*, document Stuart Davis's experiences in the bars and music halls that he frequented. In the 1912 sketch, Davis focused on the meeting of a couple on the dance floor; here, a solitary female figure is the main character, and the squatting position of the dancing woman in the background is derived from the stance of the woman in the earlier work. The present drawing was first published in the July 1915 edition of *The Masses* with the caption "Jersey City Portrait."[1]

This drawing exhibits an intriguing combination of sensitivity and stereotype. The woman in the foreground seems introspective and removed from her surroundings. Her posture—knees drawn up, arms folded, back turned on the action—and her faraway look communicate her withdrawal. While Davis rendered this figure individualistically, he cast those in the background in stereotypical African-American roles that prevailed during this period. The dancing woman's pose accentuates her buttocks and works to corroborate the myth of the highly sexed Negress whose primary attribute was her fertility. The two men at the right—one blowing smoke rings at the ceiling and the other casting his eyes downward at his turned-in toes—reinforce the stereotype of the lazy Negro. The mixed messages

communicated by Davis's drawing characterized his depictions of blacks at this time. The *Masses'* drawings actually sparked a debate between a reader of the magazine, Carlotta Russell Lowell, and Max Eastman, a *Masses* contributor. The reader claimed that Davis's pictures "depress[ed] the negroes themselves and confirm[ed] the whites in their contemptuous and scornful attitude." Eastman defended Davis, claiming that the artist treated all subjects, black and white, with the same objectivity. "He is so far removed from any motive in the matter but that of art," asserted Eastman, "that he cannot understand a protest such as Mrs. Lowell's at all."[2]

Negro Dance Hall exhibits the crude, sketchy drawing style appropriated from the French satirist Honoré Daumier, whose work the *Masses* artists studied and admired. Its composition, with the diagonally receding railing separating foreground from background, recalls Toulouse-Lautrec's late-nineteenth-century depictions of Paris café scenes.

LJS

[1] Rebecca Zurier, *Art for The Masses (1911–1917): A Radical Magazine and its Graphics* (exhib. cat.). With contributions by Earl Davis and Elise K. Kenney. New Haven: Yale University Art Gallery, 1985, p. 156.

[2] Ibid., p. 126.

13

Ebb Tide—Provincetown. 1913

Oil on canvas, 38 × 30 in. (96.5 × 76.2 cm.)
Collection Earl Davis. Courtesy of Salander-O'Reilly Galleries, New York

Although Stuart Davis is known for his extensive and painterly portrayal of the Massachusetts seaside town of Gloucester, he did spend the summer of 1914 in Provincetown, at a point when it was just beginning to attract artists and writers. Historians have noted that Provincetown has been subjected to the ultimate historical snub: We generally forget the fact that the Pilgrims landed there a full five weeks before they reached Plymouth. During the ensuing centuries, the town became the port of call of various men of the sea, and in the nineteenth century the whaling industry contributed to its growth and prosperity. Portuguese fishermen from the Azores mingled with the ubiquitous Yankees, and it is assumed that this population, which came to predominate, was more tolerant of artists—hence the attraction of this area. By the time Davis arrived there in 1913, just before the outbreak of World War I, several art schools could be found in Provincetown, most notably that of Charles Hawthorne and E. Ambrose Webster.[1] Karen Wilkin has proposed that Davis's retreat to Provincetown at this time provided him with an opportunity to reflect on the heady revelations he had experienced witnessing the Armory Show, which had taken place amid great controversy that same year.[2] Davis himself had exhibited five watercolors—*Servant Girls, Dance, The Doctor, Babe La Tour,* and *The Musicians*—all based on his observations of life during his peripatetic wanderings from New York to Newark to Hoboken to East Orange between 1910 and 1913.[3]

The impact of the Armory Show is certainly to be discerned in the present painting. Davis has rethought the sturdy, relatively straightforward realism of his so-called Ashcan works, and has adapted the poetic elegance of a Symbolist sensibility

to this depiction of a lone man in a hat, slouching across the sand dunes with either a lantern or his luncheon pail. We can detect influences from both the expressive linearity of Edvard Munch and the moody seascapes of Albert Pinkham Ryder; Davis would have seen graphic works by the former and paintings by the latter in the Armory Show. Although Davis exalted in the bright light of the Cape, and rhapsodized on how it transformed his vision and led to his working with intense, dense colors, this composition is notable for its more restricted palette of green and brown tones. Ryder's *Moonlight Marine* (The Metropolitan Museum of Art, New York. Samuel D. Lee Fund, 1934 [34.55]), which was exhibited in the Armory Show, bears a particularly apt visual relationship to Davis's composition, especially in the sinuous rings of alternately light and dark areas to define the evening sky and the ridges of the sand dunes exposed by the retreating tide.

The two summers in Provincetown not only effected a radical change in Davis's use of color, but there was also a general liberation of form and approach to his subject matter that distinguished his work from that of his Ashcan School elders. He began to widen his circle of acquaintances. An important new friend made at this time was Charles Demuth, an associate of Alfred Stieglitz's circle, who certainly would have been influential in broadening Davis's comprehension of modernist ideas.

LSS

1 See Dorothy Gees Seckler, *Provincetown Painters, 1890s to 1970s* (exhib. cat.). Edited and with a foreword by Ronald A. Kuchta. Syracuse: Everson Museum of Art, 1977.

2 Karen Wilkin, *Stuart Davis*. New York: Abbeville Press, 1987, p. 55.

3 See the exhibition catalogue, *International Exhibition of Modern Art*. New York: Association of American Painters and Sculptors, Inc., 1913.

14

Gloucester Landscape (Backyard View). 1916

Oil on canvas, 23⅞ × 29⅜ in. (60.6 × 74.6 cm.)
Collection Earl Davis. Courtesy of Salander-O'Reilly Galleries, New York

This view of a backyard is dominated by the clutter of sheds and a slightly overgrown garden. In the distance is another cluster of houses crowded close to one another just across the waterway. The freely stated brushstrokes and vibrant purples, greens, rich browns, terracottas, and stark whites distinguish Stuart Davis's work at this time. As in many of the compositions of this period, reality has been put to the service of a modernist compositional approach. While we readily recognize all the elements in a painting like this, the entire composition has been geared to annihilate all traditional spatial systems and the disciplining of the forms and colors in favor of an overall sense of design. The repetitious vertical elements—among them, plant stalks and stakes—are noteworthy here because they serve both to guide us through the jumble of the space and to unify this veritable cacophony of color and texture. Davis always asserted that the abstract elements of color and form were the real subject matter of painting, and this point of view allowed him to cogently address social involvement and artistic integrity as issues in his work throughout his career.

LSS

15

Hillside near Gloucester. About 1915–16

Oil on canvas, 18¾ × 22½ in. (47.6 × 57.2 cm.)

Museum of Fine Arts, Boston. Abraham Shurman Fund, 59.522

Stuart Davis changed summer locales from Provincetown to Gloucester, Massachusetts, upon the enthusiastic recommendation of John Sloan. According to Davis, Gloucester turned out to be "the place that I was looking for. It had the brilliant light of Provincetown, but with the important additions of topographical severity and the architectural beauties of the Gloucester schooner. . . . I went to Gloucester every year, with a few exceptions, until 1934, and often stayed late into the Fall. I wandered over the rocks, moors and docks, with a sketching easel, large canvases, and a pack on my back looking for things to paint."[1]

In this view of a distinctive tree and rock, and the series of landscapes done between 1915 and 1919 in Gloucester and in Tioga, Pennsylvania, also presented here, we see Davis experimenting with a variety of modernist styles that he would have studied firsthand at the Armory Show. For example, in this work the eccentric purples and aquamarines certainly relate to the color inventions of Gauguin and Matisse. We might even discern the influence of Mondrian in the thickly presented schematics of the forms—specifically, as they relate to the Dutch artist's early rendition of trees in his landscape paintings of about 1908. In a 1959 letter Davis noted that compositions like this were "examples of outdoor sketches from Nature. Sometimes I would do 3 or 4 in a day. . . . They were done with tube oil colors and a medium of linseed oil and turpentine . . . [and] the method was the product of direct and spontaneous reactions to certain landscapes. They should be regarded as exercises carried out in that spirit without other important consideration."[2]

LSS

[1] Stuart Davis, in "Autobiography." New York: American Artists Group Monographs, 6, 1945, n.p.

[2] Letter dated November 24, 1959, from Stuart Davis to Thomas N. Mayham, then assistant in the Department of Paintings, Museum of Fine Arts, Boston. Archives of the Museum of Fine Arts.

16

Gloucester Beach /A Cove (Rockport Beach). 1916

Oil on canvas, 30 × 24 in. (76.2 × 61 cm.)

Collection Earl Davis. Courtesy of Salander-O'Reilly Galleries, New York

The town of Rockport, Massachusetts, is just a few miles north of Gloucester, where Stuart Davis spent most of his summers starting in 1915. This bird's-eye view of Old Garden Beach[1] situates the viewer at the top of a promontory leading down to the cove. Davis has subdued our perspectival sense of the space, and subjected the landscape details to an allover cross-hatching, scribbling, and scumbling of one color onto another. Until we begin to discern such details as the sketchy figures on the large, kidney-shaped area of scumbled white paint, the composition seems to be an abstraction of relatively flat, blue, brown, green, and white elements. Several figures can also be seen standing on grassy knolls in the deep blue of the water, and a man and a woman appear to be following a strangely disjointed path at the lower-right side of the composition. Behind the stretch of beach we see brown vegetation, a portion of which is enclosed by a yellow-and-green sand dune. Beyond this area, to the right and upper right, are individual fallow fields, each plot divided by darker brown scrub. The rich, midnight blue of the water at the left side of the composition is picked up again in a band along the upper edge of the canvas. In another work

Figure 98. Stuart Davis. *Airview.* 1916. Oil on canvas. Collection Earl Davis. Courtesy of Salander-O'Reilly Galleries, New York

from the same year, entitled *Airview* (fig. 98), Davis seems to have reversed the shapes of the present composition and rendered the houses and roads in a more severely geometric manner.

LSS

[1] This site has been identified by William C. Agee and Robert Hunter.

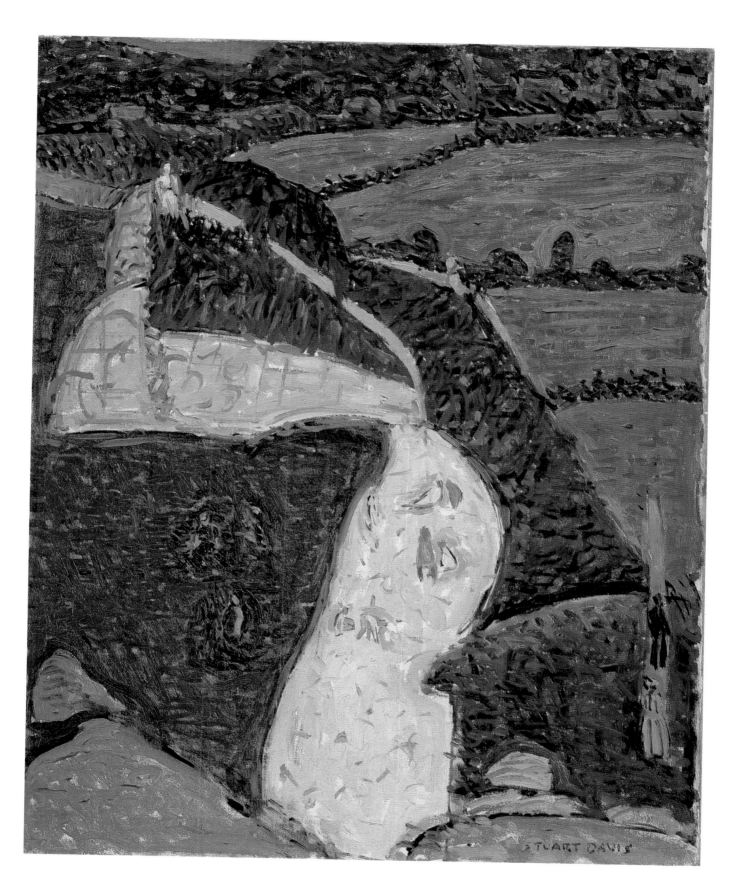

17

Summer House. 1916

Oil on canvas, 19 × 23 in. (48.3 × 58.4 cm.)

Collection Earl Davis. Courtesy of Salander-O'Reilly Galleries,
New York

18

Sketch—Church Tower. 1916

Oil on canvas, 23⅛ × 19⅛ in. (58.7 × 48.6 cm.)

Collection Earl Davis. Courtesy of Salander-O'Reilly Galleries,
New York

These two compositions of 1916 reveal an experimentation with abstraction that is surprisingly audacious at this point in Stuart Davis's career. The influence of Cubism is quite evident in the simplification of the architecture and the landscape elements in *Summer House*, and Futurism seems to lurk behind the wryly dislocated foundations of the buildings. The palette is restricted, if not subdued, and Davis has conceived the composition as a series of abutting shapes with diagonal lines that converge at various focal points. The vigorous upsweep of the forms sets up two primary lines of energy, one culminating at the top of the yellow tower at the left, and the other in the cross atop the eccentric dome of the terracotta-colored structure.

According to William Agee, *Sketch—Church Tower* was painted from Banner Ledge in East Gloucester. Of all the early experimentations with Cubist compositional structure and form that Davis carried out, this picture and *Untitled (House and Tree Shapes)* of 1916 (Collection Earl Davis) are the most daring. In both paintings, Davis reduced the entire composition to a series of flat planes, rendered in the

18

greens, grays, browns, and beiges of Braque's and Picasso's works executed just five years earlier. Here, the yellow church and tower, the greenery, and the brown areas of the landscape, as well as other miscellaneous structures and landscape details, interpenetrate, creating spatial shifts and a defiance of mass and volume that result in an interpretation of Cubism that is surprisingly sophisticated.

LSS

19

Boats Drying, Gloucester. 1916

Oil on canvas, 18½ × 22½ in. (47 × 57.2 cm.)
Private collection

This composition seems to represent some strange harbinger of patterned abstraction. It is, in fact, a depiction of rowboats marooned on piles at low tide. The intercutting of the forms is similar to that in *Sketch—Church Tower* (cat. no. 18) of the previous year. The repetition of the white crescent shapes of the boats on their piles effects an image that is both eerie and intriguing, and is a pertinent example of how Stuart Davis could transform scenes from real life into abstract compositions with great experimental verve.

At first, the peculiar character of the tides of the northern Atlantic coastline baffled the city-bred Davis. He recounts this amusing anecdote of his first boating ex-

131

19

periences in Provincetown in 1913: "On arrival I hired a room and a dory. My desire was to get into this boat and row around alot all over the place. I did, and at nightfall tied it up close to a piling where it floated on the same level with a wharf next to my room. Unfamiliar with the local habit of the sea, I was amazed next morning to find it hanging perpendicularly from its mooring. The water had disappeared, a large expanse of sand flats had taken its place. Ten foot tides were out of my experience, but adjacent townsmen thought the incident very funny."[1]

LSS

[1] Stuart Davis, in "Autobiography." New York: American Artists Group Monographs, 6, 1945, n.p.

20

Studio Interior. 1917

Oil on canvas, 18¾ × 23 in. (47.6 × 58.4 cm.)
Washburn Gallery, New York

Starting in 1913, Stuart Davis shared a studio in New York with Henry Glinten-kamp and Glenn Coleman in the Lincoln Arcade at 1931 Broadway. He stayed at this location until 1919, when he took an apartment on Greenwich Avenue. This jaunty view of the interior of the artist's studio certainly recalls Henri Matisse's *Red Studio* (1911; fig. 5). A rumpled bed hugs the lower-left edge of the composition, and at its foot a table is laid out with libations. To the right of this table is another, with additional glasses and what appears to be a typewriter. The center of the room is dominated by an easel and a phonograph, both painted purple to stand out among the predominating yellow tones of the composition. Two casual chairs and a draw-

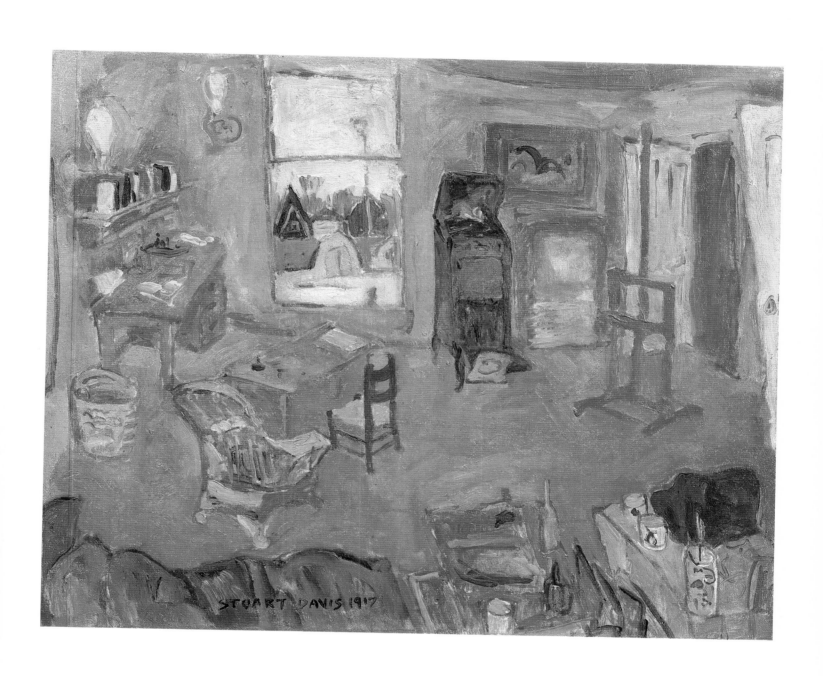

STUART DAVIS 1917

ing table can be seen at the left, and beyond them, against the left-hand wall, are a wastebasket, a desk, and a shelf full of books. One indistinguishable canvas hangs to the right of the phonograph, and another sits on the floor below it, turned to the wall. Two points of access to the outside are provided: the open double doors at the upper right of the composition, and the view through the window of city rooftops rendered as blue shapes, just left of the center in the upper half of the picture.

Karen Wilkin has suggested that several elements in Davis's composition are surrogates for those in Matisse's painting of his studio: for example, the phonograph approximates the clock in Matisse's picture and the wicker armchair the straight-backed chair at the right side of the *Red Studio*.[1] The implication is that the substitutions serve to point out the distinctions between European and American sensibilities. In the same vein, Meg Neville interprets the caricature-like quality of the scene as an attempt by Davis to reconcile the haughtier pretensions of French modernism with the more raw sensibility that is stereotypically American. She further suggests that, like the *Red Studio* and Vincent van Gogh's *Bedroom at Arles* (Rijksmuseum Vincent van Gogh, Amsterdam), this painting is a "metaphor for the self. . . . Davis . . . [evokes] . . . jazz . . . through the literal inclusion of an open phonograph . . . just as he illustrates his personal interest in painting and writing through the inclusion of an easel and a typewriter."[2] A similarly askew quality reappears in Davis's work in 1922–23 in several examples in a series of still lifes, the genesis of which seems to be the clutter on the tables at the bottom of this composition.

In December 1917, Davis opened the first solo exhibition of his work: a group of watercolors and drawings at the Sheridan Square Gallery in New York. The following year he was drafted into the army, and worked as a map maker in the Army Intelligence department.

LSS

1 Karen Wilkin, *Stuart Davis*. New York: Abbeville Press, 1987, pp. 61–62.
2 *Over Here: Modernism, The First Exile, 1914–1919* (exhib. cat.). Kermit S. Champa, developer. Providence: David Winton Bell Gallery, Brown University, 1989, p. 128.

21

Last Trolley—Gloucester. 1917

Oil on canvas, 19 × 23 in. (48.3 × 58.4 cm.)

Collection Earl Davis. Courtesy of Salander-O'Reilly Galleries, New York

The locale shown in this painting is Gloucester, Massachusetts, as attested by the tall masts of the ships seen in the distance, towering over everything else. Stuart Davis reminisced about this period in Gloucester's history in an autobiographical statement published by the American Artists Group in 1945: "Another very important thing about the town at that time was that the pre-fabricated Main Street had not yet made its appearance. Also the fact that automobiles were very few and the numerous attendant evils were temporarily avoided."[1] This is a peculiar observation from one who was an avid motorist early on, but Davis is clearly alluding to the

special charms of Gloucester that made it such a welcome relief from the bustle of city life.

This view of the trolley has been painted in intensely saturated blues, yellows, and greens and in various mixtures of these hues. The trolley has come to rest at the bottom of an incline, which is indicated by the tracks hastily sketched in in green at the left-hand side of the composition. The dusky blue of the sky indicates that night is nigh, and there seems to be an intense white reflection from the moon on the water seen just beyond the black roof in the center of the picture. What Karen Wilkin has described as the composition's "frontality and foursquareness"[2] serves to emphasize its geometric, grid-like character, which provides a curious contrast to the passion suggested by the thickly impastoed surface. Davis, here, anticipates the detached sensibility of Edward Hopper's work. The featureless figures are curiously removed from us and from each other and seem to function primarily to punctuate the pervasive yellow illuminating the interior of the trolley.

LSS

[1] Stuart Davis, in "Autobiography." New York: American Artists Group Monographs, 6, 1945, n.p.

[2] Karen Wilkin, *Stuart Davis*. New York: Abbeville Press, 1987, p. 73.

22

Garage. 1917

Oil on canvas, 19¼ × 23¼ in. (48.9 × 59.1 cm.)

Collection Earl Davis. Courtesy of Salander-O'Reilly Galleries, New York

By his own account, Stuart Davis's entry into Gloucester, Massachusetts was momentous: "When I made my initial entrance into this port at 18 miles per hour, in a classy second-hand roadster with two flat tires, I was ambushed by a cop on horseback. He chased me into a garage uncoiling a lasso as he got up momentum. I gained sanctuary, however, and the matter was amicably settled."[1] Davis was an inveterate motorist at a time when most people were convinced that these machines would be the downfall of society. He incorporated an array of motoring motifs into his work, early on and incessantly. Signs, gas-station pumps, cars, and road directions can all be found in his paintings through the 1930s.

This seemingly innocuous view of a filling station and garage is a motif that reappears in Davis's work. It is a vignette of *Multiple Views* (cat. no. 23), where it is depicted almost as it is here. This particular garage—perhaps a memento of Davis's initial arrival in Gloucester—also seems to occur at the center of *Town Square* of 1925–26 (cat. no. 62), and this last composition, in turn, forms the basis for the later *Report from Rockport* (1940; cat. no. 123). Davis included signs in his work to function both as design elements and as sly rebuses to guide the viewer in discerning additional meaning in the painting. Here, the invitation ENTRANCE at the right is amended in case we assume too much, and we encounter STOP at the extreme right of the picture.

LSS

[1] Stuart Davis, in "Autobiography." New York: American Artists Group Monographs, 6, 1945, n.p.

Multiple Views. 1918

Oil on canvas, 47 × 35 in. (119.4 × 88.9 cm.)
Collection Earl Davis. Courtesy of Salander-O'Reilly Galleries,
New York

Sometimes known as *Simultaneous Views*, this painting was executed in 1918, the
year that Stuart Davis was serving as a cartographer for Army Intelligence. It is a
curious work, almost a regression, after the rather bold experiments with Fauvist
color and Cubist form and space that he conducted particularly between 1915 and
1917. William Agee suggests that Davis was not quite "ready for an all out cam-
paign on Cubism."[1] One could also surmise that the interruption of his art work
during his service in the army necessitated a review of where he had been before he
could go on. Several compositions from the previous two years are mapped out in

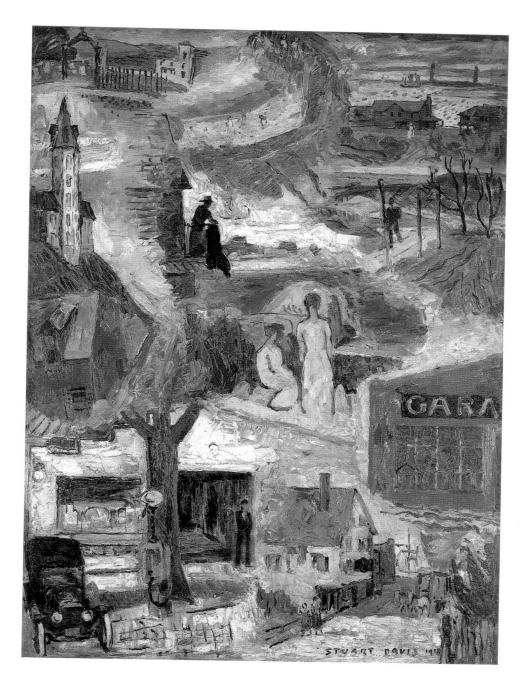

Figure 99. Stuart Davis. *Forty Inns on the Lincoln Highway*. 1916–17. Pencil and ink on paper. Collection Earl Davis. Courtesy of Salander-O'Reilly Galleries, New York

FORTY INNS ON THE LINCOLN HIGHWAY · NO.2

this painting. The garage in the 1917 painting entitled *Garage* (cat. no. 22) can be seen here, to the lower right; the automobile and gas pump in *Gas Station* of 1917 (Hirshhorn Museum and Sculpture Garden, Smithsonian Institution, Washington, D.C.) occupy the extreme lower-left corner. The white sand of Rockport Beach is visible in the center near the top edge of the composition, and we can find visual references to a number of other Davis paintings executed between 1916 and 1918, such as *Graveyard—Gloucester*, *Gloucester Terrace*, and *Giles Char* (all 1916; Collection Earl Davis).

Davis disregards the adjustments in size and color of conventional perspectival space. Brian O'Doherty likens the assemblage to "snapshots . . . articulated by means of fairly definite borders, like a soft-edged jigsaw. . . . The effect is one of simple addition rather than multiplication of parts and the introduction of simultaneity and sequences recalls the narrative habits of Trecento and comic-strip art. Davis keeps the parts separate and distinct, as if avoiding any effort to synthesize them into a unity. . . . The side-by-side accumulations of objects, memories and mementos persist . . . [in his work]."[2] The relationship to contemporary cartoons is reiterated by William Agee,[3] and, indeed, there is a humorous cartoon drawing by Davis, *Forty Inns on the Lincoln Highway* (1916–17; fig. 99), with a related composition in which he has depicted the trials and aggravations of modern travel.

LSS

1 William C. Agee, *Stuart Davis (1892–1964): The Breakthrough Years, 1922–1924* (exhib. cat.). New York: Salander-O'Reilly Galleries, 1987, n.p.

2 Brian O'Doherty, *American Masters: The Voice and the Myth*. 2nd ed. New York: Universe Books, 1988, p. 51.

3 Agee, op. cit.

Setting Sun, Tioga, Pa. 1919

Oil on canvas, 24 × 30 in. (61 × 76.2 cm.)

Collection Earl Davis. Courtesy of Salander-O'Reilly Galleries, New York

"The Tioga landscapes, painted while Davis stayed at a family summer place near the border between New York and Pennsylvania, are dense, solidified versions of the Gloucester townscapes. If Davis found real-life justification for Cubist planes in Gloucester architecture, he seems to have found an irresistible equivalence between the sun-drenched cornfields of Pennsylvania and van Gogh's views of the Provençal countryside near Arles."[1]

This landscape view fairly sizzles under the intense, yellow-white of the sun, which floods the heavens with an equally saturated yellow hue. Below, nestled under a stand of deep gray-green trees that rise to the upper right, lies a group of farm sheds. Their purplish tones are picked up by the leaves of the green corn plants, which proliferate in the lower half of the composition. Davis eschews a vista

here in favor of crowding the various elements in the composition in the foreground. Only the narrow border of brown along the bottom edge, representing the rich soil of the plant beds, provides a transition between the viewer's space and that in the painting—a sensation reinforced by the diagonal movement of the darker browns, indicating furrows. In this composition, Davis quite successfully conveys the sometimes subliminal associations that accompany descriptions of van Gogh's work. The scene literally pulsates with the feverish growth of midsummer as it unfolds through Davis's rhythmic, energetic brushstrokes.

LSS

1 Karen Wilkin, *Stuart Davis*. New York: Abbeville Press, 1987, p. 73.

25

Two Figures on Gloucester Road. 1919

Oil on canvas, 24 × 30 in. (61 × 76.2 cm.)
Collection Earl Davis. Courtesy of Salander-O'Reilly Galleries, New York

It is interesting to compare the technique of this painting with that of the view of the cornfield in Tioga, Pennsylvania (see cat. no. 24). While both works are certainly indebted to van Gogh, the Pennsylvania scene focuses on the dense color and saturated compositions of the Arles paintings (1888–89), while here Stuart Davis has composed the scene through the artful application of daubs of color that seem more "stitch-like" in character, recalling the paintings van Gogh executed in Saint-Rémy and Auvers-sur-Oise (1889–90). This particular stretch of the Gloucester landscape is dotted with mounds and rises, which encouraged Davis to establish a

rhythmic pattern of the forms, so that the two figures (a man dressed in dark clothing and the woman in a white dress, who is closer to us), both of whom are seen from the back—a favorite Davis conceit—are almost obscured from our view. Davis has laid down basic areas of yellow-green, ocher, and dark green, and then touched in darker or lighter shades of greens, reds, blues, and purples to define the dryer areas, some flowering plants, and large protruding rocks, respectively. The horizon line, where we see the roofs of a few buildings, is located almost at the top edge of the painting, and the sky is merely a band of grayish blue-green. As in *Setting Sun, Tioga, Pa.* (cat. no. 24), Davis employs a consistent saturation of color so that the overall effect is that of vertical, horizontal, and occasionally diagonal strokes of green, purple, red, blue, or orange paint, with the wavy lines of the contours of boulders and rises repeated throughout the composition.

LSS

26

Autumn Landscape. 1919

Oil on canvas, 24 × 30 in. (61 × 76.2 cm.)
Private collection

The silvery grays and the terracottas and greens of this landscape provide a nice contrast to the intense, hot colors of the paintings done a few months earlier in Tioga, Pennsylvania. Here, Stuart Davis's debt to van Gogh is not as obvious. He seems once again to be revisiting an earlier composition—specifically, *Gleam on the Lake* (Collection Earl Davis), executed in 1910. The center foreground of both compositions is occupied by a single tree, flanked by one or more others. We can glimpse

a stretch of water just beyond the foreground space; in the 1910 picture it is a lake, and in the 1919 work an inlet that empties into the ocean, which is seen in the third band of space. While the earlier painting is dominated by large, urban structures seen silhouetted against the skyline, this composition features one-family New England bungalows. The single tree that fills each composition appears two years later, in an abstracted state, in *Untitled* (cat. no. 35). This essential form would become a constant motif in Davis's work, recurring as late as 1957 in the monumental mural executed for the H. J. Heinz corporate headquarters, *Composition Concrete* (cat. no. 160).[1]

Although the biographical data on Davis for the year 1919 record his move to Greenwich Village, and his passing of the summer in Tioga, the only evidence of a visit to Gloucester is paintings such as this. It would seem from the tonalities of this work and those of *October Landscape* (Collection Earl Davis), another Gloucester scene from the same year, that Davis was there in the fall of 1919, before he embarked for Cuba in December with Glenn Coleman.

LSS

[1] This was noted by William Agee.

27

Yellow Hills. 1919

Oil on canvas, 24 × 30 in. (61 × 76.2 cm.)
The Santa Barbara Museum of Art. Gift of Heyward Cutting

In *Yellow Hills*, we see a scumbled sky like that observed in *Setting Sun, Tioga, Pa.* (cat. no. 24), and an appreciation of the varieties of color and texture in the scene, which are expressed with immediacy by Stuart Davis's skillful and deliberately wielded paintbrush. We are led into the composition by the cluster of trees and the shrubs at the bottom edge of the canvas. They only partially obscure the succession of cultivated plots in greens, beiges, and more unorthodox shades of orange, red, blue, purple, and the brilliant yellow at the crest of the hill. The saturated colors make everything seem near, so we experience this scene both in the intimacy of its detail and as a vista from the level of the railroad tracks, one of whose ties is visible at the bottom of the composition.

Although James Johnson Sweeney identified this as a Tioga landscape,[1] the handling of the paint would seem to confirm that it was among the paintings Davis executed in Gloucester during the fall of 1919.

LSS

[1] James Johnson Sweeney, *Stuart Davis* (exhib. cat.). New York: The Museum of Modern Art, 1945, p. 13.

28

Self-Portrait. 1919

Oil on canvas, 23 × 19 in. (58.4 × 48.3 cm.)

Collection Earl Davis. Courtesy of Salander-O'Reilly Galleries, New York

144

Self-Portrait. 1919

Oil on canvas, 22¼ × 18¼ in. (56.5 × 46.4 cm.)

Amon Carter Museum, Fort Worth

Unlike the earlier, 1912 *Self-Portrait* (cat. no. 3), in which Stuart Davis depicted himself as one of the cast in a fleeting street drama, these two self-portraits concentrate on the artist's physiognomy. Davis uses brilliant color and a more or less regimented application of thick daubs of paint. A similar handling of paint and texture can be seen in the landscapes of Tioga, Pennsylvania (see cat. no. 24), which date to 1919 as well. This stylistic treatment also seems to hark back to the series of starkly conceived portraits that Davis executed some six years earlier. Even in the landscape studies of the period 1915–17, which borrow heavily from Cubism, Davis retains some of the strong color and physical character of the paint of *Portrait of a Man* (cat. no. 4).

In the self-portrait that is catalogue number 28, Davis cuts a rather dashing figure, the collar of his white shirt open and an exotic Chinese hat on his head. He stares out at the viewer, although there is a slight wariness to his expression. The warm yellow tones of the hat are quite close in value to the artist's skin tone, and he appears before a brown wall to the right and a blue screen against a black background to the left. In the portrait seen in catalogue number 29, the signals are more introverted. The artist wears a dark shirt that is carefully buttoned and the collar drawn up around the neck. He stands before what appears to be a mirror, but there is no image reflected. His gaze is more furtive, and he seems a bit wan. The unkempt state of his hair suggests that he is not in the best condition either physically or psychologically, but this morose posture is belied by the picture's intense colors. Davis's electric-blue shirt is set against the brownish red void within the yellow-and-brown frame. His yellow pallor is similar to that in the self-portrait in catalogue number 28, but here it is accented with occasional brown and white tones, and garish greens at the jowls, chin, throat, and eyes—the last also rimmed with pinkish beige. This color is used as well around the ears, along with the bright red that defines the lips.

These portraits were completed on the eve of Davis's trip to Cuba in the company of Glenn Coleman. They are among the last of the monumental figure studies that the artist would do. While in Cuba he did execute a series of delightful watercolors that celebrate the exuberant mood of street life in Havana in the jaunty poses of the silhouetted figures (see cat. nos. 30, 31). His return to New York marked a new phase in his work, when he would seriously pursue his own particular interpretation of the Cubist vocabulary.

LSS

Dancers on Havana Street. 1920

Watercolor on paper, 23 × 15⅝ in. (58.4 × 39.7 cm.)
Collection Earl Davis. Courtesy of Salander-O'Reilly Galleries,
New York

Havana. 1920

Watercolor on paper, 14 × 20 in. (35.6 × 50.8 cm.)
Washburn Gallery, New York

At the conclusion of the Spanish-American War in 1898, Spain's Caribbean colony, Cuba, became an independent republic under the supervision of the United States. Although military occupation of Cuba ended in 1902, American business interests continued to influence the economic development of the island. After a brief boom during World War I, the sugar market—which had been the main source of the island's prosperity—collapsed. Gerardo Machado y Morales, who became president of Cuba in the 1920s, attempted to redress the island's dependence on a single cash crop. In addition to diversifying agricultural output and developing mining and new industries, an emphasis was placed on attracting tourism.

Stuart Davis, then twenty-seven years old, arrived in Havana with his friend Glenn Coleman in December 1919, and stayed for two months. The apocryphal story is that Davis went to recover from a bout with the flu, but it is more likely he and Coleman were merely out for an adventure. Davis's recollections reveal a young man's delight in the more risqué aspects of life, as seen in the two dozen or so watercolors that serve as a memento of this trip.[1] In *Dancers on Havana Street*, Davis focused primarily on Havana street life. Spirited figures, for the most part women, promenade and even dance in the streets and the plazas, often under the scrutiny of others who look down from wrought-iron balconies or lurk in doorways. *Havana* is a view of the main square in the old city, where the cathedral is located. Again, there are gesticulating figures, here cavorting on the cathedral steps, and to the

lower right a woman proceeds down a street where one might still find the "Bodequita del Medio," a restaurant and gathering place later frequented by Ernest Hemingway.

The rendering of these watercolors provides a marked contrast to the landscapes of Tioga, Pennsylvania, and Gloucester that Davis painted during the summer and fall of 1919. Here, the cheery, transparent washes of pinks, blues, mauves, browns, yellows, and greens, which broadly and summarily map out the scenes, indicate the influence of Gauguin and Matisse—as opposed to van Gogh. Yet, they also recall the watercolors of urban places and people Davis painted between 1910 and 1913. While the specificity of detail has been jettisoned, these watercolors, almost a decade later in date, indicate a similar, wry observation of articulated figures occupied by the peculiarities of their own lives.

Davis was not the only American artist to spend time in the Caribbean between the two world wars. Alice Neel also lived in Havana for a year with her husband, Carlos Enríquez, between 1926 and 1927. David Smith and Dorothy Dehner were in the Virgin Islands for eight months, from 1932 to 1933—Smith's *Seashell and Map*, in the collection of the Metropolitan Museum, was executed during this period —and Joseph Stella spent a year (1937–38) in Barbados, when he accompanied his ailing wife, Geraldine, to her native country.

LSS

[1] See Karen Wilkin's article on Davis's Cuban trip, "Stuart Davis: The Cuban Watercolors," *Latin American Art* 2, 2 (Spring 1990), pp. 39–43.

32

Lucky Strike. 1921

Oil on canvas, 33¼ × 18 in. (84.5 × 45.7 cm.)
The Museum of Modern Art, New York. Gift of The American Tobacco Company, Inc., 1951

33

Cigarette Papers. 1921

Oil, bronze paint, and pencil on canvas, 19 × 14 in. (48.3 × 35.6 cm.)
The Menil Collection, Houston

At first glance, these compositions seem to be collages, but they are actually painted versions of the packaging for tobacco and for cigarette papers, respectively. In a series of four paintings executed in 1921–22 (including *Sweet Caporal* and *Bull Durham*, figs. 88, 100), Stuart Davis uses consumer-oriented packaging to explore the conventions of Cubism. The transient relationship between two and three dimensions explored by the French Cubists is achieved in these paintings by simply reproducing the visual information on the three-dimensional package when it is opened up and flattened out into its original two-dimensional design. "Their abstractness is partly a function of their fragmentation. Unlike the . . . Table Still Lifes [see cat. nos. 43–46], which remain . . . about things placed on a horizontal surface in a logical way, the Tobacco pictures are about wholly unreal relationships. The component elements retain their original patterns, textures, and texts. . . . "[1]

Figure 100. Stuart Davis. *Bull Durham.*
1921. Oil on canvas. The Baltimore
Museum of Art. Edward Joseph
Gallagher III Memorial Collection,
BMA 1952.208

32

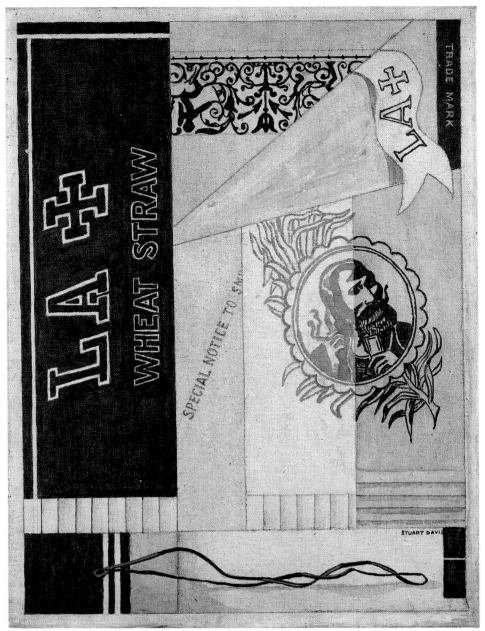

33

Davis has undoubtedly taken liberties with actuality to further his compositional goals. *Cigarette Papers* calls our attention to Davis's skill at trompe-l'oeil illusion in the twisted bit of string at the bottom (which may be the strip that was removed to open the package). It has been carefully rendered so that its three-dimensional existence—confirmed by its cast shadow—contrasts with the thinly painted flatness of the rest of the composition. One sheet has been partially pulled from the package and its corner folded down. The rest of the cigarette paper veils the cameo-like male head of the dominant advertising image. The pennant with the logo LA + seems to have lifted itself off the paper and to be flapping freely in space and casting an improbable shadow on the surface beneath it. In *Lucky Strike*, the rendering takes on a more "mechanical" character, particularly in the repetitious "bronze" relief elements at the top of the composition and the schematic form at the bottom. The paint surface is more forceful, and there is a stronger emphasis on the

vertical/horizontal relationships, with various curved and circular elements providing visual contrast.

Along with Gerald Murphy,[2] Stuart Davis is credited with being a pioneer in introducing American consumer-inspired imagery into the modernist syntax in the early 1920s. In his notes, Davis records his admiration for the techniques of advertising; he sees it as a means to move away from the temptation to sentimentalize in representation: "Don't emotionalize. Copy the nature of [the] present—photography and advertisements, tobacco cans and bags and tomato can labels."[3] The impact of these compositions is also predicated on the degree to which packaging has come to dominate our consciousness as consumers. Daniel J. Boorstin writes: "Packaging (as it displaced *packing*) created whole new vistas for the consumer. . . . While packing was designed to transport and to preserve, packaging was designed to *sell*."[4] Davis cannot have been unaware of the subliminal psychological impact of the brand names he chose. *Lucky Strike*, for example, was so named to capitalize on the gold fever that had captivated America during the 1850s, when this tobacco product was first introduced.[5] Perhaps Davis felt that he, too, had found a "lucky strike" in this subject matter, which propelled his artistic development into another dimension.

While Murphy, then working in Europe, was more directly influenced by the pristine, even decorative interpretation of Cubism by Amédée Ozenfant and Le Corbusier, Davis remained truer to that much-vaunted American empiricism. The paintings in the Tobacco series have been compared to the work of John F. Peto and William Harnett (see fig. 32), whose nineteenth-century still-life compositions manifest an abstracted, planar quality that foreshadows the planar dimensions of Cubist collage (of 1913–15). Thus, Davis reached back into history to proclaim both his Americanness and his modernity. His was a unique achievement, and he was conscious of that fact: "I feel that my tobacco pictures are an original note without parallel so far as I can see. It is along these lines I wish to develop. In poetry we have Lindsay, Masters, Sandburg and Williams, all in some way direct descendants of Whitman our one big artist. I too feel the thing Whitman felt and I too will express it in pictures—America—the wonderful place we live in."[6]

LSS

[1] Karen Wilkin, *Stuart Davis*. New York: Abbeville Press, 1987, pp. 91–92. *Sweet Caporal* is the only composition in this group characterized by an arrangement of disparate, albeit related, elements, rather than by the almost rigid presentation of congruent rectangular panels that comprise the totality of the other compositions.

[2] Gerald Murphy (1888–1964) was the second son of Patrick Francis Murphy, owner of the New York store Mark Cross. After graduating from Yale he worked briefly in the family business before studying architecture at Harvard. Murphy went to Europe ostensibly to study English gardens. He and his wife settled in Paris, where Murphy became involved in avant-garde art circles. Murphy was noted for his designs for stage sets, and his paintings came to signify the new American spirit that captivated the French especially in the early 1920s. Like Davis, he isolated icons and logos that represented modern American society.

[3] Stuart Davis, Notebook: 1920–22, December 4, 1920. Private collection.

[4] Daniel J. Boorstin, *The Americans: The Democratic Experience*. New York: Vintage Books, 1973, pp. 434–35.

[5] Robert K. Heimann, *Tobacco and Americans*. New York, Toronto, and London: McGraw-Hill, 1960, p. 132.

[6] Davis, op. cit., May 29, 1921.

Untitled (Greek Backwards). 1921

Watercolor and pencil on paper, 23 × 17¼ in. (58.4 × 43.8 cm.)
Collection Earl Davis. Courtesy of Salander-O'Reilly Galleries,
New York

Untitled. 1921

Watercolor and pencil on paper, 23 × 17 in. (58.4 × 43.2 cm.)
Collection Earl Davis. Courtesy of Salander-O'Reilly Galleries,
New York

Upon his return from Cuba, Stuart Davis began to tackle seriously the issues of
modernism that he had encountered at the Armory Show—specifically, Cubism.
The seeds of this effort can been seen in several of the Gloucester scenes done be-
tween 1915 and 1917, such as *Summer House* and *Sketch—Church Tower* (both
1916; cat. nos. 17, 18). As indicated in these two works, *Untitled (Greek Backwards)*
and *Untitled*, the experience of using the watercolor medium in Cuba had opened
up Davis's method of working, after the densely conceived 1919 landscapes. (He was
to pursue the goal of a freer style for some time, and one can read a self-exhortation
to "loosen up" in his 1922 notebook.)[1] In the group of collages and simulated collages

—such as these two—executed in 1921, Davis's orchestration of the various shapes with some patterning reminds us of the decorative aspects of the Cubist style of 1913–14. Yet, the individual zones or episodes in these works do not imitate the tightly conceived, morphological unity that French Cubism manifests. Davis acknowledges the vocabulary, but assembles it in an entirely original syntax.

Untitled (*Greek Backwards*) features the word *Greek* literally written backwards. As in *ITLKSEZ* (1921; fig. 8), Davis indulges in sarcastic mimicry of public opinion about modern art—in the first instance, with regard to its seeming illegibility ("It's Greek to me!") and deceptively elemental character ("It looks easy!"). The Cubists' love of punning and their appreciation of the formal potentialities of typography clearly influenced Davis. The Cubist appropriation of trompe l'oeil is seen in the illusionistic tear at the top of the vertical element in *Untitled* (*Greek Backwards*), which connects with the trio of triangular forms; these, in turn, aim an arrow-like projectile at the curvilinear element contained in the incomplete rectangle. The posture of this mysterious form reminds us of the languid poses of some of the figures in Davis's Cuban watercolors. A pointillist shape hovers above the scene.

Untitled seems to present a series of disjointed vignettes, which may be landscape or still-life referent. The top of the composition includes several vertical, pole-like elements. These segue into an expanse of a single color, which metamorphoses into a kind of helmet. From here, a line connects with what seems to be the beginning of a rim or the bottom of some appliance or tableware item, whose form has dissipated into a phantom shape. The right side of the main central form overlaps a second shape—this, in turn, is pierced by a form containing three horizontal lines —the bottom of which dissolves into a trapezoid in which several lines are inscribed, creating scumbled shadows.

In the early 1920s, Davis searched for the means by which he could focus on the abstract elements of painting, such as space, color, and form. He wanted to override the "sentimental" aspects of representation and to "create a direct impression on the spectator without taking him into the picture. . . . [T]he shapes used could be familiar forms such as a head, an ink bottle, a wheel, etc. . . . however, the representative elements could be obliterated by drawing say the outline of a head and then filling the space with a tobacco label."[2] Although Davis would later express a strong dislike of Surrealism, the technique described here is surprisingly close to the particular form/identity transpositions that René Magritte achieved in his work beginning in the 1930s. Davis has also created an equivalent of the mechanomorphic imagery of Marcel Duchamp and Francis Picabia with his neutral shapes and forms that appear as substitutes for human ones, constantly metamorphosing in conjunction with the other components in a composition. The dynamics of (human) interaction are visually mapped out by the various directional elements, which come to have a more prominent role in Davis's oeuvre starting in the 1940s. Also comparable is the mnemonic and structural role of language in Davis's work. In November 1921, he critically noted: "Words will have a place [in my art] also (just as in movies captions are necessary)."[3] This infatuation with the cinema informed much of the conceptual basis of modernism, and Davis paralleled this interest in integrating film, photography, and then television into his pictures. These developments in Davis's art coincided with his contact with the New York avant-garde. Just a year earlier (1920), William Carlos Williams had selected an untitled 1916 drawing of Gloucester by Davis for the frontispiece of his collection of poems *Kora in Hell* (see fig. 30).[4]

LSS

1 William C. Agee, *Stuart Davis (1892–1964): The Breakthrough Years, 1922–1924* (exhib. cat.). New York: Salander-O'Reilly Galleries, 1987, n.p.

2 Stuart Davis, Notebook: 1920–22, December 4, 1920. Private collection.

3 Ibid., November 21, 1921.

4 See Dickran Tashjian, *William Carlos Williams and the American Scene, 1920–1940* (exhib. cat.). New York, Berkeley, Los Angeles, and London: Whitney Museum of American Art, in association with the University of California Press, 1978, pp. 61, 62, figs. 27, 28. The Davis drawing is similar in style and content to *Gloucester Terrace* of 1916 (Collection Earl Davis) and *Multiple Views* of 1918 (cat. no. 23).

36

36

Tree. 1921

Oil on canvas, 12 × 16 in. (30.5 × 40.6 cm.)

Collection Earl Davis. Courtesy of Salander-O'Reilly Galleries, New York

37

Garden Scene. 1921

Oil on canvas, 20 × 40 in. (50.8 × 101.6 cm.)

Collection Earl Davis. Courtesy of Salander-O'Reilly Galleries, New York

37

38

39

Tree and Urn. 1921

Oil on canvas, 30 × 19 in. (76.2 × 48.3 cm.)

Collection Earl Davis. Courtesy of Salander-O'Reilly Galleries, New York

Tree and Urn. About 1952–54

Oil on canvas, 30 × 19 in. (76.2 × 48.3 cm.)

Collection Cornelia and Meredith Long, Houston

As Stuart Davis resumed his analysis of Cubism in 1921, he executed a series of compositions that recall some of the decorative as well as the coloristic aspects of the art of his French predecessors. *Tree* is the most severely rendered of these compositions. Here, the tree, a favorite motif, assumes an abbreviated Y shape that would recur intermittently in Davis's work throughout his career (see cat. nos. 160, 161). The surrounding landscape (background) has been organized into imprecise rectangular planes of color, all brushed in in a consistently horizontal direction. The distribution of the beiges, browns, and greens, with yellow and white touches, seems to approximate the actual occurrences of these colors in a natural landscape scene. The only other explicitly evocative element in the composition is the white arc, outlined in black—most likely a road—that extends from the bottom right up to and behind the trunk of the tree. This trajectory may continue traversing the space in the form of the black line that emerges to the left of the tree.

This Y-shaped tree reappears at the left of *Garden Scene,* also painted in 1921. *Garden Scene* features the same irregular division of the background into interlocking shapes, but this time they have a variety of textures. At the right side of the composition, we see a curious configuration that seems at once to be architectural in nature or to relate to garden statuary. At any rate, Davis maintains the same evenhanded treatment of forms and surface in this painting, which implies an equality of technique and subject that was to inform his work throughout his career and become the central thesis of his art theories.

In *Tree and Urn* (cat. no. 38), the central tree image has assumed a gesticulating pose, with several branches going off to the left and right in an upward direction and a single one on the right curving downward. The tonalities in *Tree* and *Garden Scene* are primarily green, brown, and gray; here, gray, with touches of brown, predominates. Davis activates the space in between and among the forms with unexpectedly bright hues and textured brushstrokes so that the distinctions between figure and ground are diminished. The urn in the lower-left corner has been twisted in space much like the manipulation of the absinthe glass in a painting by Picasso of 1913. One also cannot help but remark on the similarity of the three-layered base of the urn to the motif in an untitled abstraction by Davis (see cat. no. 35).

Davis returned to this composition twice in the 1950s, in works that are relatively unmodified explorations of the forms as flat planes of bright blue, red, green, black, and white (see cat. no. 39).

LSS

40

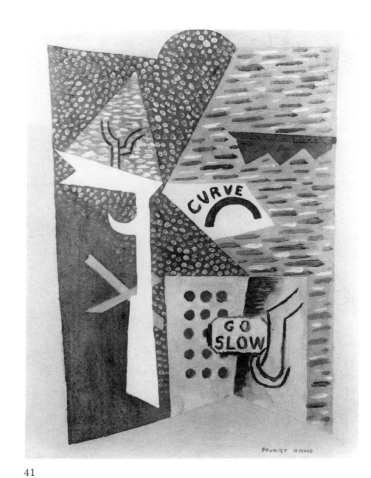

41

Landscape, Gloucester. 1922

Oil on board, 16 × 12 in. (40.6 × 30.5 cm.)
Collection Phyllis and Jerome Lyle Rappaport

Landscape. 1922

Oil on board, 15¾ × 11½ in. (40 × 29.2 cm.)
Collection Earl Davis. Courtesy of Salander-O'Reilly Galleries,
New York

Landscape, Gloucester. 1922

Oil on canvas, 12 × 16⅛ in. (30.5 × 41 cm.)
Collection John F. Lott, Lubbock, Texas

Although Stuart Davis became increasingly involved with still-life painting in the
1920s, he continued to explore the Gloucester landscape that had afforded him rich
opportunities to experiment with modernist idioms during the previous decade.
This trio of small landscapes—all approximately the same size—is a key to our un-

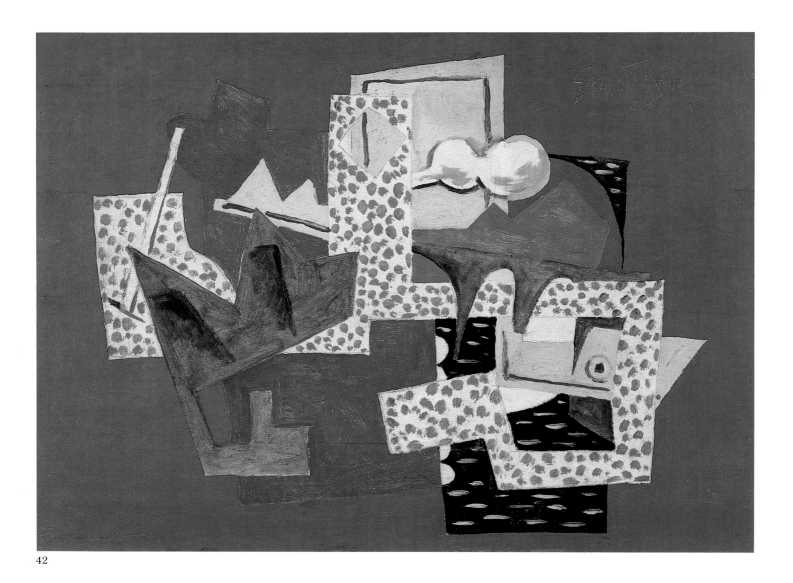

42

derstanding of Davis's work during this period and later on, as these compositions would form the basis of many future ones, particularly during the 1950s.

While Davis experimented with Cubism from several different approaches in 1921–22, these three works are distinguished by the artist's adroit adaptation of the textural and planar aspects of Cubist invention. Each painting accomplishes a specific task within the course of Davis's experimentation. *Landscape, Gloucester* (also known as *Still Life with Saw*; cat. no. 40) is arranged like a still life. The gray wedge becomes an architectural structure out of which a curved element (smoke) emerges and enters the green area patterned with yellow dots that has the particular configuration of the handle of a saw; the pale blue blade is situated right below this green area. In another interpretation, the intermittent daubs of paint within the "blade" can also be waves on the water, and the form outlined in gray the edge of a boat; the green shape, then, would be the grassy shore area. However, the yellow and the white areas in the background seem to be sheets of paper on one of which the letters GAR are written (perhaps referring to *Garage*: see cat. no. 22, or to Gar Sparks, an artist friend of Davis's),[1] and what appears to be a tube or pole is outlined in brown. While Davis is certainly demonstrating his comprehension of such Cubist strategies as creating collages of typographical elements and effecting visual tensions through trompe l'oeil, he invalidates them as painterly devices by rendering the entire composition with the same sketchy, slightly clumsy brush-

work. Given the fact that this composition would form the basis of several paintings done in the 1950s, one would assume that the grid-like arrangement is a later addition to provide the scale for the larger, subsequent versions. Yet, a sketch from a notebook that Davis kept from 1920 to 1922 shows that this kind of grid, which he called a "mesh," was a method used to pinpoint the "rhythm" of the two-dimensional design of a composition.[2]

In *Landscape* (also known as *Curve—Go Slow*), Davis achieves a much more cogent and comfortable interrelationship among the compositional elements. Several wedge or triangular shapes radiate from the juncture of the white tree-like form, the two blue wedges stippled with yellow, and the yellow parallelogram inscribed with the word CURVE—demonstrating that phenomenon. Again, it is a shoreline scene. The right-hand side of the picture is dominated by the blue area daubed with darker blue and white strokes. The front end of a boat can be seen progressing through the choppy waves. There is another body of water, contained by the areas of yellow-stippled blue, in which a tree is outlined in black; its Y shape derives from the two 1921 Cubist compositions *Tree* and *Garden Scene* (cat. nos. 36, 37). At the bottom of the composition is a kind of inset area, whose gray tonalities contrast with the blues above and around it. Is that the trunk and limb of another tree that we see near a series of flashing lights and a road sign admonishing us to GO SLOW? The entire composition is then set off against the stark, flat form that is half tree, half roadway. Again, we have to wonder if Davis is giving himself and the spectator verbal directions with the signs, which are like those one would expect to come upon while motoring. The eccentricity of the contours of the painting within the confines of the board on which it is painted is a convention that would be elaborated on the next year in the landscapes that Davis did in New Mexico (see cat. no. 49).

Landscape, Gloucester (cat. no. 42) is the most complex of these three paintings, and may be deemed the most accomplished in terms of Cubist compositional tour de force. Davis has created painterly equivalents of collaged paper in the flat, decorative planes that overlap and open out into one another in a riot of visual input. Davis carries over the standard referential vocabulary: horizontal daubs to indicate water, stippled or dotted areas to indicate land. Now, there are also silhouettes of houses at the upper right, the double sails of a boat at the upper left, and a bulbous cloud formation in the upper center. The entire compositional ensemble, with its panoply of jagged edges and irregular contours, sits squarely against the background. Davis's particular accomplishment in balancing the disparate elements of this composition reminds us especially of the work of Braque and Picasso in 1913–14. The interesting difference is that Davis adapted a vocabulary to the landscape genre that had been developed primarily to accommodate the still life. It would seem that in these paintings the abstracted landscape has become an objectified element itself, again blurring the lines between still life and landscape.

Davis would rediscover these pictures in the early 1950s, and they would form the compositional kernels for several of his most important paintings of that period. *Landscape, Gloucester* (cat. no. 40) would be the basis for *Rapt at Rappaport's* and *Semé* (cat. nos. 147, 148), *Landscape* the source for both *Composition Concrete* and *Combination Concrete* (cat. nos. 160, 161), and *Landscape, Gloucester* (cat. no. 42) would inspire *Colonial Cubism* and *Memo No. 2* (cat. nos. 152, 153).

LSS

[1] Gar Sparks also owned the Nut Shop in Newark where Davis executed his first public wall decoration (1921); a menu of the delectables available in the store was written on the wall in eccentric typography. See the essay by Lewis Kachur, pages 97–108, and fig. 89.

[2] Stuart Davis, Notebook: 1920–22, May 20, 1922. Private collection.

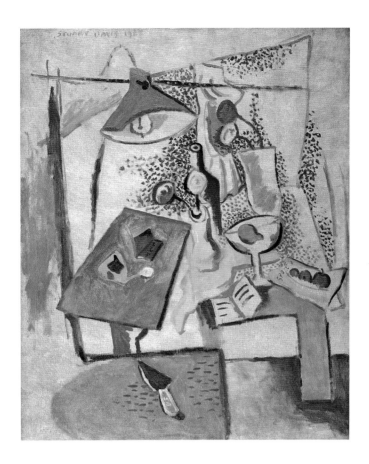

43

Three Table Still Life. 1922

Oil on canvas, 42 × 32 in. (106.7 × 81.3 cm.)
Collection Edward J. Lenkin

44

Still Life with "Dial." 1922

Oil on canvas, 50 × 32 in. (127 × 81.3 cm.)
Collection Earl Davis. Courtesy of Salander-O'Reilly Galleries,
New York

45

Still Life (Red). 1922

Oil on canvas, 50 × 32 in. (127 × 81.3 cm.)
Collection Earl Davis. Courtesy of Salander-O'Reilly Galleries,
New York

46

Still Life (Brown). 1922

Oil on canvas, 50 × 32 in. (127 × 81.3 cm.)
Collection Earl Davis. Courtesy of Salander-O'Reilly Galleries,
New York

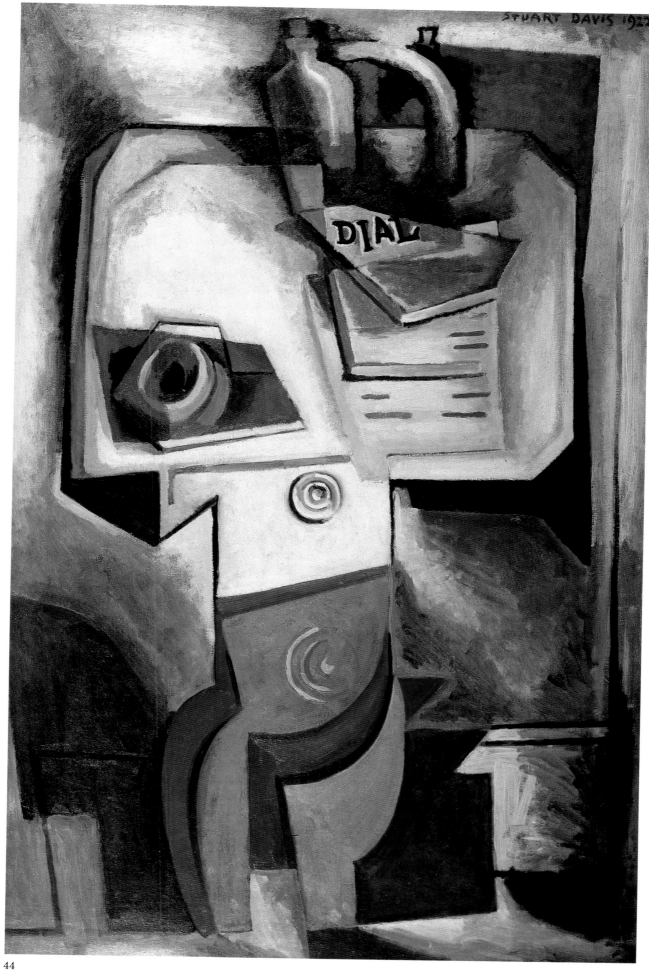

44

45

46

According to William Agee, at least two of these four imposing compositions were exhibited at the Whitney Studio Club in New York in 1926. "These paintings have a weight and authority, a gravity and reach distinctly new in his [Davis's] art. By any standard, they are among the greatest monuments of American Cubism, and, indeed, more than hold their own in the order of post-1918 international Cubism."[1] Agee proposes that *Three Table Still Life* is the earliest of the four compositions. It has an awkward, unfinished quality, the paint throughout appearing sparse, as if it were scrubbed, especially in those passages with the tables. Stippling similar to that employed in decorative Cubism, c. 1913–14, sets off the lamp at the top of the composition and activates the space around the still-life arrangements of fruit and flowers on the green table at the right. Closer scrutiny reveals that this decorative element also defines the folds of the draperies in the background. The space is framed by the curtain rod at the top of the composition, the edge of the curtain at the right-hand side, and the strong black line at the left that continues downward, articulating the form of the yellow table at the bottom of the picture. Davis combines elements familiar from Cubist still lifes—such as the pear in the fruit bowl, the flowers in the vases, the apples in the dish, and the trowel on the yellow table— with a decidedly American touch. Tobacco products, which in French Cubist works are usually clay pipes, or occasionally matchbooks, here appear as a book of ciga-

rette papers and a pouch of tobacco with the name DURHAM emblazoned on it.[2] The motif of the metal-shaded lamp flung over a horizontal rod would be a recurring one in the 1930s in Davis's abstracted views of Gloucester.

While the individual elements in *Three Table Still Life* are isolated from one another in separate pockets of space, the other three compositions—*Still Life (Red)*, *Still Life (Brown)*, and *Still Life with "Dial"*—show an interconnectedness among line, color, shape, and plane that is more recognizably Cubist. One can discern an interesting synthesis of the work of Braque, particularly in the "furniture" in Davis's pictures, which reminds us of the French artist's *Guéridon* series. The influence of Juan Gris can be seen in the planar shifts that cut vertically through Davis's compositions. *Still Life (Brown)* is the most fragmented representation, in which Davis extends the presentation of simultaneity and contingency in a most original manner. Various elements, such as the fruit bowl, fluted vase, pears, and apples, reappear in all but *Still Life with "Dial."* This last work, which is distinctly blue and purple in tonality, depicts a table on which are three copies of the avant-garde magazine *The Dial*,[3] with what appear to be an inkwell and a notebook. At the top of the composition there is a bottle with a curved handle. Whereas the tables in the other three paintings are set at diagonals, in *Still Life with "Dial"* the centrally placed table is uptilted to reveal the objects on top. This is, by far, the most pristine in presentation of the four pictures.

In his notebook, Davis goes back and forth on the subject of Cubism and European modernism. On the one hand he takes American artists to task for their "foolish worship of a foreign god,"[4] which only serves to drive up the prices of European art. American artists should not ignore their own abilities, he argues, for, after all, "America is unquestionably the healthiest nation in the world today."[5] Then, in a notebook entry one month later, Davis euphorically declares how "Cubism has freed drawing and it is now the artist's privilege to express himself in any terms he desires."[6] However, he also notes that this does not abrogate previously expressed opinions. About this time, Davis began to articulate the subject matter that would be appropriate to a new American art, singling out jazz music, advertising, newspapers, and figures from popular culture. Yet, while occasionally overstating the value of this American popular culture as a theme, Davis does seriously espouse Cubism as a means toward the achievement of paintings in which all subject matter is equal, since it ultimately will be submitted to an analysis of color, line, texture, and shape—and, for Davis, these would always constitute the real subject of a painting.

LSS

1 William C. Agee, *Stuart Davis (1892–1964): The Breakthrough Years, 1922–1924* (exhib. cat.). New York: Salander-O'Reilly Galleries, 1987, n.p.

2 There were two tobacco companies using the name Durham: Durham Tobaccos and Bull Durham; the latter became the best-known brand in the United States. For information on the American tobacco industry, see Robert K. Heimann, *Tobacco and Americans*. New York, Toronto, and London: McGraw-Hill, 1960.

3 *The Dial*, published from 1920 to 1929, was a magazine that provided a forum for modernist writers and critics, and illustrated the works of painters and sculptors. Founded and sustained by Scofield Thayer, it was another permutation of a magazine of the same name that was first edited in the 1840s as an organ of the Transcendentalists, and then appeared in various guises in Cincinnati, Chicago, and eventually New York, between 1860 and 1920. Several of Davis's drawings were reproduced in the magazine in 1920 and 1923.

4 Stuart Davis, Notebook: 1920–22, May 29, 1921. Private collection.

5 Ibid.

6 Ibid., June 21, 1921.

47

Untitled. 1922

Oil on canvas, 32 × 40 in. (81.3 × 101.6 cm.)

The Regis Collection, Minneapolis

48

Feasible #2. 1949–51

Oil on canvas, 11⅞ × 16⅛ in. (30.2 × 41 cm.)

The Saint Louis Art Museum. Gift of Morton D. May

Untitled is one of the elusive works within Stuart Davis's oeuvre. Some readings of the composition have focused on the fact that the forms suggest the letters *E*, *A*, and *T*, and, hence, that this work is related to Davis's typographical interests. Others read a percolator in the center, the black form to the right as a chair, and the eccentric curvilinear element in brown, to the left, as the specter of the coffee aroma. Whatever the precise meaning, it is clear that Davis is experimenting with interpenetrating planes and negative/positive spatial relationships in a way similar to that seen in the 1916 *Sketch—Church Tower* and in *Boats Drying, Gloucester* of 1916 (cat. nos. 18, 19). A 1922 sketch from a notebook that the artist kept between 1920 and 1922 shows a "piercing" of one plane by another that is quite similar to that being inflicted on the white form by the black one in the upper part of the present composition.[1] A notation at the bottom of the same notebook page reads: "Form is planes. Draw in planes just as you would draw in line. A light plane and a dark plane."[2]

This painting also relates to the large-scale Cubist compositions done the same year. The brown, white (ivory), and black palette of *Untitled* echoes that of *Still Life (Brown)* of 1922 (cat. no. 46). The space of *Untitled* is dominated by three irregularly shaped flat planes of color, and the figure/ground relationship is in constant flux, as each color functions both as a "figural" element and a background one. With this insistent intermingling of the forms, and the switching of compositional roles vis-à-

vis the figure/ground relationship, Davis achieves a highly personal but effective interpretation of the Cubist vocabulary, first glimpsed in his work six years previously. We can also read the leg-like forms of *Untitled* as the multiple legs of the table in *Still Life (Brown)*; indeed, the shapes in the former are comparable to the planes that define the intricate spatial dislocations and displacements of forms in the latter, without the accompanying anecdotal details such as the vases, fruits, and jugs. Davis has pared the pictorial process down to its essence. As he recorded in his notebook in May 1920: "The abstract relations of spaces come first and local phenomena are added afterward to give the character if required."[3]

That reference seems to support the allegation that this is an unfinished painting, but Davis evidently found these elements of enough interest to him, as he revised this composition thirty years later. In *Feasible #2*, he retained most of the earlier basic forms and compositional relationships. He used the reds, lavenders, yellows, kelly greens, and purplish blues that one sees in his work of the 1940s, also adding a dramatic squiggle and a few flat shapes to enliven the space within the composition. Davis is working from the premise of his color-space theory. In the 1922 picture, space is conveyed through our reading of figure/ground, light/dark relationships. In *Feasible #2*, the colors of the various shapes imply spatial positions by means of the visual "weight" and resonance of the individual hues. The three vertical bands at the upper right, the purple "pinwheel" with three "blades" just below the bands, and the squiggle and the rectangle at the upper and the lower left, respectively, seem to float in front of the other compositional elements, creating an intermediary spatial layer between the spectator and the main portion of the composition.

LSS

[1] Stuart Davis, Notebook: 1920–22, July 4, 1922. Private collection.

[2] Ibid.

[3] Ibid., May 1920.

49

New Mexican Landscape. 1923

Oil on canvas, 32 × 40¼ in. (81.3 × 102.2 cm.)
Amon Carter Museum, Fort Worth

In the summer of 1923, Stuart Davis drove from New York to Santa Fe, New Mexico, with his brother, Wyatt, and John and Dolly Sloan.[1] "Davis expected to like New Mexico on the strength of the Sloans' enthusiasm. They had sent him to Gloucester . . . years before and he had fallen in love with the place. . . . But Santa Fe disappointed him."[2] Like many before him and many since, Davis found the scenery to be all-pervasive and the historical Native American cultures omnipresent. He finally declared it to be "a place for an ethnologist, not an artist."[3]

In spite of his frustrations, Davis did execute several paintings of the New Mexican landscape. Some, like this one, show that he was not totally unaffected by the ambiance. His use of blues, purples, pinks, terracottas, and sandy beiges, complemented by forest greens and adobe tans, captures the palette of the Southwest. Davis, here, presents two small houses nestled in a forested area. Farther in the distance, a more elaborate residence can be seen, which seems to resemble a multiple-dwelling pueblo. Then, just at the foot of the sandy mesas, we see another small

49

structure. Each of the color areas is stippled with darker or contrasting values, to approximate the texture of the landscape. The spatial progression is curious. From the houses in the foreground, the space seems to dip down to the level of the pueblo, then rise up and out, first to a view of the mesas and then, farther back, to the mountains and the clouds.

Davis recognized the special challenge that New Mexico presented to the artist: "I don't think you could do much work there except in a literal way, because the place is there in such a dominating way."[4] Some scholars have interpreted his New Mexican landscapes as ironic statements, compositions that he framed within painted borders as if "to declare them as artifice."[5] In other versions of the New Mexico landscape, Davis seems to delight in perversity by using only one color— either a dull gray or a washed-out blue. Ultimately, however, he was faced with the fact that the landscape simply would not submit easily to his abstractionist interests. In fact, he spent most of his time in Santa Fe working in a room that appears in several paintings featuring saws, light bulbs, and eggbeaters. Marsden Hartley faced a similar dilemma. His *Cemetery, New Mexico* (1924; fig. 101), executed a year after Davis's picture, features darkly outlined rippling and crescent shapes rendered in dark blues and grays. Hartley painted *Cemetery, New Mexico* in Paris some

Figure 101. Marsden Hartley. *Cemetery, New Mexico.* 1924. Oil on canvas. The Metropolitan Museum of Art, New York. Alfred Stieglitz Collection, 1949

six years after his visit to the American Southwest in 1918, at which time his paintings showed a preoccupation with the local culture rather than with the spectacular landscape.

LSS

[1] John Sloan and Robert Henri were both associate members of the Taos Society of Artists, which was active from 1912 to 1927. See Patricia Janis Broder, *Taos: A Painter's Dream.* Boston: New York Graphic Society, 1980.

[2] Karen Wilkin, "Stuart Davis in His Own Time," *The New Criterion* 6, 5 (January 1988), p. 53.

[3] James Johnson Sweeney, *Stuart Davis* (exhib. cat.). New York: The Museum of Modern Art, 1945, p. 15.

[4] Sanford Schwartz, "When New York Went to New Mexico," *Art in America* 64, 4 (July–August 1976), pp. 95–96.

[5] Charles C. Eldredge, Julie Schimmel, and William H. Truettner, *Art in New Mexico, 1900–1945: Paths to Taos and Santa Fe* (exhib. cat.). Washington, D.C., and New York: National Museum of American Art, Smithsonian Institution, and Abbeville Press, 1986, p. 168.

50

Egg Beater. 1923

Oil on canvas, 37 × 22 in. (94 × 55.9 cm.)

Collection Earl Davis. Courtesy of Salander-O'Reilly Galleries, New York

51

The Saw. 1923

Oil on canvas, 37 × 22 in. (94 × 55.9 cm.)

The Art Institute of Chicago

If Stuart Davis did not succumb totally to the charms of the landscape when he visited New Mexico, he did find a thoroughly anachronistic subject matter to occupy him: "deadpan, near-monochrome 'portraits' of kitchen utensils and tools."[1] Sparsely furnished interiors, executed in grays, greens, or blues, are haunted by a single hanging light bulb, or eggbeaters with no discernible function, and saws that

50

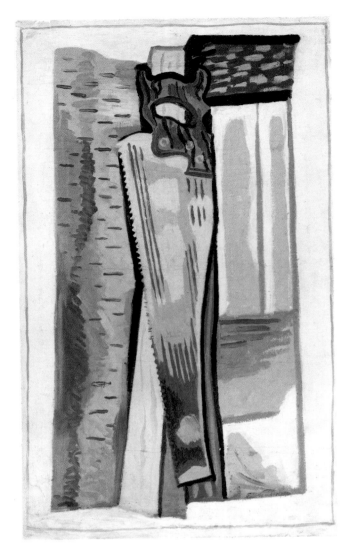

51

are frequently larger than life and seem to portend some macabre consequence. In *Egg Beater* and *The Saw*, these objects are placed against backgrounds that feature discrete areas of stippled pattern or variant shades of gray-green and blue, respectively. The decorative markings are reminiscent of the somewhat angular character of the southwestern landscape, and the bounds of the central image are as eccentric as the irregular border of *New Mexican Landscape* (cat. no. 49).

Light bulbs, eggbeaters, and saws were to recur persistently in Davis's oeuvre during the next decade. The saw, which first appeared in the 1922 composition *Landscape, Gloucester* (cat. no. 40), reappears as a central motif in *Still Life with Saw* (fig. 10) in 1930. The eggbeater was to be the central icon in the still-life ensemble that translated into the extraordinary abstractions of 1928 (see cat. nos. 65–76). As Karen Wilkin has noted, Davis may have been attracted to these objects "for their lack of art-historical associations, as a declaration of modernism. . . ."[2] In any case, he established a peculiarly American iconography that exploited consumer goods, advertising logos (see cat. no. 56), images from popular literature, and lingo borrowed from jazz (see cat. no. 104), prefiguring the so-called Pop Artists by at least four decades.

LSS

[1] Karen Wilkin, "Stuart Davis in His Own Time," *The New Criterion* 6, 5 (January 1988), p. 53.

[2] Ibid.

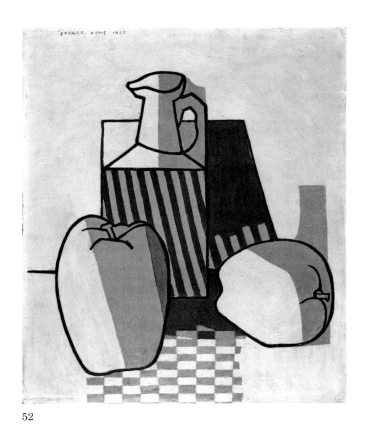

52

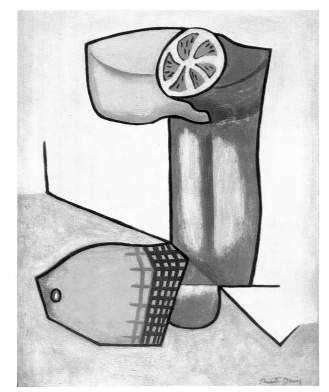

53

Apples and Jug. 1923

Oil on composition board, 21¾ × 17¾ in. (55.3 × 45.1 cm.)

Museum of Fine Arts, Boston. Gift of the William H. Lane Foundation, 1990.390

Lemon and Glass. 1924

Oil on canvas, 24 × 18⅛ in. (61 × 46 cm.)

Collection Jon and Barbara Landau, New York

Edison Mazda. 1924

Oil on cardboard, 24½ × 18⅝ in. (62.2 × 47.3 cm.)

The Metropolitan Museum of Art, New York. Purchase, Mr. and Mrs. Clarence Y. Palitz, Jr., Gift, in memory of her father, Nathan Dobson, 1982 (1982.10)

Electric Bulb. 1924

Oil on board, 24½ × 18⅝ in. (62.2 × 47.3 cm.)

Dallas Museum of Art

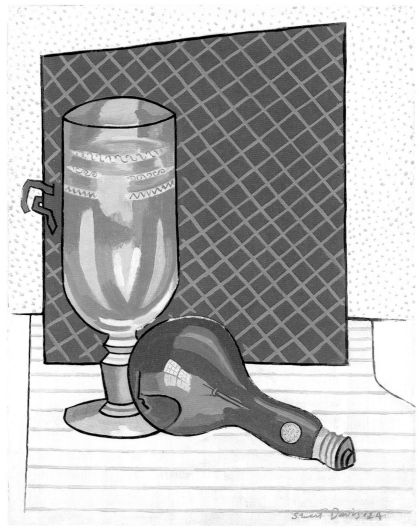

54

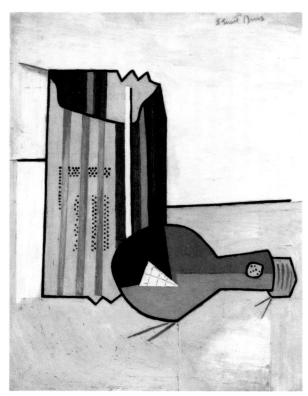

55

This group of still-life compositions, painted in 1923 and 1924, reveals the influence of Fernand Léger and Juan Gris on Stuart Davis's work, as well as an intriguing correlation between Davis's interest in advertising imagery and the commercial illustrations that he did in the 1920s. In contrast to his Table still-life compositions of 1922 (see cat. nos. 43–46), Davis has rendered the forms here as "distinct," "clear," and "independent elements. . . . The heavy black lines shape objects but are often simply autonomous planes . . . made relief-like by means of unmodeled color, by the weight and texture of the paint and the strong hues we associate with Davis's later work."[1] Whereas, in the Table still-life paintings, Davis undertakes a fractured, intermingled Cubist analysis of form, here he experiments alternately with the planar shifts that Gris featured in his work (as in the planes of color that slice through several elements in *Apples and Jug*), and the pristine definition of form of Léger.

Davis achieves a curious combination of tradition and modernity in these still-life compositions, including such traditional still-life props as fruit (in *Apples and Jug* and *Lemon and Glass*), an earthenware vessel (in *Apples and Jug*), and a wineglass (in *Edison Mazda*), but rendered in a new way. Although we may not be able to discern the order in which these compositions were painted, *Edison Mazda* does seem to mark the transition point with regard to the changeover in the content of Davis's still-life compositions: "[T]he wine glass, a traditional still-life object, is juxtaposed with the light bulb, a symbol of modern industrial culture. And the windows of the artist's studio are reflected in the bulb, much as we see reflections in the glass, silver, and copper of Old Master still lifes. The way the light bulb here juts into the picture, giving the composition a jolt of energy, hints at the jazzy urban dynamism that would characterize the artist's later work. And in Davis's cool, laconic style, embracing the objects of our modern consumer culture, are the seeds of the Pop Art of the 1960s."[2] Davis's commitment to the modern age emerges unencumbered by historical reference in *Electric Bulb*, where the light bulb is seen with its thoroughly modern cardboard container.[3] The reflection has become a gleaming triangle within the angular simplification of the entire composition. The objects are set against a plain ground, and there is an awkward spatial shift in the horizon line. Davis extends the linear contours of the forms at key points, as if extrapolating the energy lines of each form. In *Lemon and Glass*, he effects an eccentric splaying of the glass at its rim and base as if it had been subjected to some odd Futuristic dispersal in space, much like the formal peculiarities of Umberto Boccioni's *Development of a Bottle in Space* (1913; The Metropolitan Museum of Art. Bequest of Lydia Winston Malbin, 1989).

While these still-life compositions and others executed at this time are distinctive in Davis's oeuvre, they foreshadow the still-life paintings of 1927–28, the Egg Beater series (see cat. nos. 65–76). They also point to the fact that the artist will continue to lavish attention on various still-life elements in his landscapes and interiors—a strategy consistent with Davis's treatment of the individual parts of a composition as essential components necessary for our comprehension of the whole.

LSS

[1] William C. Agee, *Stuart Davis (1892–1964): The Breakthrough Years, 1922–1924* (exhib. cat.). New York: Salander-O'Reilly Galleries, 1987, n.p.

[2] Unsigned and unpublished text in the archives of the Department of Twentieth Century Art, The Metropolitan Museum of Art.

[3] This painting has also been titled *Green Yellow Glass and Electric Bulb*, which misidentifies the green-and-yellow cardboard container on the left in the composition.

Odol. 1924

Oil on canvas, 24 × 18 in. (61 × 45.7 cm.)
The Crispo Collection

The interest shown by Stuart Davis and Gerald Murphy in advertising logos points to the specific role that brand names had come to play in the lives of the American consumer public. As Daniel Boorstin has noted: "The acts of acquiring and using had a new meaning. Now men [and women] were affiliated less by what they believed than by what they consumed. . . . If an object of the same design and brand was widely used by many others, this seemed an assurance of its value."[1] Davis would play on this mentality in his 1956 work *Package Deal* (figs. 73, 118) and in the related 1957 composition *Premiere* (cat. no. 158), where the familiar brand names of grocery products have been replaced with generic designations—for example, JUICE or BAG—as well as by qualifiers that explicated the quantitative connotations a mere brand name could exude: LARGE, FREE, NEW, and *100%*.

In *Odol*, Davis has distilled the essence of the sales pitch by featuring the brand name and the slogan touting the salient properties of this disinfectant: " 'It Purifies'." The distinctive profile of the bottle, which faces left, has been set on a phantom horizon line. A clear, receptacle-like form slants to the right, creating a spatial plane that sets off the Odol bottle and the checkered pattern behind it. The bottle seems oddly flat, empty of liquid contents, with an aqua label that follows the contours of its fluted surface. These three layers of pattern and form, in turn, are set against a purple background, which, itself, is enclosed within a black frame.

In another version of *Odol*, in the collection of the Cincinnati Art Museum (fig. 102), Davis has set the Odol bottle and a partially filled glass in front of a mirror, atop a surface defined by two speckled planes. The reflection in the mirror shows the bottle slightly askew, as well as the corner of the room and the top edge of another plane, which we are to understand as existing in our own space. Here, Davis indicates the more extensive script of the advertising pitch on the labels on both sides of the bottle. However, as discussed later with regard to the 1924 composition *Lucky Strike* (cat. no. 57), Davis is not specifically interested in the content beyond the name of the product and the essential identifying information; thus, the bulk of the writing is rendered as illegible linear pattern.

Odol was advertised in Europe, Russia, and the United States as early as the 1890s, so it is not surprising that its logo appeared in the 1914 collage *Patriotic Celebration (Free World Painting): Interventionist Manifestoes* by the Italian Futurist Carlo Carrà.[2] In any case, the packaging of objects became an art raised to new heights in the early part of this century, and "produced a host of . . . new and ingenious designs. . . . Manufacturers designed closures specially adapted to powder, paste or liquid, and they designed easy-dispensing caps, measuring caps, and containers in all shapes and sizes . . . ,"[3] as seen in the bent neck of the Odol bottle.

LSS

Figure 102. Stuart Davis. *Odol*. 1924. Oil on cardboard. Cincinnati Art Museum. The Edwin & Virginia Irwin Memorial, 1972.460

[1] Daniel J. Boorstin, *The Americans: The Democratic Experience*. New York: Vintage Books, 1973, pp. 89–90.

[2] See *Art & Publicité 1890–1990* (exhib. cat.). Paris: Centre Georges Pompidou, 1990, pp. 156–59, 183.

[3] Boorstin, op. cit., p. 440.

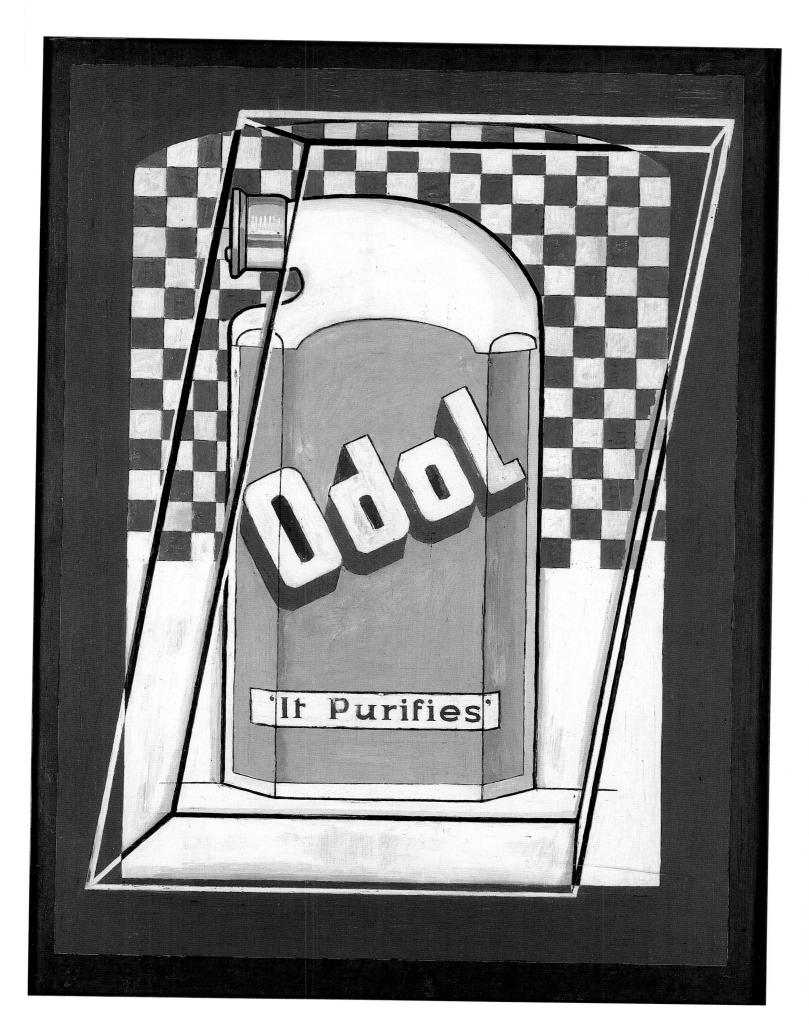

57

Lucky Strike. 1924

Oil on paperboard, 18 × 24 in. (45.7 × 61 cm.)

Hirshhorn Museum and Sculpture Garden, Smithsonian Institution,
Washington, D.C. Museum Purchase, 1974

In April 1921, Stuart Davis wrote: "I do not belong to the human race but am a product made by the American Can Co. and the New York Evening Journal."[1] Davis reaffirms his new genesis in this painting, where he reproduced the first page of the sports section of the Saturday, February 16, 1924, edition of the *New York Evening Journal*. That it is the sports section jibes with the overall character of this still-life composition—a panegyric on a gentleman's daily pleasures: the pipe or cigarette and the evening newspaper that await the weary male upon his return home from work. The various elements of the original page that Davis has chosen to emphasize or generalize represent his own interests in popular culture. Davis concentrated on the headlines. He then focused on the figures in the left-hand side of the cartoon by TAD, curtailing the reproduction of the right-hand section. Davis does not record the dialogue in the balloon shapes, so it is clearly not the in-depth content of the news that interested him, but rather the visual signals that draw the reader into the extensive verbiage on the newspaper page. "Note the success of [the] daily news which . . . is based on pictures. Altogether the motto seems to be—snappy, concise and silly."[2]

Davis shows the newspaper page folded and upright, with the bottom portion of the page forming a ledge or a tabletop element. On this ledge sits a box of Lucky Strike roll-cut tobacco, a packet of Zig Zag cigarette papers, a single crumpled paper, and an extinguished pipe. Set against a tan-and-blue background—which simulates a landscape—the entire composition seems to defy one's expectations of a continuity in the physical relationships among the various elements in the composition. The pipe stem inexplicably disappears behind the newspaper page, the

edges of the newspaper form a quirky contour, and the two shadows seem to describe forms other than those from which they are supposedly cast. Such anomalies relate to those seen in *Super Table* (cat. no. 60), which was painted the following year. Once again, Davis has freed the content from its referential forms and format, all the while tantalizing us with its familiar codes.

TAD was the pseudonym of Thomas Aloysius Dorgan, a reporter (his column appears beneath the cartoon on the original page), as well as an illustrator and cartoonist. Davis's inclusion of comic-book imagery as a serious subject in art predates the Pop Artists by almost forty years. Even the Dadaists did not use such imagery until the late 1940s, when Kurt Schwitters began to include purloined comic-book images in his collages.[3]

LSS

[1] Stuart Davis, Notebook: 1920–22, April 1921. Private collection.

[2] Ibid., June 21, 1921.

[3] John Carlin and Sheena Wagstaff, *The Comic Art Show: Cartoons in Painting and Popular Culture* (exhib. cat.). New York: Whitney Museum of American Art, Downtown Branch, 1983, p. 238.

58

Gloucester Harbor. 1924

Watercolor and crayon on paper, 12¾ × 18 in. (32.4 × 45.7 cm.)
The Butler Institute of American Art, Youngstown, Ohio

59

The Sparyard. 1924

Pen and ink, with wash and watercolor, on paper, 22⅜ × 15⅜ in.
(56.8 × 39.1 cm.)
Wellesley College Museum, Jewett Arts Center, Wellesley, Massachusetts.
The Dorothy Braude Edinburg (Class of 1942) Collection

59

William Agee has noted that Stuart Davis's watercolor, crayon, and pencil compositions of 1924 "developed the basis of the precise angle-units that dominated the purely linear works of 1932–34" (see cat. nos. 106–109).[1] These studies of Gloucester harbor "often [play] aspects of 19th-century America—a Victorian steeple and a venerable schooner, against a modern subject such as a factory, for example; the contrast between the new and the old rendered simultaneously in both figurative and increasingly abstracting styles indicates the passage of time from an earlier era into a new age."[2] The mid-1920s were still a tentative period in Davis's work. He was then two to three years away from the definitive statement of his own Cubist vocabulary in the Egg Beater series (1928; see cat. nos. 65–76) and such 1927 still lifes as *Percolator* and *Matches* (cat. nos. 63, 64). In the present two works, Davis has once again pared down his imagery. The lushly articulated modeling of the monumental Cubist still-life compositions of 1922 (see cat. nos. 44–46) and the rugged linearity of the studies of fruit, flowers, and light bulbs of 1923–24 (see cat. nos. 52–55) have given way, here, to the medium of pencil and watercolor. These views are distinguished by their resolute rectilinearity, where every line plumbs true to its individual orthogonal destiny.

The Sparyard affords us a view of the waterfront buildings from between two fluted pillars, which are surmounted by a lintel. (Spars are thick pieces of lumber or metal that serve as masts or booms to otherwise support the rigging on ships, as seen in the lintel elements that dominate the foreground of this picture. This type of structure would provide the architectural underpinnings of the Gloucester vignettes of 1935–39.) Davis varies the thickness of the lines for emphasis and to indicate some perspective. There is little or no modeling of the forms; instead, we rely on the interaction among horizontal, vertical, and diagonal lines to find our way through this composition. Davis also inscribes an idiosyncratic interior frame onto the scene—a device that first appeared in his work in 1922–23—which serves to emphasize the rectitude of the compositional elements. Smack in the center of the composition is a rigging hook that swings ominously, ghost-like, in the wind.

In *Gloucester Harbor*, we see a spire, a clock tower, and a ship's rigging and mast towering over the horizontal roof of the fish-processing factory building. Depth is achieved primarily by the presumed overlapping of the various elements, since the horizontal top of the factory cuts straight across the composition, flattening out the space. The spire and the clock tower can be seen from another angle within Gloucester in the 1925 gouache *Myopic Vista* (Whitney Museum of American Art, New York), and may be glimpsed in the distance of *Morning Walk* (*Harbor View*) of 1919 (Collection Earl Davis). *Gloucester Harbor* itself was the source for several later compositions, including a trio of small paintings done in 1941 of which *Triatic*, included here, is one (see cat. no. 128).

LSS

[1] William C. Agee, *Stuart Davis (1892–1964): The Breakthrough Years, 1922–1924* (exhib. cat.). New York: Salander-O'Reilly Galleries, 1987, n.p.

[2] Ibid.

Super Table. 1925

Oil on canvas, 48½ × 34⅛ in. (123.2 × 86.7 cm.)

Terra Museum of American Art, Chicago. Daniel J. Terra Collection

This composition is a distillation of Stuart Davis's four 1922 still lifes incorporating the theme of the table (see cat. nos. 43–46). Elements such as the fruit bowl reappear, along with a notebook opened to a drawing whose biomorphic components are suspended on a grid, suggesting a seated human figure. Crumpled drapery is bunched against the upright element of the table, which is shaped like the upended tabletop in *Still Life with "Dial"* (cat. no. 44). Davis effects a kind of texturing in the unexpected brick pattern on the surface of the upright part of the table and in the

wavy wood grain of the upper portion of its base, as well as in the lines of the black mat. He has deliberately subverted expected light/dark, solid/void identities and relationships, which makes one think particularly of the *Guéridon* paintings of Georges Braque—a series of large-scale still lifes, prominently featuring tables and related furniture. The clean-edged, pristine quality of the forms and the color signals Davis's interest in the work of Fernand Léger—an influence that was to manifest itself and persist throughout the American artist's career (see *Deuce* of 1951–54; cat. no. 150). Davis met Léger during the 1930s, when the French artist spent time in New York, and interceded on his behalf to secure Léger a mural commission from the WPA.[1]

John Lane has cited this painting as an example of a composition by Davis based on the Golden Section. This formal theory was subject to many interpretations, especially during the first three decades of this century, when associates of the Cubists came under its influence.[2] In the United States, Jay Hambidge's doctrine of Dynamic Symmetry was one of the most influential treatises on art theory, particularly in the 1920s.[3] Based on the proportional ratios set out in the Golden Section, it postulated the use of rectangular spirals as the "foundation for an elaborate set of relationships that . . . might be established between shapes."[4] On the basis of these relationships, the whole of the composition could be divided into smaller harmonizing parts. Thus, the painting would convey a pleasing quality, which would have been subliminally discerned through the experience of this underlying structure. Lane further postulates that this painting "yields to an analysis based on sixty-degree angles springing from each of the four corners, on diagonals originating at the ends of a vertical bisection, and on sixty-degree angles springing from the extremities of the bisection."[5] However, Lane concedes that "in practice, Davis depended largely on his intuitive sense of composition, a sense that had been refined by exposure to the design principles"[6] not only of Hambidge but also of Denman W. Ross and Hardesty Maratta.

LSS

[1] See entries in Davis's daily calendar for 1935—for example, October 30 and November 14 and 20.

[2] See, for example, John Golding, *Cubism: A History and Analysis, 1907–1914.* New York: George Wittenborn, 1959.

[3] John R. Lane, *Stuart Davis: Art and Art Theory* (exhib. cat.). New York: The Brooklyn Museum, 1978, p. 14.

[4] Ibid.

[5] Ibid., pp. 14–15.

[6] Ibid., p. 14.

61

Early American Landscape. 1925

Oil on canvas, 19 × 22 in. (48.3 × 55.9 cm.)

Whitney Museum of American Art, New York.
Gift of Juliana Force, 31.171

62

Town Square. 1925–26

Watercolor on paper, 11⅝ × 14½ in. (29.5 × 36.8 cm.)

The Newark Museum, New Jersey

These New England scenes offer two distinct approaches to defining space. In *Early American Landscape*, the various elements in the composition seem to float on their individual platforms or skids. Focusing on the lonely schooner that has come into view between the two trees in this Gloucester panorama, one thinks of the filming of a movie, and how foreground elements fall away to the side as the camera enters a scene. It is as if the trees, boat, houses on shore, and even the water and foliage in the background could be rolled in and out of the composition like stage props—stage left or stage right. In addition to the overlapping, Davis applies variegated patterning to various areas to establish spatial relationships, as well as to distinguish the integral identities of the compositional components. The metallic, machine-like quality of the trees and houses reveals the influence of Fernand Léger.

Town Square presents the view of Rockport, Massachusetts, one sees upon entering the town. The different scenery elements, such as the "cutout" trees and the light-colored kiosk and gasoline pump to the left and right, respectively, of the composition, have a distinctly prop-like quality. The black planes at each side of the picture, along with the tire tracks, draw our attention back to the center of the composition by means of the perspectival thrust of their diagonal edges. The garage at the center, in the background, is the same as the one Davis depicted in the 1917 *Garage* (cat. no. 22). The organization of this composition is a repeat of Davis's 1912 painting *Consumers Coal Co.* (cat. no. 1; fig. 16), and would be taken up again in several of the street scenes done three years later in Paris. The black shapes at the sides have spectral architectural details sketched in on them as if to reinforce the idea of their theatrical, make-believe nature; the curious pseudomathematical schemata of Giorgio de Chirico come to mind. Davis once noted that he particularly enjoyed depicting cars and gas pumps, but that "this compulsion was terminated when their designers went surrealist and produced things which were far beyond

my capacity to draw."[1] The curiously dislocated gas pump and kiosk find parallels in the balustrade elements in René Magritte's paintings, such as *Le Jockey perdu* (1926; Collection Harry Torczyner, New York). These forms, which suggest female mannequins, persist in Davis's work until the early 1940s—specifically, when he reexplored this composition in *Report from Rockport* (cat. no. 123), and once again relied on patterning and texture to help define spatial relationships and clarify the individual identities of the various compositional elements.

LSS

[1] Stuart Davis, "Autobiography" (1945), in Diane Kelder, ed., *Stuart Davis*. New York, Washington, and London: Praeger, 1971, p. 25.

63

Percolator. 1927

Oil on canvas, 36 × 29 in. (91.4 × 73.7 cm.)

The Metropolitan Museum of Art, New York. Arthur Hoppock Hearn Fund, 1956 (56.195)

Matches. 1927

Oil on canvas, 26 × 20 in. (66 × 50.8 cm.)

The Chrysler Museum, Norfolk, Virginia. Bequest of Walter P. Chrysler, Jr.

In both *Percolator* and *Matches*, Stuart Davis continued his experimentation with Cubism. However, in the present canvases of 1927, "Davis was no longer emulating a style but using a new language fluently and idiomatically."[1] In *Percolator*, he transforms the rounded cylindrical forms of an ordinary percolator into flat, rectangular or trapezoidal planes (or portions thereof) that pivot around a center suggested by the alignment of the right edge of the green form, the small elongated pyramidal peg, the separated portion of the tan shape in the middle of the composition, and the left side of the ocher "frame" to the upper right. Several orthogonal arrangements—for example, the large rectangular area at the base of the form to the right—suggest corridors into space. The color of the small, light-tan rectangle

Figure 103. Patrick Henry Bruce. *Still Life*. About 1920–21. Oil on canvas. The Metropolitan Museum of Art, New York. George A. Hearn Fund, 1961

at the "rear" of this space is different from that of the chalky white hue that surrounds the entire form, indicating a dimension beyond both the spectator's space and that of the painting itself. The particular way that the forms have been rendered cubic is distinctive, and is most reminiscent of the block shapes in Patrick Henry Bruce's geometric still lifes begun in 1917–18 (see fig. 103); these actual works may have been exhibited in 1920 in New York at the galleries of the Société Anonyme.[2] It is difficult to know just what kind of percolator Davis was depicting. The models available in the 1920s included two-layer cylindrical pots as well as the more modern glass examples. We may assume that the prominent number 6 indicates the percolator's cup capacity.

As distinct from *Percolator*, in *Matches* the various elements seem to unfold in vertical planar layers, and their identities are less obvious. Two books of matches —the red, blue, ocher, salmon, and black forms seen to the right—stand in front of a third book, lying on its side, represented by the black square on which there is a purplish shape and a red strip for the striking band. Behind them is a larger orange parallelogram with decorative green-and-black borders, which may be the box in which the matchbooks came. Again, the intimations of interior spaces, such as the red lines at the lower-right corners of the two standing forms, suggest that the still life is simultaneously an arena for spatial events.

Rudi Blesh has described *Percolator* and *Matches* as "island images"[3] because the cluster of forms sits, out of context, against a neutral background. This iconic treatment is analogous to Marcel Duchamp's mechanomorphic evocation, *The Chocolate Grinder No. 2* (Philadelphia Museum of Art. The Louise and Walter Arensberg Collection). Surely, the subjects of these two works are as mundane as the chocolate grinder—or, for that matter, a bicycle wheel or urinal, all of which would appeal to the anarchistic notions of Dadaism. It is interesting that Davis does not indulge in the allusive manipulation of the object that the Dadaists so enjoyed. Certainly, the sexual resonances of matches (sparks being ignited by striking) recall Francis Picabia's young lady *turned* spark plug (see fig. 109). However, years later, when Davis incorporates the spark-plug motif in his own work, it is not the anthropomorphic allusions that interest him but the graphic quality of an advertisement on a matchbook cover (see cat. no. 141).

LSS

[1] Karen Wilkin, *Stuart Davis*. New York: Abbeville Press, 1987, p. 82.

[2] See William C. Agee and Barbara Rose, *Patrick Henry Bruce, American Modernist: A Catalogue Raisonné*. New York and Houston: The Museum of Modern Art and The Museum of Fine Arts, 1979, p. 140.

[3] Rudi Blesh, *Stuart Davis*. New York: Grove Press, 1960, p. 50.

Egg Beater No. 1. 1927

Oil on canvas, 29⅛ × 36 in. (74 × 91.4 cm.)

Whitney Museum of American Art, New York.
Gift of Gertrude Vanderbilt Whitney, 31.169

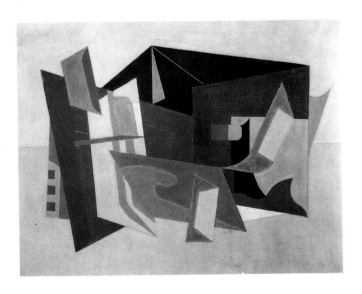

66

Egg Beater No. 1. 1927

Gouache on board, 14¼ × 17⅞ in. (36.2 × 45.4 cm.)

Collection Alice and Leslie Schreyer

67

Drawing for "Egg Beater No. 1." 1927

Pencil on paper, 15 × 20 in. (38.1 × 50.8 cm.)

Collection Earl Davis. Courtesy of Salander-O'Reilly Galleries,
New York

Egg Beater No. 2. 1928

Oil on canvas, 29¼ × 36¼ in. (74.3 × 92.1 cm.)

Collection Mr. and Mrs. James A. Fisher, Pittsburgh

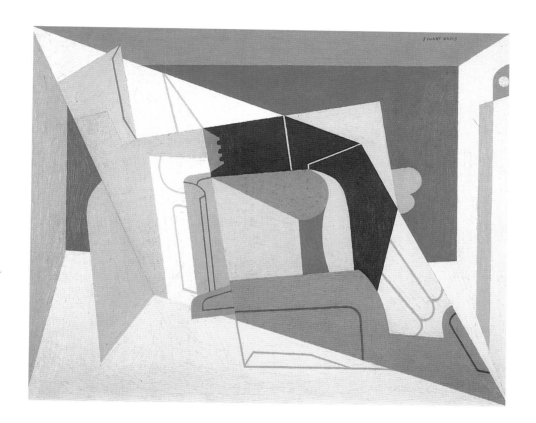

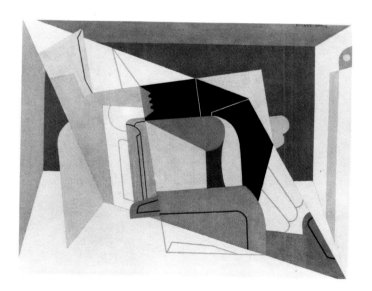

69

Egg Beater No. 2. 1928

Gouache and watercolor on board, 14½ × 19 in. (36.8 × 48.3 cm.)

Munson-Williams-Proctor Institute, Museum of Art, Utica, New York

70

Drawing for "Egg Beater No. 2." 1928

Pencil on paper, 15 × 20 in. (38.1 × 50.8 cm.)

Collection Earl Davis. Courtesy of Salander-O'Reilly Galleries, New York

Egg Beater No. 3. 1928

Oil on canvas, 25 × 39 in. (63.5 × 99.1 cm.)

Museum of Fine Arts, Boston. Gift of the William H. Lane
Foundation, 1990.391

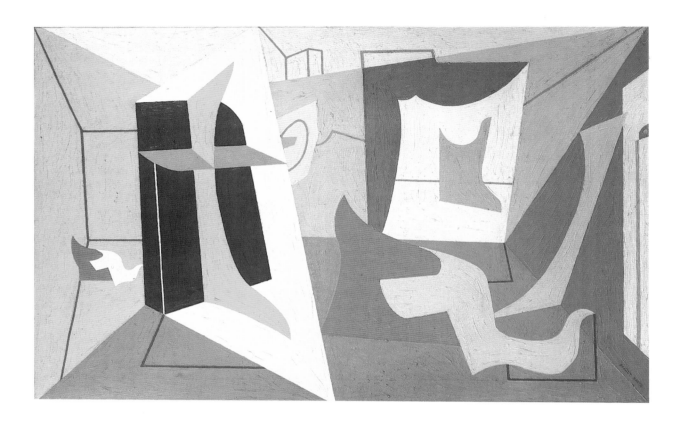

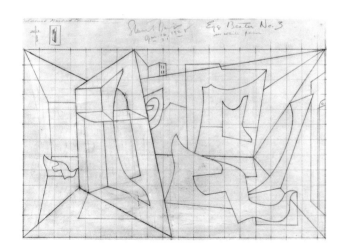

72

Egg Beater No. 3. 1928

Gouache on board, 12½ × 19½ in. (31.8 × 49.5 cm.)

Collection Warren and Jane Shapleigh

73

Drawing for "Egg Beater No. 3." 1928

Graphite and colored pencil on paper, 17 × 21⅜ in.
(43.2 × 54.3 cm.)

Whitney Museum of American Art, New York. Purchase,
with funds from the Charles Simon Purchase Fund, 80.46

Egg Beater No. 4. 1928

Oil on canvas, 27 × 38⅛ in. (68.6 × 96.8 cm.)

The Phillips Collection, Washington, D.C.

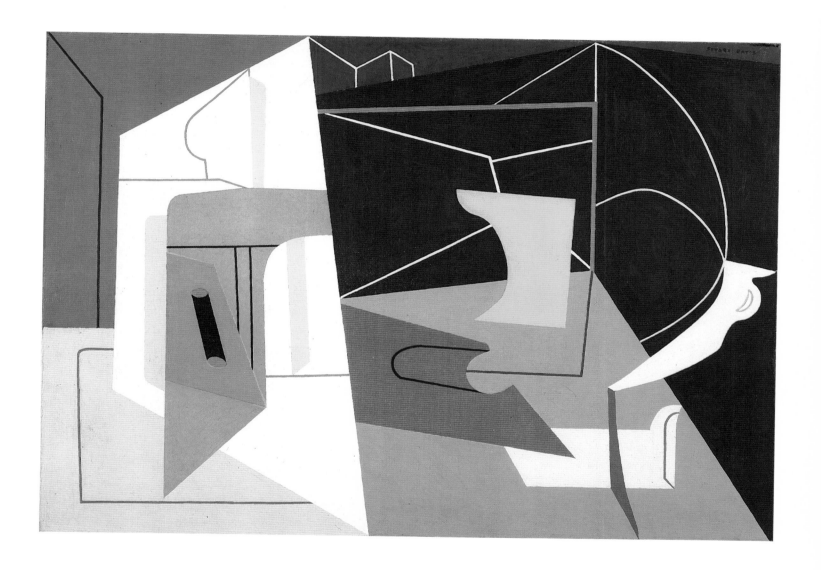

Egg Beater No. 4. 1928

Gouache on board, 14 × 19⅜ in. (35.6 × 49.2 cm.)

Collection Arthur E. Imperatore. Courtesy Luhring Augustine
Gallery, New York

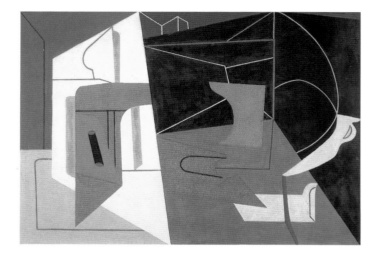

Drawing for "Egg Beater No. 4." 1928

Pencil on paper, 15¼ × 19¼ in. (38.7 × 48.9 cm.)

Meyer Associates

In 1927, Stuart Davis "nailed an electric fan, a rubber glove, and an eggbeater to a table and used them as . . . exclusive subject matter for a year."[1] He was then working "in a small room, 9′ × 11′, which made it obligatory to have a still life of a simple nature in one place."[2] It was a gesture that evoked the Surrealist situation of a sewing machine encountering an umbrella on a dissecting table, and the paintings that resulted are comparable to the non-relational still life in Giorgio de Chirico's composition *Song of Love* (1914; The Museum of Modern Art, New York. Nelson A. Rockefeller Bequest), in which a rubber glove is cast in a paradoxical juxtaposition with a red ball and a plaster cast of Michelangelo's *David*. Another source for the Egg Beater series, cited by Diane Kelder, is Man Ray's 1918 photograph of an eggbeater entitled *L'Homme* (Collection Arturo Schwarz, Milan).[3] The inclusion in art of such modern implements as the eggbeater was invariably associated, in Europe, with a quintessentially American point of view.

Yet, for all the visual and verbal punning in the Dadaist and proto-Surrealist precedents for these paintings, the Egg Beater series comprises abstract compositions that were among "the first truly abstract paintings to be made in this country in nearly a decade . . . an example of modernism that was all but independent of Europe. There would not be another burst of originality until the arrival of abstract expressionism in the mid-1940s."[4] As Davis explained: "Their subject is an invented series of planes which were . . . drawn in perspective and light and shade."[5] He eliminated optical details in order to "strip [the] subject down to the real physical source of its stimulus. I felt that a subject has its emotional reality fundamentally through our awareness of such planes and their spatial relationship."[6] This "stripped-down" analysis is based on what in the 1930s Davis was to call "space-color logic," by which "color is space, line is direction and plane is both color and form."[7] Along these lines, the spatial relationships that Davis created in these paintings are various. Instead of the entire composition conforming to an established perspectival order, "everywhere what is suggested as setting up directional

depth *inward* is frustrated by the interruption of the plane or line stopping the eye's journey, turning it along a new path, only to be turned shortly again. Curves emanating from points tangent to the edge of another plane slide the eye around, leading it always back to the recognition of the flat triangle. And though there is a suggestion of 'light and shade' just where it comes from is impossible to determine."[8]

When we examine these works we become aware of the recurring presence of the eggbeater at the left-hand sides of the compositions. In numbers 1 (at one time number 2) and 3, a horizontal form defines the handle, and the blades are suggested by a vertical shaft that terminates in a curve, indicating the bulbous framework that actually whips the food. In numbers 2 (formerly 4) and 4 (formerly 1), the form of the fan seems evident in, respectively, the orange "tear-drop" shape attached to the green stem, and the curved elements in the black area at the right in number 4. There are interesting developments in the spatial relationships between the focal assemblages and the backgrounds of the different paintings, which are even more apparent in the preliminary drawings. In *Egg Beater No. 1*, the green, black, gray, orange, blue, tan, and ocher planes and arcs form distinct shapes that are set against a background divided roughly in the middle into light purple and pale gray-green areas. It is as if the still-life forms sit in a landscape space, as in *Lucky Strike* (cat. no. 57). With *Egg Beater No. 2*, the space assumes a more room-like character, with a pale yellow floor; ivory, green, and salmon walls; and a gray-blue ceiling. The still-life assemblage then is presented as a series of integral forms with extending elements such as cast shadows or areas of overlapping forms cutting through the space in intersecting parallelogrammatic planes.

In *Egg Beater No. 3*, the eggbeater is set off by the upended, white trapezoidal plane that encases it and by the black form that seems to support it. The white plane splits the composition into two unequal parts. As a result, the more orderly perspective of the space in *Egg Beater No. 2* here goes awry, as the back wall at the left recedes into the composition. The space at the right literally opens up, so that the purple wall stretches at its top edges into an exaggerated diagonal at the upper right. Consequently, the ceiling is revealed, and the tops of two box-like constructions protrude from behind the purple wall, whose weight causes the green wall to collapse into a triangle. The tightly knit huddle of forms in *Egg Beater No. 1* and *No. 2* have dissipated and various eccentric shapes lounge on the floor and walls of the right-hand section of *Egg Beater No. 3*. *Egg Beater No. 4* retains the main spatial divisions of *No. 3*. Again, a white trapezoidal plane frames the eggbeater, and similar eccentric shapes float through the right-hand side of this composition. However, here, Davis demonstrates that peculiar juncture of still life and urban landscape that he favored. The space opens up into a kind of plaza at the right, whose uptilted ocher plane is reminiscent of like elements in the paintings of de Chirico. The back wall seems to open onto a roadside space, and, once more, what appear to be the tops of buildings close off the composition in the upper center. The artist suggests a time shift in the blunt light-and-dark contrasts. "Davis wrote of his juxtaposition of views into differing perspectives: 'This was an instinctive effort to introduce into a specific subject some of the memory and experience about it when seen at other times. It introduced Time . . . into Form by referring the immediate concrete shapes to more general shapes, which have a much more extended existence in Time and Place.' "[9]

When he went to Paris in 1928, Davis carried several of the Egg Beater paintings with him. He showed them to, among others, Fernand Léger and Gertrude Stein.

Léger "liked [them] very much and said they showed a concept of space similar to his latest development and it was interesting that 2 people who did not know each other should arrive at similar ideas. He thought the street scenes I am doing here [see cat. nos. 77–83; fig. 104] too realistic for his taste but said they were drawn with fine feeling. He invited me to send something to a show he is organizing in January."[10] An attempt to persuade Gertrude Stein to purchase a picture was less successful.[11]

Davis asserted the importance of the Egg Beater series within his career: "You might say that everything I have done since has been based on that eggbeater idea."[12] Indeed, the skill with planar shifting and framing that he perfected in these works would inform his Gloucester landscapes during the 1930s. The compositions of specific paintings would influence later ones, as in the case of *Hot Still-Scape for Six Colors—Seventh Avenue Style* (cat. no. 124), a variant of *Egg Beater No. 2*. This series, done when Davis was thirty-five years old, both predicted what would come and summed up what had gone before in his oeuvre. The paintings are among the most simple, pure, and pristine of Davis's creations, evidencing a formal discipline and intelligence that rarely deserted the artist throughout the rest of his career.

LSS

[1] James Johnson Sweeney, *Stuart Davis* (exhib. cat.). New York: The Museum of Modern Art, 1945, p. 16.

[2] Frederick S. Wight, "Profile: Stuart Davis," *The Art Digest* 27, 16 (May 15, 1953), p. 23.

[3] Diane Kelder, "Stuart Davis: Pragmatist of American Modernism," *Art Journal* 39, 1 (Fall 1979), p. 31.

[4] John Ashbery, "Our Forgotten Modernists," *Newsweek* 104 (July 30, 1984), p. 84.

[5] Sweeney, op. cit.

[6] Ibid., p. 17.

[7] Diane Kelder, ed., *Stuart Davis*. New York, Washington, and London: Praeger, 1971, p. 7.

[8] E. C. Goossen, *Stuart Davis*. New York: George Braziller, 1959, p. 22.

[9] Jane Bell, "Stuart Davis: 'The Thread of an Idea'," *The Village Voice*, February 20, 1978, p. 37.

[10] Stuart Davis, in a letter to his father, September 17, 1928, quoted in Karen Wilkin, *Stuart Davis*. New York: Abbeville Press, 1987, p. 120.

[11] See Donald Gallup, ed., *The Flowers of Friendship: Letters Written to Gertrude Stein*. New York: Alfred A. Knopf, 1953.

[12] Goossen, op. cit., p. 21.

Place des Vosges No. 2. 1928

Oil on canvas, 25⅝ × 36¼ in. (65.1 × 92.1 cm.)

Herbert F. Johnson Museum of Art, Cornell University,
Ithaca, New York. Dr. and Mrs. Milton Lurie Kramer
Collection, Bequest of Helen Kroll Kramer

Figure 104. Stuart Davis. *Place des Vosges No. 1*. 1928. Oil
on canvas. The Newark Museum, New Jersey. Anonymous
gift, 1937

Figure 105. Place des Vosges, Paris

Rue des Rats No. 2. 1929

Oil and sand on canvas, 20 × 29 in. (50.8 × 73.7 cm.)

Hirshhorn Museum and Sculpture Garden, Smithsonian
Institution, Washington, D.C. Gift of Joseph H. Hirshhorn, 1972

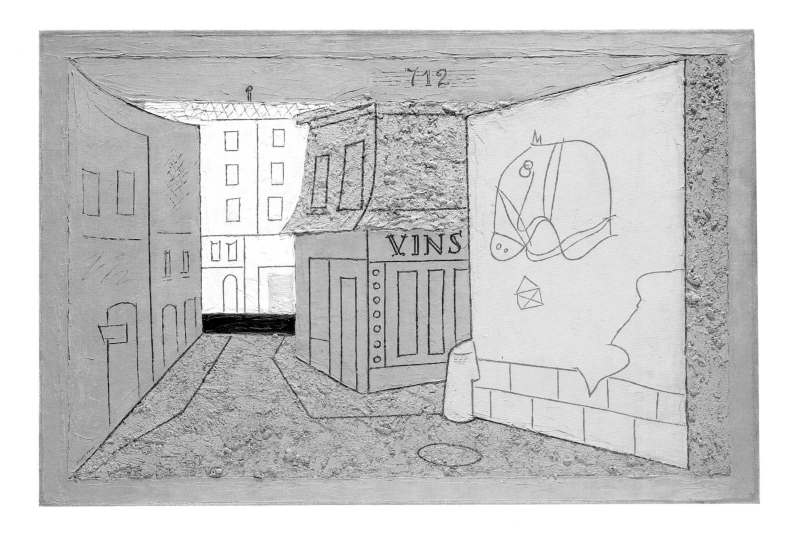

Rue Lipp. 1928

Oil on canvas, 32 × 39 in. (81.3 × 99.1 cm.)

The Crispo Collection

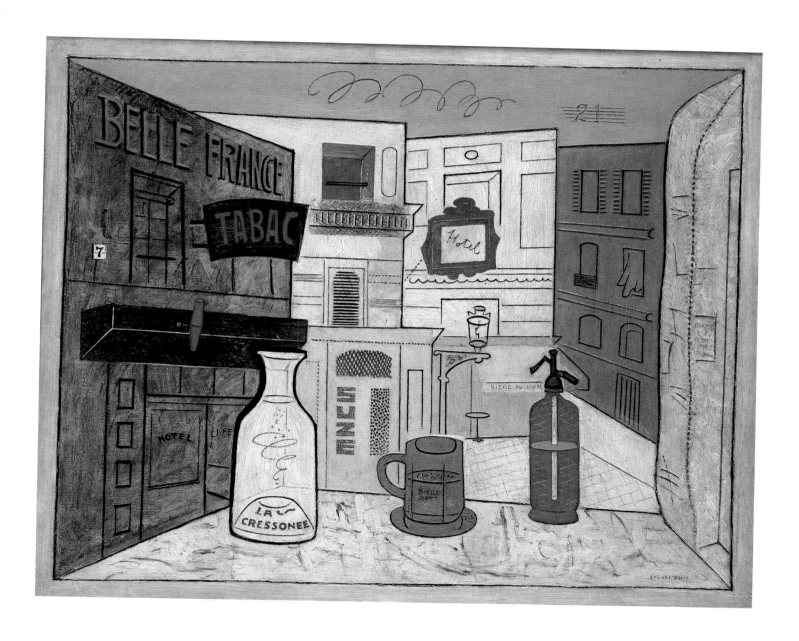

Blue Café. 1928

Oil on canvas, 18½ × 21¾ in. (47 × 55.3 cm.)

The Phillips Collection, Washington, D.C.

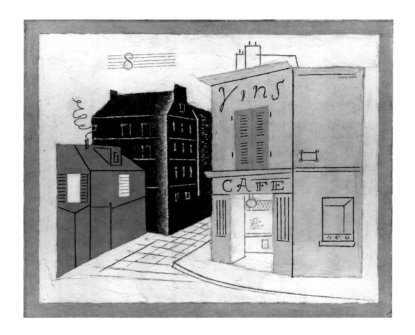

Adit No. 2. 1928

Oil on canvas, 29 × 24 in. (73.7 × 61 cm.)

Museum of Fine Arts, Boston. Gift of the William H. Lane
Foundation, 1990.394

Place Pasdeloup. 1928

Oil on canvas, 36¼ × 28¾ in. (92.1 × 73 cm.)

Whitney Museum of American Art, New York. Gift of Gertrude
Vanderbilt Whitney, 31.170

Figure 106. Place Pasdeloup, Paris

Café, Place des Vosges. 1929

Oil on canvas, 29 × 36½ in. (73.7 × 92.7 cm.)

Collection Mr. and Mrs. Roger Horchow

When Stuart Davis went to Paris in 1928, his situation, as Lewis Kachur has pointed out, was different from that of other American artists who made the trip. Davis was no novice whose work was ripe for a dramatic transformation into the latest avant-garde style. He was in his mid-thirties and had already embraced Cubism while working in Gloucester and in New York. His recently completed Egg Beater series represented one of the most radical achievements in American art since the 1913 Cubist compositions of Marsden Hartley and the Synchromist works of Stanton Macdonald-Wright and Morgan Russell a decade earlier. Davis financed his trip to Paris with money he received from Gertrude Vanderbilt Whitney and her associate Juliana Force, which allowed him to stay for a year. He had been acquainted with the Whitney Studio Club circle since the early 1920s, having had a two-person show there with Joaquín Torres-García in 1921, and a solo exhibition in 1926. The year that he returned to the United States Davis gave *Early American Landscape*, *Egg Beater No. 1*, and *Place Pasdeloup* (cat. nos. 61, 65, 82) to the Whitney Studio Club; that collection is now part of the Whitney Museum of American Art.[1]

While in Paris, Davis resided in the studio of Jan Matulka at 50, rue Vercingétorix, in Montparnasse. Several other American artists were living nearby, including Andrée Ruellan, Morris Kantor, Isamu Noguchi, and Alexander Calder. Elliot Paul, a writer friend from Gloucester, was instrumental in introducing Davis to influential people in the art world, and he also published an article on the artist in the October 1928 issue of *transition* magazine.[2]

In view of the extraordinary accomplishment of the Egg Beater series, art historians generally regard Davis's Paris paintings as somewhat of a regression, and the period as an isolated episode that ruptured the continuity in his overall development of this modernist achievement. The Paris paintings tend to be views of façades and signs in various areas of the city, for Davis had explored different neighborhoods and produced a record of a number of historical edifices. Sometimes the locales shown are imaginary composites; at other times, as in *Place des Vosges No. 1* (fig. 104) and *No. 2*, they are real. The Parisian urban landscape afforded Davis equivalents to the arrangements of planes he had worked out in the Egg Beater series,[3] and the greens, salmons, grays, and blues in the Paris paintings are similar to those in *Egg Beater No. 2* and *No. 3*. (Davis did take two of the Egg Beater pictures with him to Paris, which would certainly account for this continuity.)

Place des Vosges is a sixteenth-century enclave situated around a park that fills the central square. Although in Davis's depiction the perspective of the arcaded complex is relentlessly one directional (see fig. 105), he created an accordion arrangement of sections of the façades that allowed him to pull portions of the otherwise obscured walls forward. He emphasized this zigzag pattern by painting each plane a different color (the actual buildings are a uniform pink brick). The sensation that these are flat, two-dimensional shapes is reinforced by the outlines of the phantom architecture, viewed over the roofs of the buildings. This undoubtedly was what inspired Brian O'Doherty to characterize the Paris paintings as "confected idealized stage sets for a nostalgic musical of an American artist in Paris."[4]

Place Pasdeloup offers a view outside the small rectangular park off the Boulevard du Temple, in front of the Cirque d'Hiver (the building seen at the right in Davis's painting is now a Renault dealership; see fig. 106). Davis again chose the colors for his own compositional purposes. Red, white, and blue stripes, perhaps alluding to the French tricolor, extend across the width of the building at the center, with a band of green at street level. Here, as well as in *Adit No. 2* and *Rue des Rats*

No. 2, Davis set up diagonal planes at each side of the canvas that lead to a flat plane parallel to the picture plane.

In *Blue Café* and *Rue des Rats No. 2*, Davis isolated the main elements from the edges of the composition in a more dramatic way. He continued to paint different areas the same color—thus thwarting our experience of the essential distinction of one from another. Both pictures also have numbers set on a musical staff in the sky. The surfaces are more impastoed, and Davis seems to have incised—as much as painted—the lines in. The addition of sand to *Rue des Rats No. 2* results in a "stucco-like texture with the smooth-plaster effect of oil spread on by palette-knife."[5] Graffiti become another graphic element in this painting with the diagram of a horse's head that Davis had copied in his notebook.

Rue Lipp is the one composition that Davis reworked later, in 1959, in *The Paris Bit* (cat. no. 162). These two paintings are particularly associated with Davis's long-time friend the poet and author Robert Carlton Brown. Brown and his wife were inveterate travelers and were also in Paris at the time Davis was there. "Reference to Brown is cleverly scratched into the right-hand wall of *Rue Lipp* on a poster advertising his poems . . . [which] evolved from the example of Guillaume Apollinaire's Calligrammes."[6] The aura of Brown led Davis to make *Rue Lipp* a veritable word poem. Besides the recurring *Hotel*, CAFE, TABAC, BIERE HATT (a beer stein with a top hat inscribed within its contours), LA CRESSONEE and SUZE join the litany of words under the aegis of BELLE FRANCE. *Rue Lipp* is essentially another street scene. Davis placed a carafe, the beer stein, and a siphon on a marble café table in the foreground of the composition. "Thus we have a café-sitter's view of the stage-set space of the street and its passing spectacle. Typically, Davis manages to convey this without any figures to distract from the architectonics of the space enclosed by the buildings and wall at the right."[7] The title is not, in fact, an actual street name, but refers, rather, to the Brasserie Lipp, which Davis frequented while in Paris. In a letter to Bob and Rose Brown, he writes: "I'm glad you discovered Lipp because it's a swell place. I just came from there 6 or 7 times in the last 48 hours and expect to go back this afternoon."[8] It was Brown's death in 1959 that precipitated the completion of *The Paris Bit*. This event seemed to have irrevocably closed that chapter in Davis's life, one about which he had been particularly nostalgic during the 1950s, when he was feeling especially alienated from the American art scene.[9]

Davis returned to New York from Paris on the maiden voyage of the SS *Bremen* in August 1929. He showed his Paris paintings at the Downtown Gallery the following January. Although Davis never made it back to Paris, the particular juncture between abstraction and reality that he worked out in these paintings was to be characteristic of his art during the next decade.

LSS

1 Avis Berman, *Rebels on Eighth Street: Juliana Force and the Whitney Museum of American Art.* New York: Atheneum, 1990, p. 252.

2 Lewis Kachur, *Stuart Davis: An American in Paris* (exhib. cat.). New York: Whitney Museum of American Art at Philip Morris, 1987, pp. 2, 3, 4.

3 *Stuart Davis Memorial Exhibition* (exhib. cat.). Introduction by H. H. Arnason. Washington, D.C.: National Collection of Fine Arts, Smithsonian Institution, 1965, p. 20.

4 Quoted in Kachur, op. cit., p. 2.

5 E. C. Goossen, *Stuart Davis.* New York: George Braziller, 1959, p. 23.

6 Kachur, op. cit., p. 9.

7 Ibid.

8 Letter to Bob and Rose Brown, July 13, 1929. Robert Carlton Brown Papers, Special Collections, Morris Library, Southern Illinois University at Carbondale.

9 Kachur, op. cit., p. 10.

84

Egg Beater No. 5. 1930

Oil on canvas, 50⅛ × 32¼ in. (127.3 × 81.9 cm.)

The Museum of Modern Art, New York.
Abby Aldrich Rockefeller Fund, 1945

85

Study for "Egg Beater No. 5." 1930

Gouache and ink on paper, 22 × 14 in. (55.9 × 35.6 cm.)
The Regis Collection, Minneapolis

Stuart Davis resumed the Egg Beater series with *Egg Beater No. 5*, several months
after his return to New York from Paris. An eggbeater, mandolin, and what appears
to be a vase are disposed on the tabletop so that they seem to be continuous with it
and each other, and, given the slightly varied viewpoints, perspective is both de-
fined and denied. Davis has provided a view of the leg of the table that reveals its
inner mechanical workings. As Karen Wilkin has observed, this time "[t]he mass-
produced, nonart objects of the original setup [the Egg Beater series] . . . are re-
placed by familiar atelier props. . . . The all-American eggbeater is a foreigner
among the typical elements of a European still life. . . . It is one of the most 'French'
of his paintings, surprisingly close to the kind of modernist still life of the late 1920s
that he must have seen in Paris. Davis's debt to Picasso, Léger, and Gris is perhaps

199

more evident in *Eggbeater No. 5* than in any of the paintings he made in France."[1] However, the stylized, almost cartoon quality of the forms, with their strong outlines and abrupt definition of light and dark contrasts to convey three-dimensional modeling, marks the distinction between Davis's work and that of his slightly older French contemporaries. What we see here stylistically heralds what is to come in terms of Davis's treatment of objective reality during the next decade.

The work of Georges Braque is often overlooked by critics as an influence, or at least a precedent, for this composition (a notable exception is Brian O'Doherty). The theme of still-life compositions on a table—a series known as the *Guéridons*—first appeared in Braque's work in 1918–19, then again from 1928 to 1930 (while Davis was in Paris), and a third time, from 1936 to 1939. While the particular style of the table represented in Braque's paintings varied from the four-legged type to the more moderne iron table with curved legs, the most typical table image is one showing only a single leg and its foot—as in *The Table (Le Guéridon)* of 1921–22 (fig. 31). Braque organized the space by overlapping the misaligned, translucent planes of objects, which inevitably include a bowl of fruit, a stringed instrument, at times a sheet of music, and pipes and newspapers. The tilt-top table in *Egg Beater No. 5* also reminds us that we can look to Davis's own Cubist-influenced composition *Still Life with "Dial"* of 1922 (cat. no. 44) as another credible antecedent of this 1930 composition. One might even wonder if the same table is depicted in both paintings by Davis.

LSS

1 Karen Wilkin, *Stuart Davis*. New York: Abbeville Press, 1987, p. 131.

Anchors. 1930

Oil on canvas, 22 × 32⅛ in. (55.9 × 81.6 cm.)

The Forbes Magazine Collection, New York

Summer Landscape. 1930

Oil on canvas, 29 × 42 in. (73.7 × 106.7 cm.)

The Museum of Modern Art, New York. Purchase, 1940

Figure 107. Photograph of the actual site depicted in Stuart Davis's *Summer Landscape* (1930). The Museum of Modern Art, New York

The enduring influence of Stuart Davis's Paris sojourn can be seen in these two works, in which "there is an adaptation of the idiom of *Place Pasdeloup* [cat. no. 82] to a Massachusetts seaport town."[1] There is a comparable flattening and reduction of forms to distinctive, contained shapes, which play off the carefully choreographed extrapolation of schooner masts and rigging. Some Parisian "shorthand" appears, such as the multiple loops that represent clouds converging with electrical wiring, the tops of conglomerations of trees (in *Summer Landscape*), and a length of rope abandoned on the ground (in *Anchors*).

As seen in a photograph of the site (fig. 107) depicted in *Summer Landscape*, Davis utilized vertical elements such as chimneys, masts, and electrical poles to divide these compositions into sections, each painted a different color. In *Summer Landscape*, the composition is contiguous despite the divisions. Davis eliminated the usual distinctions between sky and land and land and water, so that the design of the colors, arranged within their various contours, is the main focus. He also distributed the color areas within the painting so that a visual balance is maintained.

The composition of *Anchors* is dominated by the objects in the lower left quadrant, for which the painting is named, and by the cart at the right, in which the fishermen's nets are being transported. In the upper portion of the painting, the view of the horizon line at the left has been divided into three sections by two masts. At the right, the viewpoint is more straight on, with the cart, cranes, masts, and rigging creating an elaborate interplay of latticed patterns. This contrasts with the left-hand side of the composition, which tilts upward—as indicated by the diagonal at the upper edge of the area in which the anchors sit. The masts, rigging, and nets on this side are cut off at the top by this shift in perspective through which Davis "condensed time and space . . . into one vision. He united the past, present, and future by giving us both immediate shapes (identifiable things) and more general shapes."[2]

In 1940, Davis wrote that in painting *Summer Landscape* he wanted to make a "permanent record" and a "profound souvenir" of a scene he found to be "arresting and beautiful."[3] The particular challenge, according to Davis, was to find a means to re-create "the pleasure felt on that morning in contemplating [the scene]."[4] In these works, Davis focused on the idea "that the interest which really existed in the scene was the result of a coherent and various order of space relations which the particular lighting of the hour made visible. This information . . . made it possible for me to eliminate . . . all irrelevancies . . . such as . . . light . . . the exact relation of the color tone of the sky, to the tree, to the water, etc. Instead I examined the view to discover the chief color-space fields which composed it. . . . These color-space quanta are abstract in the sense that they are independent of any particular objects, but they are concrete in their manifold unique configurations which are the physics of the people, objects, spaces and horizons which we know."[5] Davis was to rely on our ability to comprehend these "physics" and compensate for the transformations of reality as he developed his particular brand of abstraction during the next thirty years. LSS

[1] James Johnson Sweeney, *Stuart Davis* (exhib. cat.). New York: The Museum of Modern Art, 1945, p. 27.

[2] Alison de Lima Greene, "Twentieth-Century Art in the Museum Collection: Direction and Diversity," *The Museum of Fine Arts Houston Bulletin* 11 (Summer 1988), p. 11.

[3] Artist's statement, dated September 11, 1940. Archives of The Museum of Modern Art, New York.

[4] Ibid.

[5] Ibid.

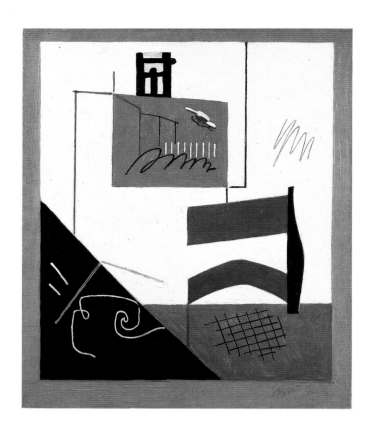

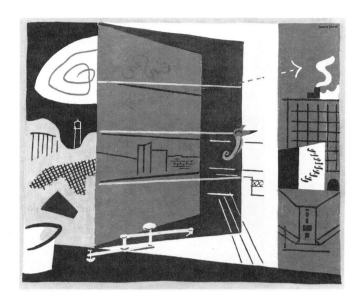

Interior. 1930

Oil on canvas, 24 × 20 in. (61 × 50.8 cm.)
The William H. Lane Collection

Composition. 1931

Oil on canvas, 17½ × 19½ in. (44.5 × 49.5 cm.)
Memorial Art Gallery of the University of Rochester.
Gift of Mr. and Mrs. Thomas G. Spencer

The influence of Henri Matisse on Stuart Davis's oeuvre is usually cited with regard to the monochromatic focus of *Studio Interior* (1917; cat. no. 20) and the broad shapes and brilliant coloration of the Havana watercolors done in 1920 (see cat. nos. 30, 31). However, Matisse's presence surely can be felt in Davis's abbreviated forms with ambiguous pictorial missions, as in *Interior* of 1930. In this composition, Davis reduces the depiction of a chair in a room to two maroon bands, anchored by a black one, to represent the back, and he includes a section of free-floating cross-hatching to define the caning of the seat. The black triangle nestled in the lower-left corner is meant to be a table. An opening in the white wall reveals a scene, bathed in blue, in which a building, a fence, and shrubbery are abbreviated in a few strokes. Set flush within a horizontal and vertical arrangement of lines, this blue rectangle may be a painting on an easel (suggested by the black form at the top) or a window. The angled gray lines and the white squiggle on the black triangle may well signify a design or drawing coming to life on the page of a notebook. One thinks of the particular abbreviations and simplifications that Matisse had achieved in his

work by 1908, in which depth and flatness were played off against one another, and used to convey "multiple viewpoints in memory or imagination."[1] In *Interior*, Davis relies on our memory of a chair and table to cement his visual shorthand.

Composition, completed a year later, actually combines scientific fact and nostalgia in a view—or, rather, three views—out a window. The reflective properties of the windowpane account for the inverted image of another scene, which is captured in the center of the opened window. To the left of the window, we glimpse the dunes of Gloucester, with a lighthouse in the distance. Chance shadows in the sand and clouds are rendered as abstract linear patterns. On the right is a city office building and lower structures that provide a contrast to the beach scene and the more "in-process" character of the central area. Davis unifies the spatial and temporal diversity of this composition by means of the dotted arrow that traverses the glass pane in the center, its ends pointing toward either side of the painting.

Davis recorded his admiration for Matisse (whose work he had viewed in the Armory Show) early on. He found affinities in the French artist's work with his own use of broad space and nonreferential color. Later, in the 1920s, as he began what was to result in his voluminous writings on art, Davis noted on one occasion simply that he thought Matisse was a better artist than Picasso.[2] In addition, he asserted that the excitement he experienced seeing Matisse's work was comparable to what he felt when listening to the piano players in the black saloons he frequented as a youth.[3]

LSS

[1] Jack Flam, *Matisse: The Man and His Art, 1869–1918*. Ithaca and London: Cornell University Press, 1986, p. 423.

[2] Stuart Davis, Notebook: 1920–22, May 2, 1922. Private collection.

[3] Diane Kelder, ed., *Stuart Davis*. New York, Washington, and London: Praeger, 1971, pp. 12, 23.

90

New York—Paris No. 1. 1931

Oil on canvas, 39 × 54¾ in. (99.1 × 139.1 cm.)
The University of Iowa Museum of Art, Iowa City. Museum Purchase

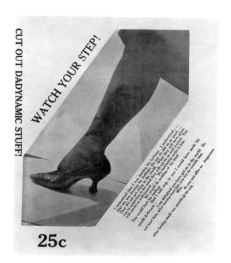

Figure 108. Page four of *New York Dada*, edited by Marcel Duchamp and Man Ray and issued in April 1921. Collection Library, The Museum of Modern Art, New York

New York—Paris No. 3. 1931

Oil on canvas, 39 × 52 in. (99.1 × 132.1 cm.)

Private collection

After completing *Egg Beater No. 5* (cat. no. 84), Stuart Davis summed up his Paris experiences and the consequences of his return to New York in three "New York—Paris" paintings. Each one is a catalogue of motifs referring to both cities. In *New York—Paris No. 1*, the large, stockinged leg of a woman dominates the composition. Given the presence of black-stockinged female legs in the work of such artists as Henri de Toulouse-Lautrec and Georges Seurat, this motif would seem to be French-referential. However, Rudi Blesh reminds us that a photograph by Alfred Stieglitz of a stockinged leg in a high-heeled shoe appeared in *New York Dada* in April 1921 (see fig. 108).[1] Loring N. Winkles amplifies the Dada association by relating this

image to motifs from Fernand Léger's film *Ballet méchanique*.[2] The association is interesting given Davis's longtime interest in and admiration for Léger, whom he had met while in Paris in 1928–29. Positioned as if about to walk out of the scene, this limb divides the composition of *New York—Paris No. 1* into one quarter at the lower left, where we see a Gloucester schooner, and the remaining three-quarters filled with, among other elements, an El station, the façade of a French café, and part of the Chrysler Building, the then newly constructed New York skyscraper, positioned oddly on its side. At the lower right, in front of the café, a small dinghy is moored. As if to complement the female content of the stockinged leg, a package of Stud chewing tobacco (on which is emblazoned a rearing horse, reinforcing the product's sexual connotations) hovers in the air at the top, along with a banner for the Orient Hotel. Throughout the composition, the size, original locale, and innate physical properties of the objects have been disregarded, but this disparate assemblage is anchored against the grid, which can barely be made out in the background.

By contrast, the components of *New York—Paris No. 3* seem isolated from one another, set against an unarticulated white background. More than in *New York—Paris No. 1* and *No. 2* (in which Davis concentrated on compressing New York and Parisian buildings), here the artist reprises some motifs and employs others that will subsequently figure in his work. The combination of vignettes recalls his 1918 memoir *Multiple Views* (cat. no. 23). The piled-up furniture in the top tier of objects and the easy chair at the lower left refer to his representations of interiors in the 1920s. The crisscrossed trees are taken from *Early American Landscape* of 1925 (cat. no. 61). The gas pumps and the rear view of a car in a landscape are Gloucester souvenirs. A Parisian hotel/café—in fact, the only Parisian motif—is situated just below the New York emblems, across from what appears to be the columned façade of the New York Stock Exchange. Just above these structures the Washington Market on Ninth Avenue in New York is depicted, along with a parking garage and two skyscrapers.

This painting is like a 1930s hieroglyphic strip, conveying the story of contemporary American society while ignoring a traditional narrative and a familiar painterly organization. Davis has found a format that he will refine in the 1932 *Mural (Men without Women)* and the 1939 *History of Communications Mural* (see cat. nos. 100, 121, 122), with their respective catalogues of iconic motifs. Davis indicates the influence of popular illustrations and advertising in the flat, almost caricatured style of these paintings. He continues the punning in such touches as the NO partially legible on the left gas pump in *New York—Paris No. 3*—a reference to No-Nox petroleum, made by Gulf Oil, that "stops knocks" in one's car engine.[3] The TICINO indicated on the sign is not the name of a street but of a restaurant in Greenwich Village that Davis frequented.[4] The artist effected a similar transposition when he titled a painting *Rue Lipp* (cat. no. 79), Lipp being the name of a well-known brasserie in Paris.[5]

LSS

[1] Rudi Blesh, *Stuart Davis*. New York: Grove Press, 1960, p. 54.

[2] Loring N. Winkles, "The Problem of European Influence in the Murals of Stuart Davis." Master's thesis, University of Cincinnati, 1977.

[3] Bruce Weber, *Stuart Davis' New York* (exhib. cat.). West Palm Beach: Norton Gallery and School of Art, 1985, p. 4.

[4] Ibid.

[5] Lewis Kachur and William Agee shared the idea with this author in a recent conversation.

House and Street. 1931

Oil on canvas, 26 × 42¼ in. (66 × 107.3 cm.)
Whitney Museum of American Art, New York. Purchase, 41.3

Trees and El. 1931

Oil on canvas, 25⅛ × 32 in. (63.8 × 81.3 cm.)
Henry Art Gallery, University of Washington, Seattle.
War Assets Collection

Brian O'Doherty has likened the bipartite composition of *House and Street* to movie stills;[1] Stuart Davis himself called it a "mental collage."[2] The image on the left is of a building on Front Street in lower Manhattan; that on the right is a view of the Third Avenue El as it turns from Front Street into Coenties Slip.[3] The left-hand scene shows a large sign with the name SMITH in front of a building that has a brick wall and two suspended ladders; at the bottom of the sign is the logo of the Bell Telephone Company, then located nearby on Pearl Street and St. James Place.[4] The designation FRONT appears near the right side of the building. In the right-hand scene is a section of the elevated subway track seen from an underpass and, beyond, several buildings, each distinguished by style, color, and pattern in such a way that Davis not only defines space, but provides a feel for the style of the architecture. The framing of the two scenes functions both to isolate one from the other, and, in the case of that on the right, to suggest the spectator's position in an underpass, beneath the tracks of the El.

The elevated subway would be depicted frequently in Davis's work, particularly during the 1920s and 1930s. Like many of his contemporaries, he was fascinated with the El as a symbol of urban life and mobility. Unlike such artists as Reginald Marsh and Raphael Soyer, Davis chose to forego the usual portrayals of city inhabitants, focusing rather on the formal aspects of the architecture and the potential for decorative patterning it offered within a total composition. During the 1930s Davis was very interested in exploring the artistic means to render reality; by the

end of the decade his later color-space theories were expanded to include texture. Indeed, despite the anecdotal elements in these scenes, the compositions can be described as studies of the arrangements of rectangular shapes.

House and Street is one of three works included here that incorporate references to Governor Alfred E. Smith, the controversial and memorable 1928 presidential candidate; the others are *Abstract Vision of New York . . .* of 1932 (cat. no. 99) and *Trees and El.* The last picture, also executed in 1931, shows the elevated train from another angle, including a view of the end of an enclosed park. A large tree dominates the right-hand side of the composition, its branches stretching over the El tracks and to the adjoining building to enclose the scene, isolated, like an island, against an orange field. As in *Early American Landscape* (cat. no. 61), the influence of Léger is apparent in the crisp definition of biomorphic forms such as the white clouds(?) amid the branches of the trees and the witty shapes of the trunk and leaves. The connections among the various parts of the composition are abrupt, emphasizing the discontinuity, since the framing elements that separate the two scenes in *House and Street* are not present. Davis also interjects a visual non sequitur in the portion of a structural beam that appears in the white area below the blue El tracks; it seems to be literally walking the inscribed line while an arrow points in the opposite direction. An equally incongruous T element extends out from this white area. Its function is mysterious although its presence seemingly is helpful in anchoring the scene within the orange field. Bruce Weber has interpreted the combination of the El and the word SMITH in this work as a rebus for Al Smith—an example of the verbal/visual punning that Davis often indulged in throughout his career.[5]

Trees and El was one in a group of over a hundred works that were purchased by the United States Department of State in 1946, and were to travel for a five-year period throughout Europe and Latin America to "show the world the progressive and sophisticated state of painting in postwar America."[6] The exhibition was shown at the Metropolitan Museum before it went on tour. This was interrupted when several Hearst publications attacked the art and the political sympathies of the artists as subversive and Communistic. By February 1947, the tour of the exhibition was withdrawn and the government set out to liquidate the paintings. Richard S. Hart, then working in the dean's office at the University of Washington, saw the government-bid notice and applied to purchase the entire collection. Other universities and museums followed suit. Taken by surprise, the government doled out the paintings by lots to various places, and the University of Washington was awarded six—works by Stuart Davis, Werner Drewes, Marsden Hartley, Max Weber, Ben-Zion, and Robert Motherwell—for the grand total of $259.00.[7]

LSS

1 Brian O'Doherty, *American Masters: The Voice and the Myth.* 2nd ed. New York: Universe Books, 1988, p. 54.

2 See Bruce Weber, *Stuart Davis' New York* (exhib. cat.). West Palm Beach: Norton Gallery and School of Art, 1985, p. 12.

3 Patterson Sims, *Stuart Davis: A Concentration of Works from the Permanent Collection of the Whitney Museum of American Art* (exhib. cat.). New York: Whitney Museum of American Art, 1980, p. 25. See also Patterson Sims's notes, dated July 17, 1987, in the archives of the Whitney Museum of American Art.

4 Ibid.

5 Weber, op. cit.

6 Carolyn S. Hartke, Notes on the War Assets Collection. Archives of the Henry Art Gallery, University of Washington, Seattle.

7 Ibid.

Salt Shaker. 1931

Oil on canvas, 49⅞ × 32 in. (126.7 × 81.3 cm.)

The Museum of Modern Art, New York.
Gift of Edith Gregor Halpert, 1954

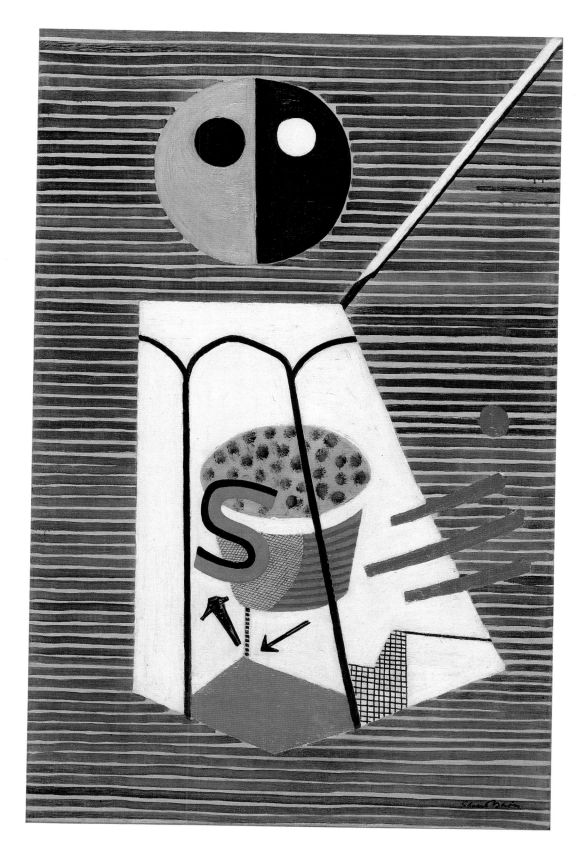

94

Radio Tubes. 1931

Oil on canvas, 50 × 32¼ in. (127 × 81.9 cm.)

Rose Art Museum, Brandeis University, Waltham,
Massachusetts. Bequest of Louis Schapiro, Boston

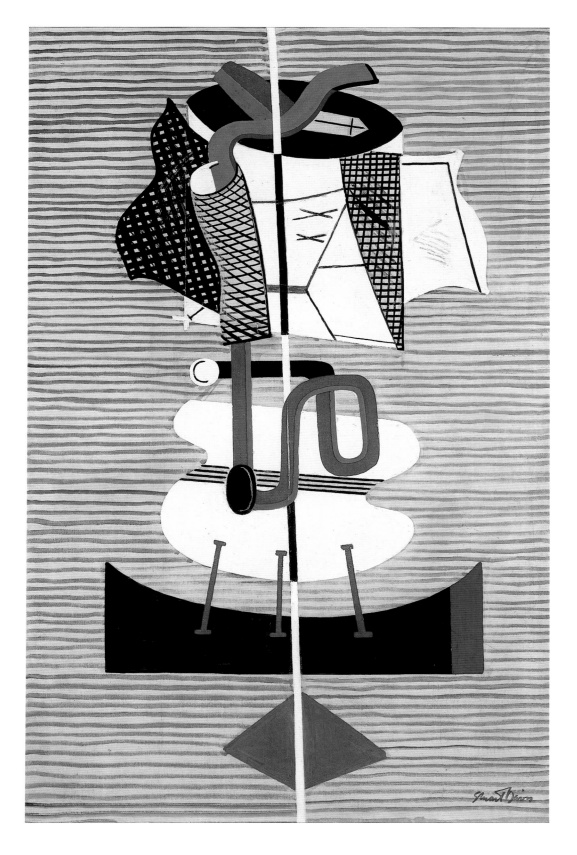

The transformation of a single, small-scale object into the subject of a major painting is the focus of these two compositions. Several stylistic forerunners may be cited. The lined backgrounds of both compositions, the cross-hatching and stippling, and the flat shapes in *Radio Tubes* are reminiscent of the more decorative aspects of Cubism. Yet, it is the delight of the Dadaists in the celebration of the ordinary and the banal that is the most pertinent precedent for these two pictures. Writing about *Salt Shaker* in 1957, Stuart Davis noted: "It is an exact likeness of a salt shaker acquired from Café l'Avenue in Paris, 1928. It has the words *Sel Cerebos* etched on the side. . . . The image has been slightly refracted in accord with the laws of Poetic License and Freehand Drawing. Symbolically it was and remains a personal identification with the topical outside in practical portable form."[1]

The subject matter of these works is distinct from the pristine presentation of a consumer product seen in *Odol* (cat. no. 56). They have more in common with Davis's abstract collages of 1921 (see cat. nos. 34, 35), in which the associative qualities of form and its camouflaging are challenged and realigned. In *Salt Shaker*, there are hints at Francis Picabia's and Marcel Duchamp's anthropomorphic punning on forms, as, for example, in the bifurcated black-and-white sphere that suggests a head in relation to the faceted form of the object's crystal body. The sphere may also be merely the top of the salt shaker, with holes for the passage of the salt. There is a second form within the body of the shaker, which perhaps represents a container of pepper, reinforcing the symbolic aspects of the essential black/white dichotomy.

Radio Tubes, by its very subject, is a response to Picabia's personification of the "jeune fille américaine" as a spark plug (1915; see fig. 109). Even Davis's particular arrangement of the filaments suggests their conductive function, which takes on a sexual nuance in Duchamp's *The Bride Stripped Bare by Her Bachelors, Even (The Large Glass)* of 1915–23 (Philadelphia Museum of Art. Katherine S. Dreier Bequest). Yet, Davis would have balked at such analyses. In direct contradiction to art-historical interpretation, he would have ascribed a more scientific, pragmatic meaning to this painting, such as the observation of the refractive properties of crystal, or the transmittal process of radio waves. Davis noted that in his 1939 *Mural for Studio B, WNYC, Municipal Broadcasting Company* (cat. no. 115) he sought to represent "radio antenna, ether waves, etc."[2] Radio was a constant in his life (and television joined it later). In his daily diary entries during the late 1930s he made notations of specific programs, particularly those featuring the work of various jazz musicians.

LSS

[1] Artist's statement, dated February 28, 1957. Archives of The Museum of Modern Art, New York.

[2] Diane Kelder, ed., *Stuart Davis*. New York, Washington, and London: Praeger, 1971, p. 92.

Figure 109. Francis Picabia. *Portrait d'une jeune fille américaine dans l'état de nudité.* 1915. Reproduced in *291,* no. 506 (July–August 1915). Collection Thomas J. Watson Library, The Metropolitan Museum of Art, New York

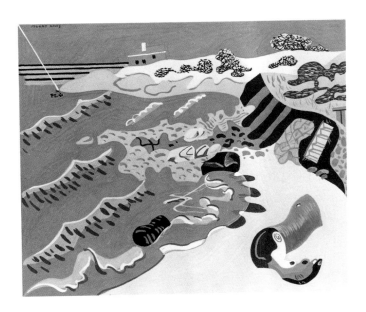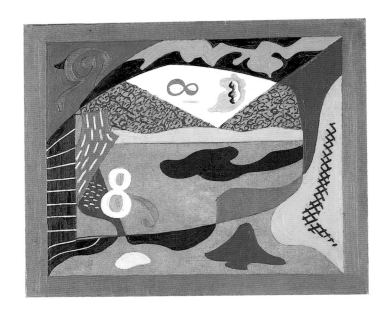

96

Sand Cove. 1931

Gouache on paper, 12⅞ × 14⅝ in. (32.7 × 37.2 cm.)
The Pennsylvania Academy of the Fine Arts, Philadelphia.
Bequest of Miss Marie Weeks

97

Lawn and Sky. 1931

Oil on canvas, 18⅝ × 22⅝ in. (47.3 × 57.5 cm.)
Archer M. Huntington Art Gallery, The University of Texas at Austin.
Lent by Mari and James Michener

Stuart Davis had harsh words for Surrealism: "Its biological base is reactionary and negative. . . . To overcome this obvious contradiction of an art of the dead, its chief exponent, Dali, has sought to give life to his space-color by the use of optical objectivity or mechanical vision. The profundities of the dream and the pathological mood become banal indeed when presented in the symbiosis of the amateur photographer."[1] Although Davis disapproved of the more illusionistic strains of Surrealism, he evidently found something of interest in the biomorphic tendencies of artists such as Joan Miró. (Davis did, eventually, meet Miró, perhaps during the Spanish artist's first visit to the United States in 1947.) In *Sand Cove*, the finger-like waves literally reach to the shoreline; a mysterious form that seems to be a disembodied hand attached to a face lies on the beach at the lower right. One thinks of Miró's own landscapes of the 1920s, such as *Person Throwing a Stone at a Bird* (1926; The Museum of Modern Art, New York) or *Hand Catching a Bird* (1926; Private collection, Paris), in which the rippled forms of toes and fingers set a precedent for Davis.

Lawn and Sky presents landscape as a continuity of fluid, biomorphic shapes. The textural patterning, here, of dots, dashes, and cross-hatching was to intensify in Davis's work by the 1940s. The shadows of unseen forms—perhaps existing out-

214

side the composition—create pools of color areas. The particular disposition of the framing element around the central area of green creates a silhouette composed of shapes occurring inside that are "irrelevant" or independent of the larger one. Figure eights lie near a pond and in the sky, in a random abandon that recalls the unexpected symbols floating in the sky in Davis's Paris paintings.

Two compositions by Davis of 1932, *Abstract Vision of New York: a building, a derby hat, a tiger's head, and other symbols (New York Mural)* (cat. no. 99) and the triptych known as *Study for "Abstract Vision of New York,"*[2] again show Miróesque influences. In these works, recognizable objects and landmarks are intermingled with fanciful forms. The moon in *New York Mural*, in particular, is extremely similar to that in Miró's *Dog Barking at the Moon* (1926; Philadelphia Museum of Art).

LSS

[1] Stuart Davis Papers, March 24, 1937. Harvard University Art Museums, Fogg Art Museum, Cambridge, Massachusetts.

[2] This triptych was subsequently separated into three paintings now known as *Pre-Wall* (Private collection), *Gaspump* (Collection Mr. and Mrs. Selig S. Burrows), and *T-Scape* (Hirshhorn Museum and Sculpture Garden, Smithsonian Institution, Washington, D.C.). The composition of *Pre-Wall* was the source for that of *New York Mural*.

98

Television. 1931

Tempera on paper, 10½ × 18 in. (26.7 × 45.7 cm.)
Private collection

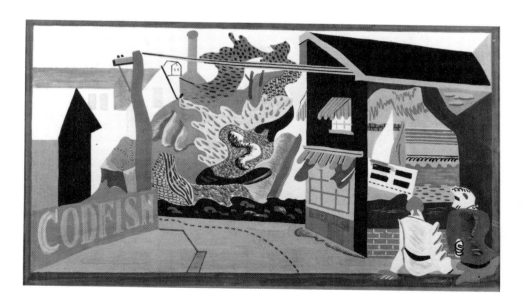

This elusive composition again reveals the influence of Surrealism on Stuart Davis's oeuvre. The decorative, biomorphic forms that define the landscape at mid-composition acknowledge the work of Joan Miró. Davis also evokes the dream imagery of Salvador Dali and René Magritte in the discrepancies of scale and the inexplicable apparition of a house by the shore within the physical confines of the awninged house at the right. The summary indication of a road relates to similar shorthand depictions in the Paris paintings of 1928–29. A couple, whose exact re-

lationship to the total scene is undefined, is seated at the lower right. Are they spectators in this living dream? Are we to see real life as a corollary to television?

Davis was an avid consumer of electronic media, but the connection between the title of this work, *Television*, and the scene depicted is not clear. We know that in his later career Davis had the habit of working in his studio with the television on (sound off). When he got his first set is uncertain. Although the technology was achieved in the laboratory in the 1930s, television was not available for mass marketing until the end of World War II. Davis felt that the medium was a seminal element that distinguished the vision of modern art: " 'An artist who has used telegraph, telephone and radio doesn't feel the same way about light and color as one who has not,' wrote Davis in 1940, and a visit to his studio usually found him sitting in his Saarinen chair, four radios scattered around him, the television set on. . . . Television had a tremendous reality for him. He had a perfect apprehension of how that medium, under its overt subject matter, kept up a kind of meta-commentary that makes . . . [it] . . . the most neutral and suggestive of media. . . ."[1]

LSS

[1] Brian O'Doherty, *American Masters: The Voice and the Myth.* 2nd ed. New York: Universe Books, 1988, p. 78.

99

Abstract Vision of New York: a building, a derby hat, a tiger's head, and other symbols (New York Mural). 1932

Oil on canvas, 84 × 48 in. (213.4 × 121.9 cm.)
Norton Gallery, West Palm Beach

In 1932, Lincoln Kirstein organized the exhibition "Murals by American Painters and Photographers" at The Museum of Modern Art in New York. The pretext of this project was to showcase the talents of American artists who felt they were not being given a fair chance in the competition for murals due to the dominance of Mexican painters in this field. The exhibition included the work of sixty-five artists, including Georgia O'Keeffe, Yun Gee, Ben Shahn, William Gropper, and Stuart Davis. Edward Steichen, Berenice Abbott, Charles Sheeler, and George Platt Lynes were among the photographers who submitted designs for photomurals. The modern industrial city afforded the most popular subject, as seen in this work submitted by Davis, and incorporated skyscrapers, building construction, industry, and political themes.

Bruce Weber has incisively deciphered the rich and complex imagery that Davis assembled in this composition.[1] At the center is the newly erected Empire State Building—painted blue, black, and red—which forms the focal point of the iconography of the painting. This building, completed in 1931, had been designed by the firm of Shreve, Lamb, and Harmon, and developed by Floyd De L. Brown. Brown had hired the recently defeated presidential candidate Al Smith as a publicist and spokesman, and, indeed, allusions to this colorful personality, whom Davis greatly admired, are present in the painting in a number of the compositional elements. At the left center we see a brown derby, which had become Smith's trademark. As Weber notes, it serves several linguistic functions, referring variously to the hat

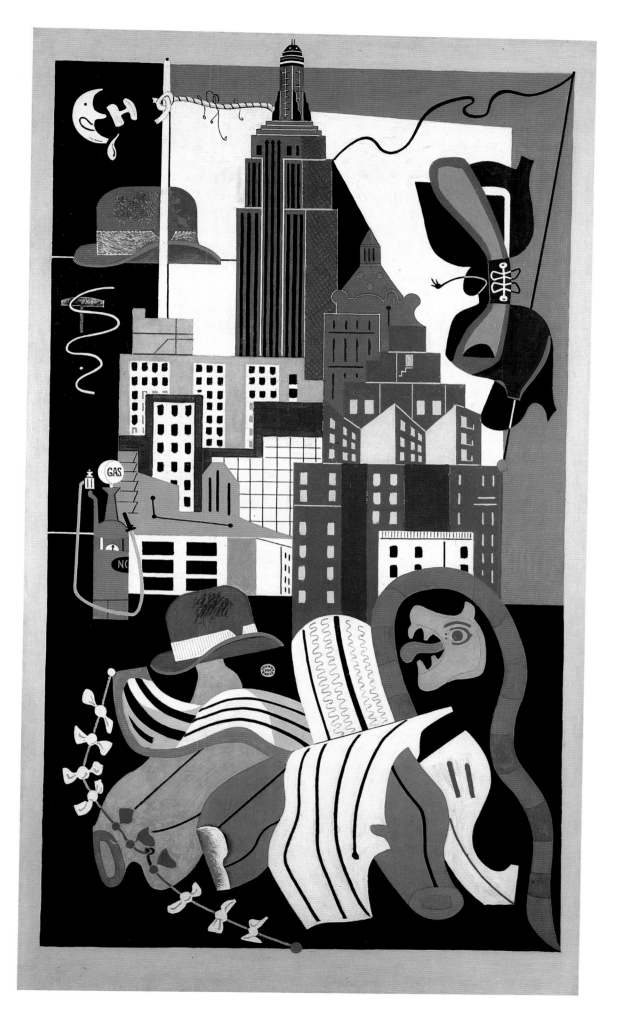

that Smith threw into the ring with his presidential candidacy in 1928 as well as to Smith's reputation as a "top banana," since the derby is situated on top of an expansive fruit—itself an allusion to Smith's 1928 campaign song, which was based on the popular tune "Yes! We Have No Bananas." The derby reappears at the upper left, next to the Empire State Building—a reference to Smith's then current occupation as agent for the new skyscraper, at the time the tallest building in the world.

Davis pays homage to the talent of political cartoonist T. E. Powers, whose name is inscribed on the smiling crescent moon in the top left-hand corner. Powers published several parodies of events in Smith's political career, including his pinning the tail on the donkey, which Weber believes is a source for the kite tail with the tiny bows in the lower-left corner of the composition; these bows, in turn, refer to Smith's penchant for wearing bow ties. Another such allusion is the composite blue, red, white, green, and black form at the upper right. Additional references to Smith include the upturned champagne glass from which a drop of liquid is falling, which alludes to his championing of the repeal of prohibition; the mooring rope and the moon, which refer to the brisk trade in smuggling illicit alcohol; and the tiger's head (and tail), symbolic of the Democratic political machine known as Tammany Hall, then under investigation for corruption, specifically in the transportation industry, which is represented by the gas pump.

Besides the Empire State Building, the skyline Davis presents includes red buildings that suggest Tudor City, a residential apartment complex, and the blue-and-red Singer Building, which was built in 1908 and, consequently, is dwarfed by the newest addition to the New York horizon. Weber asserts that Davis was quite deliberate in assembling this rich iconographic program, which is distinctive within his total oeuvre. He would have been responding to the Mexican muralists, who were then doing work in the United States, as well as to the Social Realists. However, Davis cagily sidesteps any attempts at a too-simpleminded interpretation of the painting, as indicated by the prosaic descriptiveness of the original title. In this way, as Weber concludes, "Davis cleverly retained his modernist credentials while handling politically charged subject matter in an original and subtle manner."[2]

LSS

[1] Bruce Weber, *Stuart Davis' New York* (exhib. cat.). West Palm Beach: Norton Gallery and School of Art, 1985 (see specifically pp. 12–16). The title of this painting as given here is taken from the catalogue of the 1932 exhibition at The Museum of Modern Art in New York; see *Murals by American Painters and Photographers*. Introductory essays by Lincoln Kirstein and Julien Levy.

[2] Ibid., p. 16.

100

Mural (Men without Women). 1932

Oil on canvas, 10 ft. 8⅞ in. × 16 ft. 11⅞ in. (327.3 × 518 cm.)

The Museum of Modern Art, New York. Gift of Radio City Music Hall Corporation, 1974

Originally entitled *Men without Women*, this painting was renamed simply *Mural* when it entered the collection of The Museum of Modern Art in 1974. Stuart Davis was commissioned to do the mural by Donald Deskey, who had been charged with

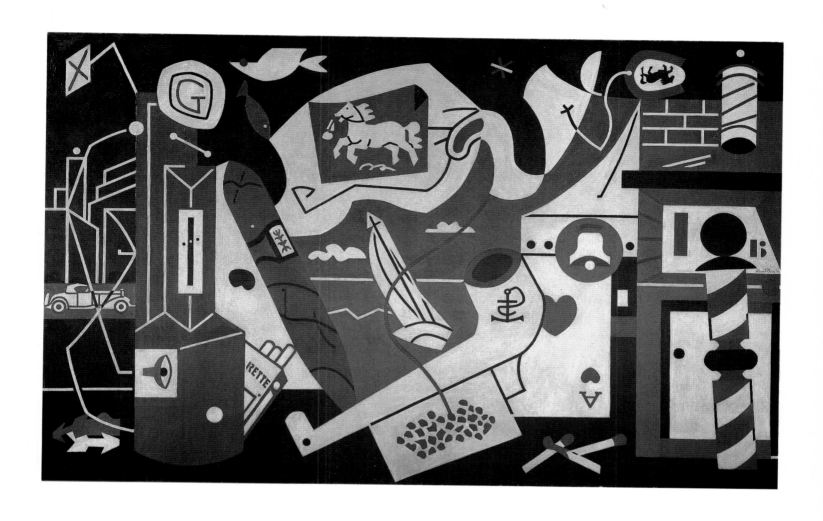

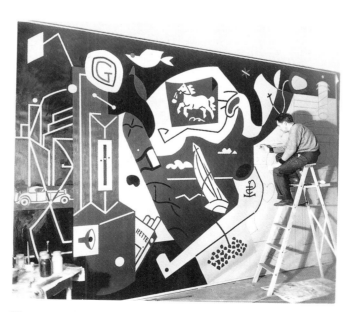

Figure 110. Photograph of Stuart Davis at work on *Mural*
(*Men without Women*). Collection Earl Davis

the overall design concepts for New York's Radio City Music Hall. Davis's sister-in-law, Miriam, also has been credited with working to secure the commission for the artist, and, certainly, his contribution to the mural exhibition at The Museum of Modern Art in 1932 (see the essay by Lowery Sims, pages 56–69) may have influenced the decision of the Radio City Music Hall committee as well.

When we compare this work to *Abstract Vision of New York* . . . (cat. no. 99), we can see that Davis has devised a different means to organize the space. The various elements in the latter are arranged in a hierarchical manner, with some of them providing visual balance if not formal symmetry as they flank the skyscrapers that form the vertical center of the composition. In *Mural (Men without Women)*, Davis again disregarded the basic rules of proportion and size, and, in addition, organized the composition so that each independent element asserts its own presence within the overall ensemble. While there are several spatial "vignettes," the artist's primary concern was with the overall design of the composition. This is reaffirmed by the limited, "nonrealistic" palette, which consists of black, white (now stained from years of exposure to tobacco smoke), olive green, and a brownish red. Davis also subjected customary notions of positive and negative form and space to his final design so that our usual associations of mass and void are constantly challenged. In spite of the fact that we can read each form—the pipe, horse logo, sports car, barbershop pole, gas pumps, sailboats, tobacco pouch, easy chair, and skyline—they have been rendered either as flat planes of color or outlines that interact, as well, with the background and foreground of the picture. The outrageous defiance of scale and the male-oriented subject matter remind us of the artist's 1924 composition *Lucky Strike* (cat. no. 57). There, the section of the newspaper page, the package of tobacco, the pipe, and the cigarette papers have been placed in close proximity to provide an opportunity for contemplation comparable to that offered in traditional still-life compositions. Although relationships of scale among the elements in the 1924 picture are closer to actuality, Davis gives each a comparable importance, thus dispensing with conventional ideas of focus and hierarchy within a single composition. In *Mural*, this is achieved through the seemingly scattered compositional elements that defy usual categories and definitions of space and time, not to mention size.

Davis initially proposed to execute the mural in large pieces of colored linoleum, but fire regulations at the Music Hall ruled out this possibility. This original concept may very well have influenced the selection of muted colors that Davis eventually used, as well as the open, linear character of the forms. The artist retired to Provincetown in the fall of 1932 to work on this project. He wrote to his lifelong friend Bob Brown: "I have a studio in town which is just large enough to accommodate the main-sail I am painting on. It is 11 × 17 feet which doesn't sound big, but measure it off and see what it looks like. I will be here all through October. It has to be done by Nov. 1st or I lose a $1000 a day in publicity money. I hope everything comes out alright and that I will once again be in [a] position to quaff the tasty and stupifying [sic] McSorley's Ale."[1] A photograph of the artist (fig. 110) in the process of completing this painting indicates its grandeur. Davis transferred the design onto the canvas from a series of scale drawings that show the various combinations of the compositional components that he had tried out beforehand.

The original title of this work, *Men without Women*, may refer to a collection of short stories published by Ernest Hemingway in 1927. The stories present men in various situations where their sexual and social identities are challenged, and resonate against the social reality of the women's suffrage movement in the 1920s and

1930s. As Lewis Kachur has noted, Davis, too, hearkened to the beleaguered status of modern man in the Radio City *Mural*: "Its subject matter of contemporary male diversions was geared to one of the few remaining male realms, for as Davis joked, by 1932, 'the flappers had taken over. Only McSorley's Ale House was left. But they couldn't get into the Men's Room . . . [at Radio City Music Hall] . . . to see my mural.'"[2] It may also be interpreted as a poignant reflection on Davis's own life at the time. Rudi Blesh has suggested that the ace of hearts in this composition refers both to card games and to amorous intentions.[3] Davis's first wife, Bessie Chosak, died the same year that this mural was executed, and for the moment Davis was a man without a woman.

LSS

[1] Letter from Stuart Davis to Robert Carlton Brown, dated October 2, 1932. Robert Carlton Brown Papers, Special Collections, Morris Library, Southern Illinois University at Carbondale.

[2] Lewis Kachur, "Stuart Davis and Bob Brown: *The Masses* to *The Paris Bit*," *Arts Magazine* 57, 2 (October 1982), p. 73.

[3] Rudi Blesh, *Stuart Davis.* New York: Grove Press, 1960, p. 54.

101

Snow on the Hills. 1932

Oil on canvas, 21⅝ × 31⅞ in. (54.9 × 81 cm.)

Georgia Museum of Art, The University of Georgia, Athens.
Eva Underhill Holbrook Memorial Collection of American Art,
Gift of Alfred H. Holbrook

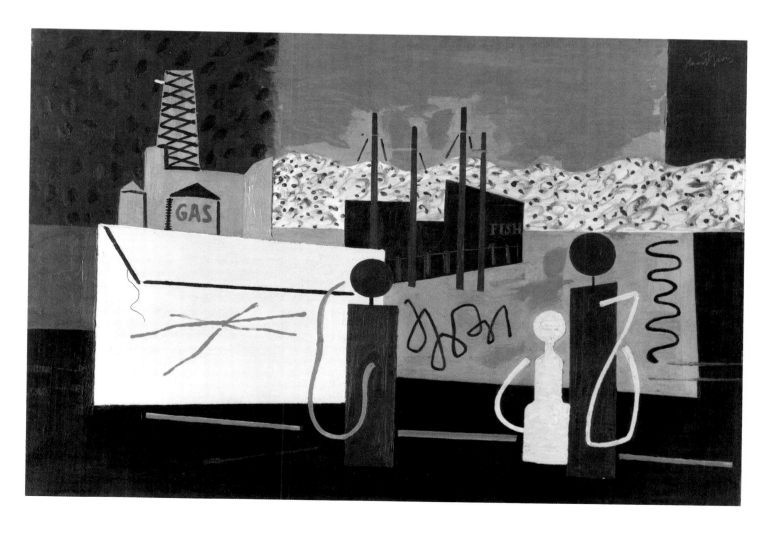

Landscape with Garage Lights. 1932

Oil on canvas, 32 × 41⅞ in. (81.3 × 106.4 cm.)
Memorial Art Gallery of the University of Rochester.
Marion Stratton Gould Fund

Stuart Davis's dealer, Edith Halpert, encouraged him to align his artistic interests with those of the "American Scene" movement in the 1930s.[1] Davis toed a precarious path between abstraction and Social Realism. In *Snow on the Hills* and *Landscape with Garage Lights*, we see Davis espousing an anecdotal viewpoint that coincides with that of the "American Scene" movement. Both compositions depict essentially the same subject: a view of Gloucester harbor that reveals the industrialization that had gone on since Davis first began to spend time there two decades earlier. In *Snow on the Hills*, a fish-processing plant (identified by FISH) occupies the center of the composition. Closer to us and to the left we see a gas tank, in front of which is an unidentified structure whose roof line has been summarily indicated. The foreground is dominated by three gas pumps, which resemble chess pieces, and in the distance is a curvilinear area that represents snow on the hills, speckled with soot. There are few details about the scene provided. Davis has relied on simple, flat, essentially overlapping planar shapes to define the space.

In *Landscape with Garage Lights*, the same scene has been jolted alive with color and a plethora of texture and detailing. Certain elements remain constant: the fish-processing plant and the masts in front of it, the gas pumps and the building just behind them, and the sooty, speckled hills. Several buildings have been added to the scene, including what seems to be a log-cabin-type structure at the lower left, and another building just behind, only identifiable by a portion of a sign reading CO. The gas tank has been replaced by a coal-processing plant, and a boat enters the scene just to the right of the fish plant. The sky is now dominated by other masts and riggings, to the left, as well as by telephone lines. The gas pumps have become anthropomorphic puns evoking the hourglass figure that was in vogue among fashion-conscious ladies a few decades earlier. The three garage lights mentioned in the title are suspended from the upper right, and beneath them is the awning of some unseen building. Davis also adds directional arrows, which "confirm the important role angles played in the creation of his composition of dynamic color-shapes. . . . Reality was initially the basis of the picture, but as the painting evolved reality became secondary to the picture's compositional demands."[2] In addition, various calligraphic flourishes function either to define elements in the composition or merely to activate the space and guide the spectator's glance through the maze of the scene.

What makes these paintings—especially *Landscape with Garage Lights*—compatible with the interests of the "American Scene" movement is that in them Davis celebrates a specific way of life in America—at the seaside, in Gloucester. While one would not claim similar intentions in all of Davis's Gloucester scenes, it is interesting that this particular locale became dominant in his work during this period, when he was so preoccupied grappling with the theoretical aspects of the roles of color, shape, texture, and line in achieving a personal brand of abstraction.

LSS

[1] Donald D. Keyes, "Stuart Davis: *Snow on the Hills*," *Georgia Museum of Art Bulletin* 12, 2 (Winter 1987), p. 23.

[2] Ibid., p. 11.

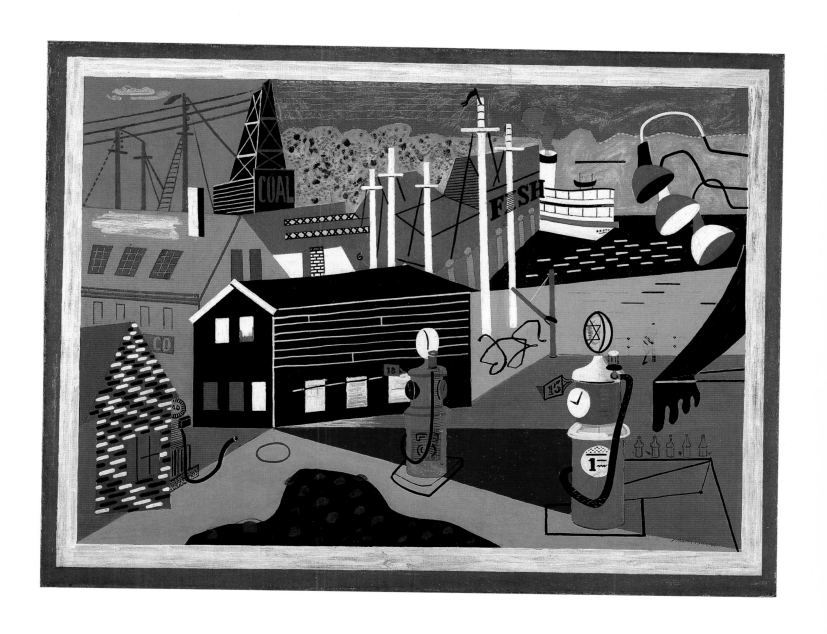

Red Cart. 1932

Oil on canvas, 32 × 50 in. (81.3 × 127 cm.)
Addison Gallery of American Art, Phillips Academy,
Andover, Massachusetts. Addison Gallery Purchase

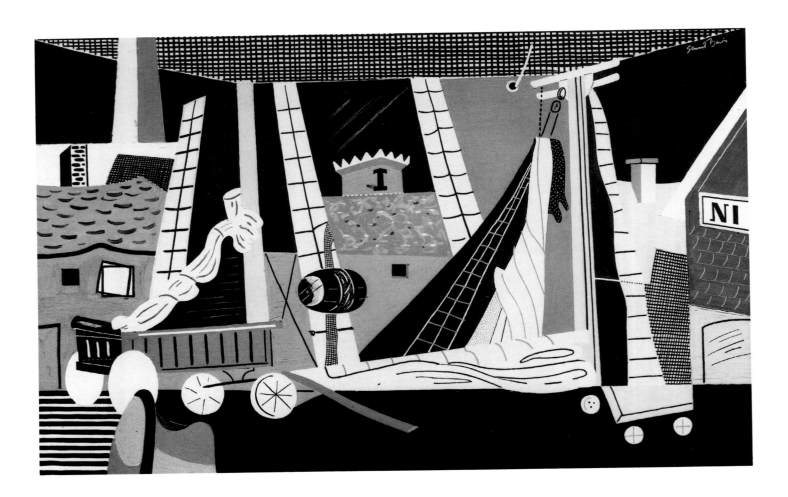

Stuart Davis spent time in Gloucester, Massachusetts, every year from 1915 to 1934. He had featured its topography, piers and wharfs, harbor, residences, schooners, and fish-processing plants as central and recurring themes in his art. This habit intensified in the 1930s even as his seasonal visits were ending.[1] As seen in the Gloucester landscape scenes executed in the 1930s (see cat. nos. 107, 109, 110), with the passing of the decade Davis's depictions become less empirically based and display a greater interest in abstracting the elements of the Gloucester environs. More importantly, they demonstrate Davis's working method of balancing the dynamics of recognizable phenomena with the will to engage a modernist vocabulary of his own.

All the on-site painting Davis did in the 1910s codified his familiarity with Gloucester. As he notes in his autobiography: "I wandered over the rocks, moors and docks, with a sketching easel, large canvases, and a pack on my back, looking for things to paint. . . ."[2] He gradually began to change his working method: "After a number of years the idea began to dawn on me that packing and unpacking all this junk . . . was irrelevant to my purpose. . . . Following this revelation my daily sor-

ties were unencumbered except by a small sketch book . . . and a . . . fountain pen."[3] Davis would then use these drawings to compose his pictures, combining different views into a single composition. He no longer needed to follow the narrative set by reality, but would "select and define the spatial limits of these separate drawings in relation to the unity of the whole picture," by which means he "developed an objective attitude towards size and shape relations."[4]

Davis had painstakingly worked out the distillation of reality into linear and color-shape terms in *Snow on the Hills* and the related painting *Landscape with Garage Lights* (cat. nos. 101, 102), both of 1932. In a series of drawings and planar studies, Davis clarified his refinement in perceiving "a conceptual, instead of an optical perspective."[5] The peculiarities of details such as form, color, and space were incorporated into the overall design of the space. Following this, Davis would assign color to the different areas so that our sense of the recognizable elements is maintained, and then he would explore the purely plastic aspects of paint and line.

Red Cart was painted in 1933, the year that Davis enrolled in the Public Works of Art Project. Compared to *Landscape with Garage Lights*, it is a less programmatic view of Gloucester. Here, familiar landmarks such as a turreted tower, a chimney, a barrel, and a seine cart are interspersed within the network of crisscrossed diagonal bands that represent fishnets hung to dry. As in *Anchors* and *Summer Landscape* (cat. nos. 86, 87), these vertical elements divide the composition into discrete views. However, the spatiotemporal discontinuity seen in the works from 1930 is carried even further here. The elements in the earlier paintings belong more or less to the same locale. There is some consistency in terms of proportion, given the expected positioning within the scene. In *Red Cart*, each of the three building types (a house, a fort, and a processing plant) is viewed from different vantage points, thus interrupting whatever continuity might be ascribed to the whole. This is counterbalanced by Davis's artful arrangement of color, which accomplishes a visual equilibrium while suggesting advancement and recession in space. "In this . . . picture, the . . . foreground and the netted area at the top are connected by orange poles. This . . . locks the side views into place . . . and creates a container for the . . . objects depicted. . . . Perhaps the most striking thing . . . is the lavish use of black as a color in its own right. . . . [T]he geometry of the picture packages the black in such a way that it stays more or less on the same plane . . . [and] . . . most of the other colors are . . . strong enough to avoid domination by the black and through that strength sanction its conventional forcefulness."[6]

LSS

[1] He did return occasionally after 1934. For example, a visit to Gloucester and Cape Ann in 1938 inspired the 1939 landscape compositions *Bass Rocks No. 1* and *No. 2*, and *Shapes of Landscape Space* (cat. nos. 116–118).

[2] Diane Kelder, ed., *Stuart Davis*. New York, Washington, and London: Praeger, 1971, p. 25.

[3] Ibid., pp. 25–26.

[4] Ibid., p. 26.

[5] Ibid.

[6] Ellen Lawrence, *Graham, Gorky, Smith, and Davis in the Thirties* (exhib. cat.). Providence: David Winton Bell Gallery, Brown University, 1977, p. 31.

American Painting. 1932–51

Oil on canvas, 40 × 50¼ in. (101.6 × 127.6 cm.)

Joslyn Art Museum, Omaha. University of Nebraska at Omaha
Collection

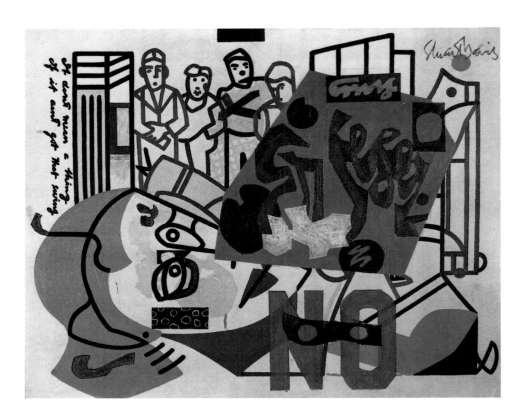

Figure 111. Stuart Davis. *American Painting.* 1932 (original state).
Oil on canvas. Photograph, Collection Earl Davis

Tropes de Teens. 1956

Oil on canvas, 45¼ × 60¼ in. (114.8 × 153 cm.)

Hirshhorn Museum and Sculpture Garden, Smithsonian
Institution, Washington, D.C. Gift of Joseph H. Hirshhorn
Foundation, 1966

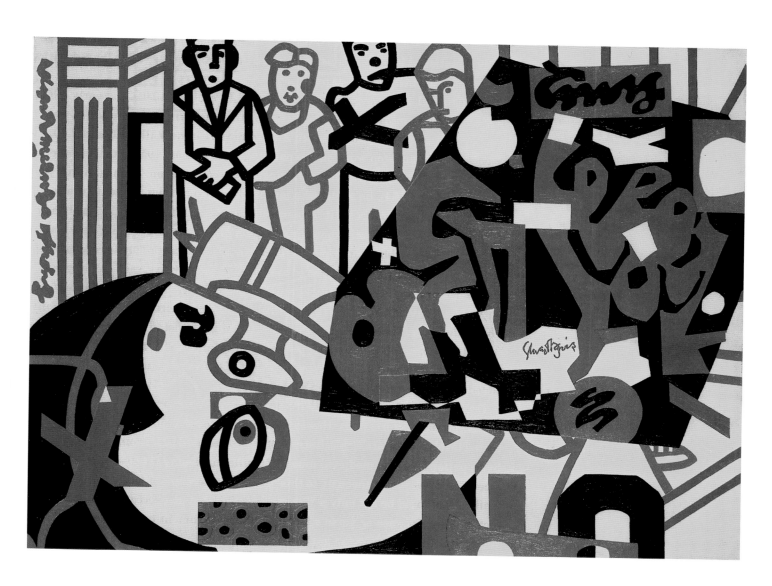

American Painting, perhaps Stuart Davis's most enigmatic combination of images,
is also atypical of his work in that it is a figural composition. As exhibited at the
new Whitney Museum's first biennial exhibition of contemporary art, *American
Painting* (fig. 111) was schematic and linear in design, and closely related to Da-
vis's contemporary drawings. The figures are disjointed, with the group of four men
at the upper left in smaller scale than the top-hatted man at the right, who is
smaller still than the hand with a pistol above him, or than the woman's head at the
lower left. There is no continuous narrative that would unite them. Instead, they
might be seen as disembodied signs of distinctly American phenomena, from jazz to
gangsterism to cartoons.

 Among other singular themes that appear only in this painting is the monoplane
in the center, between the figure groups. It has been identified by Holliday Day as

Ship's Rigging. 1932

Ink and gouache on paper, 20⅛ × 27½ in. (51.1 × 69.9 cm.)
Collection Constance Kamens

During the early 1930s, Stuart Davis focused on drawing as the fundamental basis of good art. His ideas about drawing are complex. He often used drawing as a means to painting, to emphasize his feeling that the underlying design was the key to an accomplished work of art: "Black and white is the essence of tonal perspective. The greater the contrast the greater the depth."[1] Davis preempted the sequential aspect of narrative with the idea that "a line drawing is a representation of a black wire object which defines three-dimensional space . . . selected to represent the [artist's] interest . . . in a certain aspect of nature."[2] The sense of time was expressed by means of angular variations, which, when they crossed each other in space, created new forms. The individual units of a form expressed a unit of time that "does not have reality until set in motion by duplication. . . . [It] . . . could be analogous to a second of time. The picture . . . could be called a duration of so many seconds of Time."[3] While the directional movement of line was to be arbitrary, Davis recog-

nized that certain drawings were better than others, according to the proportions of the angles and the variety of the shapes created by the convergence of these angular movements of lines in space. For this reason, Davis observed, the artist must "study good drawings to find common point relation characteristics."[4]

Davis was certainly conscious of the proportional relationships that formed the basis of the theoretical Golden Section (see cat. no. 60), but by the 1930s he assiduously would have avoided a formalistic approach to creating form. While his assertion of the primacy of intuition suggests a Surrealist automatism, Davis correlated qualities of "order, coherence and logic of [the] two-dimensional space" with the idea of an organized society and the artist's commitment to positive social values.[5]

In *Composition* and *Composition No. 5*, especially, we see the dynamics of the angular variations and proportions created by the movement of lines in space. *Composition No. 5* has a more fluid, improvisational character. Davis conjures up the hanging lamp or garage light, the various dockside buildings of Gloucester, funnels, and other forms in what seems to be one continuous sweep in time of a line traveling through space, doubling back on and intersecting with itself. This spontaneity is an illusion, since a 1932 sketchbook makes clear that Davis has combined two drawings, adding the forms at the left and right to the main scene with the large funnel, the building, and the lamp. It is interesting to observe this same composition with intermittent dark and light areas conveying a distinctive spatial presence in *Ways and Means* (1960; fig. 67), done almost thirty years later.

Composition (also known as *Study for Gloucester III*), like *Ship's Rigging* and *Untitled (Seine Cart)*, is more angular in nature and reflects Davis's identification of the triangle as the unit of time comprising its duration—which is the drawing. He also calls for a numerical variety in the two-dimensional elements, as seen in *Ship's Rigging* and *Untitled (Seine Cart)*, where the repertoire of shapes and marks combines to create spatial references of great complexity. In the latter, the cart, the schooner with its masts, the rigging, and the buildings have been collapsed into a pictorial unit whose integrity is based on the visual effect of the interrelationships of the individual units and their distribution within the composition. *Ship's Rigging* introduces a more whimsical aspect, appending a giant lamp (or fan) to the abstraction of a schooner. The time-space disjuncture created by the juxtaposition of the two elements anticipates that achieved three years later in the 1935 composition *Waterfront* (cat. no. 110). In *Ship's Rigging* and *Untitled (Seine Cart)*, Davis also introduced color and texturing. He would develop his color-space theory throughout the 1930s and 1940s, and by 1950 would resolve it with his concept of two-dimensional design by creating a visual tension between real and implied space.

LSS

[1] Stuart Davis Papers, 1933. Harvard University Art Museums, Fogg Art Museum, Cambridge, Massachusetts.

[2] Ibid., July 13, 1936.

[3] Diane Kelder, ed., *Stuart Davis*. New York, Washington, and London: Praeger, 1971, p. 58.

[4] Ibid., p. 56.

[5] Stuart Davis Papers, October 1, 1935, op. cit.

Waterfront. 1935

Oil on panel, 20 × 30 in. (50.8 × 76.2 cm.)

The University of Oklahoma Museum of Art, Norman

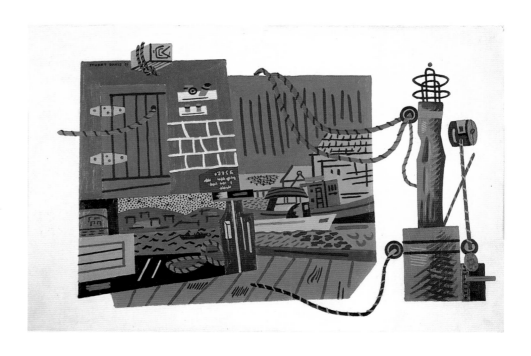

Sail Loft. 1933

Oil on canvas, 16 × 20 in. (40.6 × 50.8 cm.)

Collection Dr. and Mrs. Milton Shiffman

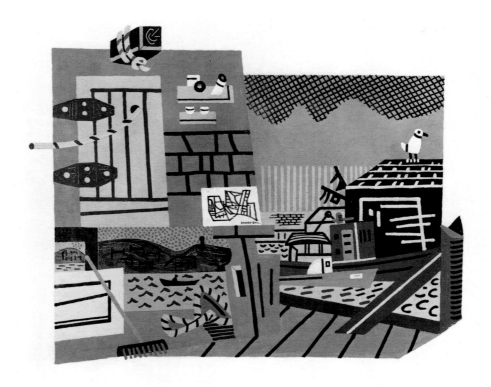

In *Sail Loft*, painted a year after *Red Cart* (cat. no. 103), Stuart Davis suggests the disparate nature of a seemingly composite view by disposing various elements in two distinct landscape areas in a single composition. At the upper left are a hinged door and a portion of the shingled roof of a sail loft and its handling tackle.[1] The rest of the composition is a landscape with a view of a harbor or cove, a wharf seen at the lower edge, and a group of houses in the distance. At the right are dock buildings and a rather oversized bird who presides over the scene. The pier in the middle divides the picture, and although the original sketch makes it clear that this is, in fact, a continuous view, Davis implies discontinuity by decorating the two halves of the canvas with different color schemes and patterning. At the center of the composition, the lower right-hand portion of the sail-loft roof, Davis inserted a line drawing similar to the series of ink drawings and black-and-white paintings he executed between 1932 and 1934 (see cat. nos. 106–109).

This composition recurs two years later in the 1935 *Waterfront*, this time as a distinct rectangular shape attached to a beacon/pulley at the right. Several details in *Sail Loft* have been changed: The color and decorative scheme in *Waterfront* create a different kind of visual dialogue. The bird on the roof has been eliminated, as has the rake on the dock. The flags on the dock buildings have disappeared, and the fisherman in the rowboat has taken on cargo. Although the beacon is integral to Gloucester, Davis has located it outside the immediate spatial context of the scene. It is treated as a still-life element, "floating" in space like the objects in *Percolator* and *Matches* (cat. nos. 63, 64), painted eight years earlier. In his theoretical writings on painting during the 1930s, Davis noted that pictures were to be based on a dialogue between different spatial and tonal systems, but "each picture part had its own absolute real value. Each part also interrelated with all others and had a relative role to play in making up the larger reality of the integral."[2] Davis literally affirms the unity between the two components of this picture by means of the length of rope leading from the beacon around and into the landscape scene.

LSS

[1] See John R. Lane, *Stuart Davis: Art and Art Theory* (exhib. cat.). New York: The Brooklyn Museum, 1978, p. 113.

[2] Ibid., p. 39.

Art of the People Get Pink Slips. 1937

Pencil, gouache, and collage on paper, 15 × 20¼ in. (38.1 × 51.4 cm.)

Private collection

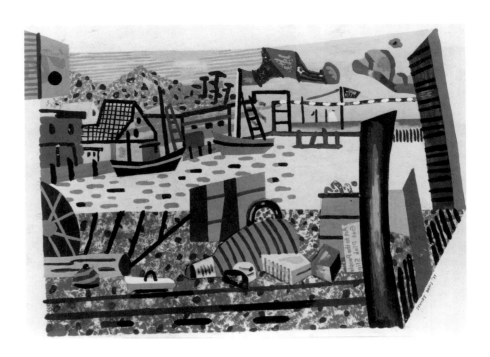

Gloucester Harbor. 1938

Oil on canvas mounted on wood, 23¹⁄₁₆ × 30⅛ in. (58.6 × 76.5 cm.)

The Museum of Fine Arts, Houston. Museum purchase, with
funds provided by the Agnes Cullen Arnold Endowment Fund

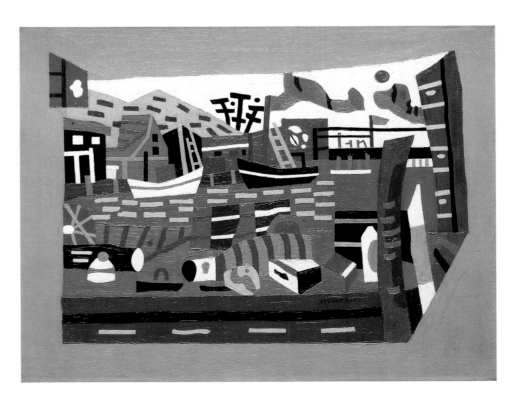

These two works are variations on the same composition. We see a view of a cove with hills and houses dockside and a bridge crossing the water in the background. The water is situated in the middle ground, and the foreground is strewn with a variety of lobster traps, toolboxes, wheels, and storage huts. On a preparatory sketch from 1933, Stuart Davis wrote: "This drawing is made on The Theory that The Real Form is unknowable even after it is drawn. That it has being thro' [sic] the Ideal Form whose laws we know. The drawing was made by impulse and observance of the adjacent angles only."[1] In subsequent studies, the linear details were "thickened" into ribbon-like elements, as seen in *Gloucester Harbor*. Davis represents such things as smoke and clouds as curvilinear squiggles—a pictorial device that appeared in his work from the late 1920s on. The right sides of both of these compositions have been pinched in and a trapezoid added in the upper left-hand corners. The piers on the right side recede on a diagonal to provide a perspectival element. In *Gloucester Harbor*, the rich tonalities of lavender, purple, maroon, green, blue, orange, brown, yellow, and black are punctuated by artfully situated areas of white to balance the pristine white of the sky.

Art of the People Get Pink Slips, executed a year earlier than *Gloucester Harbor*, is much freer in handling. Davis has stippled a pattern onto the areas representing the wharf and the mountains. This effects a more surreal optical impression, as the various elements drawn on top of those areas seem to be slightly off kilter or out of focus. Appended like a flag to the pier at the lower right is a rectangle on which is inscribed in mirror writing: "Art of the People Get Pink Slips." Davis firmly believed in government support of the arts as a means of reinforcing the artist's commitment to the working classes, and tirelessly lobbied in support of the continuance of such programs as the PWAP and the WPA.

LSS

[1] *Stuart Davis Sketchbooks*. Foreword by Earl Davis. New York: Estate of Stuart Davis, Grace Borgenicht Gallery, and The Arts Publisher, Inc., 1986, n.p.

114

Swing Landscape. 1938

Oil on canvas, 86¾ × 172⅛ in. (220.3 × 437.2 cm.)
Indiana University Art Museum, Bloomington

One of the major artistic achievements in Stuart Davis's oeuvre, *Swing Landscape* was to be installed in the Williamsburg Housing Project in Brooklyn, New York, a public-housing development designed by William Lescaze and built in 1936–37. Davis received the commission from Burgoyne Diller, who served as head of the Mural Division of the Federal Art Project in New York. In awarding commissions to Balcomb Greene, Paul Kelpe, Albert Swinden, Ilya Bolotowsky, Jan Matulka, Francis Criss, Byron Browne, George McNeil, Willem de Kooning, Harry Bowden, and Eugene Morley, as well as to Davis,[1] Diller "took a radical course in awarding them to young, largely unknown painters who worked in avant-garde styles . . . at a time when the prevailing subject matter in American art centered on narrative scenes."[2] Diller justified this focus on abstract art by arguing that "[s]ince many of the residents of this low-income housing project worked in factories . . . tenants would find painted images of more machines and factories neither interesting nor

114

stimulating. Instead, abstract patterns painted in strong vibrant colors would add to the enjoyment of residents."[3] Diller also stressed the psychological potential of undetermined "arbitrary" color to "stimulate relaxation" as well as to complement "the architect's intention in the design of [the] rooms." He was quite clear on the political ramifications of his decisions. The inclusion of artists working in abstract styles had been vigorously contested from the inception of the federally sponsored art programs. Diller attempted to predicate the cooperation of the FAP when he stated, "These murals . . . symbolize the effort that is being made by the Federal Art Project to stimulate rather than to restrict the direction of painting, which, in the last analysis, should be the artist's prerogative."[4]

In *Swing Landscape*, Davis achieved "the ultimate Davis jumble, alive edge to edge with carefully interwoven, varied forms and color combinations. Sequences of dashes, stripes and circles don't elaborate the underlying tripartite harbor scene so much as they overwhelm it. Nothing recurs, everything is generically related. Lines frequently thicken to assume the status of shapes, and a number of motives, like the large cursive loops . . . make their appearance. The variety of colors . . . becomes . . . overwhelming. . . . Davis [never] used so many, at such a high key, before or after."[5] This veritable riot of shapes and color most successfully deflects our attention away from whatever recognizable forms there are in the composition. The dominant impression is of the aggressive and insistent jutting and abutting of colored shapes next to one another. Spatial depth is all but eliminated. What we may miss is that the center section (whose left border is aligned with the small, white rectangle with red markings) and the right-hand panel (whose jagged left contour is seen where the ladder and orange-and-red barber pole meet at an angle) are based on the 1934 composition *American Waterfront Analogical Emblem* (Collection Mr. and Mrs. Norman Halper, Rockville Centre, New York). Davis has retained the house with the protruding vertical element at the lower left of the 1934 composition, as well as the cigar shape encircled with a rope, and the rigging to the right of that. In the foreground of *Swing Landscape*, Davis has dispersed lobster traps and other paraphernalia similar to that in the foreground of *Gloucester Harbor* (cat. no. 113); the latter's own rich palette seems to have prepared the way for *Swing Landscape*.

The left-hand panel is dominated by the complex of mast, rigging, cloud, and orange water at the upper left. Just to the right of this is a chimney spewing red smoke, attached to a yellow house partially submerged in the waves, which reach to the uppermost window. To the right of the house are two posts, and in the foreground, from left to right, are a section of chains, the top element of a pulley, and two funnels, similar to those in *Composition No. 5* (cat. no. 107). In the center of this morass floats a green bowler hat like that in *Abstract Vision of New York . . .* of 1932 (cat. no. 99).

Davis continues his practice of creating an effect of landscape floating free of the background. While the composition extends to the left and right edges, at the top and bottom the outermost edges of the individual forms are silhouetted against a white ground. By 1939, in *Mural for Studio B, WNYC, Municipal Broadcasting Company* (cat. no. 115), the different compositional elements will be isolated within their own enclosures, and in *Shapes of Landscape Space* (cat. no. 118), scenic references will be encased in an unrelated form.

Swing Landscape was never installed in the Williamsburg Housing Project. In his 1938 diary, Davis records that it was picked up and taken to the Federal Art Gallery on 57th Street, where it was to be installed.[6] It was then exhibited in the two-person show "Marsden Hartley, Stuart Davis," organized by Peggy Frank

(Crawford) for the Cincinnati Modern Art Society.[7] Henry Hope, then director of the Indiana University Art Museum in Bloomington, purchased it for the museum's collection, and it was accessioned in 1942. Not all of the other Williamsburg murals had such a happy ending. All but five murals executed by Bolotowsky, Greene, Kelpe, and Swinden have been lost; these five were recovered by the New York City Housing Authority, which had them restored and transferred to The Brooklyn Museum in 1990, where they are on long-term loan.

LSS

[1] The source of this information is the pamphlet written by Barbara Dayer Gallati, associate curator of American painting and sculpture at The Brooklyn Museum, for the installation of "The Williamsburg Murals: A Rediscovery," March 1990. See also Greta Berman, "Abstractions for Public Spaces, 1935–1943," *Arts Magazine* 56, 10 (June 1982), pp. 81–86.

[2] Gallati, op. cit.

[3] Berman, op. cit., p. 82.

[4] Burgoyne Diller, "Abstract Murals," in Francis V. O'Connor, ed., *Art for the Millions: Essays from the 1930s by Artists and Administrators of the WPA Federal Art Project.* Boston: New York Graphic Society, 1973, pp. 69–71.

[5] Roberta Smith, "Stuart Davis, Picture-Builder," *Art in America* 64, 5 (September–October 1976), p. 87.

[6] See Edward Alden Jewell, "Commentary on Murals: Exhibition at the Federal Art Gallery Presents WPA New York Region Survey," *The New York Times*, May 29, 1938.

[7] *Marsden Hartley, Stuart Davis* (exhib. cat.). Essays by Peggy Frank and Stuart Davis. Cincinnati Modern Art Society, 1941.

115

Mural for Studio B, WNYC, Municipal Broadcasting Company. 1939

Oil on canvas, 84 × 132 in. (213.4 × 335.3 cm.)
The City of New York

This mural, perhaps one of the most truly abstract works by Stuart Davis, artfully reconciles three main areas of thematic interest (of gray, white, and pink) against a flat, beige field. The dominating gray area presents a familiar motif—a seascape seen through the maze of the rigging and masts of a Gloucester schooner. The marked linearity of the elements relates to Davis's studies of Gloucester of 1932 to 1934 (see cat. nos. 106–109), in which his interest in drawing as the primary element of art is evident. This Gloucester vignette, which had been a constant theme in Davis's work throughout the decade, is associated with another of the artist's interests: jazz. To the lower left of the gray area we see a large, yellow saxophone, with red buttons, and an electric-blue reed, lying on its side and emitting a few desultory notes. At the lower right is a brown rectangle that encompasses and frames the outlines of a clarinet. The red strip at the extreme right of the composition presents a series of directional arrows: one descending in a backward L shape, another as an S curve, and one simply arcing slightly to the left. A squiggle curled around a horizontal bar appears at the top of this section, and what seems to be an MI is set in a white circle. This area is connected to the gray one by a stark black arrow enclosing a curvy, white linear form that echoes its shape. At the top of the composition, off to the left, is a turquoise-green band within which is a curved line of white dashes intercepted at intervals by black vertical lines.

Davis explained that the mural "represents a series of formal relations which are identified with musical instruments, radio antenna [*sic*], ether waves, operators [*sic*] panel, electrical symbols, etc."[1] For Davis, radio transmission embodied the "essence of abstraction."[2] In conceiving the mural, Davis took various elements and "composed them in a harmonious design of shape, color, and direction . . . presented in an imaginative rather than a factual relationship." He explained, "It has been my intention to place these various elements into juxtaposition with each other in a way which one often does in remembering a scene or event and the incidents relating to it . . . certain aspects of it are exaggerated and others are suppressed. The scene is rearranged and recomposed according to the importance and meaning which the different elements have had for the spectator. . . . In other words we do not simply reflect the things we see, like a mirror, but we compare them, in our ideas and emotions, with things we have seen before and with things we hope to see. . . . The result is a visual decoration which creates a mood in the spectator, just as a piece of music creates a mood, instead of giving some kind of factual information or instruction."[3]

Davis's love of music and his appreciation of jazz in particular were well known. In his lectures and writings, especially from the 1940s on, he reiterated his belief that it was possible to evolve a visual art form that was integrally as American as jazz music.[4]

LSS

[1] Stuart Davis, "Mural for Studio B, WNYC (Working Notes) (1939)"; see Diane Kelder, ed., *Stuart Davis*. New York, Washington, and London: Praeger, 1971, p. 92.

[2] Quoted in *Stuart Davis, Murals: An Exhibition of Related Studies 1932–1957* (exhib. cat.). Essay by Beth Urdang. New York: Zabriskie Gallery, 1976, n.p.

[3] See note 1.

[4] See Brian O'Doherty, *American Masters: The Voice and the Myth*. 2nd ed. New York: Universe Books, 1988, pp. 77–78.

Bass Rocks No. 1. 1939

Oil on canvas, 33 × 43 in. (83.8 × 109.2 cm.)
Wichita Art Museum, Kansas. The Roland P.
Murdock Collection

Figure 112. Stuart Davis. Study for *Bass Rocks*. 1938. Ink on paper. Amon Carter Museum, Fort Worth

Figure 113. View of the installation of "Artists for Victory" at The Metropolitan Museum of Art, New York, 1942–43, showing Stuart Davis's *Bass Rocks No. 1* (the third painting to the left of the doorway)

Bass Rocks No. 2. 1939

Oil on canvas, 33 × 43 in. (83.8 × 109.2 cm.)
Collection John and Jan Mackey

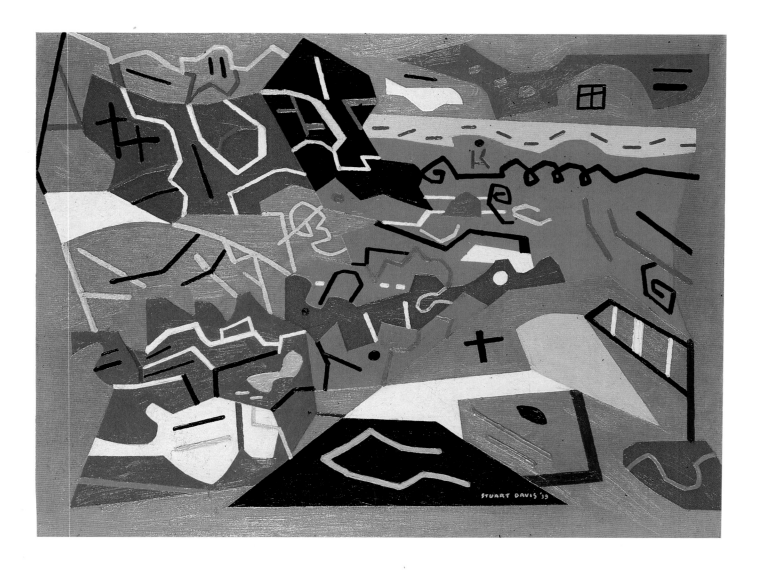

"*Bass Rocks* expresses the great variety of interest which can be found in the shapes, color, sizes, and positions of a simple subject. By implication it shows the variety of this kind of interest which can be found in all aspects of nature. Anyone looking for stories, advice on domestic or political problems, economic council [*sic*], or psychoanalytical instruction, will not find it in this picture."[1] This blunt observation was recorded by Stuart Davis three years after the *Bass Rocks* paintings were executed. In these works and in *Shapes of Landscape Space* (also 1939; cat. no. 118), Davis experimented with color shapes and with lines to convey landscape as a series of interconnecting pictorial episodes in which the underlying narrative or anecdotal details are quite beside the point. As Davis noted, these compositions "represent the color and space harmonies which I observed in a landscape subject . . . it is a selection of certain relations of spatial order and logic which were actually present in the subject. Casual observation of the scene from which they were taken would not reveal the elements from which my picture is made. These harmonies only become apparent after study and contemplation of it. . . . Pictures of this kind,

indeed all genuine art . . . keep the eye of the beholder alive, force him to make observations, and give value to, aspects of nature which everyday preoccupations too often leave unnoticed."[2]

Davis stated that he "wanted to make a picture that would recall my exhilaration in contemplating [the scene]."[3] This euphoria seems to be replete in the feverishly abrupt series of starts and stops that characterize the abstracted reduction of the rocks, beach, and sea. In *Bass Rocks No. 1*, painted in April 1939,[4] Davis traced in the main forms of a sketch done on the site in 1938 (see fig. 112)[5] in lines of black, salmon, blue, and green, over eight distinct areas of salmon, yellow, green, gray, and blue that are like the pieces of a puzzle; the lines within these various areas of color are in colors that are complementary or otherwise contrasting. There are also places where the lines are simply drawn on the white background. Davis was experimenting with what he called his "T-D-S Intervals,"[6] the Tone-Direction-Size units that he describes in his writings of 1939, which relate to his theory that the shape and color of a form can determine its spatial definition within a composition. The peculiar shapes and the placement of the colors and contrasting linear overlay effectively mitigate the original landscape details so that the pure, painterly, abstract elements of line and color prevail.

As he often did, Davis took up this composition again just two months later in June 1939.[7] In *Bass Rocks No. 2*, the landscape elements have been laid out against a red background. Davis has reinforced the identification of the separate elements in the composition by means of color—even if not the natural colors of the forms. Whereas an area such as the water at the upper right in *Bass Rocks No. 1* was stripped of its spatial function, in the second composition it has been represented in an aqua tone, fringed, near the top of the composition, by a yellow beach with red dashes. Beyond, a house and hills form part of the red background, and a patch of blue sky seems to have been cut out in the center. The rocks at the left and bottom of the composition create separate spatial episodes within their parameters. For example, the blue area to the lower left seems to be a view of the sea with a boat form against the rocks indicated in lines of white and black. What we begin to see in this composition is the more elaborate, "baroque" quality that Davis's work takes on in the 1940s; manifest is a reconciliation of the dialogue between abstraction and realism, neither of which is sacrificed in the process.

Bass Rocks No. 1 was shown at The Metropolitan Museum of Art in 1942 as part of the exhibition "Artists for Victory" (see fig. 113), which was a collaborative project of twenty-three artists' societies throughout the city. The exhibition was conceived as a gesture on the part of the Metropolitan Museum "to proclaim its faith in the American artist during one of the most critical years in our history."[8]

LSS

[1] Stuart Davis, "Bass Rocks (1942)," in Diane Kelder, ed., *Stuart Davis*. New York, Washington, and London: Praeger, 1971, p. 100.

[2] Ibid., pp. 99–100.

[3] See the letter from Davis, dated August 16, 1944. Archives of the Whitney Museum of American Art, New York.

[4] See Davis's daily calendar entries for April 16 and 17, 1939. Archives of Earl Davis.

[5] See Davis's daily calendar entries for August 29–September 6, 1938, for confirmation of his trip to Gloucester and Cape Ann.

[6] Ibid., April 17, 1939.

[7] Ibid., June 21, 1939.

[8] *Artists for Victory: An Exhibition of Contemporary American Art* (exhib. cat.). Foreword by Francis Henry Taylor. New York: The Metropolitan Museum of Art, 1942. *Bass Rocks No. 1* is listed on page 3. Davis also exhibited two graphics, *Place des Vosges* and *Adit*; see ibid., p. 37.

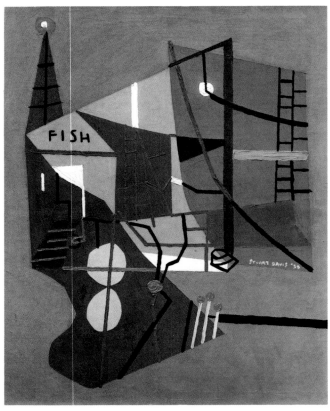

118

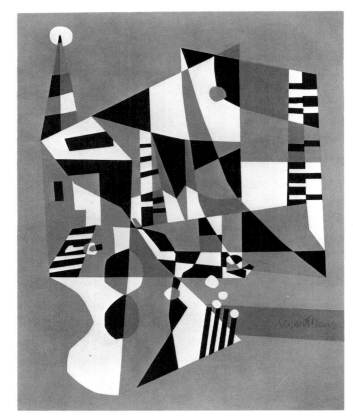

119

118

Shapes of Landscape Space. 1939

Oil on canvas, 36 × 28 in. (91.4 × 71.1 cm.)

Neuberger Museum, State University of New York at Purchase.
Gift of Roy R. Neuberger

119

Tournos. 1954

Oil on canvas, 35⅞ × 28 in. (91.1 × 71.1 cm.)

Munson-Williams-Proctor Institute, Museum of Art,
Utica, New York

120

Memo. 1956

Oil on canvas, 36 × 28¼ in. (91.4 × 71.8 cm.)

National Museum of American Art, Smithsonian Institution,
Washington, D.C. Gift of the Sara Roby Foundation

Shapes of Landscape Space is based on a drawing and a black-and-white painting,
both from 1932. Here, however, Stuart Davis seems to be truer to the drawing, es-
chewing some of the more elaborate linear elements that were added to the mast
and rigging in the center of the 1932 painting.

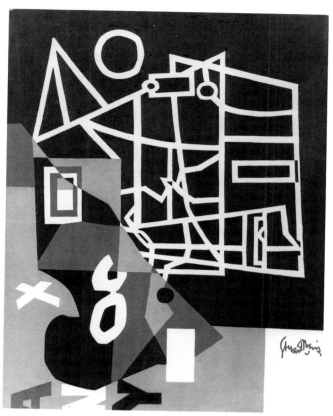

120

Davis has divided the original composition into three main color areas—brown, orange, and blue. Patches of red occur in the brown, orange, and blue passages, but within the brown area a green parallelogram and two yellow circles dominate. The placement of the color displays a disregard for the usual boundaries of integral elements in the composition, so that the building inscribed FISH is partly orange and partly brown, and the rigging-filled sky half orange and half blue. In this way, the arrangement of the colors predominates over the basic view of a fish-processing plant, a tower, and a schooner docked at a wharf in Gloucester. Davis described the 1932 drawing as the "directional analogy to [the] natural subject of [a] wharf and boats. [It is] the result of proportional space expansion and contraction [a] visualization in simple shape terms disregarding more detail incident . . . with the idea of getting a simultaneous view instead of a sequential one."[1]

Davis's focus on drawing as the essence of art in the early 1930s led to an elaboration on linear design in his work. The overlapping and contingency of lines created a stained-glass effect in which the individual units became the focus of the composition. In all of these works, Davis dispensed with the usual rectangular picture plane or snapshot view of the landscape, isolating a "random" configuration that might have been suggested by the shapes of a group of forms as well as, for example, by their cast shadows. This shape is declared as an independent element when Davis isolates it against a white or—in the case of *Shapes of Landscape Space* —a green background.

Davis foreshadows artists like Ellsworth Kelly in his declaration of the independence of a painted shape from the rectangle of the canvas. He had been interested in creating such anomalous relationships between the shapes of things and their identifying markings, colors, and textures since the 1920s. Increasingly throughout

the 1940s and 1950s, he would do the same even with recurring compositional motifs. For example, when he revisited this composition in the mid-1950s in *Tournos* (1954), he painted the individual units of the compositional grid to create an alternating, erratic pattern of white, black, blue, and green areas, set against a red background. The transformation of the function of the compositional elements is indicated by Davis's notes on the new sketches he did for *Tournos*: "The Meaning of an Image consists of the Logical-integrity of its components (a significant Content in itself) and the Mood associated with the Analogies to real things and events which its Shapes arouse."[2] Yet, Davis conveys just enough of the anecdotal details of the original composition so that we recognize that it is ultimately a portion of the skyline of Gloucester.

Two years later, in *Memo* of 1956, the original configuration would feature a widened pyramid at the upper left, and a complete subversion of the original subdivisions so that the interior grids are no longer comparable. Davis achieves varied spatial effects by contrasting the upper two-thirds of the painting, containing white lines on a black ground, with the remaining third at the bottom left, where color creates a different sensation. This painting continues his exploration of a two-part treatment in his compositions, first seen as early as 1931 in *House and Street* (cat. no. 92), and resumed in the 1950s in *Deuce* and *Lesson I* (cat. nos. 150, 151). Here, Davis also included the figure eight and the X forms that would become part of the iconographic content of his work: X, representing the "shorthand for 'eternal relations,' which included perspective, color, size and position of shapes, 8 as the symbol for infinity, and the word 'any' which alluded to his belief that any subject matter was appropriate because it was rendered neutral by art."[3]

LSS

[1] Stuart Davis, quoted in Jane Myers, ed., *Stuart Davis: Graphic Work and Related Paintings, with a Catalogue Raisonné of the Prints.* Essay by Diane Kelder; catalogue raisonné by Sylvan Cole and Jane Myers. Fort Worth: Amon Carter Museum, 1986, p. 13.

[2] Stuart Davis Papers, January 5, 1955. Harvard University Art Museums, Fogg Art Museum, Cambridge, Massachusetts.

[3] Myers, op. cit., p. 13.

121

Study for "History of Communications" Mural. 1939

Ink, pencil, and gouache on illustration board, 14⅛ × 34 in.
(35.9 × 86.4 cm.)
Private collection, Washington, D.C.

122

Study for "History of Communications" Mural. 1939

Ink on paper, 9⅝ × 29⅞ in. (24.5 × 75.9 cm.)
Minnesota Museum of Art, Saint Paul

The gigantic mural that Stuart Davis executed for the 1939 World's Fair in Flushing Meadow Park, Queens, is a compilation of images meant to convey the development of various means of communicating throughout history. The approach was

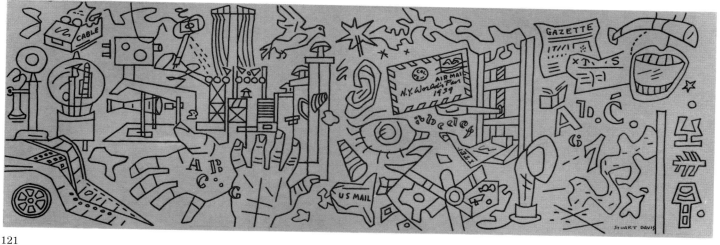

121

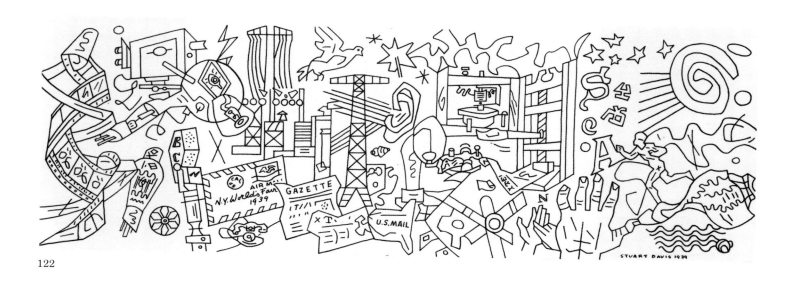

122

to demonstrate the progressive "mechanical and electrical objectification [of] the human eye, ear, voice, and bodily motion."[1]

Davis's special challenge was to convey at the same time a "3-D space harmony" and the "quality of a flat surface" that would be "simple and easy to remember."[2] Toward this end, Davis decided to limit the colors to white on black. This decision may equally be ascribed to the fact that the final mural was to be executed by sign painters, as well as to certain economic considerations that led to the abandoning of his original idea to apply luminous paint to the black background.[3] "The elimination of color minimized the surface tensions that exist in so many of Davis's works, while the swinging calligraphic white lines effectively constituted an informed monumental graffito."[4] Certainly, the fact of the mural's eventual location may also account for the degree of recognizability that Davis conferred on the individual elements.[5]

Davis first had to resolve which of the symbolic elements for each subject, of those he had listed in his notes, he would use in the composition—a choice that would be made from an ideological as well as a design point of view. In his copious notes on

this mural, Davis focused on speech and language, writing and printing, drawing and painting, the camera and sound motion pictures, television, the telegraph, songs and music, telephone and radio, and the phonograph. A juxtaposition of the corporeal agent and its mechanical replacement was to be planned out. For example, the eye would be used to represent writing, printing, drawing, painting, the camera, sound motion pictures, and television; the ear, sound motion pictures, songs and music, and the telephone and radio. This choice also had to be made on the basis of how the shapes of the objects would function "in perspective . . . isolated . . . on a single plane . . ." as "free" and "geometric" entities and in relation to other elements in space. Davis was aware that "[t]he nature of the geometric space-object can be determined by the accumulation of the individual parts."[6] Two alternatives can be seen in the two studies included here, which are the only remaining records of this mural. While many individual elements are repeated in both compositions, Davis experimented with various locations for them. The study in the collection of the Minnesota museum was the final composition for the mural. The elements in the version in Washington tend to be aligned more within horizontal and vertical registers; the Minnesota study is freer in character. Davis has used a variety of means to align the symbols: either transitional elements, or artfully thought-out intervals between the spatial nebula of each symbol.

This project inspired Davis's last extensive missive on social content in art. While reaffirming his commitment to preserving the "collective security and individual freedom," he insists on a "[f]reedom of expression in all programs for progress. The right to be an artist free from service to any other social function is as much a right under democracy as the right to unionization and collective bargaining for better living conditions."[7] Davis seems to have had a close working relationship with the officials at the World's Fair. His daily calendar for 1938 is full of notations about meetings regarding this commission. An entry in one of the artist's papers (among the collection in the Fogg Art Museum at Harvard University) entitled "Analysis of the Forces Involved in the Relations between the World's Fair and the Artists" reveals that political deals were forged to afford a wider group of artists an opportunity to compete for commissions.

LSS

[1] Diane Kelder, ed., *Stuart Davis*. New York, Washington, and London: Praeger, 1971, p. 71.

[2] Ibid., p. 81.

[3] Ibid., p. 82; see also Karen Wilkin, *Stuart Davis*. New York: Abbeville Press, 1987, p. 154.

[4] Kelder, op. cit., p. 10.

[5] *Stuart Davis Memorial Exhibition* (exhib. cat.). Essay by H. H. Arnason. Washington, D.C.: National Collection of Fine Arts, Smithsonian Institution, 1965, p. 80.

[6] Kelder, op. cit., p. 80.

[7] Ibid., p. 89.

Report from Rockport. 1940

Oil on canvas, 24 × 30 in. (61 × 76.2 cm.)

Edith and Milton Lowenthal Collection, New York

By 1940, the more ornate, decorative quality that had been gaining momentum in Stuart Davis's work during the late 1930s reached its resolution in a series of important canvases that include *Report from Rockport*; among the others are *Hot Still-Scape for Six Colors—Seventh Avenue Style, New York under Gaslight, Arboretum by Flashbulb, Ultra-Marine,* and *The Mellow Pad* (cat. nos. 124, 129, 131, 132, 135). Despite their relatively modest dimensions—the largest of these paintings, *Hot Still-Scape for Six Colors—Seventh Avenue Style,* is 36 by 45 inches—they are so intricate and ambitious in conception that they exude a sense of monumentality. Many of these compositions are reprises of earlier ones; indeed, this seems to be a moment of reflection and reevaluation for Davis after the hectic years of political proselytizing and organizing during the 1930s. In these works, Davis is also able to resolve his theories of color-space definition, which had been painstakingly articulated in his writings as he laboriously sought to reconcile political rectitude with formal integrity. Now, freed from ideological constraints, Davis's ideas allowed him to rethink his approach to earlier compositions, and to progress to the unparalleled flowering of his art during the 1950s and 1960s.

Report from Rockport revisits the vista of the main square of Rockport, Massachusetts, which Davis first depicted in 1925–26 in *Town Square* (cat. no. 62). The rather surrealist ambience of the original composition—its muted colors; ghostly edifices, the details of which are inscribed on the diagonal "walls" that flank the composition; flat, seemingly cutout trees; mysteriously anthropomorphic gas pump; and garage from the 1917 *Garage* (see cat. no. 22)—is now rendered in black, white, bright blues, reds, oranges, greens, purples, and yellows. The paint texture is much more assertive, and Davis has overlaid the original forms with a panoply of linear characters that populate the scene like invading creatures from a mad artist's imagination. In *Report from Rockport*, the diagonal thrust into space of the composition of the 1925–26 painting is preserved by the configurations of the two planes at each side of the scene, but the deep space is blunted by the application of intensely saturated hues throughout. When Davis painted *Town Square* in the mid-1920s he had not yet visited Europe (reference to Davis's Paris trip of 1928 is to be found, here, in the word SEINE emblazoned in red-and-black letters on the white-and-orange banner at the far right of the composition),[1] and America was struggling through its final transformation from a primarily agrarian to an urban society. In 1940, when Davis painted this picture, he noted in a dialogue on modern art that the experience of modern life, with its telephones, telegraphs, airplanes, electricity, automobiles, and motion pictures, irrevocably transforms one's artistic vision. The country was then emerging from the Depression, and the machines of industry were poised for what was to be the ultimate test of its readiness—World War II. Davis provides us with a record of the changes in American society, as experienced by one individual who made it his business to keep his finger on the pulse of American culture. This painting is literally a report of that change in attitude and vision, which had occurred over a period of fifteen years.

LSS

[1] "Seine" also is used to designate a type of fishnet, as well as the cart in which the net is transported (see cat. no. 108).

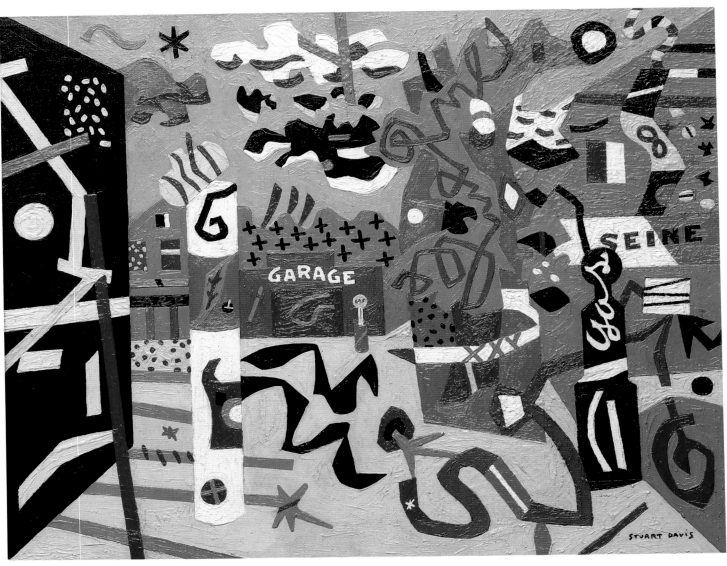

123

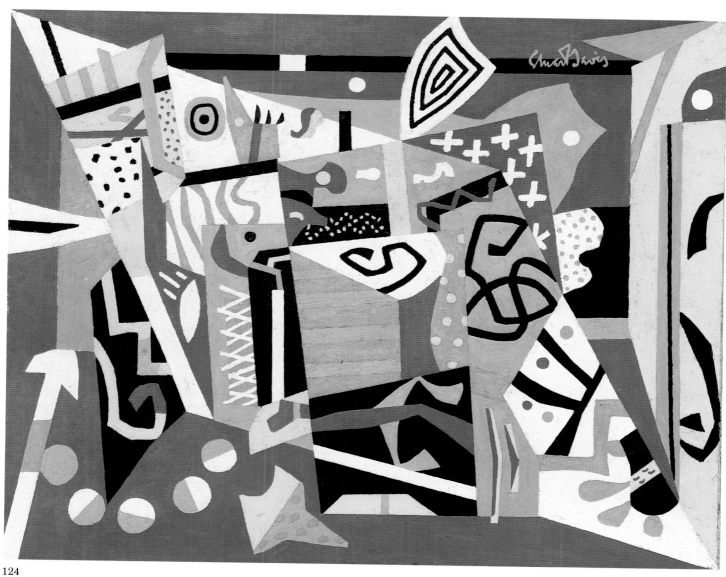

124

Hot Still-Scape for Six Colors—Seventh Avenue Style. 1940

Oil on canvas, 36 × 45 in. (91.4 × 114.3 cm.)

Museum of Fine Arts, Boston. Gift of the William H. Lane
Foundation and the M. and M. Karolik Collection, by exchange,
1983.120

Writing in the December 1940 issue of *Parnassus* magazine, Stuart Davis provides the most cogent and evocative explanation of this painting:

> It is composed from shape and color elements which I have used in painting landscapes and still lives [*sic*] from nature. Invented elements are added. Hence the term "Still Scape." It is called "Hot" because of its dynamic mood, as opposed to a serene or pastoral mood. Six colors, white, yellow, blue, orange, red, and black, were used as the materials of expression. They are used as the instruments in a musical composition might be, where the tone-color variety results from the simultaneous juxtaposition of different instrument groups. It is "7th Avenue Style" because I have had my studio on 7th Ave. for 15 years.
>
> The subject matter of this picture is well within the experience of any modern city dweller. Fruit and flowers; kitchen utensils; fall skies; horizons; taxi cabs; radio; art exhibitions and reproductions; fast travel; Americana; movies; electric signs; dynamics of city sights and sounds; these and a thousand more are common experience and they are the basic subject matter which my picture celebrates. The painting is abstract in the sense that it is highly selective, and it is synthetic in that it recombines these selections of color and shape into a new unity, which never existed in nature but is a new part of nature. An analogy would be a chemical like sulphanilamide which is a product of abstract selection and synthetic combination, and which never existed before, but is none the less real and a new part of nature.
>
> This picture gives value and formal coherence to the many beauties in the common things in our environment, and is a souvenir of pleasure felt in contemplating them.[1]

This painting summarizes many of Davis's formal and aesthetic ideas as they have been thrashed out over the last decade. The early 1940s in particular may be seen as a moment of nostalgia and regrouping after Davis's traumatic reevaluation of the ideological function of art. Like *Report from Rockport* (cat. no. 123), this painting recalls an earlier work—in this case, *Egg Beater No. 2* of 1928 (cat. no. 68). The muted greens, grays, mauves, ivories, terracotta, and ochers of the earlier work have been supplanted by a cacophony of color and patterning. While many of the original configurations of the planar divisions of the composition have been retained, the studious planar exercise is now a panegyric to the riotous aspects of American urban culture. Individual areas "open up" to discrete episodes, from seaside views to landscapes dominated by large, playful trees. The decorative squiggles suggest the persistence of Joan Miró's influence, and remind us of the linear inventions in Davis's 1921 collages (see cat. nos. 34, 35). Davis has drawn upon the theories he developed during the 1930s of utilizing color, shape, and texture to organize and define space, and in spite of his political shift he has not abandoned his conviction that modern art should speak to the most direct and accessible aspects of American culture.

LSS

[1] Stuart Davis, "Stuart Davis," *Parnassus* 12 (December 1940), p. 6.

Composition. 1940

Oil on canvas, 8¼ × 12 in. (21 × 30.5 cm.)
Collection Dr. and Mrs. Arthur E. Kahn, New York

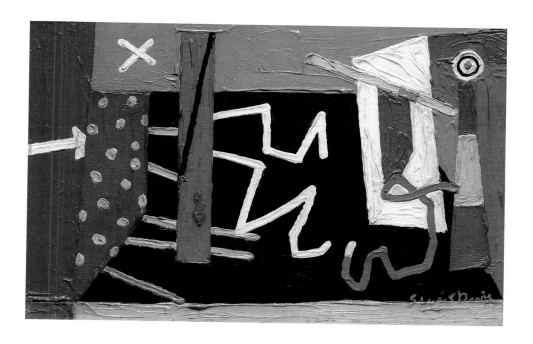

Summer Landscape No. 2. 1940

Oil on canvas, 10 × 14 in. (25.4 × 35.6 cm.)
Nevada Museum of Art, Reno

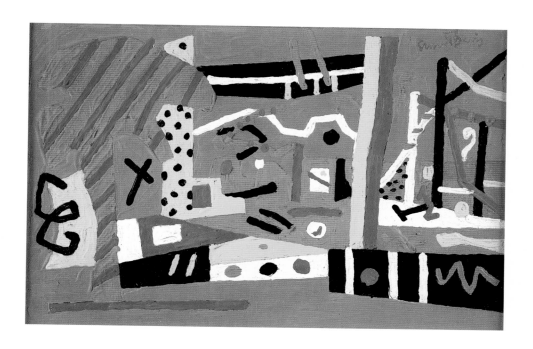

Art Space No. 1. 1940

Oil on canvas, 10 × 14 in. (25.4 × 35.6 cm.)
Collection Mr. and Mrs. Perry J. Lewis

Triatic. 1941/51

Oil on canvas, 10 × 14 in. (25.4 × 35.6 cm.)
Private collection

The preceding four, charming, small-scale works from 1940 and 1941 provide a quick and admittedly delicious experience of Stuart Davis's art of the previous two decades. *Triatic* and *Art Space No. 1* replay the 1924 watercolor-and-crayon composition *Gloucester Harbor* (cat. no. 58). *Summer Landscape No. 2* is, in the words of Eugene C. Goossen, an "anniversary work," executed ten years after the 1930 *Summer Landscape* (cat. no. 87). *Composition* recalls the composition of the 1925–26 *Town Square* (cat. no. 62).

When Davis reworked earlier compositions, the latest versions inevitably manifested embellishments, enlargements, or focused details. For example, while the 1930 *Summer Landscape* was an abstraction of a scene observed in Gloucester, the 1940 version, according to Goossen, presents a "distilled record of all that has gone between. The first finds formal symbols for what was seen; the second refers primarily to its constructive means."[1] In the 1940 *Summer Landscape No. 2*, the internal design of the forms is not totally estranged from textural mimicry, as seen in the diagonal striping of the trees at the left side of the picture. All details of fences, houses, ships' rigging, and masts—and those in *Art Space No. 1*, as well—are now rich, globular daubs of color. By varying the palettes of these two compositions (there is a third variant), Davis hints at seasonal changes, but, more pertinently, he explores the spatial implications of assorted combinations and juxtapositions of hues of different values and saturation. Likewise, in *Triatic* and in *Art Space No. 1*, the towers, masts, rigging, and roofs on the Gloucester skyline are overtaken by the decorative play of horizontal, vertical, and diagonal bands of color. This composition is also one of several done in varying color combinations.

The most sprightly of these four works is *Composition*, which lives up to its pseudonymous designation, *June Jitterbug Jive*, in the jaunty, deflected forms that traverse the canvas and bounce off each other like symbols in search of definition. Although the traces of the composition from which this painting is derived (*Town Square*; cat. no. 62) are scant, *Composition* shows how Davis increasingly relied on color shapes divorced from familiar references as the 1940s progressed.

LSS

[1] E. C. Goossen, *Stuart Davis*. New York: George Braziller, 1959, p. 29.

129

New York under Gaslight. 1941

Oil on canvas, 32 × 45 in. (81.3 × 114.3 cm.)

The Israel Museum, Jerusalem. Gift of Mrs. Rebecca Shulman, New York

In 1934, Stuart Davis established a studio and apartment at 43 Seventh Avenue in New York, where he lived until 1955. Reference to this residence is at the center of *New York under Gaslight*, a composite of buildings "around the Brooklyn Bridge and the Canal Street section."[1] This composition, a jazzy replay of the 1930 oil *The Barber Shop* (fig. 114), presents a rather static, desolate scene, with a variety of tenements and office buildings crammed together at the left. In the center, a large building advertises a free room and a dentist's office. Just in front—across the street, in actual fact—is a row of service shops: a barber's, a tobacconist's, and a laundry, before which stands a rather discouraged-looking statue. We can glimpse one of the piers of the Brooklyn Bridge in the distance. A strange lantern form

129

Figure 114. Stuart Davis. *The Barber Shop.* 1930. Oil on canvas. Neuberger Museum, State University of New York at Purchase. Gift of Roy R. Neuberger

hangs from the ceiling of an establishment only identified by the scalloped awning that extends into the composition from the viewer's space.

In *New York under Gaslight*, "[e]verything is brightened, complicated and intensified."[2] The buildings have been covered with more decorative elements. The lettering on the dentist's sign has been enlarged, and the spaces seen beyond the windows and doorways are furnished and occupied. The forlorn statue has been replaced by a dapper, goateed gentleman with hat and cane in hand, atop a more sumptuous marbleized pedestal. The gas lantern now flickers rather brightly over the suddenly animated scene.[3]

"Visual puns abound in this painting. The interior of the Garcia Cigar Store includes a scantily clad woman and on the door of the barber shop . . . appears an enlarged version of the cover on a package of Stud tobacco. . . . The advertisement for the cigar, 'Between the Acts' [partially visible at the lower right of *The Barber Shop*] has been replaced . . . [by] . . . the jazz-inflected phrase 'Dig this fine, art-jive'. Above it a bold image of a hand appears. Its index finger points toward the center of the painting, leading the viewer's eye to the alluring woman in the cigar store. . . . The artist cleverly painted a dent on the letter 'D' on the 'Dent[ist]' sign and painted only the first half of the 'M' on the 'ROOM' sign which appears on a window above, intentionally leaving no 'room' for all of the final letter of the word."[4]

At the lower left of *New York under Gaslight*, Davis has added a pile of rubble amidst which are the remnants of the foundation of a house and a stoop. Davis reminds us that in the riotous excitement of urban growth nothing lasts forever, and familiar landmarks can disappear with each successive generation, although, as seen in the example of the statue, they are occasionally saved and restored.

LSS

[1] Bruce Weber, *Stuart Davis' New York* (exhib. cat.). West Palm Beach: Norton Gallery and School of Art, 1985, n. 64, p. 24.

[2] Ibid., p. 17.

[3] According to William Agee, tobacco stores kept such lamps lit so that customers could light their newly purchased cigars. (We know from photographic evidence that Davis enjoyed cigars.)

[4] Weber, op. cit., p. 17.

Ana. 1941

Gouache on paper, 15⅝ × 15½ in. (39.7 × 39.4 cm.)
Collection Mrs. Max Ellenberg

"In *Ana* of 1941 Davis alluded to the shifting nature of his interests in abstraction and representation. He evidently chose the title to refer to the black woman at the lower left and his concept of 'analogical' subject matter: a picture having 'similarity without identity to its subject . . . a memorandum in visual shorthand.' At first glance the subject of the picture appears to be a building in New York under construction. . . . Much of the . . . picture consists of patterns of dots, grids, circular and rectangular forms, and calligraphic lines."[1]

Davis, in fact, based this composition on a series of eleven photographs he took in 1940–41 of the random accumulations to be found in a scrap heap or dump. The photographs show piles of wires, automobile axles and hubcaps, ∟ beams, chains, and wheels—all of which can be singled out among the morass of *Ana*. The elegant black, white, and brown tangle of scrap metal dangling from a huge magnet in the center of the composition and the large piles of tan, white, and black metal are visible in the middle photograph in the top row, and in the photograph below that (see fig. 115).

The profusion of color and decorative elements in *Ana* is consistent with developments in Davis's work during the 1940s. Compositions such as *Arboretum by Flashbulb*, *Ultra-Marine*, and *The Mellow Pad* (cat. nos. 131, 132, 135) feature an allover quality that invites a reconsideration of Davis's position vis-à-vis the newly emerging Abstract Expressionists group. While individual elements in these paintings adhere more closely to reality, Davis has defied usual relationships of scale, literally assembling collages of different views—such as those captured in the photographs—into cohesive wholes. Here, the components abut abruptly against one another, whereas in *Arboretum by Flashbulb* and *Ultra-Marine* they fit into one another like the pieces of a puzzle. Davis effects a convincing correlation between his customary calligraphic flourishes and actual industrial implements and materials.

The identity of the black figure at the lower left continues to be a mystery. Davis made the figure so small it is almost lost amidst the rest of the composition, yet its presence hardly seems capricious. Generally assumed to be a female because of the painting's title, *Ana*, the figure, however, is wearing breeches, and, with one truncated arm and the other brandishing chains, seems to have stepped out of a slave narrative. It differs markedly from his representations of black performers and habitués of jazz clubs and saloons in the 1910s (see cat. nos. 11, 12). The artist had been criticized for what were perceived as stereotypical portrayals of blacks and other ethnic groups in his caricature-like figural drawings.[2] Later, during the 1930s, Davis, in turn, was to be critical of Thomas Hart Benton's depictions of blacks and Jews.[3] Davis's specific objection was as much about Benton's aesthetic provincialism as about his naïve, "fence-sitting" politics[4]—all the more reprehensible because of the social, economic, and political realities that governed the lives of American blacks at the time. One wonders if Davis is commenting on the fate of African-Americans, who, during the previous three decades, had fled the de facto slavery of the sharecropping system in the South only to find a new slavery in the factories and mills of the North. The late 1930s and early 1940s saw a renewed effort on the part of blacks to eliminate discriminatory practices in business, manufactur-

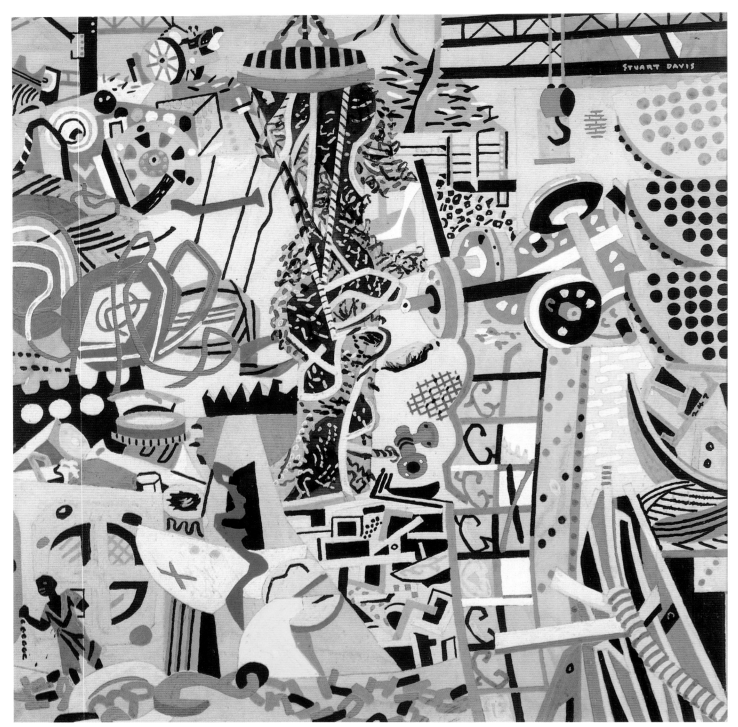

130

ing, the service industries, and the armed forces.[5] As a seasoned activist, Davis surely would have observed these events with interest.

LSS

[1] Bruce Weber, *Stuart Davis' New York* (exhib. cat.). West Palm Beach: Norton Gallery and School of Art, 1985, p. 16.

[2] See Rebecca Zurier, *Art for The Masses (1911–1917): A Radical Magazine and its Graphics* (exhib. cat.). With contributions by Earl Davis and Elise K. Kenney. New Haven: Yale University Press, 1985, p. 126.

[3] See Henry Adams, *Thomas Hart Benton: An American Original*. New York: Alfred A. Knopf, 1989, pp. 246–51.

[4] Wayne L. Roosa, "American Art Theory and Criticism during the 1930s: Thomas Craven, George L. K. Morris, Stuart Davis." Ph.D. diss., Rutgers–The State University of New Jersey, 1989, p. 367.

[5] See Roi Ottley and William J. Weatherby, eds., *The Negro in New York: An Informal History*. Dobbs Ferry and New York: The New York Public Library, 1967, pp. 265–93.

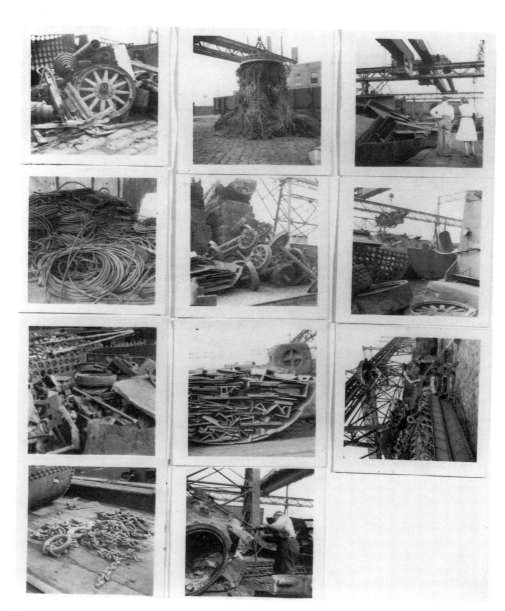

Figure 115. *Ana* iconography. About 1940–41. Black-and-white photographs by Stuart Davis. Collection Earl Davis

Arboretum by Flashbulb. 1942

Oil on canvas, 18 × 36 in. (45.7 × 91.4 cm.)

Edith and Milton Lowenthal Collection, New York

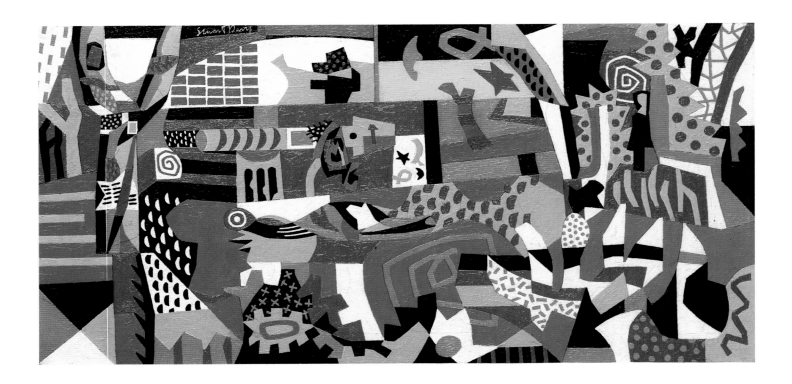

132

Ultra-Marine. 1943

Oil on canvas, 20 × 40⅛ in. (50.8 × 101.9 cm.)

The Pennsylvania Academy of the Fine Arts, Philadelphia.
Joseph E. Temple Fund

The small scale of *Arboretum by Flashbulb* and of *Ultra-Marine* is belied by the complexity of the internal structure of both compositions. As Karen Wilkin observes: "Davis's seminal paintings of the early 1940s differ from his later pictures most obviously in terms of scale. . . . The later paintings are notably generous and expansive, while the densely packed mid-career works . . . among the very best pictures being made in the United States at the time . . . can sometimes seem miniaturized."[1] The question of scale is important for evaluating Stuart Davis's achievement within the progressive segments of American painting in the 1940s. Davis eliminated natural references in his work, and, as seen particularly in *Ultra-Marine*, disposed the color shapes across the composition in a manner that may be called allover—a hallmark of the emerging generation of Abstract Expressionist painters. Yet, scale was an integral issue for the new American painting, whether because of the desire to express a correlation between it and the public pretensions

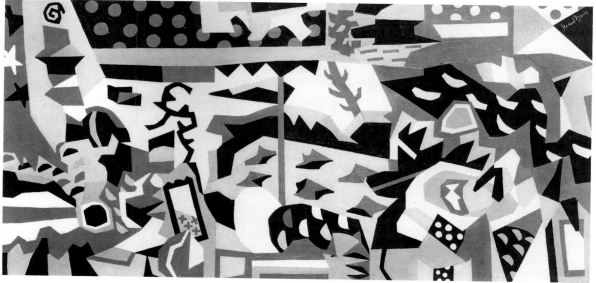

132

of Depression-era murals, or the wish to recapture the feeling of grandeur one encountered in our national landscape. Given Davis's extensive experience with large-scale murals during the previous decade, this retreat to works of more intimate proportions is not merely technical insecurity. It may mirror the artist's increasing withdrawal from active public participation as a result of his final disillusionment with both Stalinist socialism and the working class throughout the world.

While the marks and shapes in these works do not reflect the reliance on chance and spontaneity that engaged Pollock or de Kooning, they may be seen as "a manifestation of Davis's pleasure in being able to invent, improvise, and elaborate, without practical considerations."[2] So, instead of borrowing the technical analogies in his work from surrealist automatism or the workings of the unconscious, Davis's source is jazz—an art form that he had long considered to be the quintessential American expression, and a parallel for a type of visual art that could also be regarded as peculiarly American.

Arboretum by Flashbulb is organized more along the lines of conventional landscapes probably because it is based somewhat on Davis's 1921 composition *Sword Plant* (Collection Earl Davis). The Y-shaped tree at the left in the earlier composition and the smaller accompanying plants are reconstructed in *Arboretum by Flashbulb*, as are the two trees at the right and the aloe plant below them. The strip of water connecting both sides of the composition here is red and orange, with a black band cutting through it vertically. Besides the plant life one can make out a bird form with a circular eye, which recalls the bird that is the focal point of *Summer Twilight* (1931; fig. 72). John Lane has attributed the at-times "hide-and-seek" nature of Davis's abstracted reality to his interest in Gestalt theory: "The Gestalt theory of the perceptual process provided Davis with a link between nature, himself, and the work of art. It supplies an answer to the question of why, in the face of Davis's increasingly abstract handling of form during the early forties, the salient characteristics of the content of his art continued to be its analogy to experience in the natural world."[3]

Ultra-Marine, executed a year later, manifests a more nonobjective quality. In it, "colored planes—red, green, light blue, orange, black, and white—are carefully adjusted to be equal in quantity and visual weight across the surface, so that areas

of greater incident simply read as eddies in a dense . . . allover pattern."[4] Here, we are less caught up in the specifics of reference. Our eye and mind may engage each section or area of color and pattern randomly. The decorative aspects abound—even the stars are free of their celestial duties. While we may wonder for a minute if the red-and-black forms in the blue field are birds, we tend more to enjoy the deviant element of the one red-and-green example within the formation. This painting was in a sense the culmination of Davis's quest to clarify his "configuration theory."[5] Considering that "[t]he whole picture is a psychological Gestalt," he worked to "develop a pictorial scheme to which the response would be a complete experience rather than a sum of discrete reactions to particular elements within the general fabric."[6] What is fascinating in all this is that through the rubrics of jazz improvisation and the associative methods of Gestalt theory, Davis developed an approach to art making that paralleled that of the Abstract Expressionists. Yet, because Davis eschewed totemic interest, and kept the apocryphal vision of war from his art, his true relationship to the Abstract Expressionists has largely been dismissed.[7]

LSS

[1] Karen Wilkin, *Stuart Davis*. New York: Abbeville Press, 1987, pp. 167, 170.

[2] Ibid., p. 170.

[3] John R. Lane, *Stuart Davis: Art and Art Theory* (exhib. cat.). New York: The Brooklyn Museum, 1978, p. 55.

[4] Wilkin, op. cit., p. 172.

[5] Lane, op. cit., p. 57.

[6] Ibid.

[7] For a notable exception, see ibid., pp. 65–73.

133

G & W. 1944

Oil on canvas, 18¾ × 11⅝ in. (47.6 × 29.5 cm.)

Hirshhorn Museum and Sculpture Garden, Smithsonian Institution, Washington, D.C. Gift of The Marion L. Ring Estate, Washington, D.C., 1988

134

For Internal Use Only. 1944–45

Oil on canvas, 45 × 28 in. (114.3 × 71.1 cm.)

Private collection

In 1961, Stuart Davis reminisced about his association with Piet Mondrian: "Of course I had known Mondrian for a number of years as a leader in the modern movement. The aspect he represented didn't interest me very much."[1] Davis first met Mondrian in New York about 1940. (He had seen him from afar eleven years earlier in a Paris café, but did not have contact with him at that time.) Mondrian "was greatly interested in jazz and had been told of my high regard for it. On this basis we spent a friendly evening talking about that subject. . . . The summation of these conversations and entertainments was that Mondrian pronounced certain examples

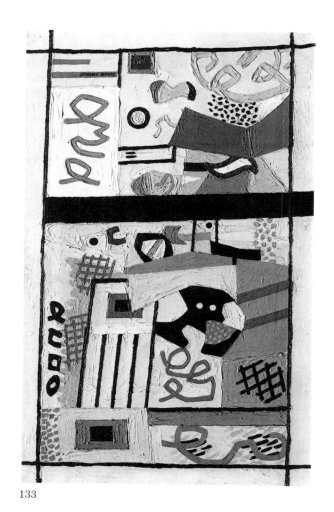

133

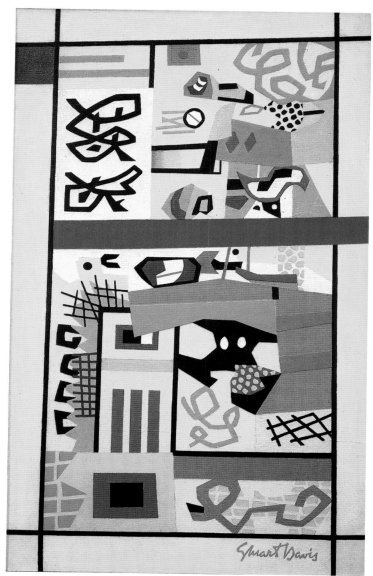

134

of boogie-woogie to be 'Pure' or 'The True Jazz'. . . . I found him to be a most amiable and sympathetic man despite certain minor semantic oppositions in the designation of our enthusiasms. His preference for the term 'Abstract' left me unmoved, but there seemed to be mutual unstated agreement that Nature was a great thing provided you didn't get mixed up in it."[2]

Davis had one more encounter with Mondrian when the latter attended the opening of Davis's 1943 exhibition at the Downtown Gallery in New York. Jazz and boogie-woogie music were provided, and, as Davis later recalled, "the situation was much enjoyed by Mondrian, and he took time to compliment me on my work, pointing out that in the latest I was approaching Pure Plastic Art. . . ."[3]

Mondrian died in New York in 1944. It is tempting to think of *G & W* and *For Internal Use Only* as tributes to the Dutch artist, whose sparse pictorial architecture is an especially evident influence in the latter work. Davis enclosed the composition within an internal rectangle formed by thin black lines. A black square in the upper left corner abuts the rectangle, which is pierced by a red bar that cuts almost all the way across the width of the canvas. All the elements are set against a yellow background, with each of the two distinct areas created by the red bar filled

with clusters of lively, abstract, eccentric colored shapes, dots, squiggly loops, dashes, and bars. This jumble allegedly was inspired by Davis's glimpsing at a distance a combination of type with a comic strip. He was fascinated by the "accidental juxtaposition of colors and shapes,"[4] and reworked the combinations of forms in *For Internal Use Only* until he was satisfied with the result. For Davis, the process was like composing music.[5] The same forms were repeated for the most part in *G & W*, but Davis did simplify some of the colored shapes and eliminated internal decorative details, and the quality of the paint is more gritty and textural, less pristine and flat. He seems almost to have been playing on the "Pure Plastic" motto of Mondrian and his followers in the physicality and the plasticity of the paint in this composition. Davis has also moved away from specific Mondrian quotations in the tentative, sketchy quality of the line, and in the palette, which disdains any reference to the primary colors that Mondrian favored.

Davis considered the "Pure Plastic" aesthetic as decorative, and lacking serious meaning.[6] He also took exception to the elitist attitude assumed by artists working in this mode. In Davis's view, "there is no such thing as 'pure art'. . . . It is always impure in that it refers to all elements of life experience."[7] He had strong feelings about the necessity for artists to relate to their audience, which, to him, meant the working classes. For Davis, the "value of art was to be judged according to the value of what it expressed to the group with whom the artist was aligned, and how it helped their interests."[8] Thus, it was logical that he would be concerned about abstract art, which he felt had "no significance to most people unused to generalizations in visual terms."[9]

LSS

[1] Stuart Davis, "Memo on Mondrian," *Arts Magazine Yearbook* 4 (1961), p. 67.

[2] Ibid., pp. 67–68.

[3] Ibid., p. 68.

[4] Emily Genauer, *Best of Art*. Garden City, New York: Doubleday, 1948, p. 81.

[5] Davis, in an interview with Dr. Malcolm H. Preston, on a program in the series *American Art Today*, produced by Hofstra University, Hempstead, New York, and broadcast on WOR-TV in the 1950s.

[6] Stuart Davis Papers, April 17, 1938. Harvard University Art Museums, Fogg Art Museum, Cambridge, Massachusetts.

[7] Ibid., 1936.

[8] Ibid., March 25, 1936.

[9] Ibid. (just prior to March 24, 1936).

The Mellow Pad. 1945–51

Oil on canvas, 26 × 42 in. (66 × 106.7 cm.)

Edith and Milton Lowenthal Collection, New York

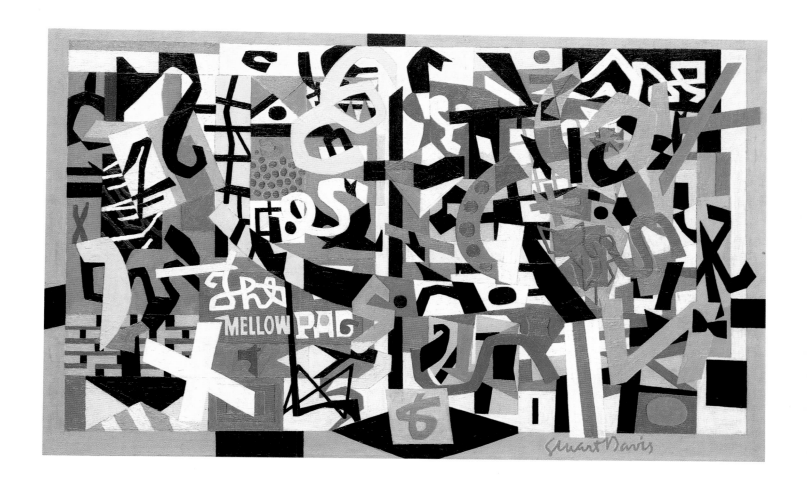

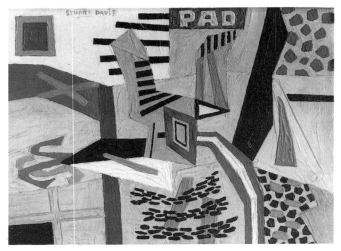 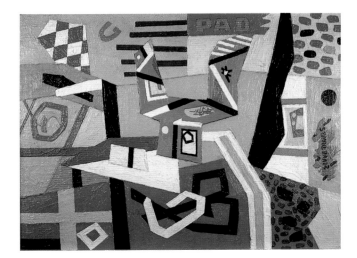

136 137

Pad #1. 1946

Oil on canvas, 9⅞ × 12¾ in. (25.1 × 32.4 cm.)
Honolulu Academy of Arts. Gift of Friends of the Academy, 1948

137

Pad #2. 1946

Oil on canvas, 12 × 16 in. (30.5 × 40.6 cm.)
Collection Françoise and Harvey Rambach

138

Pad #3. 1947

Oil on canvas, 10 × 14 in. (25.4 × 35.6 cm.)
Private collection

139

Pad #4. 1947

Oil on canvas, 14 × 18 in. (35.6 × 45.7 cm.)
Edith and Milton Lowenthal Collection, New York

140

Pad #5. About 1947– 49

Oil on canvas, 10 × 15 in. (25.4 × 38.1 cm.)
Sid Deutsch Gallery, New York

In his Pad series, Stuart Davis introduced the idea of the surface of the canvas as an
area where events occur, or, as he would later call it, "a Cool Spot at an Arena of

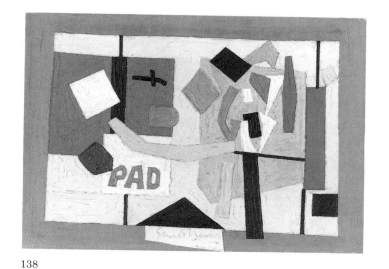

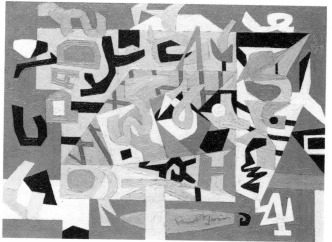

138

139

Hot Events."[1] Davis plays on the double meaning of "pad" as a book of paper used by artists to draw on, and as the designation for one's home or haven in "hip" lingo, which Davis admired.

The Mellow Pad, begun in 1945 and completed in 1951, is both the genesis and the summation of the Pad series. Between 1946 and 1949, Davis did five smaller independent compositions that might be considered preludes to the completed *Mellow Pad*. All manifest "an important development [in Davis's work] in the use of words and phrases in the paintings. In . . . earlier works, such as the Paris paintings . . . [the] words or phrases . . . seem to be selected and scattered casually throughout the painting, and to have no significance except as organizational motifs with a greater or lesser degree of associational reference. In the *Pad* paintings, however, the single word or phrase entrenched in the . . . organization begins to have not only a compositional but what might be called a symbolic point of departure, a theme around which the picture is constructed."[2] This observation is borne out by the fact that the word PAD appears in all the paintings in the series, with the exception of *Pad #5* (which is probably unfinished). In *Pad #1, #2,* and *#3,* the word is isolated within a rectangle, a square, or a band. In *Pad #4,* the word appears on its side, written vertically, the size of the letters varied in accord with the surrounding eccentric forms. The colors inside the open shapes are also different, indicating that here letters are, indeed, compositional elements—not merely a caption. In *The Mellow Pad,* the title is actually spelled out near the lower left in white and yellow letters of variegated script, on a magenta field, serving both as caption and design element.

These paintings are commonly described as nonrepresentational, but *Pad #1* and *#2* are based on the central part of the 1921 composition *Tree* (cat. no. 36). Davis has re-created not only the Y-shaped tree but also the curved "path" leading up to it from the bottom edge of the canvas, approximating the rectangular sections into which the background of the earlier painting was divided. In addition, Davis animated the surface of both *Pad* paintings with various decorative and textural elements, all the while respecting the basic contours that define each composition. Davis himself affirmed the representational intent of these two paintings in a written statement in 1947: "My work is generally regarded as abstract. I do not regard it as such. All of my paintings . . . are derived from specific subjects . . . not . . . from theories of ideal order, fantasies or some imagined concept of 'pure' art."[3] He then

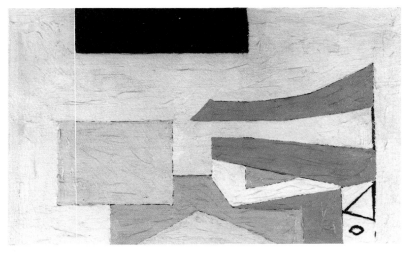

140

goes on to describe the landscape elements, if only "to show how I anchor my creative excursion to a concrete object."[4]

Pad #3 seems to be more nonrepresentational, although we can see a rather dislocated clump of forms representing the leaves of a tree topping the vertical element near the right. The composition shares several basic forms with the unadorned *Pad #5*, and, seen in tandem, the two pictures reveal a type of "before" and "after" view of Davis's work. In *Pad #3*, Davis is thinking about "Logic" as an "Instrument of Idea."[5] The relative absence of excessive markings seems to indicate a kind of "purification" before he goes on to complete *Pad #4*. Here, an analogous relationship to the improvisational impulse of the jazz soloist (tempered with an underlying structure) appears most obvious. The surface of the composition fluctuates from one color plane to another and back, providing a visual base for the squiggles, zigzags, curlicues, and loops that seem to materialize like notes spewed forth from a musical instrument. "For the first time," Davis observed, "the traditional confusion about the relation of Subject to Art has been eliminated. Art is seen as the product of an Action entirely distinct from the reaction to Subject."[6]

This 1947 pronouncement might very well have described the painterly goals of the then-emerging Abstract Expressionists group. In addition, the way has been indicated for completing *The Mellow Pad*. "In this painting Davis presented his answer for an all-over style. He also set forth a highly inventive solution to . . . [the] . . . critical issue . . . [of] . . . how to marry innovative form with meaningful content."[7] The basis for this composition is that of the 1931 bipartite *House and Street* (cat. no. 92). "*The Mellow Pad* was started on the premise that *House and Street* was a good painting, and that its simplicity could be used as a base on which to develop new material."[8] Although Davis had certainly worked from this premise before, with *The Mellow Pad* he seems to have formularized the process, which would become his main working method in the 1950s and 1960s. We can scarcely make out the underlying form except in the particular curtailing of the edges of the composition just short of the edge of the canvas, as if the profusion of swirling, looping, and zooming forms were trapped in a strange planar dimension suspended in the cosmos. Davis allows an occasional band to reach out to the edge of the canvas, anchoring this mass securely in place. However, as referential as this assembly may be, Davis includes certain clues that affirm his "theory of the Neutral Subject."[9] As John Lane notes: "Among the motifs appearing in *The Mellow Pad* . . . are 'X' and 'N' letters that stand for the idea of 'X and N relations.' The 'N' . . . refers to the notion of neutrality of subject matter."[10] On the other hand, "the *X* sometimes

stands for *external*—as opposed to *internal* . . . the generating 'dynamic forces' of two-dimensional composition."[11]

Constantly alternating between a representational and abstractionist stance, Davis found a correlation to his approach in Gestalt theory. "On several occasions Davis used *The Mellow Pad* as an example to illustrate summaries of his Gestalt-influenced forties art thought. The extraordinarily crowded and activated surface of the painting conforms to Davis's thinking . . . when he noted, 'In any given picture, the amount of perceptive material that has been successfully organized stands in direct ratio to the strength of the response. . . . The old idea of the statically complete picture is eliminated by the new concept of the painting as a record of the fresh day-by-day creative decisions.' "[12]

LSS

[1] Stuart Davis, "The Place of Painting in Contemporary Culture: The Easel is a Cool Spot at an Arena of Hot Events," reprinted in Diane Kelder, ed., *Stuart Davis*. New York, Washington, and London: Praeger, 1971, pp. 143–45.

[2] *Stuart Davis, 1894–1964* (exhib. cat.). Essay by H. H. Arnason. London: USIS, American Embassy, 1966, n.p.

[3] Unpublished statement by Stuart Davis, dated March 31, 1947. Archives of Earl Davis.

[4] Ibid.

[5] Stuart Davis Papers, March 6, 1947. Harvard University Art Museums, Fogg Art Museum, Cambridge, Massachusetts.

[6] Ibid., September 12, 1947.

[7] John R. Lane, *Stuart Davis*: *Art and Art Theory* (exhib. cat.). New York: The Brooklyn Museum, 1978, p. 17.

[8] Stuart Davis Papers, July 26, 1947, op. cit.

[9] Ibid.

[10] John R. Lane, "Stuart Davis and the Issue of Content in New York School Painting," *Arts Magazine* 52 (February 1978), p. 155.

[11] Karen Wilkin, *Stuart Davis*. New York: Abbeville Press, 1987, p. 203.

[12] Lane, *Stuart Davis*: *Art and Art Theory*, op. cit., p. 62.

141

Little Giant Still Life. 1950

Oil on canvas, 33 × 43 in. (83.8 × 109.2 cm.)

Virginia Museum of Fine Arts, Richmond.
The John Barton Payne Fund

142

Study after "Little Giant Still Life." About 1950

Oil on canvas, 12 × 16 in. (30.5 × 40.6 cm.)

Collection Earl Davis. Courtesy of Salander-O'Reilly Galleries, New York

143

Little Giant Still Life (Black-and-White Version).
About 1950–53

Casein on canvas, 33 × 43 in. (83.8 × 109.2 cm.)

Collection Earl Davis. Courtesy of Salander-O'Reilly Galleries, New York

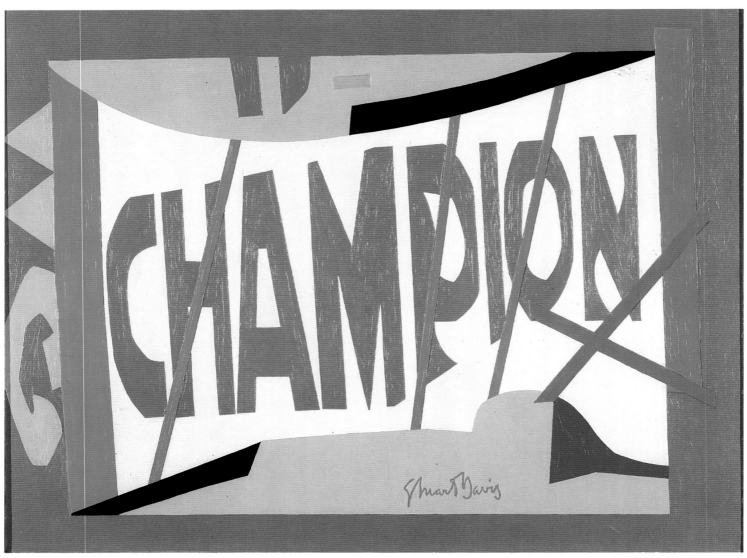

141

Figure 116. Matchbook cover advertising Champion spark plugs, showing letters crossed out by Stuart Davis. Collection Earl Davis

142

143

Visa. 1951

Oil on canvas, 40 × 52 in. (101.6 × 132.1 cm.)

The Museum of Modern Art, New York.
Gift of Mrs. Gertrud A. Mellon, 1953

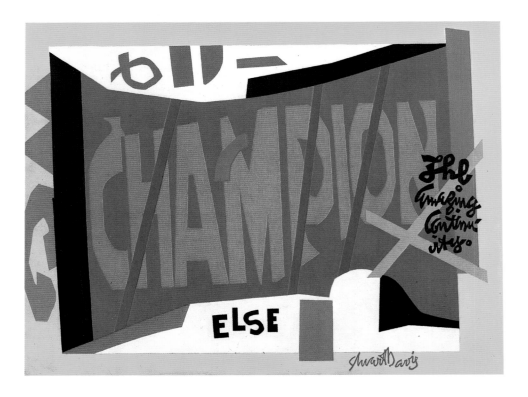

145

Schwitzki's Syntax. 1961

Oil, wax emulsion, and masking tape on canvas,
42 × 56 in. (106.7 × 142.2 cm.)

Yale University Art Gallery, New Haven.
The Katharine Ordway Fund

Little Giant Still Life is the heraldic image with which Stuart Davis opened the 1950s phase of his career. After the densely populated, ornate work of the 1940s, this word piece is notably spare and tense in character. As Davis described it: "Little Giant Still-Life is an Idea of Insignificance. The Mellow Pad is an Idea of Complexity. Both Ideas are Equal in their reality as Experience."[1] As seen in his notebooks, Davis devised the frame for the central image, and the bars that transect it, separately. His selection of the word CHAMPION was deliberate (Davis modeled the image on a matchbook cover advertising Champion spark plugs; see fig. 116), and while the shapes of the letters and their placement clearly refer to a commercial product, at the same time they grant the work a heroic stature based on the semantic resonances of the word. That stature may be both ironic in the Dadaist sense, given the banality of the source of this image, as well as ideological, given the heroic pretensions of the Abstract Expressionists group, whose work Davis increasingly had to confront during the 1950s.

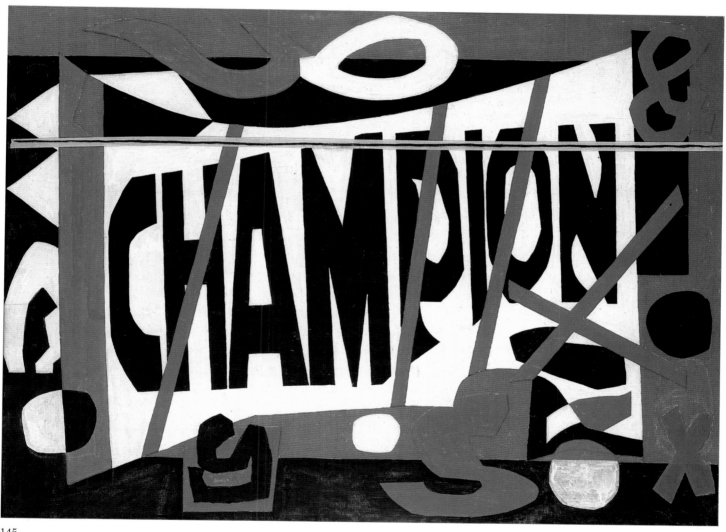

145

Although words, logos, letters, numbers, and symbols had appeared in Davis's work since the 1910s, this is the first composition in which a single word was given such a prominent role, serving, in fact, as the subject, rather than as a commentary on it. "Davis felt he neutralized the subject matter . . . [b]y crossing out three letters in the word 'Champion' with diagonals."[2] He proclaimed his interest in the "lack of interest"[3] that the subject manifested. This issue of subject matter in Davis's work is again framed by Abstract Expressionism. In response to the mythic and totemic subjects and gestural automatism of the younger generation, Davis's pristine, cerebral approach was more compatible with his own temperament. By "taking the subject matter for his paintings from his own theoretical concepts . . . [t]his singular resolution to the form and content problem was what ultimately set him apart from the Abstract Expressionists,"[4] and in hindsight can be seen as foreshadowing the reductive, more restrained quality of Davis's art of the 1960s.

Davis had barely finished *Little Giant Still Life* when the composition for *Visa* began to form in his mind. "He changed the color scheme, thickened the diagonals, added several new decorative motifs, inscribed the word 'Else', and . . . the phrase 'The Amazing Continuity'."[5] As can be seen in the small study for *Little Giant Still Life*, Davis had already explored the use of a darker background for the word CHAMPION, opting for white in the larger version. In *Visa*, the turquoise green against which the magenta lettering is set creates a psychedelic, vibrating effect, much like the original idea for Davis's World's Fair mural of 1939 (see cat. nos. 121, 122). Davis retains the same framing elements from *Little Giant Still Life*, adding to *Visa* a loop at the upper left, the word ELSE in the white space at the bottom of the composition, and the phrase *The Amazing Continu-ity.*, which summed up Davis's career; it was a theoretical comment on his work, underscoring his practice of constantly reworking motifs and subject matter from the past and the present, which was to become habitual during the last fourteen years of his life.

The title *Visa* also has a specific context. The early 1950s were a period when Davis's reputation in the international arena was growing. The work of the Abstract Expressionists was just beginning to be shown in Europe, but it was artists such as Davis, Alexander Calder, and Isamu Noguchi who were associated with the American art establishment. Consequently, Davis and Calder were chosen to represent the abstract tendencies in American art at the Venice Biennale in 1952. "Feeling his new stature, Davis began to use multi-national words in his titles: *Visa* [cat. no. 144], *San Pao* [cat. no. 146], and later *International Surface* [cat. no. 159]."[6]

When Davis revisited the Champion composition ten years later, in 1961, he focused on what he called "the Dichotomy of Front-Back Topical Combos [Combinations]."[7] As a result, *Schwitzki's Syntax* is characterized by "split" elements, which begin to obviate the distinction between figure and ground by featuring the color of one form within the confines of another—as in the green-and-white circle at the bottom right and the black-and-white one straddling the green band at the lower left. Davis replaced the elements at the top of the composition with one loop in white (background) and a curlicue form in green (figure), and placed a large ampersand in the upper-right corner and an *X* in the lower-right corner, below a black circle. The most striking statement of this "Front-Back" spatial dichotomy is the strip of masking tape with a black line drawn through its center, which Davis applied straight across the upper section of the composition. This effectively places the rest of the composition—regardless of the established spatial relationships among the elements—"behind" this element's physical reality. As in the artist's final work, *Fin (Last Painting)* (cat. no. 175), tape—which Davis used to mark off the composition

in process—begs the question of whether the work is complete or unfinished. The scumbled quality of certain areas and the evidence of a wax-emulsion medium, presumably used underneath the oil paint, also reinforce the idea of this work as being "in process." This is one instance where Davis confronts the questions of process and completion, which had arisen on the international art scene during the 1940s and 1950s.

LSS

[1] Stuart Davis Papers, April 11, 1952. Harvard University Art Museums, Fogg Art Museum, Cambridge, Massachusetts.

[2] John R. Lane, *Stuart Davis: Art and Art Theory* (exhib. cat.). New York: The Brooklyn Museum, 1978, p. 71.

[3] Ibid.

[4] Ibid.

[5] Ibid.

[6] Lewis Kachur, "Stuart Davis: A Classicist Eclipsed," *Art International* 4 (Autumn 1988), p. 21.

[7] Stuart Davis Papers, June 19, 1961, op. cit.

146

Owh! in San Pao. 1951

Oil on canvas, 52¼ × 41¾ in. (132.7 × 106.1 cm.)
Whitney Museum of American Art, New York. Purchase, 52.2

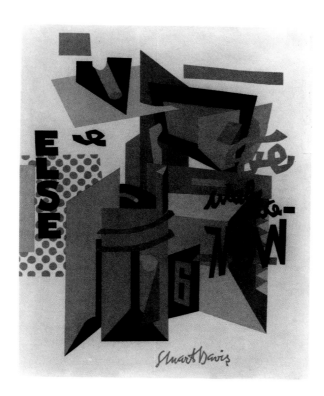

"Owh! in San Pao has the general compositional character of a Still Life, seen in a blasting international mood. A sense of object was achieved through the miserable jungles of subjective choice. Instead of a Utensil we see an Event."[1] In his paintings of the 1940s and 1950s, Stuart Davis increasingly diverted the spectator's attention from the objects or places depicted in the works to a contemplation of the visual effects. This phenomenon is best demonstrated in Davis's rehashing of composi-

tional motifs from the 1920s and 1930s during this period. Here, he has revisited his Cubist composition *Percolator* of 1927 (cat. no. 63). In *Owh! in San Pao*, Davis replaced the staid tonalities of melon, mauve, lavender, ocher, bottle green, gray, brown, and beige in *Percolator* with a more high-voltaged palette of electric blues, turquoises, pinks, oranges, yellow, and black. The planes that had formerly served in the Cubist analysis of form are now cacophonous neighbors, with each plane asserting itself individually and in its interactions with its neighbors. Davis records his progress in the August 19, 1951, entry in his calendar: "Great displacement of Time-Space took place as [I] work on Motel [the original title of *Owh! in San Pao*]." In Davis's color-space theory, the shape of a color area and its interaction with the one next to it establish a spatial order. Thus, by modifying the plan of the original composition, the identity of the percolator has changed from a kitchen appliance (albeit an abstracted one) to a visual event of interrelated colors. Davis further annihilates the objecthood of the percolator by adding words and various calligraphic elements that disrupt the space and create the impression that the forms are "coming apart" and the "planes floating across the canvas."[2]

Davis conveyed the exhilaration of this process in terms of himself as the painter maneuvering a speeding car up and down and through hurdles: "Put the Mellow Shift on Motel['s] Color Dimensions. Its Great but my Energy is Greater." "Put the Shift in reverse on Motel. Man, watch the Gravel flee." "Went into 4th Speed on the Motel Stutz. It has Pants in its Ants but-Look Out." "Grinding Gears on Motel. Stutz Bearcat on 63° incline. What power that car has." "The Motel Stutz turned into a Lincoln like a Real Gone Icon." "Motel Lincoln given a real Shake Down Cruise. Has a cough in its exhaust. Bought Gas Mask for tomorrow."[3] He added: "Finished Color-Shape Content of Motel at Export Level. Name Changed to 'Owh! in San Pao'."[4]

The change in title is interesting, especially given the fact that Davis's work was represented in the first São Paulo Bienal, which opened in October 1951. Davis himself explained the title as a play on sounds: "It has been scientifically established that the acoustics of Idealism give off the Humanistic Sounds of Snoring, whereas Reality always says 'Ouch!' Clearly then, when the realism has San Pão as its locale, a proper regard for the protocol of alliteration changes it to 'Owh!' "[5] Among "hip" circles, similar mimicry of a cry of pain also expressed extreme pleasure in experiencing or creating a marvelous musical cadence or the appreciation of a particularly apt turn of phrase. This is just one of the first of Davis's onomatopoetic plays on the titles of his paintings during the 1940s and 1950s.

Davis's reputation on the international scene ("the export level") grew during the next few years. He had a solo exhibition at the 1952 Venice Biennale, and his work was included in the 1956 Biennale and the First Inter-American Biennial of Painting and Graphic Work in Mexico in 1958. He was the recipient of the Solomon R. Guggenheim Museum International Award, also in 1958. Davis seems to have foreseen the changing fortunes of American art when he observed in 1951: "Art is International Currency."[6]

LSS

[1] Unpublished statement by Stuart Davis. Archives of Earl Davis.

[2] Karen Wilkin, *Stuart Davis*. New York: Abbeville Press, 1987, p. 202.

[3] See Davis's daily calendar entries for August 26–31, 1951, respectively. Archives of Earl Davis.

[4] Ibid., September 1, 1951.

[5] Diane Kelder, ed., *Stuart Davis*. New York, Washington, and London: Praeger, 1971, p. 105.

[6] See Lewis Kachur, "Stuart Davis: A Classicist Eclipsed," *Art International* 4 (Autumn 1988), pp. 17–21, especially Davis's daily calendar entry for July 27, 1951.

Rapt at Rappaport's. 1952

Oil on canvas, 52 × 40 in. (132.1 × 101.6 cm.)

Hirshhorn Museum and Sculpture Garden, Smithsonian
Institution, Washington, D.C. Gift of Joseph H. Hirshhorn
Foundation, 1966

Semé. 1953

Oil on canvas, 52 × 40 in. (132.1 × 101.6 cm.)

The Metropolitan Museum of Art, New York.
George A. Hearn Fund, 1953 (53.90)

The source of both of these compositions is Stuart Davis's 1922 *Landscape, Gloucester* (cat. no. 40), but thirty years later the color and spatial relationships among the compositional elements have radically changed. The earlier work was sparsely painted in subdued tones of green, ocher, and gray, but in these two paintings from the early 1950s, Davis demonstrates his virtuoso handling of color and shape by organizing a palette of brilliant reds, oranges, greens, and blues, with black and white, in different relationships. While the peculiar combination of still-life and landscape elements creates a tantalizing effect in the 1922 painting, in *Rapt at Rappaport's* and *Semé* these elements are now color planes over which Davis has inscribed *X*'s and *O*'s and various squiggles and words that at times indicate—and at other times obscure—the space within the painting.

Rapt at Rappaport's was the focus of the article "Stuart Davis Paints a Picture," published in the Summer 1953 issue of *Artnews*. Davis relates how the rediscovered 1922 work "set off a chain reaction . . . as these initial shapes and diversions . . . [suggested] . . . new associations."[1] The article also illuminates Davis's working method of isolating various areas of the canvas by means of tape, "so that they can be treated separately for a time."[2] The tape therefore served a similar function, marking the coordinates of various parts of the composition, as the masts of schooners did in his earlier pictures. Davis builds a composition through the juxtaposition of colors that cannot be worked out in advance, but whose interrelationships become clear as the work progresses. At this stage in his career, he is still working from his color-space-tone theories, with each color functioning to define the spatial nuances in various portions of the painting. This becomes clearer when we compare *Rapt at Rappaport's* to *Semé*. As noted, the basic colors are the same, with green serving as the background in both compositions. In *Rapt at Rappaport's*, the principal shapes are orange, blue, red, and black, while in *Semé* the same areas are red, orange, blue, and white. Although white is more widely distributed in the former painting, because the "blade" area of the "saw" from the 1922 composition is white in *Semé*, the visual weight of this composition seems to be lighter. However, conversely, the black of that same area in *Rapt at Rappaport's* provides a deep spatial "hole," which affords more of an illusion of depth than does the flatness of the white in *Semé*. A similar effect results from Davis's use of red, white, and blue to define the wedge shape within the orange field in *Rapt at Rappaport's*, as opposed to orange, black, and green on the corresponding red plane in *Semé*.

The title *Rapt at Rappaport's* is so boldly placed within the composition that one might be tempted to ascribe more importance to its relationship to the conception of

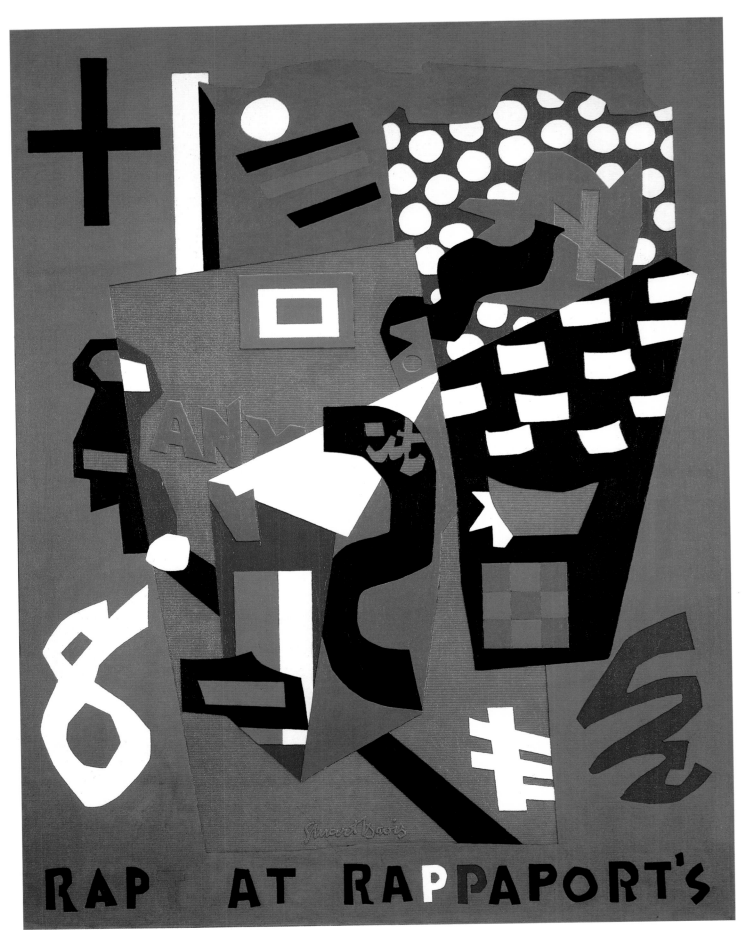

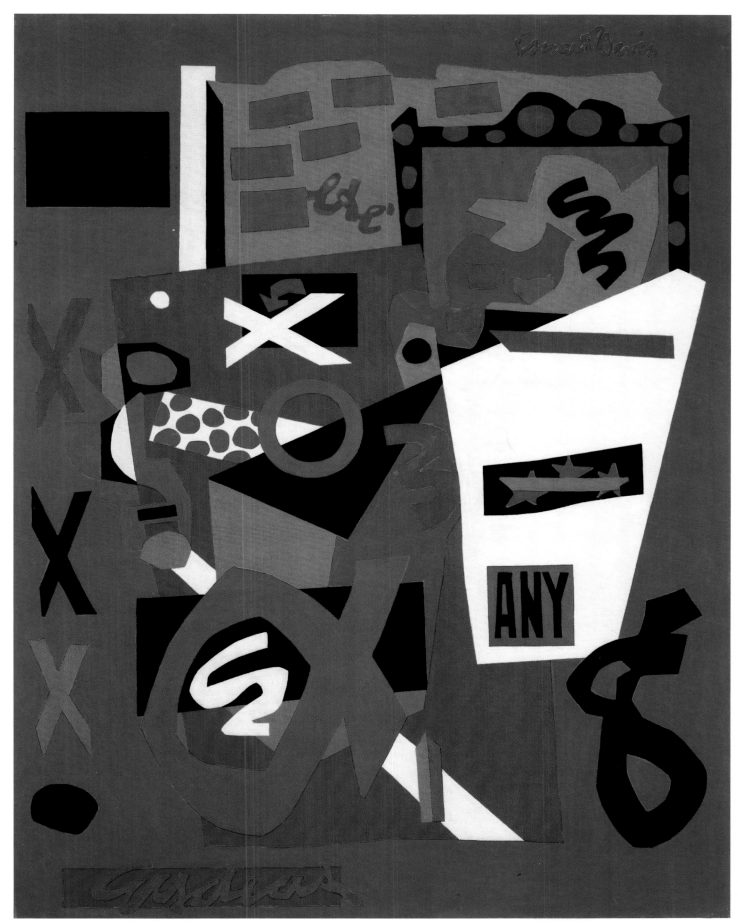

148

the composition than is warranted. In the same *Artnews* article cited above, Davis asserts that the title was in his head a while before he began the composition.[3] It evokes the snappy, alliterative nature of "jive" talk—and, hence, associations with jazz. One repeated suggestion of a source is Rappaport's Toy Bazaar in New York, with the title read as a play on "wrapped" and "rapt" (as in *enraptured*).[4] Most likely it was the result of successive alliteration on Davis's part. A drawing for this painting among the artist's notes of July 31, 1952, includes "Engrossed at Grossingers" as an alternate title. Davis further observed that former students of his from Yale associated the title with the slogan of Mort's Liquor Store in New Haven: "Let Mort Wrap a Quart." Davis's reaction to this deduction: "So much for art education."[5]

In *Semé*, as well as in *Rapt at Rappaport's*, Davis uses typographical elements less systematically than he did in earlier works. Nonetheless, there are specific meanings to the words that not only help to decipher the visual material but also indicate Davis's thoughts about subject matter. Davis interprets the title *Semé* as "strewn—lots of *things*,"[6] and, indeed, these compositions are made up of bright and colorful elements that seem to have been carelessly tossed into the whole. He continues: "In this painting [as in *Rapt at Rappaport's*] the word ANY means any subject matter is equal to art, from the most insignificant to one of relative importance. What is significant in subject matter is what is spontaneously given."[7] *Eydeas*, which is scrawled at the lower left in the typical Stuart Davis handwriting that would become more codified in the next decade, is an onomatopoetic fusion of the words *eye* and *idea*. Davis reaffirms his professed nonjudgmental approach to art making: "The Analogy content of this word consists of EYE and Ideas, a casual and unimportant combination (although made into a valid structural element in the painting). But its inanity is also valid in today's concept of Subject. I noted however on seeing it at the Met, that the Analogy content went unnoticed by me. A less intricate Subject now seems possible."[8]

LSS

[1] Dorothy Gees Seckler, "Stuart Davis Paints a Picture," *Artnews* 52, 4 (Summer 1953), p. 31.

[2] Ibid., p. 74.

[3] Ibid., p. 31.

[4] See notes in the archives of the Hirshhorn Museum and Sculpture Garden, Smithsonian Institution, Washington, D.C., and Georgia Dullea, "Family Toy Store Bows to Change," *The New York Times* (August 24, 1981), p. B 14.

[5] Unpublished statement by Stuart Davis. Archives of Earl Davis.

[6] From the archives of the Department of Twentieth Century Art, The Metropolitan Museum of Art, New York. The 1962 edition of *Cassell's French-English, English-French Dictionary* defines "semé" as "sowed; sown; strewn [with flowers]; spangled [with stars]."

[7] Ibid.

[8] Stuart Davis Papers, December 5, 1953. Harvard University Art Museums, Fogg Art Museum, Cambridge, Massachusetts.

Something on the 8 Ball. 1953–54

Oil on canvas, 56 × 45 in. (142.2 × 114.3 cm.)

Philadelphia Museum of Art. Purchased: Adele Haas Turner
and Beatrice Pastorius Turner Memorial Fund

"*Something on the Eight Ball* is a switch on the usual phrase 'behind the eight ball.'
I used it without knowledge of hearing it before in a conversation with some jazz
musicians [and] it got a laugh, causing me to remember it. Strangely enough, three
days later a man I had not seen for twenty-five years phoned me long distance for
advice on where to send a protégé of his to study art in New York. In describing the
unusual talents of this boy he ended by saying, 'I really think he's got something on
the eight ball.' I decided then and there that I had a good usable title for the picture
I was working on."[1] Stuart Davis cultivated a supposed nonchalance about his work
in the 1950s. As has been discussed, he philosophically stressed the equality of
source material through iconographic markers such as the recurrence of the word

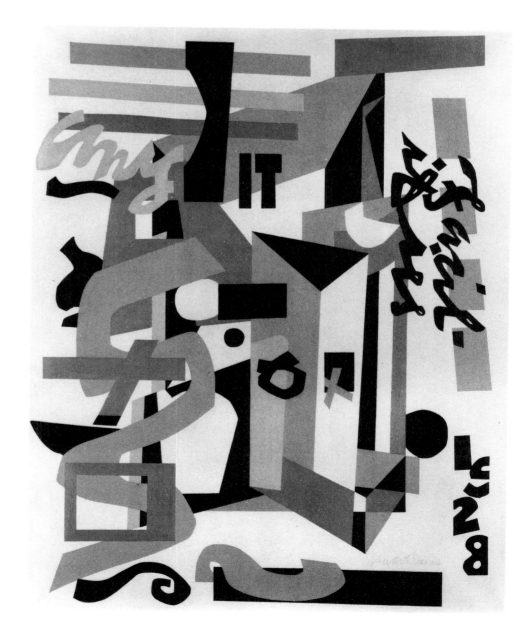

any in his compositions. Although Davis was no longer prowling the world in search of subject matter as he had during his youth, he took advantage of the new technologies as sources of information. For example, he developed a habit of working in his studio with a television on at all times (the sound was off). He also listened to jazz music either on the radio or on phonograph records as he worked.[2] From these sources, as well as from random conversations and everyday events, thoughts and verbal plays would strike his fancy, and would inevitably be hashed out in the stream-of-consciousness manner in which he kept his journal and made notations in his daily calendar.

Davis chose the titles of his paintings in a similar associative process, and would "apply them to a painting for purposes of identification when they seem[ed] appropriate in sound, not for any descriptive reason."[3] This auditory interest carried over, as we have already seen, into an appreciation of puns. Here, not only the title but also the word *Facilities* included in the composition is pertinent. Written out as *Facil-ities* (facile it is),[4] it marks a return to the somewhat defensive critical response expressed in the titles of two works from the early 1920s: *Untitled (Greek Backwards)* (cat. no. 34) and *ITLKSEZ* (fig. 8).

The compositional source for this painting is *Matches* of 1927 (cat. no. 64).[5] The sensation of "floating" and "coming apart,"[6] observed in *Owh! in San Pao* (cat. no. 146), is even more pronounced here in the openness that Davis achieves by allowing the yellow background to intrude into the forms themselves. This sensation is complemented by the more deliberate dispersal of the various colors throughout the composition to create an allover equilibrium. The words and calligraphic squiggles seem to swirl around in the space, tenuously anchored by the elongated pyramid form at the center of the composition.

LSS

[1] Diane Kelder, ed., *Stuart Davis*. New York, Washington, and London: Praeger, 1971, p. 104.

[2] See Brian O'Doherty, *American Masters: The Voice and the Myth*. 2nd ed. New York: Universe Books, 1988, p. 78.

[3] Kelder, op. cit., p. 104.

[4] O'Doherty, op. cit., p. 74.

[5] The indication of the date 1928, at the lower right, would seem to refer to that of the earlier composition on which this painting was based. Davis similarly included 1922 to refer to the landscape that inspired *Composition Concrete* and *Combination Concrete* (cat. nos. 160, 161). In this case it looks as if Davis was mistaken about the date of *Matches*, now given as 1927.

[6] Karen Wilkin, *Stuart Davis*. New York: Abbeville Press, 1987, p. 202.

Deuce. 1951–54

Oil on canvas, 26 × 42¼ in. (66 × 107.3 cm.)

San Francisco Museum of Modern Art. Gift of Mrs. E. S. Heller,
55.4734

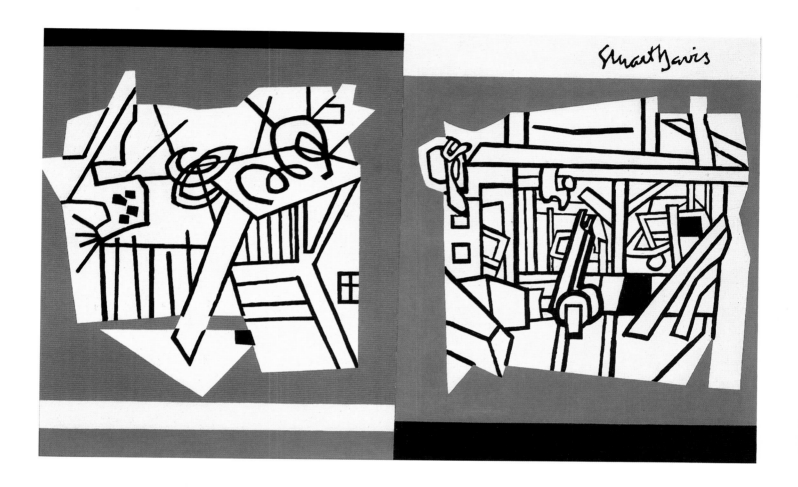

151

Lesson I. 1956

Oil on canvas, 42 × 60 in. (106.7 × 152.4 cm.)

Private collection

Stuart Davis had experimented with bipartite compositions since the 1930s (see cat.
no. 92). In *Deuce*, the black-and-white design on the left is silhouetted against red,
and that on the right against blue. The images appear to be coming into view as the
background color is stripped away. The left-hand side is a distillation of the curli-
cues and linear elements that characterized Davis's textile designs executed in the
1930s and 1940s (see figs. 48–51), as well as the richly articulated Pad paintings;
the right-hand side, a rather specific reference to the work of Fernand Léger, in-
cludes an interplay of tubing that creates a scaffolding like that in the French art-
ist's 1950 composition *The Construction Workers* (Musée National Fernand Léger,

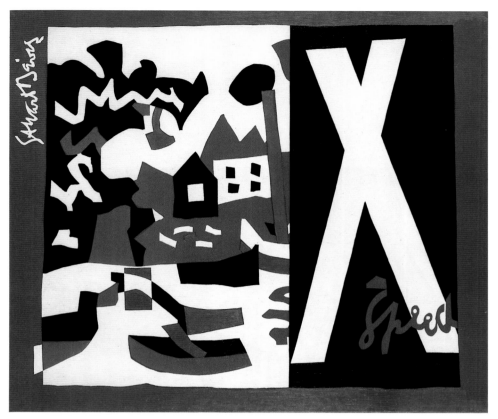

151

Biot). The forms also resemble the horizontal support beams of ships' rigging seen in Davis's Gloucester paintings of the 1930s.

Davis uses the constancy as well as the occasional variable widths of the black lines to convey depth and color. This is clear when the black-and-white designs are looked at separately against each of their color backgrounds. Visual balance is achieved through the comparable values of the intricate play of lines and the flat color areas. *Lesson I* employs the red, white, black, and green palette of *Memo No. 2* (cat. no. 153) in another examination of spatial anomalies. Here, contrast is achieved by omission. At the left, the third dimension disintegrates into the white background. Negative areas (whites) are activated by the suggestion of the completion of forms. The right side of this composition is obliterated by a black area over which a large, white *X* is inscribed. The *X* is undoubtedly another affirmation of the neutrality of the subject matter. By crossing out the rest of the scene Davis jolts us from our psychological involvement with the left-hand side by declaring the remainder of the painting to be beside the point—even invalid.

LSS

Colonial Cubism. 1954

Oil on canvas, 45 × 60⅛ in. (114.3 × 152.7 cm.)

Walker Art Center, Minneapolis. Gift of the T. B. Walker Foundation, 1955

Memo No. 2. 1956

Oil on canvas, 24 × 32 in. (61 × 81.3 cm.)

Southwestern Bell Corporation Collection, Saint Louis

Colonial Cubism is an ironic accommodation to the view of America as an artistic backwater. This outlook had persisted in the United States and in Europe until the end of World War II, and was one against which Stuart Davis had particularly struggled throughout his career. With the ascension of the Abstract Expressionists, French Cubism was seen as anathema, and American artists began to define "their achievement against Cubism . . . by transcending it [Pollock] . . . [and] by attacking it [de Kooning]."[1] Davis, on the other hand, "mobilized Cubism through vernacular energies and his formidable wit."[2] Compared to his complex, multilayered works, such as *Semé* or *Something on the 8 Ball* (cat. nos. 148, 149), *Colonial Cubism* is composed of flat, unornamented planes. The Cubist landscape that Davis painted in 1922, *Landscape, Gloucester* (cat. no. 42; fig. 14), is the basis for *Colonial Cubism*. The decorative details that helped define the hillside, clouds, water, and schooners in the original composition have given way to blacks, whites, blues, and oranges, as well as several small sections of red, all set against a rich, red background. Two white orbs have been added to the upper right; they balance the blue shape and the orange star on the left. "Davis referred to this painting as having overtones of one of the better types of Cubism without becoming too expatriate about it. . . . [He] was obviously rethinking some of the tenets of cubism. But a comparison of this painting with any cubist work of Picasso, Léger or any other European cubist will reveal how completely Davis created his own world from the cubist elements."[3] While he asserted the peculiarly "American"—"original"—quality of his work, Davis was at odds with the Abstract Expressionists, undoubtedly uncomfortable with their cultivated "psychological intensity" and "emotional unbuttonedness."[4] Thus, this composition is a defiant reaffirmation of his dedication to his long-established artistic path.

In *Memo No. 2*, Davis lays out the same composition in a series of flat, white areas and black shapes etched with white lines. An eccentric red replaces the orange and blue shapes in *Colonial Cubism*. As in *Memo* of 1956 (cat. no. 120), which was based on the 1939 *Shapes of Landscape Space* (cat. no. 118), in *Memo No. 2* Davis uses color to establish a variety of spatial relationships that ultimately supersede any anecdotal references in the scene.

LSS

[1] Brian O'Doherty, *American Masters: The Voice and the Myth*. 2nd ed. New York: Universe Books, 1988, p. 49.

[2] Ibid.

[3] *Stuart Davis, 1894–1964* (exhib. cat.). Essay by H. H. Arnason. London: USIS, American Embassy, 1966, n.p.

[4] Karen Wilkin, *Stuart Davis*. New York: Abbeville Press, 1987, p. 192.

154

Ready to Wear. 1955

Oil on canvas, 56¼ × 42 in. (142.9 × 106.7 cm.)

The Art Institute of Chicago. Gift of Mr. and Mrs. Sigmund
Kunstadter, 1956.137

155

Cliché. 1955

Oil on canvas, 56¼ × 42 in. (142.9 × 106.7 cm.)

The Solomon R. Guggenheim Museum, New York, 55.1428

Stuart Davis vividly demonstrated the implications of his color-space theory in
these two compositions based on identical configurations and executed the same
year. *Ready to Wear* is painted with the same red, white, and sea blue as *Allée* (cat.
no. 156), the mural for Drake University in Des Moines, Iowa, that Davis also com-
pleted in 1955. The pristine handling of the colors and the sedate facture resulted
in comparatively flat, cutout shapes that, nonetheless, assert their distinct charac-
ters within the whole. Compared to the obfuscation of forms that occurred in the
updated paintings of 1951–54 (for example, *Owh! in San Pao, Rapt at Rappaport's,
Semé,* and *Something on the 8 Ball* [cat. nos. 146–149]), the planar organization in
Ready to Wear seems to proceed from a more purely abstract arrangement of form.
Davis even divides the background, providing a contrast in the visual effects of col-

ors "sitting "on top of one another—as in the difference between the blue areas functioning against the black versus the black against the blue.

In *Cliché*, Davis employs almost the same design as in *Ready to Wear*, outlining the main areas in black, and painting the entire composition orange. Spatial nuances are achieved through variations in the thickness of the lines rather than through the juxtaposition of various color values. The result is that the forms in *Cliché* seem to regress behind the assertive tyranny of the lines, while the color shapes in *Ready to Wear* push to the front of the composition. Several of the elements in *Ready to Wear*, such as the partial white square and the smaller blue square that interact with the blackened tip of the undulating blue form at the top, have not been transposed over into *Cliché*. The large, white *X*, which maintains a triadic relationship with the black rectangle and the red oval at the upper right in *Ready to Wear*, is also absent from *Cliché*, where it may have been replaced by the letters XRD (crossroad?), which occupy the area containing the black oval at the far right in *Ready to Wear*. Davis toys with the inevitability of the figure/ground relationship established in *Cliché* through small gestures, such as occasionally breaking the continuity of the black lines. With *Cliché*, Davis revisits the black-and-white compositions that he executed in the early 1930s, at a time when he was preoccupied with drawing as the essence of art making. Throughout the 1950s and 1960s he would do black-and-white renderings of compositions after the fact (see cat. nos. 143, 167, 169, 170), as if revisiting the formal terrain of his work.

LSS

156

Allée. 1955

Oil on canvas, 96 × 396 in. (243.8 × 1005.8 cm.)
Drake University, Des Moines, Iowa

Allée is the only extant mural by Stuart Davis that belongs to the same institution for which it was commissioned. Originally installed in the North Dining Room of Hubbell Hall at Drake University (see fig. 117), it was moved to the upper gallery of Olmstead Center in 1981, where it presently hangs. Davis was commissioned to do the mural by Eero Saarinen, who designed the main campus of Drake University in 1955. For Davis, the work was "seen not only as a painting, but as a wall integrant in the Color-Space simplicity of Eero Saarinen's architectural interior."[1] In a statement written in 1955, after the installation of the mural, Davis explains the thoughts and ideas that went into its conception in an atypically sentimental and direct way:

> *Allée* is a French word meaning an alley or long vista. . . . Also, there is another French word with the same sound which means "go". I like this association. I like the variety, the animation, the vigorous spirit which is part of college life. This feeling of energy and vigor was in my mind during the painting of the mural.
>
> Following my first visit to the Drake campus, I carried back to my studio a strong impression of the simplicity and directness of the architecture. I set out to make the mural harmonize with the room. The composition of the mural is vigorous in keeping with its surroundings. The figures in the mural are severely rectilinear. I did not clutter it up with detail, yet there is considerable variety of size and positional relationships.

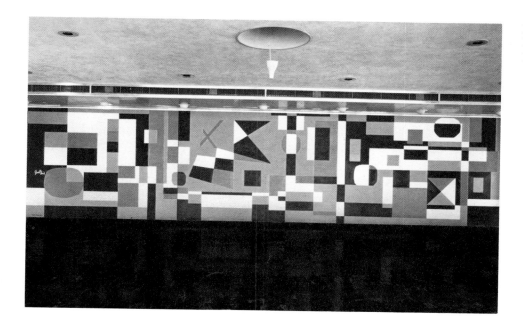

Figure 117. View of the North Dining Room, Hubbell Hall, Drake University, Des Moines, Iowa, where *Allée* was originally installed

I remember the whiteness of the room—its ceilings and walls—the black floors, the blue sky outside those high windows, and the red rectangles of the brick dormitories. Therefore, I decided to use blue as the main color on a white background and chose red and black as the other two colors. I determined to use only four colors. This was a real challenge. . . . As a result, I feel the mural is more colorful than if I had used many more colors.

Do not look for meanings and symbolism which are not there. Instead, look for the color-space relationships which give the painting its vigorous tone and its structural feeling. The placing of the figures and colors were [sic] done with feelings and thoughts which were the product of my interest in life. The meaning of the mural will change as the viewer gives meaning to it.

I feel I was successful in doing what I set out to do which does not depend on events or depicted replicas for its meaning. I tried to achieve simplicity and directness. When I think of a college campus, I think of intellectual issues debated with vigor, of football, poetry, jazz music, of excitement. These were in my mind when I painted the mural. During the long month the mural was in my studio, I had the notion it would look all right when it was mounted; now that I have seen it in the Dining Hall, I feel that it does.[2]

Davis's affectionate fabrication of campus life is perhaps to be expected from a man who dropped out of high school to study with Robert Henri because his precocious talent simply couldn't wait. It may not be unreasonable to suppose that the more formal quality of this work can, indeed, be credited to Davis's self-consciousness about the academic resonances of the locale. He has given more than a passing nod to Mondrian, whom he first engaged in the 1940s with *G & W* and *For Internal Use Only* (cat. nos. 133, 134). In spite of the overall emphasis on horizontal and vertical lines, Davis created a subtly different nuance in each of the three panels. The left one is the most spare, with the squares and rectangles relatively large and open and only the circle at the left breaking the rectilinear pattern. The right-hand panel is a richer mix of squares, rectangles, and circles, with one passage where two crisscrossed lines have created four triangles. The center panel is the most dramatic of all, with an off-kilter "checkerboard" element linked to a large, double-"peaked" form, and an *X* and a black square cornering off the space. Around this spectacle Davis laid an uneven border of interacting rectangles and squares, and we notice especially with the black half-circle on the left side of the center panel and the blue

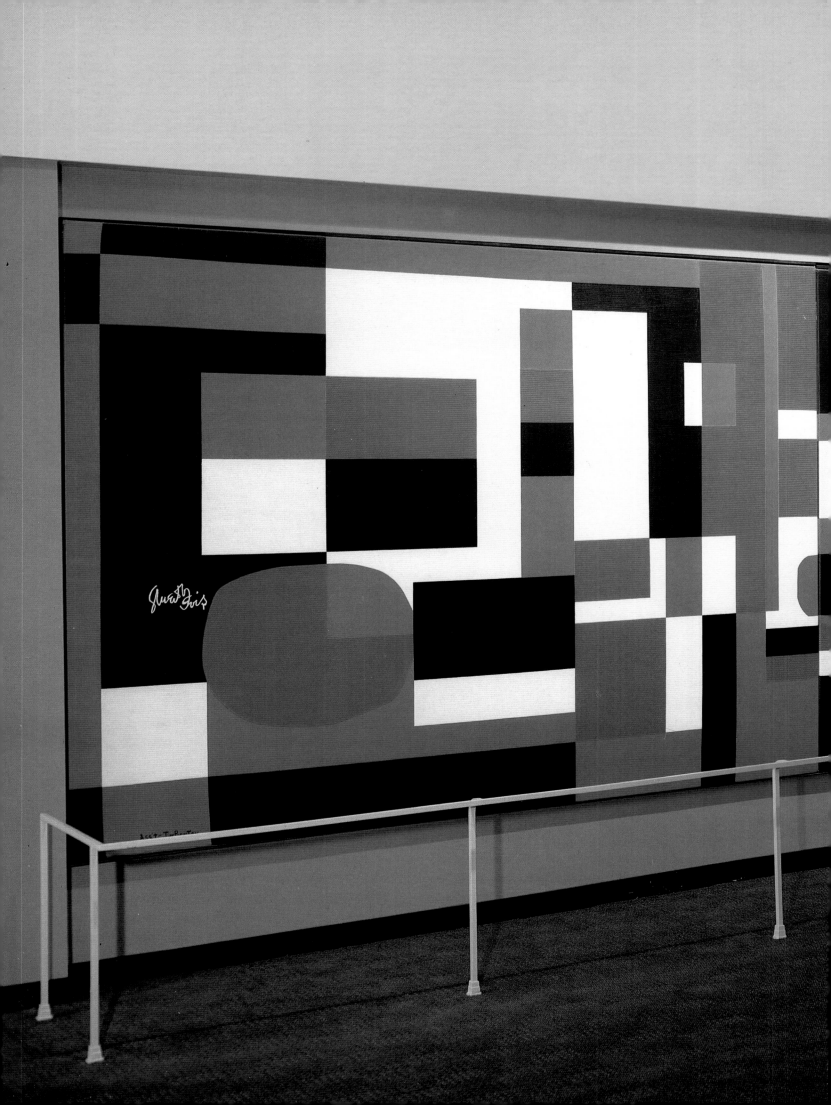

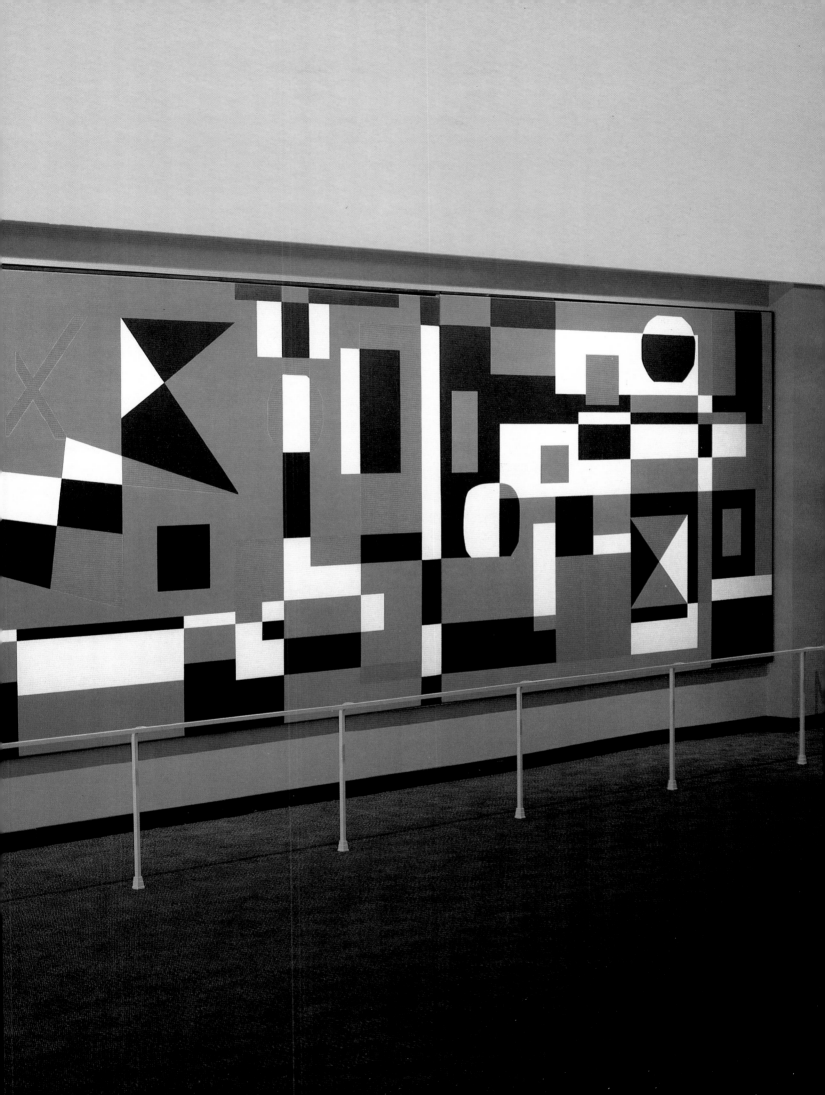

one on the right side of the left panel how a design on the edge of one panel is completed and complemented by that on the adjoining panel. The central motif will appear again seven years later in *Unfinished Business* (1962; cat. no. 171), this time in the red, green, yellow, and black palette that Davis seems to have favored in the 1960s.

LSS

[1] *Stuart Davis Memorial Exhibition* (exhib. cat.). Introduction by H. H. Arnason. Washington, D.C.: National Collection of Fine Arts, Smithsonian Institution, 1965, p. 44.

[2] Excerpt from the pamphlet published by Drake University on the occasion of the installation of *Allée*, courtesy Office of Buildings, Drake University; reprinted in *Stuart Davis: Motifs and Versions* (exhib. cat.). Forewords by William C. Agee and Lawrence B. Salander. New York: Salander-O'Reilly Galleries, 1988, n.p.

157

Stele. 1956

Oil on canvas, 52¼ × 40⅛ in. (132.7 × 101.9 cm.)
Milwaukee Art Museum. Gift of Mrs. Harry Lynde Bradley,
M63.129

"As an art student I was intrigued by the faces of Cyprean statues in the Metropolitan Museum. The way the sunlight fell on them in late afternoon. Subsequently I learned about statues in general. The qualitative arithmetic of this span of experience was resolved in the titular equation, 'Stele'."[1] This painting (based on *Matches* of 1927; cat. no. 64) is a variation on *Something on the 8 Ball* (cat. no. 149), completed two years earlier. With its restrained palette of mat black, blue, blue-green, red, white, and gray, and its focus on horizontal and vertical lines, *Stele* presents a flat, monolithic impression that contrasts with the febrile exhilaration of *Something on the 8 Ball*. The color and composition here reflect the rectilinearity of the mural that Stuart Davis executed a year earlier for Drake University, *Allée* (cat. no. 156), which contains nods to both Mondrian and Neoplasticism, but, nonetheless, is embellished with Davis's customary parenthetical vocabulary that includes circles and *X*'s. Although *Stele* is certainly a pared-down version of *Something on the 8 Ball*, it does retain certain compositional elements—such as the large double *S* at the left-hand side—that demonstrate a continuity in Davis's exploration of variations on the theme of *Matches*. The appearance of the word TABAC in this composition is also somewhat atypical. It does not seem to serve the iconographical purpose that certain words do in Davis's works, but it certainly fulfills a compositional role, providing a serendipitous element in an otherwise cautious painting.

LSS

[1] Unpublished statement by Stuart Davis. Archives of Earl Davis.

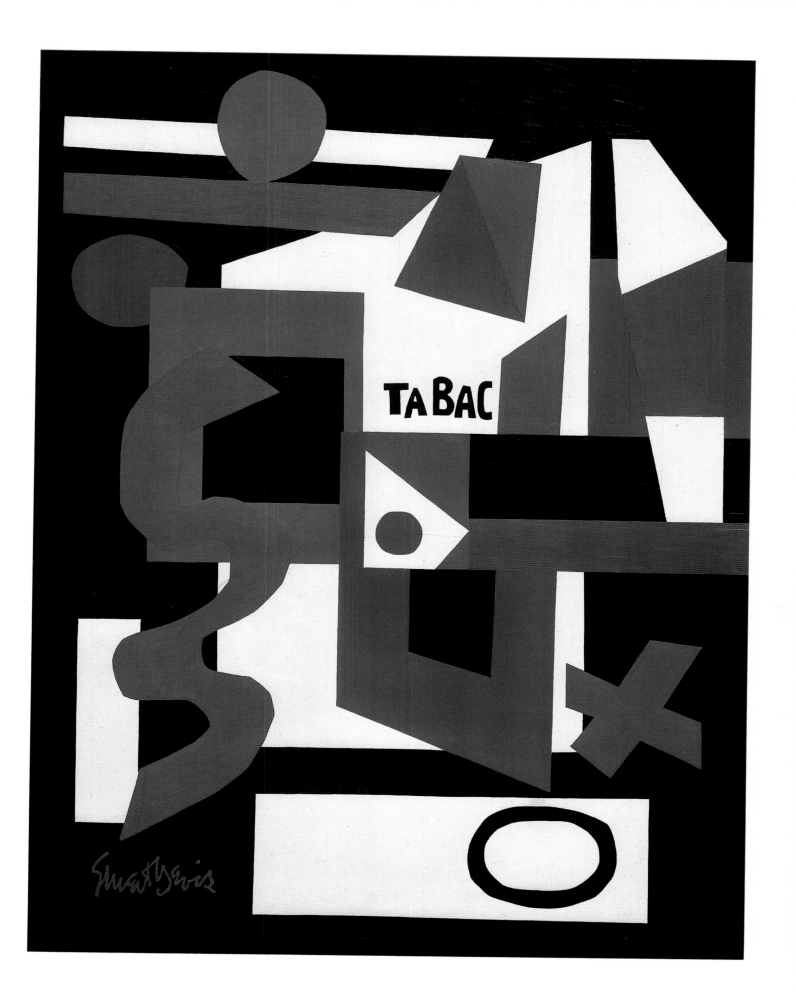

Premiere. 1957

Oil on canvas, 58 × 50 in. (147.3 × 127 cm.)

Los Angeles County Museum of Art. Museum Purchase,
Art Museum Council Fund

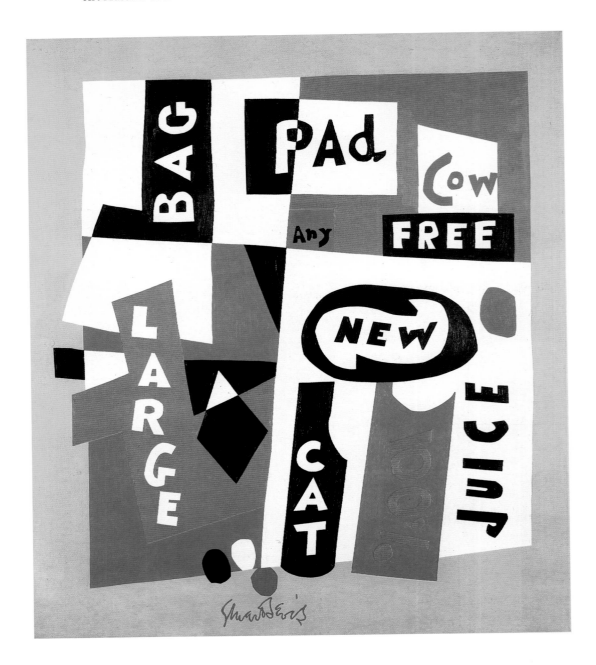

International Surface No. 1. 1958–60

Oil on canvas, 57 × 45 in. (144.8 × 114.3 cm.)

National Museum of American Art, Smithsonian Institution,
Washington, D.C. Gift of S. C. Johnson & Son, Inc.

Premiere is based on the 1956 composition in gouache *Package Deal* (figs. 73, 118),
which resulted from a commission from *Fortune* magazine to create a painting that

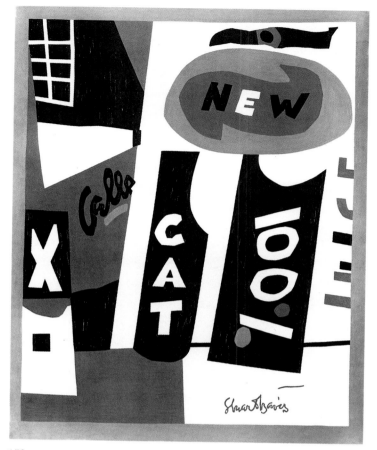

159

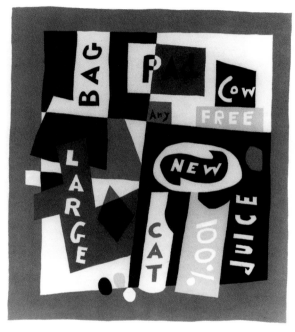

Figure 118. Stuart Davis. *Package Deal*. 1956. Gouache on paper. Private collection (see also fig. 73)

Figure 119. Stuart Davis. Study for *Package Deal*. 1956. Pencil on paper. Collection Earl Davis. Courtesy of Salander-O'Reilly Galleries, New York

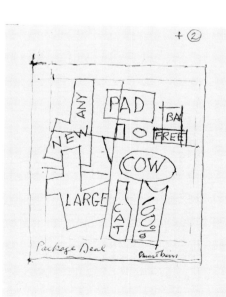

Figure 120. Stuart Davis. Study for *Package Deal*. 1956. Pencil on paper. Collection Earl Davis. Courtesy of Salander-O'Reilly Galleries, New York

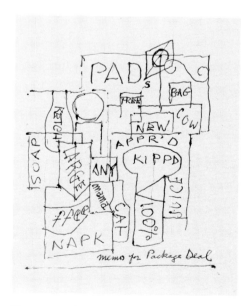

Figure 121. Stuart Davis. Study for *Package Deal*. 1956. Pencil on paper. Collection Earl Davis. Courtesy of Salander-O'Reilly Galleries, New York

focused on the "glamor of packaging."[1] In 1956, seven artists had been asked to interpret the packaging of consumer goods. Stuart Davis chose to visit the grocery store, where he purchased a bagful of food and household products. He laid the items on the floor in his studio and spent several days working on drawings until he "saw something . . . that seemed feasible."[2] As the studies demonstrate (see figs. 74, 75, 119–121)—there are twenty-nine in all—the images evolved from Davis's gradual reduction of empirical reality to a more "generalized view of the world."[3] He was not concerned with reproducing the packages but, rather, was "inspired by the sensory impacts of the stuff."[4] One is struck by how this treatment of consumer items differs from that in Davis's advertising still-life compositions of the 1920s. Instead of focusing on the logo—the chief aspect in identifying a product—or the packaging, which sought to achieve a specific persuasive effect, Davis reduced the products to a series of words that convey their basic qualitative and quantitative nuances. This composition is a masterpiece of generic promotion: "*100%*," "JUICE," and so on. The shapes have nothing to do with the identities of the products. One thinks of the word surrogates that René Magritte used to effect a subversion of agreed linguistic designations that are central to all language systems. Davis likewise subverted the usual descriptive relationship between an object and what it is called—a strategy he first mapped out in the 1920s (see pages 56–69).

What Davis was concerned with in *Package Deal* and *Premiere* was the issue of "optical intervals." Color was to serve as a "memo of differences of position" of the shapes, as the indication of "place or position."[5] "I thought . . . that the interval between black and white and Cadmium Yellow was off beat. . . . And so in this particular picture [*Premiere*] I used this novel idea . . . of changing the position of the yellow from Lemon Cadmium to Medium Cadmium and—well that sounds like an immaterial thing, but it was exciting and I've used it ever since."[6]

In a reworking of this motif one year later, in *International Surface No. 1*, Davis juxtaposes the lower-right quadrant of *Premiere* with a variety of personal symbols such as the *X* (reminiscent of the negating element in *Lesson I*; cat. no. 151), the checkerboard motif, and the word *Celle*, which appears at the left center of the canvas. Davis thus places the specifically American consumer subject matter of *Premiere* in a larger context, with a reference to his Paris years ("Celle"), thereby creating a more "international" effect and an "international surface."

LSS

[1] Stuart Davis, in an interview with James Elliott, Spring 1961. Tape in the archives of Earl Davis.

[2] Ibid.

[3] Ibid.

[4] James Elliott. "Première," *Los Angeles County Museum of Art Bulletin* 14, 3 (June 1962), p. 9.

[5] See note 1.

[6] See note 4, p. 11.

Composition Concrete. 1957

Oil on canvas, 17 × 8 ft. (518.2 × 243.8 cm.)

The Carnegie Museum of Art, Pittsburgh.
Gift of the H. J. Heinz Company, 1979

If *Allée* (cat. no. 156) is the longest extant work ever executed by Stuart Davis, then *Composition Concrete*, at seventeen feet high, is certainly the tallest. Commissioned by Gordon Bunshaft and Eero Saarinen for the lobby of the Research Center of the H. J. Heinz Company in Pittsburgh (see fig. 122), this work originally hung in a nineteen-foot-high foyer with a plaster ceiling and a terrazzo floor, on a wall paneled

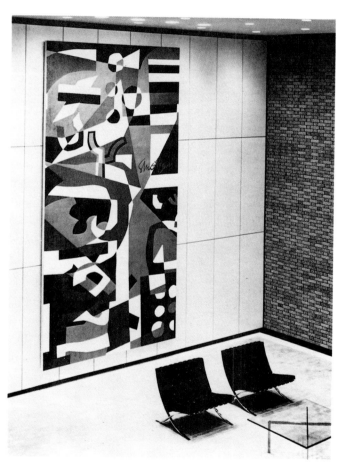

Figure 122. View of the lobby of the H. J. Heinz Research Center, Pittsburgh, where *Composition Concrete* was installed from 1957 to 1961. (Photograph from *Carnegie Magazine*, May 1980)

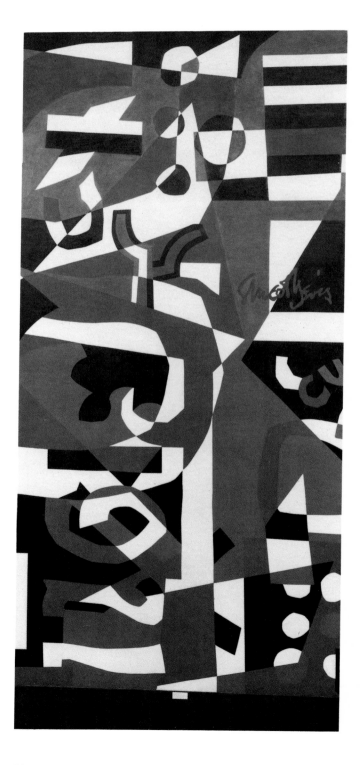

Figure 123. Stuart Davis. Study for *Composition Concrete* (*Variation*). 1957–60. Casein on canvas. The Regis Collection, Minneapolis

with white plastic, which was flanked by two brick walls. Below the painting were two black Mies van der Rohe chairs.[1] While Davis used the same red, white, blue, and black palette as in *Allée*, executed two years before, this composition is quite different from Davis's strictly geometric vocabulary in the earlier mural. In *Composition Concrete*, indications of a landscape may be seen in spite of Davis's habit of creating a new color area every time one form overlaps another. The result is a crystalline faceting of the composition, in which light is literally created by the pure white, stark black, clear sky blue, and cherry red. The key to discerning the landscape is what has been described as the Y shape in the upper section of the composition (see fig. 123). This is, in fact, identical to the abbreviated tree form that Davis invented in his Cubist compositions of 1921 (see *Untitled* and *Garden Scene*, cat. nos. 35, 37), and which also appears in *Landscape* of 1922 (cat. no. 41). This last painting has been acknowledged as the source of the composition of *Combination Concrete* (cat. no. 161), executed one year after *Composition Concrete*. Yet, careful scrutiny of the elements in *Composition Concrete* reveals that *Landscape* was the basis for this later work as well. Davis used a more truncated version of the composition, consisting only of what amounts to the left half of the 1922 painting. From the tree form here, we can discern the equivalent of the white branch in the 1922 picture, the triangular shapes that fan out from the junction of one angle of that form, and then the parallelogram that, in the 1922 work, reads CURVE; in fact, at the mid-section of the right edge of *Composition Concrete* one can make out the CU of CURVE. The artist includes the date of the earlier version aligned along the left edge of the canvas.

Davis's working method here seems to be atypical. Usually when repeating motifs he worked from the general to the specific, as seen in the relationship between *Standard Brand* of 1961 and *Blips and Ifs*, which was painted in 1963–64 (see cat. nos. 163, 164). However, here he proceeds from the specific to the general. A clue to this is that the lines in *Composition Concrete* reach to the edge of the canvas, so that the rest of the composition, in turn, runs off the edge. The main image of *Combination Concrete*, on the other hand, floats within a red field that extends out to the edges, much the same way that the image in the 1922 painting is situated on the canvas. Also, if one compares the large, open circles, rectangles, and squares that have been placed over the elements in the original plan of *Composition Concrete*, we can see that Davis carried most of them over quite literally in the finished painting. It is reasonable to assume that Davis began both of these paintings in 1957, perhaps planning the composition of *Combination Concrete* before going on to *Composition Concrete*. Since the mural commission would have had a more specific deadline, Davis may have waited until the following year to complete *Combination Concrete*.[2]

Davis explained that the title refers to "concrete music or sounds recorded on tapes which are cut and respliced in pattern to make a composition."[3] This improvisational attitude is an important component of Davis's creative process particularly during this period in his career. Through this method, the original sources of Davis's composition become "neutralized . . . and their relationships are pure composition."[4]

LSS

[1] Herdis Bull Teilman, " 'Composition Concrete,' 1957, by Stuart Davis," *Carnegie Magazine* 54 (May 1980), p. 5.

[2] I am grateful to Earl Davis for relating the conversation he had with William C. Agee regarding the dating of these works.

[3] Teilman, op cit., p. 7.

[4] Ibid.

Combination Concrete. 1958

Oil on canvas, 71 × 53 in. (180.3 × 134.6 cm.)
Private collection

Figure 124. Stuart Davis. *Combination Concrete (Black-and-White Version)*. 1958. Casein on canvas. Collection Earl Davis. Courtesy of Salander-O'Reilly Galleries, New York

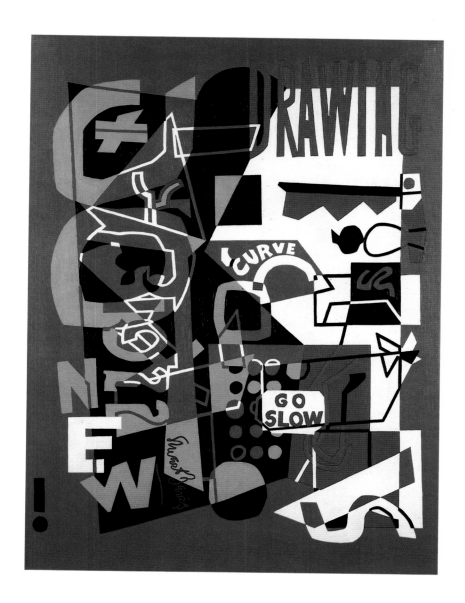

As we have seen from the discussion of *Composition Concrete* (cat. no. 160), the present painting, too, is a variation on Stuart Davis's 1922 painting *Landscape* (cat. no. 41). It is perhaps easier to see the reinterpretation of the 1922 composition in the black-and-white version of *Combination Concrete*, which was also painted in 1958 (see fig. 124). Davis has replicated all of the salient features of the original plan, situating the perimeters of the composition's eccentric shape well within the borders of the canvas. Over this composition he drew open and closed circular forms, squiggles, horizontal S forms, and various planar elements that approximate parallelograms and trapezoids. Also layered over the scene are the words DRAWING at the upper right and NEW at the lower left, the latter just to the left of and partly overlapping the numbers 1922—an allusion to the date of the original composition. Here, Davis creates a faceting effect similar to that in *Composition Concrete*, taking each occasion of a juncture of one or more forms in this elaborate overlay to employ another color. Again, he seems to have divided the composition in half, with the

right portion retaining the red, blue, white, and black color scheme of *Composition Concrete* while the left portion—which approximately corresponds to the 1922 plan as seen in *Composition Concrete*—is rendered in warm shades of red and orange, with black, touches of white, and green (in the artist's signature).

The particular calligraphy or symbology that Davis uses in these paintings is fascinating in its consistency. Besides the words, which invariably have specific iconographic meanings, there is a whole repertoire of *X*'s and circles, plus signs, inverted *E*'s, and so on, which, according to Karen Wilkin, "have equivalents in Davis's notebooks, in the 'equations' and formulas he devised to clarify his color-space theories. The floating *e*, for example, is used to symbolize the word *configuration*, while the *X* sometimes stands for *external*—as opposed to *internal*—which Davis described as the generating 'dynamic forces' of two-dimensional composition."[1] However, Wilkin warns us against a too-specific interpretation of the elements: "These symbols, like the shorthand words . . . often change meaning. . . . They are probably meant to tease. If they do contain specific meanings, Davis seems to have preferred that they remain private and unreadable."[2]

LSS

[1] Karen Wilkin, *Stuart Davis*. New York: Abbeville Press, 1987, p. 203.

[2] Ibid.

162

The Paris Bit. 1959

Oil on canvas, 46 × 60 in. (116.8 × 152.4 cm.)

Whitney Museum of American Art, New York. Purchase, with funds from the Friends of the Whitney Museum of American Art, 59.38

This is one of two versions, begun in the late 1950s, of Stuart Davis's Paris-period painting *Rue Lipp* (cat. no. 79). The two pictures form what the artist would have called a complementary-color pair, for *Study for "The Paris Bit"* (1957–60; The Regis Collection, Minneapolis) is painted in red and green with an orange border, while *The Paris Bit* is in the colors of the French and American flags. Likewise, the former is open and planar while the latter is dense and calligraphic.

Many of the words and phrases in the picture are unique to *The Paris Bit*—for instance, *unnecessary* at the upper center and LINES THICKEN at the top. The latter would seem to be self referential, alluding to the broad lines of the composition's framework. Other words and symbols clarify the original elements in *Rue Lipp*: EAU is superimposed over the water bottle on the table; BELLE FRANCE appears once again, seeming to summarize Davis's reaction to Paris; and '28 recalls the date of the earlier canvas. Above the mirror-image, squiggly signature one finds a combined top hat and beer mug—a color rendition of the beer/hat optical pun found in *Rue Lipp*. The TABAC sign in the latter is integrated here into the infrastructure at the lower right.

With *The Paris Bit*, Davis strove to fashion a memorial to his poet friend Bob Brown, who had died on August 7, 1959, four days before Davis began work on this canvas. Instead of including Brown's name, as he had at the right side of *Rue Lipp*, Davis created a concrete mixture of word and image, in the spirit of Brown's experimental "image-poems." The exuberance of the word play is dampened by the rather somber tones of the saturated hues, with the black casting a funereal note.

LK

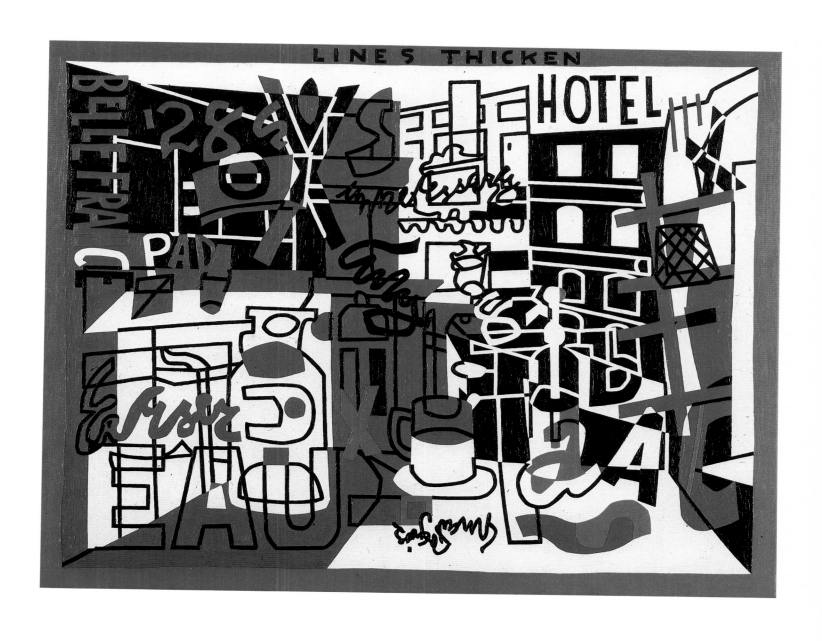

Standard Brand. 1961

Oil on canvas, 60 × 46 in. (152.4 × 116.8 cm.)

The Detroit Institute of Arts. Founders Society Purchase,
General Membership Fund

164

Blips and Ifs. 1963–64

Oil on canvas, 71⅛ × 53⅛ in. (180.7 × 134.9 cm.)

Amon Carter Museum, Fort Worth

Stuart Davis: There should be applause. Davis, at sixty-seven, is still a hot shot. Persistent painters are scarce; painters with only a decade or less of good work are numerous. . . . The "amazing continuity" of Davis's work does not seem to have been kept with blinders, in fact, could not have been. Neither has Davis been startled into compromises with newer developments. Some older artists abandoned developed styles for one of the various ideas included under "Abstract Expressionism," spoiling both. Davis must also have faced the fact of increased power and different meanings. Instead of compromising, he kept all that he had learned and invented and, taking the new power into account, benefited.[1]

This review by Donald Judd, then a rising young sculptor, is a surprisingly generous appraisal of Davis's 1962 exhibition at the Downtown Gallery in New York, just

two years before the older artist's death. One of the paintings Judd singled out was *Standard Brand*. Like *Premiere* (cat. no. 158), this painting demonstrates how writing, script, and words could be thoroughly integrated into the fabric of the composition. Against the smaller yellow square and the black, red, and yellow rectangles of various larger sizes, Davis arranged the words *any*, Pad, and COMPLET, along with assorted circular elements, an off-kilter cross, and a black dash. *Any* is placed so that the white script can be seen simultaneously against black and yellow. The irregularly printed red and white letters of Pad are set within a black panel, against a yellow field. COMPLET appears in elongated green letters also on the yellow field and, visually, it plays off the artist's signature, in green script on the red rectangle. Davis used various styles of lettering to give the words different visual weights, in order for them to contribute to the "color-space" effect of the composition. The different orientations of the words also reinforce the horizontal/vertical dichotomy that dominates in this work. Although Davis's signature is often placed at unusual angles in his later paintings, here it particularly begs the question of the canvas's ultimate orientation. This is a just dilemma, since Davis often reoriented compositional motifs when he employed them in successive paintings.

When Davis reworked this composition just two years later, in *Blips and Ifs*, he characteristically homed in on one section of the original—specifically, on the juncture of the four corners in the upper left of *Standard Brand*. Green alternates with black here. *Any* has one yellow letter. Pad (only partially seen) is made up of black letters on yellow, with red and white inserts, and COMPLET (also partially seen) is composed of alternating red, yellow, white, and green letters. Davis underscored this telescoped view of the earlier composition with the word TIGHT, which he inserted in the yellow field containing Pad. "The fragmentation of the words . . . heightens the sense of nonassociative abstract reality. Color shapes and rhythmic ribboned movements are simplified to a grandiose scale in which the compression of all elements reinforces the explosive tension."[2] Karen Wilkin sees an affinity in these works with the late cutouts of Henri Matisse.[3] Yet, unlike the dislocated letters one might find in Matisse's work, in Davis's paintings they always maintain their syntactical integrity. Indeed, we find ourselves caught up in an ironic play on the word *complet* in this "incomplete" view.

Davis's signature had assumed an increasingly compositional role in the paintings of the late 1950s and early 1960s. Here, it is set at a ninety-degree angle when the composition is viewed upright, and reads like a series of zigs and zags. One of the six or seven areas of white paint on the canvas, it helps to enliven the visual balance. As Brian O'Doherty notes: "The author is present but hardly recognizable."[4]

LSS

[1] Donald Judd, "In the Galleries: Stuart Davis," *Arts Magazine* 36, 10 (September 1962), p. 44.

[2] *Stuart Davis Memorial Exhibition* (exhib. cat.). Introduction by H. H. Arnason. Washington, D.C.: National Collection of Fine Arts, Smithsonian Institution, 1965, p. 49.

[3] Karen Wilkin, *Stuart Davis*. New York: Abbeville Press, 1987, p. 216.

[4] Brian O'Doherty, *American Masters: The Voice and the Myth*. 2nd ed. New York: Universe Books, 1988, p. 74.

Anyside. 1961

Oil on canvas, 28 × 42 in. (71.1 × 106.7 cm.)
Private collection

Municipal. 1961

Oil on canvas, 24 × 30 in. (61 × 76.2 cm.)
Private collection

Stuart Davis revisited the New York street scene in a group of paintings done in the mid-1950s. *New York Waterfront Drawing for Canvas* (Collection Earl Davis) was based on the 1938 painting *New York Waterfront* (Albright-Knox Art Gallery, Buffalo, New York); *Park Row*, a 1953 gouache (fig. 70), became the source of *Municipal*; and the 1956 gouache on paper *Waterfront* (Private collection) was the source for *Anyside*.

Both *Municipal* and *Anyside* demonstrate Davis's primary interest in working with "large planes of unmodulated color. . . ."[1] The consistently opaque quality of the planes in *Municipal* becomes a visual pairing of similar flat elements and a section of black-and-white architectural detailing and street vignettes in *Anyside*. As in the earlier *Memo* (cat. no. 120), in *Municipal* Davis uses black and white lines of varying thicknesses to compete with the optical effects of the color areas, most pronouncedly in a passage that corresponds to a view of the Municipal Building, across from New York's City Hall, which gives its name to this painting. While *Municipal* lacks perspectival elements, *Anyside* is characterized by the diagonally oriented planes that flank the composition on either side and lead back into space. This device is a familiar one in Davis's work, having been employed as early as 1910 in *Consumers Coal Co.* (cat. no. 1; fig. 16). In *Anyside*, again, green, black, red, and yellow shapes are contrasted with the white-and-black "phantom" scene off-center to the left, which serves to activate the other white areas in the composition. As was the artist's wont during this period, the scene is overlaid with a panoply of symbols and flourishes, some serving a more specific iconographic role than others.

LSS

[1] Bruce Weber. *Stuart Davis' New York* (exhib. cat.). West Palm Beach: Norton Gallery and School of Art, 1985, p. 17.

167

Untitled (Black-and-White Variation on "Pochade").
About 1958–60

Casein on canvas, 45 × 56 in. (114.3 × 142.2 cm.)
Collection Earl Davis. Courtesy of Salander-O'Reilly Galleries, New York

Letter and His Ecol. 1962

Oil on canvas, 24 × 30¼ in. (61 × 76.8 cm.)

The Pennsylvania Academy of the Fine Arts, Philadelphia.
John Lambert Fund

169

170

**Letter and His Ecol (Black-and-White
Version No. 1).** About 1962–64

Casein on canvas, 24 × 30 in. (61 × 76.2 cm.)

Collection Earl Davis. Courtesy of Salander-O'Reilly Galleries,
New York

**Letter and His Ecol (Black-and-White
Version No. 2).** About 1962–64

Casein on canvas, 24 × 30 in. (61 × 76.2 cm.)

Collection Earl Davis. Courtesy of Salander-O'Reilly Galleries,
New York

Stuart Davis's characteristically Yankee temperament shied away from any expressionistic manifestations in art: "Expressionism . . . fails in its Purpose of Spontaneity because it omits the reality of Logic as a prime tool of the act of Perception. A Tool which is integral and simultaneous to Perception."[1] As Brian O'Doherty observed, Davis's approach to his work was "elusive . . . personal but impersonal, spontaneous but classic, slangy but articulating impeccably. To hear it, however, one must tinker with those engines, those objects which Davis so carefully assembled."[2] *Letter and His Ecol* is a composition in which Davis gathered some of those "objects." It is replete with academic references, which seems contrary to Davis's longtime association with anti-academic circles in the art world. One wonders if he were not feeling more like an academic in the presence of the younger generation of artists. The progression of art styles was speeding up. Whereas Davis and the American Abstract Artists held sway on the art scene for over twenty years, between 1950 and 1962 Abstract Expressionism was already giving way to the Minimalists and the Color Field and Pop artists.

At the top center of this composition is a black orb containing the first few letters of the words *Institut* and *École*. The rest of the composition is a distinctive roster of the more vaguely defined symbols in Davis's work. The omnipresent ANY appears in the lower right, and diagonally opposite, in the upper left, we find the *X* that promises to guide our way through the composition with its elongated, pointed arm. Next to this the artist's signature writhes in static frenzy. Because of the organization of the elements into irregular registers, this composition conveys a more "pedantic" quality when compared with *Standard Brand* or *Unfinished Business* (cat. nos. 163, 171), which share a similar horizontal-vertical orientation. The symbols, while evocative of those Davis previously presented in his work, seem to have a more exclusively visual function here. As Davis notes, in his inimitable jargon: "Letters LOCK Scale / Letters LOCK Color. Letters [establish] Front-Back. . . ."[3]

Davis created a relatively lively alternation of red, green, yellow, and black, both in sections of the background and in graphic elements, as well as in portions of the shapes in the foreground. The complexity of the color-space scheme in *Letter and His Ecol* is captured in the two black-and-white versions that Davis did as studies afterward. In these, the disposition of the symbolic elements as hieroglyphs is more evident. Davis also varied the thickness of the lines in the two versions. Earlier, he had considered the potentiality of line to suggest color and tone: "A basic Absolute of a Black & White Line Drawing is its TONE in which all Figures in its total configuration are Equally Visible."[4] Davis had been making black-and-white renderings after select compositions since 1950. *Untitled (Black-and-White Variation on "Pochade")* is another example. In most cases Davis reprised the original composition, highlighting the clarity of the drawing, which he felt was the basis of any good painting. In his variation on *Pochade* (1958; Thyssen-Bornemisza Collection, Lugano), Davis focused on the lower center and the lower-right quadrant of the painting. As in the case of *Letter and His Ecol*, Davis did a second black-and-white version of *Pochade* in which the thickness of the lines was varied. The result is that each painting has "its own mood and feel; it is a kind of *tour de force* for Davis, demonstrating just how different two pictures which are ostensibly the same could be."[5]

LSS

[1] Brian O'Doherty, *American Masters: The Voice and the Myth*. 2nd ed. New York: Universe Books, 1988, p. 74.

[2] Ibid.

[3] Stuart Davis Papers, February 5, 1962. Harvard University Art Museums, Fogg Art Museum, Cambridge, Massachusetts.

[4] Ibid., September 15, 1956.

[5] *Stuart Davis (1892–1964), Black and White* (exhib. cat.). Essay by Karen Wilkin; notes by William C. Agee. New York: Salander-O'Reilly Galleries, 1985, no. 6, n.p.

171

Unfinished Business. 1962

Oil on canvas, 36 × 45 in. (91.4 × 114.3 cm.)
The William H. Lane Collection

Stuart Davis based this 1962 composition, as noted, on the central panel of his 1955 mural *Allée* (cat. no. 156), and included the twin-peaked form with the checkerboard appendage and the *X* to its upper left. He rendered segments of these forms in red, black, and green, and placed them against a yellow background. Words such as the recurring PAD fill the right-hand section; just opposite, an *N* and several *O*'s join the *X* and *C* forms. The entire composition is then framed in red.

The emphasis on diagonals creates a more dramatic perspectival space, causing the forms to appear to shift back and forth. Davis addressed this type of formal strategy at various times in his notebooks. An entry on October 3, 1954, reads: "A Figure is Given an Intuitive Percept of a position in relation to Previous Coordinates." These coordinates, in turn, have to be "consciously established" to guarantee the integrity of the composition. Davis uses the "previous coordinates" of the motif from *Allée* as his jumping-off point, ensuring that this new work will be a successful composition. This approach parallels Davis's earlier interest in the Golden Section (see cat. no. 60). In 1956, Davis addressed the role of color in relation to spatial placement in his works of the 1940s: "The Tangibility of an Area always includes . . . its Coordinate as well as its Shape. Naturally, this Front-Back position is dialectical."[1] Subsequently, on a drawing/diagram related to *Unfinished Business*, he wrote: "Art is an elegant Diary of Empty Words in Visual Grammar and Syntax to celebrate the fact of Life . . . in daily experience as an observation. . . ."[2] Davis reiterated his idea that a painting is an arena of "real" space, as he did with the concept of the Pad paintings. The daily experience Davis refers to is implicit in the cumulative evidence of his work—in his choice of subject matter and its references and analogies. The title *Unfinished Business* suggests a note of dissatisfaction, even urgency, on Davis's part over the fact that he may not have quite reached the conclusion of his artistic quest. That he ultimately did may have been signaled in the blunt positioning of the word FIN in his last work (see cat. no. 175).

LSS

[1] Stuart Davis Papers, June 8, 1956. Harvard University Art Museums, Fogg Art Museum, Cambridge, Massachusetts.

[2] Ibid.

Evening in Istanbul. 1961

Oil on canvas, 14 × 18 in. (35.6 × 45.7 cm.)

Collection Samuel and Francine Klagsbrun

On Location. 1963

Casein and pencil on paper, 8⅜ × 11⅝ in. (21.3 × 29.5 cm.)

Collection Earl Davis. Courtesy of Salander-O'Reilly Galleries, New York

Punch Card Flutter. 1963

Oil on canvas, 24 × 33 in. (61 × 83.8 cm.)

Collection Earl Davis. Courtesy of Salander-O'Reilly Galleries,
New York

Fin (Last Painting). 1964

Oil, casein, wax emulsion, and masking tape on canvas,
55⅞ × 39¾ in. (141.9 × 101 cm.)

Collection Earl Davis. Courtesy of Salander-O'Reilly Galleries,
New York

These four compositions (cat. nos. 172–175) represent the culmination of the play
on themes and variations in Stuart Davis's work. The source of the compositions is
a newspaper photograph of a château in France (see fig. 76). *On Location* and *Punch
Card Flutter* capture the essence of the photograph, showing the tree in the center
and the geometric forms of the medieval architecture of the château. *Evening in
Istanbul* is a detail view derived from the peculiar configurations of the tree seen in
the 1960 gouache *Château* and the 1961 painting *Twilight in Turkey* (figs. 79, 83).
Given the fact that Davis had been successful reviewing and revitalizing composi-
tions from earlier in his career, these penultimate creations interject a new theme
at a point when one would expect the artist to be resting on his laurels. Davis him-
self noted: "Punch Card Flutter Erases Cliché Subject."[1] The jagged, jigsaw nature
of this composition is comparable to that of *Letter and His Ecol* (cat. no. 168), al-
though both mark a return to a more picturesque narrative mode. Davis shifts the
color relationships in *On Location* to their chromatic complements in *Punch Card
Flutter*. The black background becomes white, thus opening up the space and even
suggesting a daylight-versus-night contrast. The tree changes from yellow with

white foliage to black with yellow, and the area to the upper left assumes the erratic contours of computer punch cards.

Fin is the painting that was left on Davis's easel when he died. The composition is an adaptation of that of *On Location* and *Punch Card Flutter*, this time rotated ninety degrees, so that the top edges become the right side. The forms are flatter and looser. Some sections are more mat in character, and other areas are laid out broadly in casein. The background, which has been divided into two by the tree, is red on the top and yellow on the bottom, and the architecture here is a white block. Masking tape is still adhered to the surface, marking the canvas off into sections that define the limits for the words, and establishing the sizes of the letters in accordance with the needs of the composition. The fact that Davis actually painted on black lines that seem to function in tandem with the strips of tape raises the question of his intention, as well as the extent to which this painting is to be considered finished. However, the eloquent FIN in the upper-left corner seems to answer this question.

LSS

[1] Stuart Davis Papers, May 22, 1963. Harvard University Art Museums, Fogg Art Museum, Cambridge, Massachusetts.

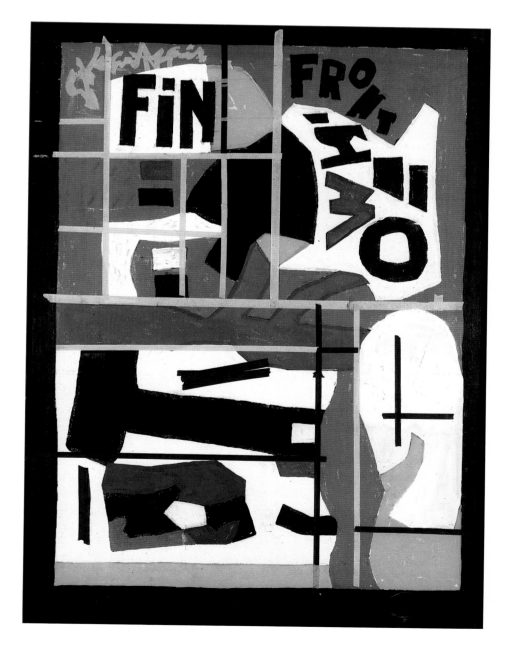

Chronology

1892

December 7: Stuart Davis is born in Philadelphia to Edward Wyatt Davis and Helen Stuart Davis (née Foulke). His father is art editor of the *Philadelphia Press*, to which John Sloan, William Glackens, George Luks, and Everett Shinn contribute drawings during the 1890s. His mother is a sculptor.

1901

The Davis family moves to East Orange, New Jersey, when Edward Davis becomes art editor and cartoonist at the *Newark Evening News*; he later works at *Judge* and *Leslie's Weekly*. Summers are spent in Avon and Belmar, New Jersey.

1906

February 14: Birth of his only brother, Wyatt Davis.

1908

Enters East Orange High School.

1909

Fall: Leaves high school to study with painter Robert Henri at the Robert Henri School of Art, 1947 Broadway, New York.

1910

The Davis family moves to Newark, New Jersey. Davis shares an apartment on James Street in Newark with two young men.

April 1–30: His work is shown for the first time in the "Exhibition of Independent Artists," 29 West Thirty-fifth Street, New York.

1911–12

Lives in Newark while attending the Henri School in New York.

1912

Leaves the Henri School. Establishes a studio with Henry Glintenkamp in the Terminal Building, Hudson Street, Hoboken, New Jersey. Ends formal education.

Fall: Begins working for *The Masses*.

1913

February 17–March 15: Shows five watercolors in the "International Exhibition of Modern Art," Sixty-ninth Regiment Armory, New York, and in Chicago. Summers in Provincetown, Massachusetts. Establishes a studio with Henry Glintenkamp and Glenn Coleman in the Lincoln Arcade, at 1931 Broadway, New York. Joins the staff of *The Masses*, producing covers and drawings for art editor John Sloan. Does cartoons for *Harper's Weekly*.

1914

Summers in Provincetown.

1915

At the suggestion of John Sloan, summers in Gloucester, Massachusetts (returns almost annually until 1934).

1916

Resigns from *The Masses* after an argument over editorial policy. Exhibits with the Society of Independent Artists.

1917

December: First solo exhibition, "Stuart Davis: Watercolors and Drawings," at the Sheridan Square Gallery, New York.

1918

Serves in World War I as a cartographer in the United States Army Intelligence department, preparing materials for the peace conference.

1919

Occupies an apartment on Greenwich Avenue in New York. Stays and paints at a family summer place in Tioga, Pennsylvania.

Fall: Goes to Gloucester, where he executes several landscapes.

December 26: Travels with Glenn Coleman to Cuba, remaining for about two months.

1920

William Carlos Williams selects an untitled

1916 drawing by Davis of Gloucester for the frontispiece of his book of poems *Kora in Hell: Improvisations*. Davis contributes a drawing to the *Little Review* 7 (July–August 1920) to accompany the first publication of "Nausicaa," a section of James Joyce's *Ulysses*.

1921

Begins Tobacco still-life series and series of Cubist landscapes. Executes a group of collages.

April: Exhibition, "Stuart Davis, Joaquín Torres-García, Stanislaw Szukalski," held at The Whitney Studio Club, New York.

1922

The Davis family moves to 356 West Twenty-second Street, New York. Davis contributes still-life and portrait drawings to *The Dial* (continues into 1923). Paints Cubist still-life series.

1923

Spends the summer painting in Santa Fe, New Mexico, with his brother, Wyatt, and John and Dolly Sloan.

1925

By the mid-1920s, the Davis family acquires a house at 51 Mount Pleasant Avenue, Gloucester, where Davis maintains a studio.

February: First solo museum exhibition at The Newark Museum.

1926

December: Retrospective exhibition at The Whitney Studio Club, New York.

1927

Edith Gregor Halpert of The Downtown Gallery, 113 West Thirteenth Street, New York, becomes his dealer, and presents the first of his eleven one-person shows, "Stuart Davis Exhibition: Recent Paintings, Watercolors, Drawings, Tempera." Davis begins the Egg Beater series.

February: His work is included in the

Société Anonyme show at the Barbizon.

April: Two-person exhibition with Glenn Coleman at the Valentine Gallery, New York.

1928

May: Juliana Force of The Whitney Studio Club purchases two of his paintings, enabling Davis to go to Paris.

June: Sets up a studio at 50, rue Vercingétorix, Paris, where he paints and makes a series of lithographs.

Fall: Does a cover for *transition* 14 (Fall 1928), a magazine founded in Paris by Elliot Paul and Eugène Iolas.

October: His work is included in "Paris by Americans" at The Downtown Gallery, New York.

1929

Marries Bessie Chosak, a native of Brooklyn, in Paris.

Late August: Returns to New York. Lives and works in Greenwich Village in an apartment at Thirteenth Street and Seventh Avenue. Spends late summer in Gloucester. John Graham introduces Davis to Arshile Gorky. Solo exhibition of watercolors at the Whitney Studio Galleries, New York.

1930

Solo exhibition, "Hotels and Cafés," at The Downtown Gallery, New York.

1931

Teaches at the Art Students League of New York (through 1932). Makes a series of lithographs. Lives and works in an apartment near St. Mark's Place, New York. Paints the New York—Paris series.

1932

May: Contributes to the mural exhibition at The Museum of Modern Art, New York.

June 15 Bessie Chosak Davis dies. Davis is commissioned by Donald Deskey to paint the mural *Men without Women* for the men's lounge at Radio City Music Hall, New York.

November: His work is shown in the "First Biennial of Contemporary American Painting" at the Whitney Museum of American Art, New York.

1933

Davis's family moves to the Chelsea Hotel, 222 West Twenty-third Street, New York. He takes a room above Romany Marie's restaurant on Eighth Street.

December: Joins the Public Works of Art Project (which is incorporated into the Works Progress Administration, or WPA, in 1935).

1934

Joins the Artists' Union and is soon elected president. Enrolls in the Emergency Relief Bureau for Artists. Davis's designs for printed linens to be used for dress fabrics are

exhibited in a Downtown Gallery group show "Practical Manifestations in American Art," along with paintings and drawings. Shares the top floor of a building at Fourteenth Street and Eighth Avenue with his brother and sister-in-law. Meets Roselle Springer.

July: Moves into a studio and apartment at 43 Seventh Avenue (remains there until 1955).

1935

January: Becomes editor of *Art Front*, published by the Artists' Union (serves until January 1936).

February: His work is included in "Abstract Painting in America" at the Whitney Museum of American Art, New York. Enrolls in the Works Progress Administration Federal Art Project.

March: Participates in the exhibition "Modern American Art in Modern Room Settings" at the Modernage Furniture Company, New York.

1936

Becomes a charter member of the American Artists Congress and is elected executive secretary. Terminates relationship with The Downtown Gallery. Belongs to various political and art-oriented organizations, including the John Reed Club; the American Painters, Sculptors and Gravers Society; the Co-ordination Council; the Mural Artists Guild; the American Group; and the Artists Committee for Action.

1937

Designs a book jacket for *Concert Pitch*, a novel by Elliot Paul that would be published by Random House in 1938. Is elected national chairman of the American Artists Congress. Begins work on his first WPA mural, *Swing Landscape* (now installed at Indiana University, Bloomington), for the Williamsburg Federal Housing Project, Brooklyn, New York.

1938

February 25: Marries Roselle Springer in Maryland.

May: Completes *Swing Landscape*.

1939

Completes *History of Communications*, a mural (subsequently destroyed) for the Hall of Communications at the New York World's Fair. The WPA sponsors Davis's *Mural for Studio B, WNYC, Municipal Broadcasting Company*, executed for the radio station of the Municipal Broadcasting Corporation. Makes three color prints for the Graphic Arts Division of the WPA. Leaves the WPA.

February: Exhibition, "Stuart Davis: Paintings," held at the Katharine Kuh Gallery, Chicago.

1940

Resigns from the American Artists Congress. Teaches at the New School for Social Research, New York (through 1950).

1941

Rejoins The Downtown Gallery, now at 43 East Fifty-first Street, New York (has one-person shows in 1943, 1946, 1954, 1956, 1958, 1960, and 1962). Retrospective exhibitions with Marsden Hartley are held at Indiana University and the Cincinnati Modern Art Society.

1942

A rug design, *Flying Carpet*, is commissioned by The Museum of Modern Art, New York, for a special exhibition of rugs designed by ten American painters (the rugs are hand-woven at V'Soske Inc.).

April: His work is included in "Masters of Abstract Art" at Helena Rubinstein's New Art Center, New York.

December: Participates in the "Artists for Victory" exhibition at The Metropolitan Museum of Art, New York.

1944

The Terminal of 1937 wins first prize in the "Portrait of America" exhibition sponsored by Pepsi-Cola; the painting is reproduced on 600,000 1945 Pepsi-Cola calendars as the illustration for January. *Arboretum by Flashbulb* wins honorable mention at the "International Exhibition," Carnegie Institute, Pittsburgh. Meets Edith and Milton Lowenthal, who purchase *Report from Rockport* and become important collectors of Davis's work.

1945

March: Included in "Four Modern American Painters" at the Institute of Contemporary Art, Boston.

October 17: Retrospective exhibition at The Museum of Modern Art, New York. Wins the J. Henry Schiedt Memorial Prize in the "140th Annual Exhibition" at The Pennsylvania Academy of the Fine Arts, Philadelphia.

1946

A book on Davis is included in a series of pocket-sized volumes on leading contemporary American artists published by the American Artists Group, for which each artist supplied a foreword about his work. Wins the Norman Wait Harris Bronze Medal and three hundred dollars in the "Fifty-seventh Annual American Exhibition of Watercolors and Drawings" at The Art Institute of Chicago. Participates in the American painting exhibition at the Tate Gallery, London. Executes a painting for a Container Corporation of America advertisement published in *Time* magazine September 16, and in *Fortune* magazine in October. His work is included in the

exhibition "Advancing American Art" cir-culated by the United States Information Agency.

1947

Wins the Hallowell Prize at the St. Botolph Club, Boston.

1948

Look magazine includes Davis in a list of the ten best painters in America, based on a poll of museum directors and critics. Wins the Second Purchase Prize in the LaTausca Pearls exhibition at the Riverside Museum, New York.

1949

The Castleton China company reproduces a Davis drawing in the collection of The Museum of Modern Art, New York, on a new line of china.

1950

Wins the John Barton Payne Medal and Purchase Prize for *Little Giant Still Life* in the "Seventh Virginia Biennial Exhibition" at the Virginia Museum of Fine Arts, Richmond.

1951

Serves as visiting art instructor at Yale University, New Haven.

January: Participates in the "Abstract Painting and Sculpture in America" exhibition at The Museum of Modern Art, New York.

October: His work is shown in the "1 Bienal de São Paulo" at the Museu de Arte Moderna, São Paulo. Wins the Ada S. Garrett Prize in the "60th Annual American Exhibition: Paintings and Sculpture" at The Art Institute of Chicago.

1952

Wins a John Simon Guggenheim Memorial Foundation fellowship.

March: Does a cover for *Art Digest*.

April 17: Son, George Earl Davis, is born.

June 14: Solo exhibition opens at the American Pavilion, XXVI Biennale, Venice.

1953

William H. Lane (who will become the major private collector of Davis's work) purchases his first Davis pictures, *Rurales No. 2, Cuba* of 1920 and *Egg Beater No. 3* of 1928.

1954

Becomes a member of the directing faculty of the Famous Artists School, Westport, Connecticut (until 1964).

1955

Moves to a studio and apartment at 15 West Sixty-seventh Street, New York. Designs a jacket for a recording of chamber music by Charles Ives for Columbia Records. Executes the mural *Allée* for Drake University, Des Moines, Iowa.

1956

Elected to the National Institute of Arts and Letters. Work is included in the XXVII Biennale, Venice. Wins honorable mention in the "151st Annual Exhibition" at The Pennsylvania Academy of the Fine Arts, Philadelphia.

1957

March 30: Retrospective exhibition opens at the Walker Art Center, Minneapolis, and travels to Des Moines, San Francisco, and New York.

Included in the exhibition "New Mexico as painted by Stuart Davis, Marsden Hartley, Yasuo Kuniyoshi, John Marin, Georgia O'Keeffe, John Sloan" at The Downtown Gallery, New York. Executes the mural *Composition Concrete* for the H. J. Heinz Research Center, Pittsburgh. Wins the Brandeis University Fine Arts Award for Painting.

1958

Participates in the "Primera Bienal Interamericana de Pintura y Gravado" in Mexico. Wins The Solomon R. Guggenheim Museum International Award.

1959

His work is included in "American Painting and Sculpture" in Moscow, a traveling exhibition organized by the United States Information Agency.

1960

Wins The Solomon R. Guggenheim Museum International Award a second time.

1961

Wins The Art Institute of Chicago Witkow-sky Cash Prize.

1962

Wins the American Institute of Architects Fine Arts Gold Medal.

April: Show, "Stuart Davis: Exhibition of Recent Paintings, 1958–1962," held at The Downtown Gallery, New York.

1964

Wins the Mr. and Mrs. Frank G. Logan Medal and Prize in the "Sixty-seventh Annual American Exhibition: Directions in Contemporary Painting and Sculpture" at The Art Institute of Chicago. Wins The Art Institute of Chicago Joseph E. Temple Gold Medal and Prize, and a gold medal from The Pennsylvania Academy of the Fine Arts, Philadelphia, for *Letter and His Ecol*.

June 24: Dies of a stroke in New York.

December: The United States Post Office issues a commemorative stamp designed by Davis honoring the fine arts.

Bibliography

BY THE ARTIST

Articles, Interviews, Statements, and Other Writings by Stuart Davis

In Chronological Sequence

Note: Many of the writings included here have been reprinted, or published for the first time, in *Stuart Davis*, edited by Diane Kelder. Documentary Monographs in Modern Art. New York, Washington, and London: Praeger, 1971.

"A Painter of City Streets: An Analysis of the Work of Glenn Coleman." *Shadowland* 8, 6 (August 1923), pp. 10–11, 75. Reprinted in *Stuart Davis*, edited by Diane Kelder, pp. 173–75. Documentary Monographs in Modern Art. New York, Washington, and London: Praeger, 1971.

"Dear Mr. McBride." *Creative Art* 6 (February 1930), suppl. pp. 34–35. Reprinted in *Stuart Davis*, edited by Diane Kelder, pp. 109–10. Documentary Monographs in Modern Art. New York, Washington, and London: Praeger, 1971. [Letter on the French influence on Davis's paintings.]

"Davis Translates His Art Into Words." *The Art Digest* 5, 14 (April 15, 1931), p. 8.

"Self-Interview." *Creative Art* 9 (September 1931), pp. 208–11.

"Introduction." In *Recent Painting in Oil and Watercolor* (exhib. pamphlet). New York: The Downtown Gallery, 1931. Reprinted in *Stuart Davis*, edited by Diane Kelder, p. 111. Documentary Monographs in Modern Art. New York, Washington, and London: Praeger, 1971.

"American Scene." *The Art Digest* 6, 12 (March 15, 1932), p. 16.

Introduction. In *Glenn O. Coleman: Memorial Exhibition* (exhib. brochure), pp. 6–7. New York: Whitney Museum of American Art, 1932.

"Letters from Our Friends—Stuart Davis." *Art Front* 1, 1 (November 1934), p. 2. Reprinted in *Stuart Davis*, edited by Diane Kelder, p. 151. Documentary Monographs in Modern Art. New York, Washington, and London: Praeger, 1971.

"Paintings by Salvador Dali: Julien Levy Gallery." *Art Front* 1, 2 (January 1935), p. 7. Reprinted in *Stuart Davis*, edited by Diane Kelder, pp. 175–76. Documentary Monographs in Modern Art. New York, Washington, and London: Praeger, 1971.

"The New York American Scene in Art." *Art Front* 1, 3 (February 1935), p. 6. Reprinted in *Stuart Davis*, edited by Diane Kelder, pp. 151–54. Documentary Monographs in Modern Art. New York, Washington, and London: Praeger, 1971.
Thomas Hart Benton's rejoinder: "On the American Scene." *Art Front* 1, 4 (April 1935), pp. 4, 8.

"Davis's Rejoinder [to Thomas Hart Benton]." *The Art Digest* 9, 13 (April 1, 1935), pp. 12, 13, 26–27.

"A Medium of Two Dimensions." *Art Front* 1, 5 (May 1935), p. 6. Reprinted in *Stuart Davis*, edited by Diane Kelder, pp. 114–16. Documentary Monographs in Modern Art. New York, Washington, and London: Praeger, 1971.

"The Artist Today: The Standpoint of the Artists' Union." *American Magazine of Art* 28 (August 1935), pp. 476–78, 506.

"Some Chance!" *Art Front* 1, 7 (November 1935), pp. 4, 7. Reprinted in *Stuart Davis*, edited by Diane Kelder, pp. 154–58. Documentary Monographs in Modern Art. New York, Washington, and London: Praeger, 1971.

"The American Artists' Congress." *Art Front* 2, 8 (December 1935), p. 8.

"Introduction." In *Abstract Painting in America* (exhib. cat.). New York: Whitney Museum of American Art, 1935. Reprinted as "Abstract Painting in America." *Art of Today* 6, 3 (April 1935), pp. 9–10. Reprinted in *Readings in American Art Since 1900: A Documentary Survey*, edited by Barbara Rose, pp. 124–25. Praeger World of Art Series. New York and Washington: Praeger, 1968. Reprinted in *Stuart Davis*, edited by Diane Kelder, pp. 112–14. Documentary Monographs in Modern Art. New York, Washington, and London: Praeger, 1971.

"Thanks, All of You!" *The Art Digest* 10, 12 (March 15, 1936), pp. 25–26. [Rejoinder to Peyton Boswell, Jr., "Some Comments on the News of Art" (editorial). *The Art Digest* 10, 11 (March 1, 1936), pp. 3–4, 19.]

"Opinions Under Postage: American Artists' Congress Apparently Wants Project Unreservedly Praised." *The New York Times*, September 27, 1936, sect. 10, p. 9. [Letter objecting to Edward Alden Jewell's criticism of Federal Art Project exhibition at The Museum of Modern Art, New York.]

"Why an Artists' Congress?" In *Stuart Davis*, edited by Diane Kelder, pp. 158–62. Documentary Monographs in Modern Art. New York, Washington, and London: Praeger, 1971. [Papers from First American Artists' Congress, New York, 1936, pp. 3–6.]

"The Artists' Congress and American Art." In *Second Annual Membership Exhibition* (exhib. cat.). New York: American Artists Congress, 1938.

"Federal Art Project and the Social Education of the Artist (ca. 1938)." In *Stuart Davis*, edited by Diane Kelder, pp. 162–65. Documentary Monographs in Modern Art. New York, Washington, and London: Praeger, 1971.

"Letters to the Editors: Art at the Fair." *The Nation* 149 (July 22, 1939), p. 112.

"Opinions Under Postage: Abstraction." *The New York Times*, August 20, 1939, sect. 9, p. 7.

"Art and the Masses." *The Art Digest* 14, 1 (October 1, 1939), pp. 13, 34.

"Abstraction Is Realism: So Asserts Stuart Davis in New Letter on Non-Objective Art Controversy." *The New York Times*, October 8, 1939, sect. 9, p. 10.

Foreword. In *Hananiah Harari* (exhib. pamphlet). New York: Mercury Galleries, 1939.

"Is There a Revolution in the Arts?" *Town Meeting: Bulletin of America's Town Meeting of the Air* 5 (February 19, 1940), pp. 11–14. Reprinted in *Stuart Davis*, edited by Diane Kelder, pp. 121–23. Documentary Monographs in Modern Art. New York, Washington, and London: Praeger, 1971. [Radio broadcast from Town Hall, New York, NBC, February 15, 1940.]

"Opinions Under Postage: Stuart Davis Explains His Resignation from Artists Congress." *The New York Times*, April 14, 1940, sect. 9, p. 9.

"Davis Asks a Free Art" [letter to the editor]. *The New York Times*, July 7, 1940, sect. 9, p. 12.

"Stuart Davis." *Parnassus* 12 (December 1940), p. 6. [Includes the artist's commentary on his painting *Hot Still-Scape for Six Colors —Seventh Avenue Style*.]

"Abstract Painting Today (1940)." In *Stuart Davis*, edited by Diane Kelder, pp. 116–21. Documentary Monographs in Modern Art. New York, Washington, and London: Praeger, 1971. [Previously unpublished article commissioned by Art for the Millions, 1940.]

"Abstract Art in the American Scene." *Parnassus* 13 (March 1941), pp. 100–103. Reprinted in *Stuart Davis*, edited by Diane Kelder, pp. 123–28. Documentary Monographs in Modern Art. New York, Washington, and London: Praeger, 1971.

"The American Artist Now." *Now* 6, 1 (August 1941), pp. 7–11. Reprinted in *Stuart Davis*, edited by Diane Kelder, pp. 165–69. Documentary Monographs in Modern Art. New York, Washington, and London: Praeger, 1971.

" 'Bombshell' Opinions." *The New York Times*, October 12, 1941, sect. 9, p. 9. [Response to a communication by Samuel Kootz.]

"Foreword." New York: Pinacotheca, 1941. [Leaflet published by *The Pinacotheca*, December 1941.]

"Art in Painting." In *Marsden Hartley, Stuart Davis* (exhib. cat.). Introduction by Peggy Frank. Cincinnati: Cincinnati Modern Art Society, 1941.

"Eggbeater Series (1941)." In *Stuart Davis*, edited by Diane Kelder, p. 99. Documentary Monographs in Modern Art. New York, Washington, and London: Praeger, 1971. [From a lecture, "How to Construct a Modern Easel Painting," given at The New School for

Social Research, New York, December 17, 1941.]

"Davis and 'Abstraction.' " *The New York Times*, September 27, 1942, sect. 8, p. 5. [Letter to Edward Alden Jewell denying that *Arboretum by Flashbulb* is an abstract painting.]

"Art of the City." In *Masters of Abstract Art* (exhib. cat.), pp. 12–13. New York: Helena Rubinstein's New Art Center, 1942.

"Bass Rocks." In *Contemporary American Painters Series*. New York: Jack C. Rich, 1942. Reprinted in *Stuart Davis*, edited by Diane Kelder, pp. 99–100. Documentary Monographs in Modern Art. New York, Washington, and London: Praeger, 1971.

"The Cube Root." *Artnews* 41, 18 (February 1–14, 1943), pp. 22–23, 33–34. Reprinted in *Stuart Davis*, edited by Diane Kelder, pp. 128–31. Documentary Monographs in Modern Art. New York, Washington, and London: Praeger, 1971.

"What About Modern Art and Democracy? With Special Reference to George Biddle's Proposals." *Harper's Magazine* 188 (December 1943), pp. 19–20, 36. Reprinted in *Stuart Davis*, edited by Diane Kelder, pp. 131–42. Documentary Monographs in Modern Art. New York, Washington, and London: Praeger, 1971.

"The 'Modern Trend' in Painting." *Think* 11, 1 (January 1945), pp. 19–20, 36–37.

"The Digest Interviews: Stuart Davis." *The Art Digest* 20, 6 (December 15, 1945), p. 21. [Interview with Ben Wolf.] For correction, see *The Art Digest* 20, 7 (January 1, 1946), p. 23.

"Statement." In *Personal Statement: Painting Prophecy 1950* (exhib. pamphlet), unpaginated. Washington, D.C.: David Porter Gallery, 1945.

Stuart Davis. American Artists Group Monographs, 6. New York: American Artists Group, 1945. Reprinted as "Autobiography: Stuart Davis" in *Stuart Davis*, edited by Diane Kelder, pp. 19–30. Documentary Monographs in Modern Art. New York, Washington, and London: Praeger, 1971.

"Contrasts." *American Artist* 10, 4 (April 1946), pp. 34–35. [Comparison of paintings by Luigi Lucioni and Stuart Davis.]

Introduction. In *Gar Sparks* (exhib. pamphlet). New York: Julien Levy Gallery, 1946.

"Guernica—Picasso (1947)." In *Stuart Davis*, edited by Diane Kelder, pp. 176–78. Documentary Monographs in Modern Art. New York, Washington, and London: Praeger, 1971. [Paper written for a symposium on *Guernica* at The Museum of Modern Art, New York, November 25, 1947.]

Introduction. In *George Wettling* (exhib. brochure). New York: Norlyst Gallery, 1947.

"The Modern Artist Speaks." [Paper delivered at a symposium at The Museum of Modern Art, New York, May 5, 1948. Transcript in the Archives of American Art, Smithsonian Institution, Washington, D.C.]

Rivera, Diego, and Stuart Davis. "Two Famous Painters Fight the Battle of Abstract Art." *Look*, January 30, 1951, pp. 68–69.

"Arshile Gorky in the 1930's: A Personal Recollection." *Magazine of Art* 44 (February 1951), pp. 56–58. Reprinted in *Stuart Davis*, edited by Diane Kelder, pp. 178–83. Documentary Monographs in Modern Art. New York, Washington, and London: Praeger, 1971.

"Does Modern Art Make Sense?" *Town Meeting: Bulletin of America's Town Meeting of the Air* 16 (April 10, 1951), pp. 2–9. [Radio broadcast. George V. Denny, moderator; Thomas Hart Benton and Perry T. Rathbone, speakers.]

"What Abstract Art Means to Me: Statements by Six American Artists." *The Museum of Modern Art Bulletin* 18, 3 (Spring 1951), pp. 2–15. Stuart Davis's statement reprinted in *Stuart Davis*, edited by Diane Kelder, p. 142. Documentary Monographs in Modern Art. New York, Washington, and London: Praeger, 1971.

"Visa (1952)." In *Stuart Davis*, edited by Diane Kelder, pp. 100–102. Documentary Monographs in Modern Art. New York, Washington, and London: Praeger, 1971. [Statement written at the request of Alfred H. Barr, Jr., November 3, 1952.]

"Statement." In *Contemporary American Painting* (exhib. cat.), pp. 183–84. Urbana: University of Illinois, 1952.

"Recollections of the Whitney." [Radio broadcast for American Art Festival, WNYC, 1953. Transcript in the artist's file, Whitney Museum of American Art, New York.]

"Symposium: The Creative Process." *The Art Digest* 28, 8 (January 15, 1954), pp. 15–16, 30–32, 34.

"Something on the Eight Ball (1954)." In *Stuart Davis*, edited by Diane Kelder, pp. 103–4. Documentary Monographs in Modern Art. New York, Washington, and London: Praeger, 1971. [Memorandum to Henry Clifford, director of the Philadelphia Museum of Art.]

"The Place of Painting in Contemporary Culture: The Easel Is a Cool Spot at an Arena of Hot Events." *Artnews* 56, 4 (Summer 1957), pp. 29–30. Reprinted in *Stuart Davis*, edited by Diane Kelder, pp. 143–45. Documentary Monographs in Modern Art. New York, Washington, and London: Praeger, 1971. [Paper initially read at a panel discussion in Houston, April 4, 1957.]

"Handmaiden of Misery." *Saturday Review* 40 (December 28, 1957), pp. 16–17. Reprinted in *Stuart Davis*, edited by Diane Kelder, pp. 123–28. Documentary Monographs in Modern Art. New York, Washington, and London: Praeger, 1971. [Review of *Arshile Gorky* by Ethel K. Schwabacher.]

"Interview." In *Stuart Davis* (exhib. cat.), pp. 44–45. Minneapolis: Walker Art Center, 1957. Reprinted in *Stuart Davis*, edited by Diane Kelder, pp. 146–47. Documentary Monographs in Modern Art. New York, Washington, and London: Praeger, 1971.

"An Inquiry by the Editors of *Artnews*: Is Today's Artist with or against the Past?" *Artnews* 57, 4 (Summer 1958), pp. 26–29, 42–45, 55–58.

Davis, Stuart, et al. "Statements and Documents." *Daedalus* 89, 1 (Winter 1960), pp. 79–126.

"This Is My Favorite Painting." *Famous Artists Magazine* 9, 2 (Winter 1960), p. 12.

"Stuart Davis." In Katharine Kuh. *The Artist's Voice: Talks with Seventeen Artists*, pp. 52–67. New York and Evanston: Harper & Row, 1960. Reprinted in *Readings in American Art Since 1900: A Documentary Survey*, edited by Barbara Rose, pp. 125–26. Praeger World of Art Series. New York and Washington: Praeger, 1968. [Interview with Katharine Kuh.]

"Memo on Mondrian." *Arts Yearbook* 4 (1961), pp. 66–68. Reprinted in *Stuart Davis*, edited by Diane Kelder, pp. 183–86. Documentary Monographs in Modern Art. New York, Washington, and London: Praeger, 1971.

"Stuart Davis, 1894–1964: Last Interview." *Artnews* 63, 5 (September 1964), pp. 43, 56. [Interview with William Innes Homer.]

Davis, Earl, ed. *Stuart Davis Sketchbooks*. New York: Estate of Stuart Davis, Grace Borgenicht Gallery, and The Arts Publisher, Inc., 1986.

"Stuart Davis on Art and the Artist." Unidentified publication, pp. 32–45. [Deposited in the artist's file, Whitney Museum of American Art, New York.]

ABOUT THE ARTIST

Monographs and Publications Related to Solo Exhibitions

In Chronological Sequence

Retrospective Exhibition of Paintings by Stuart Davis (exhib. pamphlet). New York: The Whitney Studio Club, 1926.

Watercolors by Stuart Davis (exhib. pamphlet). New York: The Whitney Studio Club, 1929.

Stuart Davis: Hotels and Cafés (exhib. pamphlet). New York: The Downtown Gallery, 1930.

Stuart Davis (exhib. pamphlet). New York: The Downtown Gallery, 1931.

Stuart Davis (exhib. checklist). Philadelphia: Crillon Galleries, 1931.

Stuart Davis, The American Scene: Recent Paintings, New York and Gloucester (exhib. pamphlet). New York: The Downtown Gallery, 1932.

Stuart Davis: Recent Paintings, Oil and Watercolor (exhib. pamphlet). New York: The Downtown Gallery, 1934.

Stuart Davis: Selected Paintings (exhib. pamphlet). New York: The Downtown Gallery, 1943.

Sweeney, James Johnson. *Stuart Davis* (exhib. cat.). New York: The Museum of Modern Art, 1945. [Reviewed in *American Artist* 10, 4 (April 1946), p. 47.] Reprinted in *Three American Modernist Painters: Max Weber, Maurice Sterne and Stuart Davis*. New York: Arno Press for The Museum of Modern Art, 1969.

Stuart Davis: Retrospective Exhibition of Gouaches, Watercolors, and Drawings, 1912–1941 (exhib. pamphlet). New York: The Downtown Gallery, 1946.

Stuart Davis: Exhibition of Recent Paintings (exhib. pamphlet). New York: The Downtown Gallery, 1954.

Stuart Davis: Exhibition of Recent Paintings 1954–56 (exhib. pamphlet). New York: The Downtown Gallery, 1956.

Arnason, H. H. *Stuart Davis* (exhib. cat.). Minneapolis: Walker Art Center, 1957.

Goossen, E[ugene]. C. *Stuart Davis*. New York: George Braziller, 1959.

Blesh, Rudi. *Stuart Davis*. New York: Grove Press, 1960.

Stuart Davis: Exhibition of Ten of the Paintings Used as Color Illustrations in Stuart Davis by Rudi Blesh (exhib. pamphlet). New York: The Downtown Gallery, 1960.

Stuart Davis Memorial Exhibition (exhib. cat.). Essay by H. H. Arnason. Washington, D.C.: National Collection of Fine Arts, Smithsonian Institution, 1965.

Stuart Davis 1894–1964: Gedächtnis-ausstellung (exhib. cat.). Essay by Heinz Ohff. Berlin: Amerika-Haus, 1966.

Stuart Davis, 1894–1964 (exhib. cat.). Essay by H. H. Arnason. London: USIS, American Embassy, 1966.

Stuart Davis (exhib. cat.). Essay by H. H. Arnason. Paris: Musée d'Art Moderne de la Ville de Paris, 1966.

Kelder, Diane, ed. *Stuart Davis*. Documentary Monographs in Modern Art. New York, Washington, and London: Praeger, 1971.

Stuart Davis, Murals: An Exhibition of Related Studies, 1932–1957 (exhib. cat.). Essay by Beth Urdang. New York: Zabriskie Gallery, 1976.

Winkles, Loring N. "The Problem of European Influence in the Murals of Stuart Davis." Master's thesis, University of Cincinnati, 1977.

Lane, John R. *Stuart Davis: Art and Art Theory* (exhib. cat.). New York: The Brooklyn Museum, 1978.

Richards, Jane. "Introduction." In *Stuart Davis: The Hoboken Series* (exhib. cat.). New York: Hirschl & Adler Galleries, 1978.

Stuart Davis: Works on Paper (exhib. cat.). Introduction by Diane Kelder. New York: Grace Borgenicht Gallery, 1979.

Sims, Patterson. *Stuart Davis: A Concentration of Works from the Permanent Collection of the Whitney Museum of American Art* (exhib. cat.). New York: Whitney Museum of American Art, 1980.

Stuart Davis: Prints and Related Works (exhib. cat.). Foreword by Diane Kelder. New York: Staten Island Museum, 1980.

Stuart Davis: Still Life Paintings, 1922–24 (exhib. cat.). New York: Grace Borgenicht Gallery, 1980.

Kachur, Lewis. *Stuart Davis: The Formative Years, 1910–1930* (exhib. cat.). Manitowoc, Wisconsin: Rahr-West Museum, 1983.

Stuart Davis: Works from 1913–1919 (exhib. pamphlet). New York: Washburn Gallery, 1983.

Stuart Davis (1892–1964): Black and White (exhib. cat.). Essay by Karen Wilkin; notes by William C. Agee. New York: Salander-O'Reilly Galleries, Inc., 1985.

Weber, Bruce. *Stuart Davis' New York* (exhib. cat.). West Palm Beach, Florida: Norton Gallery and School of Art, 1985.

Davis, Earl, ed. *Stuart Davis Sketchbooks*. New York: Estate of Stuart Davis, Grace Borgenicht Gallery, and The Arts Publisher, Inc., 1986.

Myers, Jane, ed. *Stuart Davis: Graphic Work and Related Paintings, with a Catalogue Raisonné of the Prints*. Essay by Diane Kelder; catalogue raisonné by Sylvan Cole and Jane Myers. Fort Worth: Amon Carter Museum, 1986.

Stuart Davis: Provincetown and Gloucester Paintings and Drawings (exhib. pamphlet). New York: Grace Borgenicht Gallery, 1986.

Agee, William C. *Stuart Davis (1892–1964): The Breakthrough Years, 1922–1924* (exhib. cat.). New York: Salander-O'Reilly Galleries, Inc., 1987.

Kachur, Lewis. *Stuart Davis: An American in Paris* (exhib. cat.). New York: Whitney Museum of American Art at Philip Morris, 1987.

Wilkin, Karen. *Stuart Davis*. New York: Abbeville Press, 1987.

Stuart Davis (1892–1964): Motifs and Versions (exhib. cat.). Foreword by William C. Agee; introduction by Lawrence B. Salander; quotations from the artist edited by Karen Wilkin and Lori Potolsky. New York: Salander-O'Reilly Galleries, Inc., 1988

Roosa, Wayne L. "American Art Theory and Criticism During the 1930s: Thomas Craven, George L. K. Morris, Stuart Davis." Ph.D. diss., Rutgers–The State University of New Jersey, 1989.

Stuart Davis, Scapes: An Exhibition of Landscapes, Cityscapes and Seascapes Made Between 1910 and 1932 (exhib. cat.). Essay by Earl Davis. New York: Salander-O'Reilly Galleries, Inc., 1990.

Selected Articles Published in Periodicals

In Alphabetical Sequence

Ager, Cecelia. "Stuart Davis." *Vogue*, January 15, 1946, pp. 81, 126–27.

"The All-American." *Time*, March 15, 1954, p. 84.

"Americans in Paris." *New York Evening Post*, October 13, 1928.

"Art: Growth of an Abstractionist." *Time*, November 5, 1945, pp. 57–58.

"Art News of America: Awards and Honors." *Artnews* 49, 4 (Summer 1950), p. 9.

Ashbery, John. "Our Forgotten Modernists." *Newsweek* 104 (July 30, 1984), p. 84.

Ashton, Dore. "Forces in New York Painting 1950–1970." *Artscanada* 36, 4 (December 1979–January 1980), pp. 23–25.

Bailey, Weldon. "Exhibition of Paintings by Stuart Davis." *The Philadelphia Record*, December 13, 1931.

Bear, Donald. "Davis Work at Museum Evaluated." *Santa Barbara News Press*, August 7, 1949.

Bell, Jane. "Stuart Davis: 'The Thread of an Idea.' " *The Village Voice*, February 20, 1978, pp. 37, 83.

Benedikt, Michael. "New York Letter: Stuart Davis 1894–1964." *Art International* 9, 8 (November 20, 1965), p. 44.

Bennett, Charles G. "Davis Mural to Leave Its City Limbo." *The New York Times*, August 18, 1965, p. 44.

Berman, Greta. "Abstractions for Public Spaces, 1935–1943." *Arts Magazine* 56, 10 (June 1982), pp. 81–86.

"Big Art Exhibit Will Open Today: Newark Museum Association Has Unique Collection at Free Public Library." *Newark Star*, February 13, 1911.

"Blaring Harmony." *Time*, May 18, 1962, pp. 62, 67.

Bonte, C. H. "In Gallery and Studio: Stuart Davis Holding a One-Man Show at the Crillon Galleries." *The Philadelphia Inquirer*, December 13, 1931.

"Book Notes." *American Artist* 10, 4 (April 1946), pp. 46–47. [Review of *Stuart Davis* by James Johnson Sweeney.]

Boswell, Peyton, Jr. "Some Comments on the News of Art: Trying to Settle It." *The Art Digest* 10, 11 (March 1, 1936), pp. 3–4, 19.

———. "Comments: Painted Jazz." *The Art Digest* 17, 10 (February 15, 1943), p. 3.

Bourdon, David. "Stuart Davis: Mural." *Arts Magazine* 50, 6 (February 1976), pp. 60–61.

Bowdoin, W. G. "Modern Work of Stuart Davis at Village Show." *New York Evening World*, December 13, 1917.

Brenson, Michael. " 'Stuart Davis's New York': 80 Paintings and Drawings." *The New York Times*, January 31, 1986, p. C 32.

Breuning, Margaret. "Art World Events: Stuart Davis Exhibition Reveals Returning Two-Dimensional Pattern." *New York Evening Post*, May 7, 1934.

Burnett, Whit. " 'Egg Beater' Painter Led American Interpretive Art." *New York Herald*, July 7, 1929.

Burrows, Carlyle. "Stuart Davis Retrospective." *New York Herald-Tribune*, October 21, 1945.

Cahill, Holger. "Stuart Davis in Retrospect: 1945–1910." *Artnews* 44, 13 (October 15–31, 1945), pp. 24–25, 32.

Cary, Elizabeth Luther. "Americans Abroad." *The New York Times*, October 13, 1929, sect. 9, p. 12.

Coates, Robert M. "The Art Galleries." *The New Yorker*, February 13, 1943, p. 58. [Review of The Downtown Gallery exhibition.]

———. "The Art Galleries: One American, One French." *The New Yorker*, March 20, 1954, pp. 81–83.

———. "The Art Galleries: MacIver, Davis, and Corot." *The New Yorker*, November 17, 1956, pp. 229–32.

———. "The Art Galleries: Expressionismus über Alles." *The New Yorker*, October 19, 1957, pp. 120–23.

———. "The Art Galleries: Stuart Davis." *The New Yorker*, October 2, 1965, pp. 193–99.

"Collage: From Men's Room to MOMA." *Artnews* 74, 6 (Summer 1975), p. 150.

"Contrasts." *American Artist* 10, 4 (April 1946), pp. 34–35.

Cosnil, Michel-Louis. "Stuart Davis." *Informations et Documents* [Paris] 225 (March 1, 1966), pp. 40–45.

"Critics Laud Young Artist: Paintings of Stuart Davis, East Orange Youth, Well Received." *Newark Morning Ledger*, June 1, 1918, p. 3.

"Crossword-Puzzle Motif in Art Expressed on Canvas at Museum." *Newark Evening News*, February 9, 1925, suppl. p. 11.

"Davis' 'American Scene.' " *The Art Digest* 6, 12 (March 15, 1932), p. 16.

"Davis Translates His Art into Words." *The Art Digest* 5, 15 (April 15, 1931), p. 8.

Decker, Duane. "It's Jazz for Art's Sake." *Collier's*, August 11, 1951, pp. 38–39.

Deitcher, David. "Comic Connoisseurs." *Art in America* 72, 2 (February 1984), pp. 100–114.

de Kooning, Elaine. "Stuart Davis: True to Life." *Artnews* 56, 2 (April 1957), pp. 40–42, 54–55. Reprinted as "Stuart Davis: True to Life: The Consistent Invention of America's Pioneer Abstractionist Is Seen in His Retrospective at Minneapolis (1957)" in *Stuart Davis*, edited by Diane Kelder, pp. 197–200. Documentary Monographs in Modern Art. New York, Washington, and London: Praeger, 1971.

Devree, Howard. "Why They Paint the Way They Do: Leading American Artists Speak Their Minds Explaining Their Attitudes to Art and Life." *The New York Times Magazine*, February 17, 1946.

Doty, Robert. "The Articulation of American Abstraction." *Arts Magazine* 48, 2 (November 1973), pp. 47–49.

du B[ois], G[uy] P[ène]. "Stuart Davis." *Arts Weekly* 1, 3 (March 26, 1932), p. 48.

Eddleston, Babette. "Stuart Davis, a Fond Remembrance: A Former Student Recalls How His Class Was Conducted, How He Taught, and What She Learned." [Typescript in the artist's file, Whitney Museum of American Art, New York.]

"Editorial: Very Free Association." *The Art Digest* 26, 12 (March 15, 1952), cover, p. 5.

Elliott, James. "Premiere." *Los Angeles County Museum of Art Bulletin* 14, 3 (1962), cover, pp. 3–15. [Special issue devoted to the painting *Premiere*.]

"Esquire's Art Institute II." *Esquire* 24, 3 (September 1945), pp. 68–69.

Feinstein, Sam. "Stuart Davis: 'Always Jazz Music.' " *The Art Digest* 28, 11 (March 1, 1954), pp. 14, 24.

Fitzsimmons, James. "Americans from Venice." *The Art Digest* 27, 6 (December 15, 1952), pp. 16–17.

Geldzahler, Henry. "Stuart Davis." *Interview* 17 (December 1987), pp. 124–28. [Review of *Stuart Davis* by Karen Wilkin.]

Genauer, Emily. "Two Americans Give Solo Shows: Hartley and Davis Developed Since Exhibit of Thirty Years Ago." *New York World-Telegram*, February 6, 1943.

———. "Stuart Davis' Paintings Shown at Modern Museum." *New York World-Telegram*, October 20, 1945, p. 8.

———. "New Works at Modern Museum." *New York World-Telegram*, February 28, 1946.

Getlein, Frank. "Exhibit Honors Stuart Davis." *The Sunday Star* [Washington, D.C.], May 30, 1965, p. D 5.

Gibbs, Jo. "Stuart Davis Paints the Better Eggbeater." *The Art Digest* 20, 9 (February 1, 1946), p. 9.

Gilbert, Morris. "Eggbeater Artist Defends Credit to France for Help Given American Painters." *New York World-Telegram*, February 21, 1940, p. 13.

"Glintenkamp-Davis Studio to Move to New York City." *Inquirer* [New Jersey newspaper], September 21, 1913.

Glueck, Grace. "Art Notes: Legacy." *The New York Times*, December 13, 1964, p. 26.

Godsoe, Robert Ulrich. "The Art Marts." *Whitestone Herald*, May 3, 1934.

G[oodrich], L[loyd]. "In the Galleries." *The Arts* 16, 6 (February 1930), pp. 432, 434. [Review of The Downtown Gallery exhibition.]

———. "Rebirth of a National Collection." *Art in America* 53, 3 (June–July 1965), pp. 78–89. [Reprint of various statements by the artist.]

Gorky, Arshile. "Stuart Davis." *Creative Art* 9 (September 1931), pp. 212–17. Reprinted in *Stuart Davis*, edited by Diane Kelder, pp. 192–94. Documentary Monographs in Modern Art. New York, Washington, and London: Praeger, 1971.

Goslin, Mildred E. "The Modernist: A Few Impressions from Stuart Davis—One of Them." *The Breeze* [Manchester, Massachusetts], December 1932.

Greenberg, Clement. "Stuart Davis." *The Nation*, February 20, 1943, p. 284.

———. "Art." *The Nation*, November 17, 1945, p. 533. [Review of Stuart Davis retrospective at The Museum of Modern Art, New York.]

Hadler, Mona. "Jazz and the Visual Arts." *Arts Magazine* 57, 10 (June 1983), pp. 91–101.

Hamilton, George Heard. "Essays on Autumn Books: U.S. Art Begins to Get a Literature." *Artnews* 58, 6 (October 1959), pp. 43, 56–57. [Review of *Stuart Davis* by E. C. Goossen.]

Harris, Ruth Green. "Stuart Davis." *The New York Times*, January 26, 1930, sect. 8, p. 13.

Henry, Gerritt. "Reviews and Previews: Stuart Davis." *Artnews* 70, 2 (April 1971), p. 10.

H[ess], T[homas] B. "The Jazzy Formalism of Stuart Davis." *Artnews* 53, 1 (March 1954), pp. 19, 59–60.

Homer, William Innes. "Stuart Davis, 1894–1964: Last Interview." *Artnews* 63, 5 (September 1964), pp. 43, 56.

Hughes, Robert. "Stuart Davis: The City Boy's Eye: In Brooklyn, a Fresh View of a Major American Painter." *Time*, March 20, 1978, p. 65.

Jewell, Edward Alden. "Davis Tames a Shrew: How What Seemed 'Abstract' Proved 'Realistic.'" *The New York Times*, April 29, 1928, sect. 10, p. 18.

———. "Art in Review: Stuart Davis Offers a Penetrating Survey of the American Scene." *The New York Times*, March 10, 1932, p. 19.

———. "An Experiment by Artists—Other Events." *The New York Times*, December 16, 1934.

———. "'Practical' Artists Hold an Exhibition." *The New York Times*, December 18, 1934.

———. "On the Abstract Trail: Whitney Exhibition an Inventory of One Modernist Movement in America." *The New York Times*, February 17, 1935, sect. 8, p. 9.

———. "Art Under Democracy: Annual of American Artists Congress Raises Some Far-Reaching Questions." *The New York Times*, May 8, 1938, sect. 10, p. 7.

———. "Commentary on Murals." *The New York Times*, May 29, 1938, sect. 2, p. 2.

———. "Abstraction and Music: Newly Installed WPA Murals at Station WNYC Raise Anew Some Old Questions." *The New York Times*, August 6, 1939, sect. 9, p. 7.

———. "Mr. Davis, Ralph Earl and Others." *The New York Times*, October 21, 1945, sect. 2, p. 7.

Judd, Donald. "In the Galleries: Stuart Davis." *Arts Magazine* 36, 10 (September 1962), p. 44.

Kachur, Lewis. "Stuart Davis." *Arts Magazine* 53, 7 (March 1979), p. 23.

———. "Stuart Davis." *Arts Magazine* 55, 3 (November 1980), p. 2.

———. "Letter and His Ecol: A Few Words from Davis." [Unpublished abstract of talk submitted to the Whitney Museum of American Art, New York, 1981. Typescript in the museum's artist's file.]

———. "America's Argenteuil: Artists at Gloucester." *Arts Magazine* 56, 7 (March 1982), pp. 138–39.

———. "Stuart Davis and Bob Brown: *The Masses* to *The Paris Bit*." *Arts Magazine* 57, 2 (October 1982), pp. 70–73.

———. "Stuart Davis: A Classicist Eclipsed." *Art International* 4 (Autumn 1988), pp. 17–21.

Kainen, Jacob. "Historic Congress of Artists to Represent Finest Traditions of American Culture." *Sunday Worker*, February 9, 1936.

Kelder, Diane. "Stuart Davis: Pragmatist of American Modernism." *Art Journal* 39, 1 (Fall 1979), pp. 29–36.

Keyes, Donald D. "Stuart Davis: *Snow on the Hills*." *Georgia Museum of Art Bulletin* [Athens, Georgia] 12, 2 (Winter 1987), pp. 1–24.

Kimmelman, Michael. "Views of American Life in 'Urban and Suburban.'" *The New York Times*, April 8, 1988, sect. 3, p. 30.

———. "The Lean, Sharp Formalism of Stuart Davis." *The New York Times*, November 25, 1988, p. C 18.

Klein, Jerome. "Stuart Davis Criticizes Critic of Abstract Art: Painter Sees Lack of Sympathy in Review of Work by New Group." *The New York Post*, February 25, 1938, p. 24.

Knap, Ted. "Abstract Art Paints New Postal Stamp Era." *New York World-Telegram and Sun*, December 2, 1964, p. 37.

Knowlton, Walter. "Around the Galleries." *Creative Art* 8 (May 1931), p. 375.

Korner, Beatrice. "Unlimited Self-Expression—A Comment on Some Recent Paintings from the United States." *Canadian Art*, Spring 1950.

Kramer, Hilton. "Month in Review: Stuart Davis." *Arts Magazine* 31, 2 (November 1956), pp. 54–55.

———. "Critics of American Painting." *Arts Magazine* 34, 1 (October 1959), pp. 26–27, 29–30. [Review of *Stuart Davis* by E. C. Goossen.]

———. "Music Hall Mural Going to Museum." *The New York Times*, April 3, 1975, p. 39.

———. "Is a Museum the Only Place for Art?" *The New York Times*, April 13, 1975, p. D 29.

———. "Feast from the Mind's Eye of Stuart Davis." *The New York Times*, January 20, 1978, sect. 3, pp. 1, 18.

———. "Stuart Davis—Modernist and Thinker." *The New York Times*, January 29, 1978, sect. 2, p. 25.

———. "Art: Stuart Davis and William Bailey." *The New York Times*, January 12, 1979, sect. 3, p. 14.

———. "Art: Stuart Davis in His Pivotal Period." *The New York Times*, October 10, 1980, p. C 24.

————. "Art from Gloucester, the Bypassed Haven." *The New York Times*, February 5, 1982, p. C 23.

————. "An American Cubist: Rediscovering Stuart Davis." *Art & Antiques*, January 1988, pp. 93–94.

Lane, John R. "Stuart Davis and the Issue of Content in New York School Painting." *Arts Magazine* 52, 6 (February 1978), pp. 154–57.

"Largest Mural Work Ever Finished Here Goes to 'Roxy's,' N.Y." *Gloucester Daily Times* [Gloucester, Massachusetts], November 12, 1932.

Larson, Kay. "American Modern." *New York Magazine*, March 1, 1982, pp. 64–65.

Lidman, David. "The World of Stamps: Abstract Design Slated for Fine-Arts Issue." *The New York Times*, September 20, 1964, sect. 10, p. 27.

Loory, Stuart H. " 'Cat' by Stuart Davis: 'Pop' Art Comes to The White House." *Capital Times* [Madison, Wisconsin], January 8, 1988.

Loughery, John. "Stuart Davis' New York." *Arts Magazine* 60, 7 (March 1986), pp. 132–33.

Lucas, John. "The Fine Art Jive of Stuart Davis." *Arts Magazine* 31, 10 (September 1957), pp. 32–37.

Lynton, Norbert. "Things Seen: Painter of the American Scene." *The Times* [London], July 21, 1964, p. 7.

McBride, Henry. "Whitney Studio Club Opens an Exhibition." *New York Sunday Herald*, May 8, 1921.

————. "Stuart Davis Comes to Town: Downtown Exhibition of His Art Proves a Lively One." *The New York Sun*, April 4, 1931, p. 12. Reprinted as "Downtown Gallery's Exhibition of His Work Proves a Lively One (1931)" in *Stuart Davis*, edited by Diane Kelder, pp. 191–92. Documentary Monographs in Modern Art. New York, Washington, and London: Praeger, 1971.

McCoy, Garnett. "The Artist Speaks: Part 4, Reaction and Revolution 1900–1930." *Art in America* 53, 4 (August–September 1965), pp. 68–87.

————. "The Artist Speaks: Part 5, Poverty, Politics and Artists 1930–1945." *Art in America* 53, 4 (August–September 1965), pp. 88–107.

McLaughlin, Lillian. "A Happy Conjunction of Life and Art on Drake University Campus." *Tribune* [Des Moines], February 15, 1964.

"Modern Art in Chaos: Painter Stuart Davis Takes a Stand for Non-Objectivity Against the Unbelievers." *Cue*, June 19, 1948, p. 17.

Monroe, Gerald M. "Art Front." *Archives of American Art Journal* 13 (1973), pp. 13–19.

Mumford, Lewis. "The Art Galleries: The Rockefeller Collection." *The New Yorker*, January 7, 1933, p. 53.

M[unro], E[leanor] C. "Reviews and Previews: Stuart Davis." *Artnews* 59, 4 (Summer 1960), p. 14.

M[unsterberg], H[ugo]. "Stuart Davis." *Arts Magazine* 32, 9 (June 1958), p. 59. [Review of Delacorte Gallery exhibition.]

N[ewbill], A[l]. "Early Stuart Davis." *The Art Digest* 28, 14 (April 15, 1954), pp. 22–23. For correction, see "Letter to the Editor." *The Art Digest* 28, 16 (May 15, 1954), p. 3.

"New Fine Art Stamp Is Unveiled." *The New York Times*, December 3, 1964, p. 24.

"A New U.S. Stamp." *American Artist* 28, 10 (December 1964), p. 8.

"New York by Stuart Davis." *The New York Sun*, April 16, 1934, p. 16.

"New York Criticism: Stuart Davis and Abstraction." *The Art Digest* 8, 16 (May 15, 1934), p. 14.

"New York Season: Exhibition at the Downtown Gallery." *The Art Digest* 4, 9 (February 1, 1930), p. 17.

"Obituary: Stuart Davis, 69, Leading Painter." *New York Herald-Tribune*, June 26, 1964, p. 6.

O'Connor, John, Jr. "Painting in the United States, 1944: A Review of the Founder's Day Exhibition." *The Carnegie Magazine* 18 (October 1944), pp. 143–51.

O'Doherty, Brian. "Stuart Davis: A Memoir." *Evergreen Review* 10, 39 (February 1966).

"Painting for Preserves." *Time*, May 19, 1958, pp. 79–80. [Concerning *Composition Concrete*, Davis's mural for the H. J. Heinz Company.]

Paul, Elliot. "Stuart Davis, American Painter." *transition* 14 (Fall 1928), pp. 146–48. Reprinted in *Stuart Davis*, edited by Diane Kelder, pp. 189–91. Documentary Monographs in Modern Art. New York, Washington, and London: Praeger, 1971.

Phillips, Duncan. "Modern Wit in Two-Dimensional Design." *A Bulletin of the Phillips Memorial Gallery*, pp. 19–23. Washington, D.C.: Phillips Memorial Gallery, 1932.

Raynor, Vivien. "Art: 'Drawn' Paintings in Stuart Davis Show." *The New York Times*, November 22, 1985, p. C 26.

————."Art: Stuart Davis." *The New York Times*, August 14, 1987, p. C 29.

Reinhardt, Ad. "About Artists by Artists: Stuart Davis." *New Masses* 57, 9 (November 27, 1945). Reprinted as "Review of Stuart Davis Exhibition at The Museum of Modern Art (1945)" in *Stuart Davis*, edited by Diane Kelder, p. 196. Documentary Monographs in

Modern Art. New York, Washington, and London: Praeger, 1971.

Reisner, Robert George. "Writer Compares Modern Art and Jazz." *Down Beat*, November 16, 1951, p. 6.

"Reviews and Previews." *Artnews* 57, 4 (Summer 1958), p. 14.

R[iley], M[aud]. "Stuart Davis Exhibits His Abstracted Views." *The Art Digest* 17, 9 (February 1, 1943), p. 7.

Rosenberg, Harold. "The Art World: The Last Exiles." *The New Yorker*, April 3, 1978, pp. 108–11.

Russell, John. "Stuart Davis: The Hoboken Series." *The New York Times*, February 10, 1978, sect. 3, p. 20.

————. "Art: Stuart Davis Cameo Opens at the Whitney." *The New York Times*, August 22, 1980, p. C 18.

————. "Art: A Show of Comics at Downtown Whitney." *The New York Times*, August 12, 1983, p. C 21.

————. "Art: Compelling Show of Early Stuart Davis." *The New York Times*, November 11, 1983, sect. 3, p. 22.

Sargeant, Winthrop. "Why Artists Are Going Abstract: The Case of Stuart Davis." *Life* 22, 7 (February 17, 1947), pp. 78–83.

Seckler, Dorothy Gees. "Stuart Davis Paints a Picture." *Artnews* 52, 4 (Summer 1953), pp. 30–33, 74–75.

Shirey, David L. "A Warm, Humorous View of the City." *The New York Times*, May 20, 1979, sect. 11, p. 25.

Shuster, Alvin. "Stamps for Art's Sake." *The New York Times Magazine*, September 20, 1964, p. 30.

Smith, Roberta. "Drawing Now (And Then)." *Art Forum* 14, 8 (April 1976), pp. 52–59.

————. "Stuart Davis, Picture-Builder." *Art in America* 64, 5 (September–October 1976), pp. 80–87.

————. "Art: The Apprenticeship of Stuart Davis as a Cubist." *The New York Times*, November 27, 1987, p. C 26.

————. "The Land and Sea of Stuart Davis, Quick Study." *The New York Times*, March 2, 1990, p. C 30.

Storr, Robert. "Stuart Davis at Washburn." *Art in America* 72, 1 (January 1984), p. 129.

"Stuart Davis." *Arts Magazine* 52 (May 1978), p. 34. [Review of Hirschl & Adler Galleries exhibition.]

"Stuart Davis." *The New York Times*, January 31, 1976, p. 21. [Review of Zabriskie Gallery exhibition.]

"Stuart Davis at the Downtown Gallery." *Artnews* 44, 19 (January 15–31, 1946), p. 23.

"Stuart Davis, Painter of Abstracts, Dies From Heart Attack." *New York World-Telegram and Sun*, June 26, 1964, p. 23.

"Stuart Davis Retrospective." *Limited Edition* 4 (November 1945), pp. 1–2.

"Stuart Davis Retrospective." *New York Herald-Tribune*, October 21, 1945, sect. 5, p. 7.

"Stuart Davis, the Difficult." *The Art Digest* 6, 2 (April 1932), p. 2.

"Stuart Davis: 'Un Peintre de l'abstrait.'" *U.S.A.: Revue Américaine* [Published by the U.S. Office of War Information] 2, 7 (1945), pp. 96–97.

Sullivan, Karen, and Delores McBroome. "Manhattan Masterpiece: Was Stuart Davis's Radio City Mural the American Blueprint for Picasso's *Guernica*?" *Art & Antiques*, December 1989, pp. 43–44.

Sundell, Margaret. "Lost WPA Murals Rediscovered." *The Journal of Art* 1 (June–July 1989), p. 3.

Sweeney, James Johnson. "Sweeney Setting His American Scene." *Artnews* 49 (May 1950), pp. 18–20, 56–57.

"Sweeney Picks Payne Medal Winners." *Richmond Times-Dispatch*, May 6, 1950.

Sylvester, David. "Expressionism, German and American." *Arts Magazine* 31, 3 (December 1956), pp. 25–27.

Teilman, Herdis Bull. " 'Composition Concrete,' 1957, by Stuart Davis." *Carnegie Magazine* 54 (May 1980), pp. 4–9.

Tillim, Sidney. "Month in Review: Stuart Davis Exhibition at the Downtown Gallery." *Arts Magazine* 34, 9 (June 1960), pp. 48–49.

"Two Grand Old Men Win Two Big Prizes." *Time*, February 7, 1964, pp. 74–75. [Concerning Guggenheim International Award.]

T[yler], P[arker]. "Reviews and Previews." *Artnews* 55, 7 (November 1956), p. 6.

Urdang, Beth. "Stuart Davis." *Arts Magazine* 51, 3 (November 1976), p. 6.

Valentine, Ross. "The Case of the *Little Giant*." *Richmond Times Herald*, May 28, 1950.

"Varèse Returns with Praise for American Art Progress: Names Stuart Davis as Foremost Painter of Modern School." *New York Herald*, January 4, 1929.

Vaughan, Malcolm. "Modern Art Mural Exhibit—A Sorry Show." *New York American*, May 7, 1932, p. 32.

"The Virginia Museum Picks Its Winners." *The Art Digest* 24, 16 (May 15, 1950), p. 17.

Weisenborn, Fritzi. "Stuart Davis Exhibition at Katharine Kuh Galleries." *Sunday Times* [Chicago], February 5, 1939.

"Whitney Studio Club Gives Black and White Exhibition." *New York American*, April 22, 1928, p. M 8.

Wight, Frederick S. "Profile: Stuart Davis." *The Art Digest* 27, 16 (May 15, 1953), pp. 13, 23.

Wilkin, Karen. "Stuart Davis in His Own Time." *The New Criterion* 6, 5 (January 1988), pp. 50–55.

———. "Stuart Davis: The Cuban Watercolors." *Latin American Art* 2, 2 (Spring 1990), pp. 39–43.

Wilson, Patricia Boyd. "Eggbeater No. 1." *The Christian Science Monitor*, November 16, 1970.

Wolf, Ben. "Stuart Davis: Thirty Years of Evolution." *The Art Digest* 20, 3 (November 1, 1945), pp. 10, 34.

———. "The Digest Interviews: Stuart Davis." *The Art Digest* 20, 6 (December 15, 1945), p. 21.
For correction, see *The Art Digest* 20, 7 (January 1, 1946), p. 23.

Selected Group-Exhibition Catalogues and Related Publications

In Chronological Sequence

International Exhibition of Modern Art ["Armory Show"] (exhib. cat.). New York: Association of American Painters and Sculptors, 1913.

Glenn Coleman and Stuart Davis (exhib. cat.). New York: Valentine Gallery, 1928.

Paris by Americans (exhib. pamphlet). New York: The Downtown Gallery, 1928.

A Small Intimate Exhibition (exhib. pamphlet). New York: Société Anonyme, Inc., 1928.

American Print Makers: Third Annual Exhibition (exhib. cat.). New York: The Downtown Gallery, 1929.

Fifty Prints of the Year (exhib. pamphlet). New York: The American Institute of Graphic Arts, 1930–31.

Old and Modern Masters in the New York Art Market: From the Collections of Leading New York Dealers (exhib. cat.). New York: American Art Association/Anderson Galleries, 1931.

Painting and Sculpture by Living Americans: Ninth Loan Exhibition (exhib. cat.). New York: The Museum of Modern Art, 1931.

Murals by American Painters and Photographers (exhib. cat.). Foreword by Nelson Rockefeller and Lincoln Kirstein; essays by Lincoln Kirstein and Julien Levy. New York: The Museum of Modern Art, 1932.

First Biennial Exhibition of Contemporary American Painting (exhib. cat.). Foreword by Juliana Force. New York: Whitney Museum of American Art, 1933.

Practical Manifestations in American Art: Davis, Fiene, Hirsch, Kuniyoshi, Laurent, Nakian, Shahn, Sheeler, Zorach (exhib. cat.). Introduction by Edith Gregor Halpert. New York: The Downtown Gallery, 1934.

Abstract Painting in America (exhib. cat.). Introduction by Stuart Davis. New York: Whitney Museum of American Art, 1935.

American Artists' Congress: First Annual Membership Exhibition (exhib. cat.). New York: American Artists' Congress, Inc., 1937.

American Artists Congress: Second Annual Membership Exhibition (exhib. cat.). Essay by national chairman Stuart Davis. New York: American Artists Congress, 1938.

Artists for Victory: An Exhibition of Contemporary American Art (exhib. cat.). Foreword by Francis Henry Taylor. New York: The Metropolitan Museum of Art, 1942.

Four Modern American Painters: Peter Blume, Stuart Davis, Marsden Hartley, Jacob Lawrence (exhib. brochure). Boston: Institute of Contemporary Art, 1945.

Three Contemporary Americans: Carl Zerbe, Ralston Crawford, Stuart Davis (exhib. pamphlet). Chicago: The Arts Club of Chicago, 1945.

Abstract and Surrealist American Art (exhib. cat.). Texts by Daniel Catton Rich, Frederick A. Sweet, and Katharine Kuh. Chicago: The Art Institute of Chicago, 1948.

Creative Art for Commerce (exhib. pamphlet). New York: The Downtown Gallery, 1950.

Abstract Painting and Sculpture in America (exhib. cat.). Essay by Andrew Carnduff Ritchie; catalogue by Margaret Miller; bibliography by Bernard Karpel. New York: The Museum of Modern Art, 1951.

Forty American Painters, 1940–1950 (exhib. cat.). Preface by H. H. Arnason. Minneapolis: The University Gallery, University of Minnesota, 1951.

New Mexico as Painted by Stuart Davis, Marsden Hartley, Yasuo Kuniyoshi, John Marin, Georgia O'Keeffe, John Sloan (exhib. pamphlet). New York: The Downtown Gallery, 1957.

Nine American Painters (exhib. cat.). Salt Lake City: University of Utah, 1958.

The Dial and the Dial Collection (exhib. cat.). Worcester, Massachusetts: Worcester Art Museum, 1959.

Friedman, Martin L. *The Precisionist View in American Art* (exhib. cat.). Minneapolis: Walker Art Center, 1960.

Ten Americans (exhib. cat.). Milwaukee: Milwaukee Art Center, 1961.

Agee, William C. *The 1930's: Painting and Sculpture in America* (exhib. cat.). New York: Whitney Museum of American Art, 1968.

Geldzahler, Henry. *New York Painting and Sculpture: 1940–1970* (exhib. cat.). New York: E. P. Dutton and Co., in association with The Metropolitan Museum of Art, 1969.

The Thirties Decade: American Artists and Their European Contemporaries (exhib. cat.). Foreword by Richard N. Gregg; introduction by William A. McGonagle; essay by Allen Porter. Omaha: Joslyn Art Museum, 1971.

Lawrence, Ellen. *Graham, Gorky, Smith, and Davis in the Thirties* (exhib. cat.). Providence: David Winton Bell Gallery, Brown University, 1977.

Paris–New York (exhib. cat.). Essays by Pontus Hulten et al. Paris: Centre National d'Art et de Culture Georges Pompidou, 1977.

Park, Marlene, and Gerald E. Markowitz. *New Deal for Art* (exhib. cat.). Hamilton, New York: Gallery Association of New York State, 1977.

Seckler, Dorothy Gees. *Provincetown Painters, 1890s–1970s* (exhib. cat.). Edited and with a foreword by Ronald A. Kuchta. Syracuse, New York: Everson Museum of Art, 1977.

Tritschler, Thomas. *American Abstract Artists* (exhib. cat.). Albuquerque, New Mexico: University Art Museum, 1977.

Tashjian, Dickran. *William Carlos Williams and the American Scene, 1920–1940* (exhib. cat.). New York, Berkeley, Los Angeles, and London: Whitney Museum of American Art, in association with the University of California Press, 1978.

The Dial: Arts and Letters in the 1920s. Edited by Gaye L. Brown. Worcester, Massachusetts: Worcester Art Museum, 1981.

The Edith and Milton Lowenthal Collection (exhib. cat.). New York: The Brooklyn Museum, 1981.

American Artists Abroad 1900–1950 (exhib. cat.). New York: Washburn Gallery, 1982.

Carlin, John, and Sheena Wagstaff. *The Comic Art Show: Cartoons in Painting and Popular Culture* (exhib. cat.). New York: Whitney Museum of American Art, Downtown Branch, 1983.

Lane, John R., and Susan C. Larsen, eds. *Abstract Painting and Sculpture in America, 1927–1944* (exhib. cat.). Pittsburgh and New York: Museum of Art, Carnegie Institute, and Harry N. Abrams, Inc., 1983.

One Hundred Masterpieces of American Painting from Public Collections in Washington, D.C. (exhib. cat.). Washington, D.C.: Smithsonian Institution Press, 1983.

American Masters: The Thyssen-Bornemisza Collection (exhib. cat.). Introduction by John I. H. Baur. Lugano: International Exhibitions Foundation, 1984. [Circulating exhibition.]

Zurier, Rebecca. *Art for The Masses (1911–1917): A Radical Magazine and its Graphics* (exhib. cat.). Foreword by Alan Shestack; additional texts by Earl Davis and Elise K. Kenney. New Haven: Yale University Art Gallery, 1985.

Eldredge, Charles C., Julie Schimmel, and William H. Truettner. *Art in New Mexico, 1900–1945: Paths to Taos and Santa Fe* (exhib. cat.). Washington, D.C., and New York: National Museum of American Art, Smithsonian Institution, and Abbeville Press, 1986.

Wilson, Richard Guy, Dianne H. Pilgrim, and Dickran Tashjian. *The Machine Age in America, 1918–1941* (exhib. cat.). New York: The Brooklyn Museum, in association with Harry N. Abrams, Inc., 1986.

Six Abstract Painters (exhib. brochure). New York: Grace Borgenicht Gallery, 1987.

Stich, Sidra. *Made in U.S.A.: An Americanization in Modern Art, the '50s and '60s* (exhib. cat.). Berkeley, Los Angeles, and London: University of California Press, 1987.

Wagstaff, Sheena. *Comic Iconoclasm* (exhib. cat.). London: Institute of Contemporary Arts, 1987.

The Blues Aesthetic: Black Culture and Modernism (exhib. cat.). Essays by Richard J. Powell et al. Washington, D.C.: Washington Project for the Arts, 1989.

Over Here: Modernism, The First Exile, 1914–1919 (exhib. cat.). Kermit S. Champa, developer. With essays by Robert Branfron et al. Providence: David Winton Bell Gallery, Brown University, 1989.

Varnedoe, Kirk, and Adam Gopnik. *High and Low: Modern Art, Popular Culture* (exhib. cat.). New York: The Museum of Modern Art and Harry N. Abrams, Inc., 1990.

Related Publications

In Alphabetical Sequence

Baigell, Matthew. *The American Scene: American Painting of the 1930's.* American Art and Artists. New York and Washington: Praeger, 1974.

Barr, Alfred H., Jr. *What Is Modern Painting?* Introductory Series to Modern Art, 2. 5th, rev. ed. New York: The Museum of Modern Art, 1952.

———. *Masters of Modern Art.* New York: The Museum of Modern Art, 1954.

Baur, John I. H. *Revolution and Tradition in Modern American Art.* Cambridge, Massachusetts: Harvard University Press, 1951.

Berman, Avis. *Rebels on Eighth Street: Juliana Force and the Whitney Museum of American Art.* New York: Atheneum, 1990.

Blesh, Rudi. *Modern Art USA: Men, Rebellion, Conquest, 1900–1956.* New York: Alfred A. Knopf, 1956.

Brown, Milton W. *American Painting from the Armory Show to the Depression.* Princeton: Princeton University Press, 1955.

Buettner, Stewart. *American Art Theory 1945–1970.* Studies in the Fine Arts: Art Theory. Ann Arbor: U. M. I. Research Press, 1981.

Cummings, Paul. *American Drawings: The Twentieth Century.* New York: The Viking Press, 1976.

Genauer, Emily. *Best of Art.* Garden City, New York: Doubleday, 1948.

Heimann, Robert K. *Tobacco and Americans.* New York: McGraw-Hill, 1960.

Henri, Robert. *The Art Spirit.* New York: Harper & Brothers, 1923.

Janis, Sidney. *Abstract and Surrealist Art in America.* New York: Reynal & Hitchcock, 1944.

McKinzie, Richard D. *The New Deal for Artists.* Princeton: Princeton University Press, 1973.

O'Connor, Francis V., ed. *Art for the Millions: Essays from the 1930s by Artists and Administrators of the WPA Federal Art Project.* Greenwich, Connecticut: New York Graphic Society, 1973.

O'Doherty, Brian. *American Masters: The Voice and the Myth.* Photographs by Hans Namuth. New York: Random House [1973]. 2nd ed. New York, Universe Books, 1988. Paperback ed., without photographs: *American Masters: The Voice and the Myth in Modern Art.* New York: E. P. Dutton, 1982.

Turner, Elizabeth Hutton. *American Artists in Paris 1919–1929.* Ann Arbor and London: U. M. I. Research Press, 1988.

Whiting, Cecile. *Antifascism in American Art.* New Haven and London: Yale University Press, 1989.

Zurier, Rebecca. *Art for The Masses: A Radical Magazine and its Graphics, 1911–1917.* Introduction by Leslie Fischbein; artists' biographies by Elise K. Kenney and Earl Davis. Philadelphia: Temple University Press, 1988. [Based on the 1985 exhibition catalogue.]

Index

Photograph Credits

Photographs have been supplied by the lenders, with the exception of the following:

Abbeville Press, New York: fig. 53; Armen Photographers, The Newark Museum, New Jersey: fig. 104, cat. no. 62; Tom Barr Photography, Pittsburgh: cat. no. 68; Scott Bowron Photography, New York: figs. 15, 18, 27, 30, 33, 38–41, 77, 83, cat. nos. 11, 12, 17, 25, 34, 36, 38, 67, 143; Will Brown: cat. no. 19; Michael Cavanagh and Kevin Montague: cat. no. 114; Geoffrey Clements, Staten Island, New York: figs. 2, 12, 67, 73, 74, 118, 124, cat. nos. 65, 73, 92, 112, 146; Delaware Art Museum, Wilmington: figs. 21, 24, 25; Richard L. Feigen & Co., Inc., New York: cat. no. 98; Lynton Gardiner, New York: figs. 56, 61, 116, cat. nos. 7, 26, 56, 66, 79, 91, 106, 123, 125, 131, 135, 139, 142, 151, 161, 172; Emil Ghinger: cat. no. 77; Carmelo Guadagno: cat. no. 155; Helga Photo Studio, Upper Montclair, New Jersey: fig. 19; Hickey-Robertson, Houston: cat. no. 33; Historical Society of Pennsylvania, Philadelphia: fig. 20; Tom Jenkens, Dallas Museum of Art: cat. no. 83; Bob Kolbrener, Saint Louis: cat. no. 72; Michael Korol: cat. no. 130; Kruger Photographic Services Corp., Reno, Nevada: cat. no. 126; R. Lemke, Amon Carter Museum, Fort Worth: cat. no. 164; L.

Lorenz, Amon Carter Museum, Fort Worth: cat. no. 29; Robert E. Mates Studio, New Jersey: cat. nos. 61, 82; Jerry Mathiason, Minneapolis: cat. no. 122; Michael McKelvey: cat. no. 101; Mr. and Mrs. J. H. Motes, Stamford, Connecticut: figs. 105, 106; Museum of Fine Arts, Boston: fig. 8, cat. nos. 88, 171; Henry Nelson: cat. no. 116; Otto Nelson: cat. no. 86; Osamu Nishihira: figs. 22, 23, 26, 28, 29; David Penney, Des Moines, Iowa: cat. no. 156; Photo R.M.N. (Réunion des Musées Nationaux): fig. 17; Photography Unlimited by Dorn's Inc., Red Bank, New Jersey: cat. nos. 108, 137; Eric Pollitzer, Hempstead, New York: cat. no. 118; Dick Ruddy, Albuquerque, New Mexico: fig. 90; Terry Schank, Chicago: cat. no. 166; Daniel Skira & Partners: fig. 148; Lee Stalsworth: fig. 45, cat. nos. 43, 57, 78, 105, 147; Jim Strong, Inc., New York: cat. no. 26; Joseph Szaszfai, Yale University Art Gallery, New Haven, Connecticut: fig. 6, cat. no. 145; Taylor & Dull, Inc., New York: cat. no. 111; Ron Testa, Wilmette, Illinois: fig. 84; William Thornton, Artech, Inc. Fine Arts Services, Seattle, Washington: cat. no. 138; Charles Uht, New York: cat. nos. 167, 170; Malcolm Varon, New York: cat. nos. 157, 162; Washburn Gallery, New York: fig. 46, cat. nos. 20, 28, 31, 35, 117; George Wettling: page 16.